P9-CKT-327

Paul Klee Rediscovered

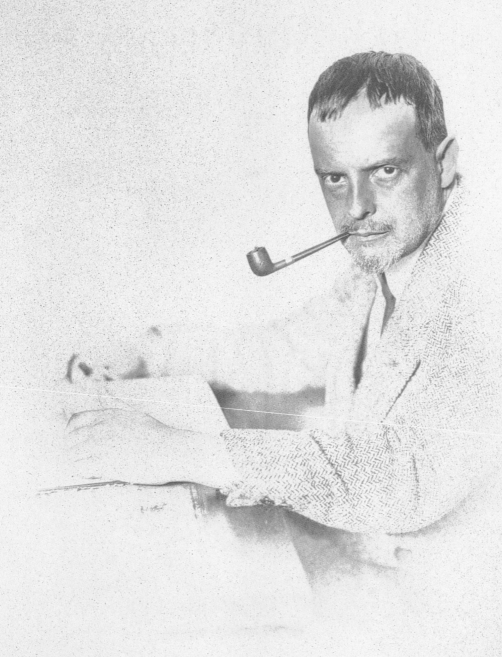

für Frau Hanny Bürgi
in Freundschaft 1924

Klee

Paul Klee Rediscovered

Works from the Bürgi Collection

Edited by

Stefan Frey and Josef Helfenstein

Merrell Publishers

Copyright © 2000 Merrell Publishers Limited, London, Kunstmuseum Bern/Paul-Klee-Stiftung, ProLitteris, Zurich, D.A.C.S., London, and the authors

All rights reserved. No part of this publication may be reproduced, stored in a retrieval system, or transmitted in any form or by any means without the prior written permission of the copyright owners and the publishers.

First published in 2000 by
Merrell Publishers Limited
42 Southwark Street
London SEI IUN
www.merrellpublishers.com

Distributed in the USA and Canada by Rizzoli International Publications, Inc.
through St Martin's Press, 175 Fifth Avenue, New York, New York 10010

British Library Cataloguing-in-Publication Data:
Frey, Stefan
Paul Klee rediscovered
1.Klee, Paul, 1879–1940 – Exhibitions
2.Painting, Swiss – Exhibitions
3.Painting, Modern – 20th century – Switzerland
I.Title
II.Helfenstein, Josef
759.9'494

ISBN 1 85894 115 6

This publication has been financially assisted by Pro Helvetia, Arts Council of Switzerland.

Cover Illustration: Paul Klee, *Fire Source*, 1938 (cat. no. 135)
Frontispiece: Paul Klee, Wiesbaden, 1924, dedication: "für Frau Hanny Bürgi in Freundschaft 1924 Klee" (to my friend Hanny Bürgi 1924 Klee)

Catalogue

Conceived by: Stefan Frey, Josef Helfenstein
Edited by: Janis Adams, Stefan Frey, Keith Hartley; Christine Flechtner, Steffan Biffiger (Benteliteam)
Jacket designed by: Matthew Hervey
Designed by: Arturo Andreani (Benteliteam)
Translated by: Fiona Elliot, Nigel Bagshaw
Photographs: Peter Lauri, Bern, for the works by Paul Klee; for others see photographic credits
Photolithography: Images 3 SA, Lausanne
Overall production: Benteli Verlags AG, Wabern/Bern
Printed by: Benteli Hallwag Druck AG, Wabern/Bern

Printed and bound in Switzerland

CONTENTS

Alexander Klee Preface 7

Christoph Bürgi Foreword 8

Stefan Frey Hanni Bürgi-Bigler, Collector and Patron of Paul Klee: 11
The History of the Collection

Josef Helfenstein Meeting Place: The Bürgi Collection 33
Paul Klee's Life and Work

Michael Baumgartner *Fire Source*, 1938 166

Nathalie Bäschlin, Béatrice Ilg, Patrizia Zeppetella Paul Klee's Painting Equipment: 183
Working Processes and Picture Surfaces

Stefan Frey Rolf Bürgi's Commitment to Paul and Lily Klee 199
and the Creation of the Paul Klee Foundation

Osamu Okuda "Return to Old Haunts": 219
The Paul Klee Exhibition at the Kunsthalle Bern in 1935

Richard Calvocoressi Klee's Reception in Scotland and England 1930–1945 229

Wolfgang Kersten Paul Klee: The *Bürgi Sketchbook*, 1924/25 247
Introduction to an Analysis of His Technical Methods

Stefan Frey Appendix: Reports and Documents 255
List of Exhibitions 269
List of Works 270
Bibliography / List of Abbreviations 283
Index of Names 285
Photographic Credits 287

PREFACE

The life of my grandfather Paul Klee was closely linked with the city of Bern; important parts of his œuvre were created in Bern – notably his late works, which came to mean so much on a personal level to the Bürgi family through their support for the émigré artist. It is exceptional both for the city of Bern and for the wider cultural landscape of Switzerland that a new museum is to be built, dedicated to the work of Paul Klee. This will give his œuvre a new focal point and will bring together the heritage of this great 20th-century artist in unique concentration. For generations to come the Paul Klee Museum, initiated by his descendants and already in the planning stages, will be at the heart of research into the life and work of Paul Klee.

It is therefore particularly fortuitous that this important incentive should coincide with the first public presentation of the entire collection of works by Klee owned by the Bürgi family. The meticulous documentation in this catalogue and in the February issue of the journal *Du* not only tell the history of the Bürgi Collection but also shed new light on an important part of the history of the artist's estate. The generous provision of access to the archives of the Bürgi family, which were consulted in conjunction with documents from the archives of the descendants of Paul Klee, has made it possible to present a detailed account of the past shared by the Bürgi and Klee families.

It is a good omen for the future that today the Bürgi and Klee families, setting aside old misunderstandings, are once again working together to realise the vision they first had in the 1940s for the estate of the artist Paul Klee.

Alexander Klee

FOREWORD

The first presentation of the Bürgi Collection with its approximately 150 works offers the reader an overview of the whole of Paul Klee's development as an artist. Having been assembled during the lifetime of the artist (1879–1940) and his widow Lily Klee (1876–1946) the collection also tells of my grandmother's and my father's taste and their loyality to Paul Klee which was to be so significant to his life and work.

Numerous documents and personal dedications bear witness to the long friendship between my grandmother Hanni Bürgi (1880–1938), her son Rolf (1906–1967) – my father – and Paul and Lily Klee. Hanni Bürgi, whose husband Alfred Bürgi was the owner of a construction company in Bern, was deeply interested in the arts and took private singing lessons with Paul Klee's father, Hans Klee. Through this connection she met the young artist by 1908 at the latest and soon afterwards bought a number of drawings, the first of many purchases. Hanni Bürgi was not only the first serious collector of Klee's works, but with these purchases she was also laying the foundations of the present Bürgi Collection; by the late 1930s it contained ca. 70 works and Rolf Bürgi continued to add to the collection after the death of his mother.

The early enthusiasm shown by my grandmother is all the more remarkable, in that the young Klee was little known and scarcely appreciated at the time. Hanni Bürgi acquired much of her collection as a member of the Klee Society set up by the collector Otto Ralfs of Braunschweig in 1925. Paul Klee expressed his gratitude to his first patroness for her support and her faith in his art with numerous gifts. After emigrating in late 1933 from Düsseldorf to Bern, Paul and Lily Klee enjoyed close friendly contact with Hanni Bürgi, her son Rolf and her daughter-in-law Käthi, my mother. In 1935, in response to a suggestion from Hanni Bürgi, the Kunsthalle Bern put on the first major exhibition of Klee's work in Switzerland.

My father, who was often in the company of the Klees even as a child, was still only a schoolboy when he purchased his first work by Paul Klee. After the

Klees' apartment in Dessau had been searched by the German police and the SA in 1933, it was Rolf Bürgi who intervened and secured the return of confiscated papers as well as Paul and Lily Klee's exit permits. From 1933 until the death of Paul Klee, my father supported the Klees as a friend and adviser in all matters. After that he took over the administration of the artist's estate on behalf of Lily Klee and her son Felix. In this capacity, shortly before Lily Klee's death in 1946, he oversaw the sale of the entire estate to the Bern collectors Hermann Rupf and Hans Meyer-Benteli, the publisher, in order to prevent it being liquidated to the benefit of war compensations in accordance with the Washington Agreement. On the initiative of my father, in 1947 Hermann Rupf, Hans Meyer-Benteli, Rolf Bürgi himself and the Bern architect Werner Allenbach set up the Paul Klee Foundation, which has had its home in the Kunstmuseum Bern since 1952.

Since the marriage of my parents, each new member of the family has shared the love for Paul Klee's art and contributed in one way or another to looking after the collection.

Stefan Frey and Josef Helfenstein, curator of the Paul Klee Foundation, have been jointly responsible for the concept and preparation of this book. I should like to express my gratitude to them and to all those who have been involved in the realisation of this publication. My gratitude also goes to the Benteli team for their care in its production. This English-language edition has been edited by Keith Hartley and Janis Adams of the National Galleries of Scotland.

Christoph Bürgi

STEFAN FREY

HANNI BÜRGI-BIGLER, COLLECTOR AND PATRON OF PAUL KLEE: THE HISTORY OF THE COLLECTION

While Hanni Bürgi became something of a patron of the arts through her
Klee collection, the real driving force sweeping her along was her burning
interest in what was going on in the arts in general […].
Unaffected by the weight of refined tradition, for her family was
part country folk part bourgeoisie, Hanni Bürgi's unique instinct led
her to reject anything shallow, her naïve directness drew her to the true
and the genuine in any art form –
whatever proved to be so, became part of her inner being.
(Marguerite Frey-Surbek 1938)

In just over two and a half decades – during which time she was in close contact with Paul Klee – Hanni Bürgi (fig. 4) built up the second largest collection of Klee's pictures in the world.[1] Married to an owner of a construction company in Bern who died suddenly in his forties, she had an unusually fine feel for the arts. Shortly after Hanni Bürgi's death in 1938 Lily Klee wrote: "She was Klee's 1st collector, & she has left a very beautiful, full collection of his works, which reflects the whole of his development as an artist."[2] In fact Hanni Bürgi was not the very first to buy works from Paul Klee – friends and supporters of the artist like the writer Alexander Eliasberg in Munich or the physician Fritz Lotmar and his brother Heinz in Bern had already bought pictures from him earlier than her.[3] Furthermore, between 1910 and the death of her husband in 1919, Hanni Bürgi's purchases were relatively modest in comparison, for instance, with the extensive acquisitions during the same period by the industrialists Bernhard Koehler in Berlin or Oskar Miller in Biberist near Solothurn.[4] Hanni Bürgi, however, has the distinction of having been the most enduringly loyal of all Klee's collectors.

Even during her lifetime Hanni Bürgi was known as a "champion of Paul Klee's art"[5] only to a small circle of friends and Klee enthusiasts. Today, like many of those who once nurtured modern art, she has been all but forgotten.[6] In this essay we will look back at Hanni Bürgi's private and public interest in art, for her support for the arts and her son Rolf's activities on behalf of Paul and Lily Klee were to have a lasting influence on the reception of Klee's art and on cultural life in the city of Bern.

Fig. 1
Elise and Johann
Christian Bigler-
Siegenthaler, Bern,
1903

Fig. 2
Hanni Bürgi,
Bern, 1901

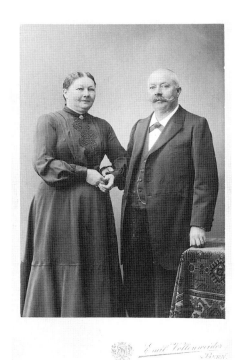

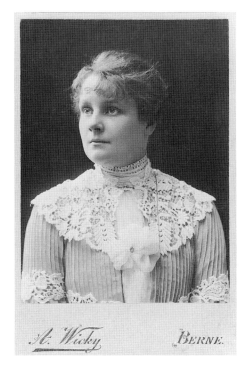

Fig. 1
Elise and Johann
Christian Bigler-
Siegenthaler, Bern,
1903

Fig. 2
Hanni Bürgi,
Bern, 1901

The Biography of Hanni Bürgi-Bigler and Alfred Bürgi

Olga Johanna "Hanni" Bigler came into the world on 23 December 1880 in Waldeck near Bern – now Ostermundigen – as the eighth of nine children born to the innkeepers Johann Christian Bigler (1847–1909) and Elise Bigler, née Siegenthaler (1853–1920) (fig. 1).[7] In 1882[8] the family moved to Bern, where Hanni probably attended the Neue Mädchenschule[9] (New Girls' School) after primary school. In her free time she had to help out in her parents' inn, the "Wirthschaft Bigler-Siegenthaler"[10] at 6 Aarbergergasse, at the corner of Waisenhausplatz. In the public rooms on the ground floor the customers were mainly carriers or market people, while the more elegant restaurant on the first and second floors was, amongst other things, a meeting-place for politicians and intellectuals.[11] Hanni, lively and spirited, is said to have set her sights on higher things even as a young girl, for she was not best pleased to have been born the daughter of country-bourgeois innkeepers.[12]

At barely eighteen and a half, on 1 May 1899 Hanni Bigler (fig. 2) married Alfred Bürgi, a graduate in engineering from the Eidgenössische Technische Hochschule (Federal Technical University) in Zurich who was already making his way as a young entrepreneur in the construction industry.[13] A member of the Guild of Carpenters since 1898, he had been born into an upper middle-class family in Bern on 17 October 1873, the fourth of eight children. His parents were master builder Friedrich Bürgi (1838–1909) and Magdalena Bürgi, née von Känel (born 1846). In compliance with his father's wishes, immediately after graduating he had entered his father's renowned construction company, founded in 1868, and from 1902 he and his father ran the company jointly. During the following seven years the company "Fr. & A. Bürgi"[14] not only fulfilled numerous

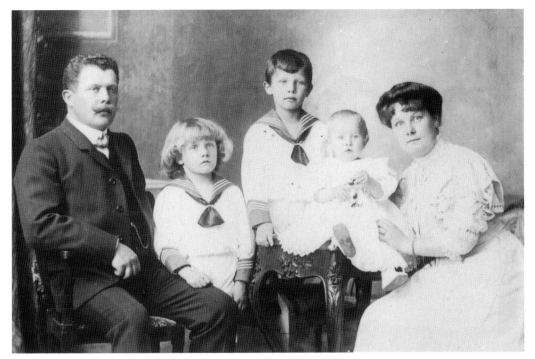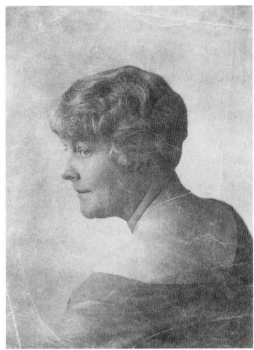

Fig. 3
The Bürgi Family
(left to right: Alfred,
Fredi, Fritz, Rolf and
Hanni), Bern, ca. 1907

Fig. 4
Portrait of Hanni
Bürgi, Bern, 17.6.1926

private commissions, they also – alone or with other construction companies – were responsible for most public buildings in the rapidly expanding federal capital. When Friedrich Bürgi retired from the business in 1909 shortly before his death, Alfred and his youngest brother Hermann (1881–1941)[15] took over the company, which continued to expand as "A. & H. Bürgi"[16] until a recession set in due to the outbreak of war.

The various moves made by the Bürgi family reflect Alfred Bürgi's professional success. A few months after their wedding, Alfred and Hanni Bürgi moved from an apartment house at 14 Länggassstrasse to a two-family house at 16a Erlachstrasse[17] (both properties were owned by Alfred's parents[18]), and it was here that their sons were born: Fritz (1900–1948), Alfred, called "Fredi" (1901–1926) and the considerably younger Rolf (1906–1967) (fig. 3). From 1912 until 1920[19] the Bürgi family lived in their own grand villa at 20 Wildhainweg[20] (fig. 5), in what was once one of the most exclusive residential areas in Bern[21]. To judge by her modish attire, it would seem that Hanni Bürgi fulfilled her duties as mistress of the house with all the required aplomb (fig. 6).

Like his father, the young Alfred Bürgi took up a career in public life.[22] In 1913 he was elected a part-time member of the Municipal Council, and, as a member of the Swiss army, had risen to the rank of Lieutenant Colonel in the Artillery by 1918. There is documentary evidence of his membership in 1917/1918 of the "Verein ‹Kunsthalle Bern›", the "Museums-Gesellschaft Bern", the "Bernische Kunstgesellschaft", and that he was also a passive member of the "Sektion Bern der Gesellschaft Schweiz. Maler, Bildhauer und Architekten" – all of which amply demonstrates his broad interest in culture and the arts.[23] However, barely 46 years old, Alfred Bürgi fell victim to Spanish flu on 2 January 1919 while on active service.[24]

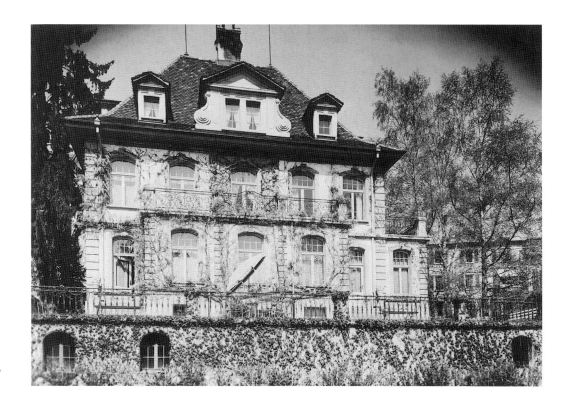

Fig. 5
The south façade
of the Villa Bürgi
at 20 Wildhainweg,
Bern, after 1940

The Links between the Bürgi Family and the Klee Family

By 1908 at the latest Hanni Bürgi was personally acquainted with Paul and Lily Klee.[25] Paul Klee had grown up in Bern, and in 1906, on his marriage to the Munich pianist Lily Stumpf, he moved to his wife's native city, where their only child, Felix, was born in 1907. Besides pursuing his own artistic work Paul Klee was in charge of the household and his son's education, while Lily Klee provided financially for the family for over ten years as a piano teacher and concert pianist. Until he was called to the colours in spring 1916 as a member of the German home guard, the largely unknown and impecunious artist, together with his son and sometimes with his wife too, generally spent the summer and autumn months in Bern with his parents or with relatives at Lake Thun. On his first annual visits Paul Klee and Hanni Bürgi met primarily through their children. As he wrote to Lily in Munich in 1908: "Bubi [Felix] also had a visit from Mrs Bürgi with her three lads".[26] Two years later he reported to her that "Felix had to decline an invitation from Rolf [Bürgi]."[27]

Hanni Bürgi first met Paul Klee in his parents' house (fig. 7).[28] The successful entrepreneur's wife did not devote herself exclusively to her duties as a wife and mother, but also kept some time for her interest in the arts. She played the piano, read widely and by 1903 was taking regular, private singing lessons with the music teacher Hans Klee in his home. The Bern artist Marguerite Frey-Surbek described the progress of her friend's vocal training:

At first Mrs Hanni Bürgi approached the musical sphere with some trepidation, but was then completely caught up by it, and like most of those who studied with Hans Klee – a maestro who made no concessions – she learned

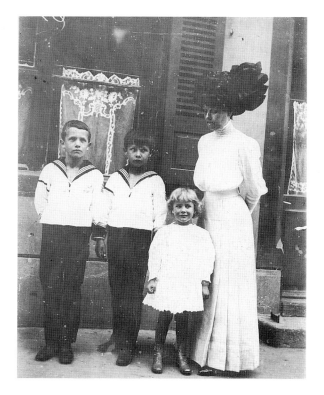

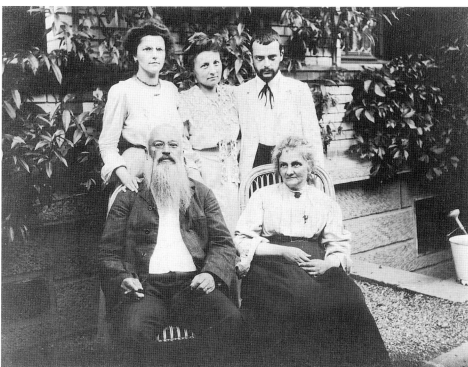

Fig. 6
Hanni Bürgi with
her sons Fritz, Fredi
and Rolf in front
of her parents' inn,
Bern, ca. 1910

Fig. 7
The Klee Family in
the garden of the
house at Obstberg-
weg 6 after the civil
marriage ceremony
of Paul and Lily
Klee-Stumpf (left to
right: Mathilde, Lily
and Paul; seated:
Hans and Ida), Bern,
15.9.1906

*to understand the endlessness of this territory, which in itself preserved her
from dilettantism, and her intensive vocal studies did not lead to 'production'
but to heightened musicality; anyone who heard her singing Brahms or Schu-
bert in those days, did not find themselves – critically or pleasurably – at a con-
cert, but at a short consecration [...].*[29]

The contact between singing teacher and pupil led to a life-long friendship
between the Bürgi and the Klee families; Hans Klee joined the Bürgis for an
evening meal at least once a week. He often went on holiday with them[30] and
Hanni Bürgi continued to concern herself with his well-being when he reached
old age.[31] Paul and Lily Klee were also regular visitors to the Bürgis' house from
1910 onwards,[32] as Lily recorded in her memoirs:

*How many pleasant evenings & hours we spent together in Alfred & Hanny
Bürgi's beautiful, welcoming house on Wildhainweg [...]. In those days I often
accompanied Hanny as she sang with her melodious mezzo voice: Ganymed by
Schubert or "dark as dark["] by J. Brahms. Which was one of her favourite
songs.*[33]

Sometimes Paul Klee used to go with Alfred Bürgi in his light carriage to the Oster-
mundigen quarries[34] (fig. 8) where the company "F. & A. Bürgi" quarried sandstone
for its construction projects between 1906 and at least 1910.[35] Rolf Bürgi remem-
bered these excursions: "He used to draw, while my father was busy with his em-
ployees and the workers."[36] Paul Klee notably incorporated and developed motifs
from the quarry and the stone-cutting site in Waldeck[37] – the birthplace of Hanni
Bürgi – in both drawings and watercolours between 1907 and 1915 (cat. nos. 17,
27, 28).[38]

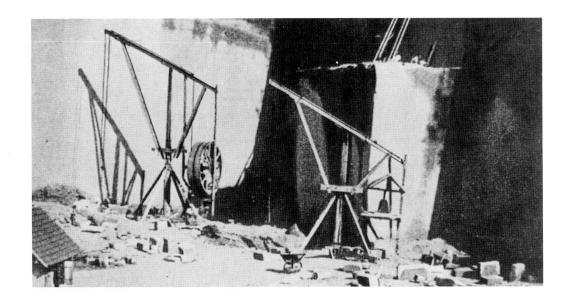

Fig. 8
Ostermundigen
quarry with crane,
ca. 1900

Alfred and Hanni Bürgi's First Acquisitions of Works by Paul Klee

In 1909 or 1910[39] Alfred and Hanni Bürgi purchased the pen, ink and wash drawing *Gepflegter Waldweg*, 1909,62 (cat. no. 21) privately from Paul Klee for 100 francs. This was their first purchase from the artist, and it shows an area of woodland at "Waldegg b. bern"[40] – probably an alternative spelling for the birthplace of Hanni Bürgi. In 1915, in all likelihood during Klee's last summer visit to Bern before he was called up into the German army, the Bürgis bought three watercolours in grey tones (at 100 francs each) with views of Lake Stockhorn in Simmental in the Bernese Alps (cat. nos. 44–46), and received the charcoal drawing *Strasse in der Hirschau*, 1907,22 (cat. no. 13) as a present from the artist. In his œuvre catalogue, Paul Klee records Alfred Bürgi as the owner of these "sheets", as he called them,[41] although it was the latter's wife Hanni who had instigated the transaction. As Rolf Bürgi reported, his mother had also had the courage to hang Klee's works in her own home "despite energetic protests from her family and friends"[42]. He later said:

> *Almost everyone who came to the house thought the paintings were impossible, and my father will certainly also have had his doubts. But since he had great respect for Klee, father and son, he tolerated his art out of human fellow-feeling.*[43]

During the war years from 1916–1918, the Bürgi family in Bern and the Klees in Munich maintained contact with each other[44]; Alfred's brother Emil Bürgi, a professor of pharmacology and physiological chemistry, a poet and a collector,[45] even tried in 1917 and 1918 to arrange leave abroad for Paul Klee who was stationed in the flying school at Gersthofen.[46] However, Hanni Bürgi did not add to her small collection of Klee's works until mid-1919, a few months after her husband's sudden death. Once again she made her purchase directly from the artist, this time during his first summer visit after the war to his parents' house in Bern. She paid a total of 700 francs for the three watercolours *Schiffsrevue*, 1918,9[47] (cat. no. 51), *Sonne im Garten*, 1918,60 and *Der Mond war im Abnehmen und*

zeigte mir die Fratze eines Engländers eines berüchtigten Lord's, 1918,147.[48]
Shortly after this sale, Paul Klee wrote to his wife:

> *Mrs Bürgi seems a little better now, the pictures she has just bought give her great joy. As far as her appearance goes she seems a little grey, was she already like that last summer? Her posture is slightly bowed. Sometimes she laughs, although she doesn't want to laugh...*[49]

Further Additions to the Klee Collection by Hanni Bürgi

Alfred Bürgi left his family a considerable inheritance, much of which was tied up in the construction company and in property.[50] Nevertheless, due to the economic crisis that followed the war, Hanni Bürgi was obliged somewhat to moderate her bourgeois lifestyle, not least in order to give her sons the education their social standing demanded. Fritz graduated in medicine from Bern.[51] Fredi studied architecture at the Eidgenössische Technische Hochschule in Zurich, and the plan was that he should enter his late father's business. The future of the schoolboy Rolf was undecided as yet.[52] In 1920/1921 Hanni Bürgi sold her villa at 20 Wildhainweg[53] and moved with her sons into an apartment in her own property at 8 Länggassstrasse where they lived for the next ten years.[54]

Hanni Bürgi now used part of the funds at her disposal to acquire works of art. It had become "a pressing need" for the young widow to "pursue her artistic interests"[55]. The purchase of the three Klee pictures in 1919 marked the beginning of the subsequent steady growth of the collection, which the artist actively encouraged by offering discounts on direct sales.[56] It seems from the few surviving documents and the catalogue of the first show of the collection in 1931, that up until 1925 Hanni Bürgi must have purchased several works on paper by Paul Klee each year. The catalogue lists sixteen works acquired between 1908 and 1924, although it is not possible to date their purchase more exactly than this; these include cat. nos. 16, 18, 19, 23, 24, 33, 59, 61, 80.[57]

In the early to mid-1920s, Paul and Lily Klee were only occasionally in the company of Hanni Bürgi. After Klee's professional breakthrough in 1919/1920, he and his wife spent their summer holidays in Germany or on the Mediterranean, and only stopped in Bern when they were passing through. However, with presents such as the first monograph on the artist, by H. von Wedderkop (fig. 9), and a portrait photograph by the renowned Wiesbaden photographer Adolf Elnain (see frontispiece), the artist kept his collector up-to-date with his growing professional reputation. Moreover, in order to provide an opportunity for Hanni Bürgi and other friends to continue to purchase his works directly, it seems that each year he sent a "Swiss folder for private sales"[58] to his family in Bern. In 1919 he had made a particular point of negotiating his right to such private sales in his exclusive contract with the Munich gallery "Neue Kunst – Hans Goltz".[59] In January 1921 he left twenty-eight drawings from between 1908 and 1919 with his sister, each priced at 150 francs, and gave her the following instructions:

> *For Mrs Bürgi the old price of 60 francs each applies. Professor Bürgi is to receive two works to thank him for his trouble. Only the heads should be reserved for Mrs Bürgi, who needs a match for a head already in her collection.*[60]

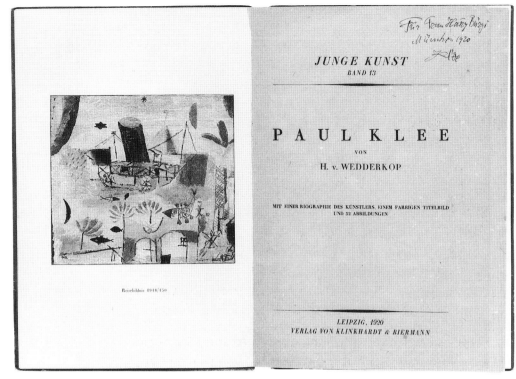

Fig. 9
Title page and
frontispiece of the Klee
monograph
by H. von Wedderkop
with a dedication by
the artist: "Für Frau
Hanny Bürgi München
1920 Klee" (For Mrs
Hanny Bürgi Munich
1920 Klee)

Despite Klee's suggestion, Hanni Bürgi chose *junge Allee*, 1910,18 (cat. no. 22), most probably because she owned relatively few of Klee's early landscape drawings. Professor Emil Bürgi, in return for "medical help," chose two works[61] that have not been identified as yet.

Visits to Weimar and Dessau

In early August 1925, Hanni Bürgi and her son Rolf paid the Klee family a five-day visit to Weimar which Rolf later described:

> We went for walks, every evening there was music, there were long conversations with my mother, but Klee also talked about art with me, and even more about philosophical and religious questions.[62]

Since his earliest childhood Rolf had been aware of Klee's art through his mother's interest:

> Already as a small boy I was present during discussions about Klee's pictures and I heard how vehemently and steadfastly my mother defended his art. Later, after the death of my father, I was allowed to give my opinion when it came to choosing pictures.[63]

The artist fulfilled the 19 year-old's wish to acquire one of his works in his own right, by letting him have the watercolour *Dünenlandschaft* 1924,194 (cat. no. 79) at a special price of 60 francs, payable in twelve monthly instalments of five francs.[64] As a going-away present he gave Hanni Bürgi the lithograph *Kopf*, 1925,84 (cat. no. 84) with the dedication: "for Mrs H Bürgi in memory of the beautiful days in Weimar, August 1925 K".

It seems that in 1926 Fredi Bürgi, Hanni Bürgi's middle son, stayed with Paul and Lily Klee for a week in Weimar. Lily wrote in her memoirs:

He was an architect & very talented, he studied with Le Corbusier in Paris after he had finished his studies at the E.T.H. in Zurich. He [...] visited the Bauhaus & often came to see us.[65]

When Fredi died in an accident in July 1926,[66] his mother travelled "in her suffering to Dessau"[67] to be with the Klees. The following year, in late September or early October 1927, Hanni Bürgi and Rolf once again visited the Klees in Dessau.[68] In the late 1920s, however, Klee and his wife saw Hanni Bürgi more often in Switzerland than in Germany, since they always contacted her even when they were only in Bern for a short while.[69] Between their meetings they corresponded with each other (excerpts from such correspondence as has survived may be found on pp. 255f.).

The Klee Society

In the "long conversations" between Paul Klee and Hanni Bürgi in Weimar in 1925, the subject must also have turned to the Klee Society which the Braunschweig collector Otto Ralfs had set up on Klee's behalf on 1 July 1925. The idea of a Klee Society had been born partly in response to the closure of the Staatliches Bauhaus in Weimar and partly also as a reaction to the dismal state of the art market due to inflation and the persistent economic crisis in Germany. By paying monthly contributions to the Society of at least 50 Reichsmarks, its members would guarantee the artist an additional income of between 6,000 and 10,000 Reichsmarks[70] to tide him over this period of economic and professional uncertainty. According to the amount that had accrued, members could purchase works at a special rate – either from Klee's studio or from a selection that Otto Ralfs would send either at the end of the year or early the following year: Klee Society members were given a further 30% discount on the already favourable studio prices. At the end of the year each received a "Christmas bonus", a special issue in the form of a print made especially for the members, or a drawing or a watercolour, dedicated by the artist.

On 1 October Hanni Bürgi joined the Klee Society as its first Swiss member. Her monthly contribution was 50 Reichsmarks.[71] This society of benefactors included all the leading collectors of Klee's works in Germany and Switzerland, although few remained members, as Hanni Bürgi did, right from its founding until it was finally dissolved.[72] Before becoming a member of the Klee Society Hanni Bürgi owned approximately twenty-five works by Paul Klee. While she was a member of the society and in the subsequent years until her death in 1938, she either purchased or was given a good forty more works.[73] As a rule she chose new purchases from the selection sent by Otto Ralfs. In the first three years of her membership she chose a total of seven coloured sheets, including cat. no. 85.[74] During the same period, she also received three of the annual special issues by the artist (cat. nos. 86, 88, 94). On the occasion of his marriage in 1928, her eldest son, Fritz, received *Zuflucht der Schiffe,* 1927,251[75] (cat. no. 96) as a present from Paul Klee. Since her purchases between 1925 and 1927 exceeded her

payments to the Klee Society, in the fourth and fifth years of her membership Hanni Bürgi refrained from further acquisitions. Thus her collection only grew by one special issue each in 1928 and in 1929 (cat. nos. 101, 102) and the etching *rechnender Greis*, 1929,99 (cat. no. 104), which the artist gave her as a present in autumn 1929.

Hanni Bürgi most likely relinquished her share in her late husband's construction company in 1929, and had her assets transferred as capital to her bank account. When her middle son Fredi died in an accident in July 1926, her hopes were dashed of a successor from the family entering the company. She immediately converted some of these new funds into art. Since it seems that a planned "joint summer trip" with Paul and Lily Klee had come to nothing,[76] she made up for lost time with the Klees by visiting them in Dessau at the end of the year, when they no doubt all celebrated her 50th birthday together. Hanni Bürgi seized the opportunity to choose her two purchases for her sixth year of membership directly from the artist's studio, one of these being cat. no. 112.[77] Paul Klee also gave her another special issue (cat. no. 106). In addition, without going through the Klee Society, she also purchased the coloured sheets *treuer Hund*, 1930,147 and *Decoration für ein orientalisches Singspiel*, 1930,102[78], as well as her first oil painting, *Nächtliches Fest*, 1921,176.[79] In the seventh and eighth years of her membership she added to her collection with five works from the selection that was sent to her; these included cat. nos. 111 and 117.[80] Furthermore there were also the two annual special issues (cat. nos. 73, 116). In order to pay off the debts to the Klee Society she had incurred with her considerable acquisitions, in the ninth year of her membership, Hanni Bürgi did not choose anything from the annual selection.[81] In 1933 the only addition to her collection was the annual special issue from the artist (cat. no. 120).

Due to the world economic crisis and the cultural politics of the National Socialists, which forced Paul Klee to emigrate from Düsseldorf to Bern in 1933, from 1929 onwards the Klee Society saw a constant decline in its numbers. It had to cease operating at all in Germany in 1935. It is not clear precisely whether or not it was also dissolved in Switzerland. Aside from Richard Doetsch-Benziger (a wholesale merchant in Basel),[82] Hanni Bürgi was the only remaining Swiss member, and from January until May 1934 she increased her monthly payments from 50 to 60 Reichsmarks (see fig. 10). Even though her regular payments to the artist may possibly have ceased after that point, in the years to follow Klee continued to give her the Klee Society discount on her purchases and always gave her a work with a dedication at Christmas or for her birthday (cat. nos. 121, 125, 126, 128).

The Friendship between the Klees and Hanni Bürgi in Bern after 1934

After the Klees moved from Düsseldorf to Bern in late 1933, they quickly found themselves welcomed back to their old circles of friends and acquaintances, with whom they had "always remained in intimate contact"[83] during the twenty-six years they had lived in Germany. Besides the collectors Hermann Rupf and his wife Margrit,[84] Paul and Lily Klee were above all "regularly & often together"[85]

Klee-Ges. Konto Frau Hanny Bürgi

Einzahlungen Entnahmen

 RM RM
Sept. 1925 – August 1926 Sumpfvögel — 330
 je 50 RM. — 600 Abwandernder Vögel — 450
 Vogel Pep — 400
Sept. 1926 – Aug. 1927 — 600 Abenteuer zur See — 300
 „ 27 – „ 28 — 600 Orient. Garten landschft — 265
 „ 28 – „ 29 — 600 Heissblühendes — 400
 „ 29 – „ 30 — 600 Blumensäger — 400
 „ 30 – „ 31 — 600 Früchte — 500
 „ 31 – „ 32 — 600 trinkender Engel — 500
 „ 32 – „ 33 — 600 Einsames — 335
Sept. 33 bis Dez. 33 — 200 Feuer mann — 270
Januar 34 bis Mai 34 — 300 Überflutung — 335
 junger Baum — 535
 Summa 5300
 Summa 5020

 Bern den 15 Mai 1934

Fig. 10
Record of transactions,
drawn up by Paul Klee,
for the "account of
Mrs Hanny Bürgi"
with the Klee Society,
15.5.1934

with Hanni Bürgi. Their contact was probably at its most regular in 1935, when Paul Klee visited his patroness at least once a week while Lily was away on a rest-cure.[86] In spring 1935 at the latest, Paul Klee and Hanni Bürgi adopted the more familiar "du" as a form of address[87] – the two ladies had already changed to the "du" form earlier on.[88] The concern that the Klees felt for Hanni Bürgi's declining health cast a shadow over their friendship.[89] Her health had been fragile for years and in autumn 1934 it took a turn for the worse; she began to suffer intermittent heart attacks, which were a considerable mental burden for Hanni to bear.[90] Lily Klee described the course of events: "[…] to be in a state of perpetual ill-health is unbearable for this woman, who has always been hard on herself & never spared herself. It has cast her into a deep depression."[91] At this difficult time of the collector's life, Paul Klee dedicated the watercolour *trüb umschlossen*, 1934,74 (cat. no. 125) to her for Christmas 1934. Hanni's eldest son Fritz thanked Klee:

I was astonished and at the same time very happy when I saw what an effect this picture had on Mama, she was quite transformed by it. There is nothing that could have given her greater pleasure.[92]

In her last years Hanni Bürgi acquired only a few more works by Paul Klee. In 1934 she subscribed, for 120 Reichsmarks, to the luxury edition of the monograph

Fig. 11
Will Grohmann,
Paul Klee. Handzeich-
nungen 1921–1930,
Potsdam/Berlin 1934;
luxury edition in
hand-made pro-
visional binding by
the Demeter work-
shop

Paul Klee. Handzeichnungen 1921–1930 (fig. 11), which included the pen and Indian ink drawing *tanzt auch*, 1926,99 (cat. no. 91).[93] Will Grohmann, working closely with the artist himself, had planned this as the start of a three-volume œuvre catalogue of Klee's drawings.[94] The seizure of the book by the National Socialists in April 1935 put an end to the project.[95] At the major Klee exhibition at the Kunsthalle Bern in 1935, Hanni Bürgi bought the panel painting *Botanisches Theater*, 1934,219 (fig. 3, p. 221) at a special price of 3,500 francs.[96] Listed in the catalogue at 5,000 francs,[97] this painting was amongst the most expensive offered for sale during the artist's life.[98] This major acquisition most probably marks the end of Hanni Bürgi's activities as a collector. Between 1932 and 1935,[99] the painting *Ort der Verabredung*, 1932,138 (cat. no. 118) had also found a place in her collection. It is no longer possible to establish the dates of acquisition of the three etchings *Erste Fassung "Weib und Tier"*, 1903 (cat. no. 4), *Perseus. (der Witz hat über das Leid gesiegt.)*, 1904,12 (cat. no. 6) and *Greiser Phönix (Inv. 9.)*, 1905,36 (cat. no. 10), nor of the drawing *Gaby*, 1934,69.[100]

Hanni Bürgi's Wider Commitment to Art

Among those particularly active helpers who between 1911 and 1918 promoted the difficult foundation and financing of the projected Bern Kunsthalle Hanni Bürgi was one of the "most enthusiastic and enthusing"[101]. Her husband Alfred subscribed to shares in the venture, to the value of 100 francs,[102] thereby becoming a member of the "Verein ‹Kunsthalle Bern›".[103] His membership transferred to his wife's name after his death,[104] and after the opening of the Kunsthalle in 1918, Hanni Bürgi remained a faithful supporter for the next two decades "no longer organising, but – whether contented or critical – always demonstrating her unflagging interest in the works on show […]"[105].

In 1931 the Kunsthalle Bern[106] presented a group exhibition which included works by Paul Klee owned privately in Bern; now for the first time Hanni Bürgi made available her entire collection of Klee pictures (simply listed as coming from the "Sammlung H. B., Bern") as well as those owned by her sons Rolf and Fritz.[107] Her contribution of fifty-one works altogether constituted almost half of all the works by Klee in the exhibition. Beside many positive reactions, the exhibition also provoked spiteful criticism directed both at Paul Klee's art and at those who collected his work. The *Neue Berner Zeitung* wrote:

> *[…] we will not tolerate the walls of two rooms in our Kunsthalle being hung with artful dodges like the disasters by this Mr. Klee, which are then called contemporary art. Praise the Lord we are far too healthy to accept such stammering reflexes of an infantile brain as art. […] Apart from a few exceptions, these 108 terrifying, fantastic excesses are owned privately in Bern. This is greatly to be deplored and is a disturbing sign of our times.*[108]

Attacks of this kind may well be the reason that four years later, when Hanni Bürgi made six works available for a Klee exhibition at the Kunsthalle Basel, she did so anonymously – the location of the works given in the catalogue as "private collection, Bern"[109]. Besides a painting from the Rupf Collection,[110] these were the only loans that Paul Klee included in the later exhibition, which he himself conceived.

Prior to this first presentation of her collection in the Kunsthalle Bern in 1931, Hanni Bürgi had only made pictures available for one other exhibition; in 1929 she had lent the Galerie Alfred Flechtheim in Berlin six coloured sheets under her own name for the special exhibition to mark Paul Klee's 50th birthday.[111] Klee himself had established contact between the gallery and Hanni Bürgi. In summer 1929 he had asked her to send a photograph of his watercolour *Vogel Pep*, 1925,197, to the gallery.[112] Shortly afterwards this watercolour was reproduced in two Klee monographs: one by Will Grohmann in December 1929 and the other by René Crevel in 1930, with the owner identified in both cases.[113] Apart from the above exhibition catalogues and monographs – and with the exception of a hectographed list of works for the exhibition at the Kunstmuseum Bern in 1937[114] and obituaries in 1938 – Hanni Bürgi's collection received no further mention in contemporary literature on Paul Klee.

By early 1932 at the latest, Hanni Bürgi had become a member of the "Verein der Freunde des Berner Kunstmuseums" (Friends of the Kunstmuseum Bern)[115] whose main purpose was – and still is – to acquire works for the Kunstmuseum Bern.[116] By 1935 she was on the Friends' Board and played a crucial part in the society's most important purchase. In March 1935, together with the chairman of the Board, Fritz von Fischer, and the director of the Kunstmuseum Bern, Conrad von Mandach, she visited the exhibition at the Kunsthalle Bern[117] to mark Klee's "return to old haunts"[118] – on the day before it closed. The result of this visit is recorded in the Friends' minutes as follows:

> *After a tour through the exhibition, the painting "Ad Parnassum" was suggested as a representative work for the museum. An offer of 4,000 francs is to be made to the artist. If he is unable to accept this, then "die Meeresküste" will be purchased instead.*[119]

Paul Klee was willing to accept the requested reduction of 500 francs.[120] "With unerring judgement the society chose from the wealth of works on display the masterpiece that still crowns the Klee collection in the Kunstmuseum Bern",[121] as the director of the Kunstmuseum Bern from 1965 until 1980, Hugo Wagner, later remarked (fig. 2, p. 220).

When it came to major purchases the Kunstmuseum Bern frequently counted on private support from the Verein der Freunde des Berner Kunstmuseums.[122] For example, when the museum bought Ernst Ludwig Kirchner's monumental painting *Alpsonntag, Szene am Brunnen*, 1918–1924 from the exhibition *Ernst Ludwig Kirchner* at the Kunsthalle Bern (5.3–17.4.1933) for the sum of 4,250 francs, Hanni Bürgi contributed 200 francs.[123]

The arrival of the painting *Ad Parnassum* at the Kunstmuseum Bern will have given Hanni Bürgi particular pleasure,[124] for

> *as the most determined champion of Paul Klee's art she was the inspiration behind the Klee exhibition at the Kunsthalle in 1935, and so effectively supported its realisation that it was an immense success both for the artist and for the Kunsthalle,*[125]

as the director of the Kunsthalle, Max Huggler, reported. She had already personally introduced Paul Klee to Max Huggler (fig. 12) in January 1934, shortly after the Klees had moved from Düsseldorf to Bern.[126] According to Huggler, the "Klee exhibition was not embarked upon without some concern as to the pub-

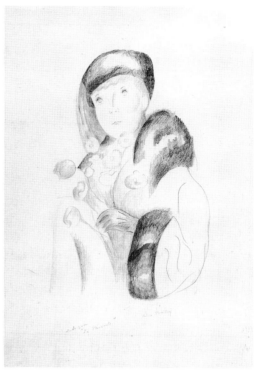

Fig. 12
Max Huggler, Bern,
August 1944

Fig. 13
Alice Bailly, *Etude
pour "La Passante"*,
ca. 1920, pencil on
paper, 47,5×32,6 cm,
private collection

lic response it might receive"[127]; he would still have been all too aware of the negative comments on the Klee exhibition at the Kunsthalle Bern in 1931. Therefore, having consulted with the artist, he approached the art historian Will Grohmann in Dresden, the leading expert on Klee's work, and asked him to give "an introductory talk on the meaning and the wider significance of the art of Paul Klee"[128] at the opening. The fee for the lecture was 100 francs – 20 francs of this were contributed by the art section of the Lyceum Club Bern,[129] while Hanni Bürgi personally covered the remaining 80 francs and the travel costs.[130] Huggler later commented that

> *this prelude, but particularly the energetic efforts of the artist's friends, did much to ensure that the exhibition and hence the artist's work as well made such a decisive impact on the wider public.*[131]

Not only Paul Klee, not only Painting...

Hanni Bürgi's collection was not exclusively devoted to works by Paul Klee. She also bought pictures by a number of other artists amongst her friends and acquaintances. The second main focus in the collection was on the works of the painter Alice Bailly from Geneva, with whom Hanni Bürgi was in touch – at times very closely – for almost twenty years.[132] It is likely that the collector met the painter – frequently struggling to overcome her financial difficulties – in late 1919 or early 1920 when the latter spent a few months in Bern.[133] This was when Hanni Bürgi bought a wool embroidery picture, *Bildnis Lucienne Florentin* (1918),[134] probably her first work by Alice Bailly. After the death of their mother,

Fritz and Rolf Bürgi donated this work[135] to the Kunstmuseum Bern "in memory of their late mother".[136] In *Etude pour "La Passante"* (fig. 13) we see a portrait of the collector by Alice Bailly, most probably made in 1920.[137] In the 1920s and early 30s Hanni Bürgi bought another two wool embroidery pictures[138] as well as two paintings[139] and a watercolour[140]. Max Huggler recalled that Hanni Bürgi's resolute support for the artist smoothed her "path to the friends of art in Bern"[141].

There are only incomplete accounts of the remainder of Hanni Bürgi's collection. She owned a number of heads made by the Bern sculptor Max Fueter in terracotta and bronze of her sons and grandchildren.[142] There is documentary evidence that she had two watercolours by Louis Moilliet.[143] It is not certain whether her collection also contained works by the painters Marguerite Frey-Surbek and her husband Victor Surbek, who were lifelong friends of Hanni Bürgi.

Besides her passionate interest in collecting art, Hanni Bürgi furthered her interests in music. Victor Surbek painted a portrait of her, probably to mark her 50th birthday, which shows her standing by the Bechstein grand piano in the music room (fig. 14). In spring 1923 she became a member of the Lyceum Club in Bern,[144] which, as its statutes state, had been founded to bring together women who were interested in artistic, literary, scientific, and social issues.[145] She twice invited the members of this women's club to her home for formal occasions: in 1925 for a lecture on modern art and a programme of music, and in 1930 for a guided tour of her Klee collection.[146] As president of the music section of the Lyceum Club in Bern from 1928 until 1938,[147] she organised a number of concerts each year. For some of these concerts she engaged the composer and pianist Albert Moeschinger[148] who had been living in Bern since 1929[149]. She recommended him for other public concerts in Bern[150] and also gave him material support.[151] As Hanni Bürgi's "protégé"[152] who was also acquainted with Paul and Lily Klee[153] he expressed his gratitude to his patron in a number of compositions which he dedicated to her in the 1930s.[154] In 1936, two years before her death, he composed the string quartet *Trauermusik für Frau Hanny Bürgi* (Funeral Music for Mrs Hanny Bürgi).[155]

In order to fulfil her social duties, once or twice a year Hanni Bürgi would invite friends and acquaintances to a private house concert, for which she engaged promising young talent.[156] Besides Albert Moeschinger and the Prague Quartet with Lado Cerny, performers such as Walter Gieseking, one of the most renowned German pianists after the war,[157] also accepted her invitations.[158] It is highly likely that Paul and Lily Klee were present at these performances. In autumn 1936 they were unable to attend the last of her grand musical evenings because they were taking a cure in Montana, as Lily Klee reported: "After much thought & although we were sorry to do so, we declined the invitation to Hanny's grand musical evening on 23.9, her farewell soirée to her big apartment & social occasions."[159]

Hanni Bürgi: Death and Obituaries

In autumn 1936 Hanni Bürgi's health worsened to such an extent that she had to give up her "vast apartment" at 21 Alpenstrasse for a "tiny little very mod-

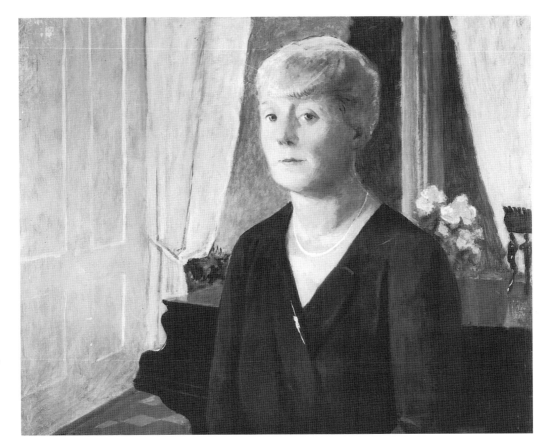

Fig. 14
Victor Surbek,
*Portrait of Mrs
H. Bürgi-Bigler*, 1930,
oil on canvas,
69.5/70×82 cm,
Estate of Victor and
Marguerite Surbek-
Frey, Bern

ern, delightfully, idyllically situated apartment"[160] near to where the Klees lived. In view of the fact that Paul Klee had also been seriously ill since August 1935, and was never fully to recover, it was above all Lily who kept in personal contact with Hanni Bürgi between 1936 and 1938. After two suicide attempts in December 1936, Hanni Bürgi was taken into a clinic for nervous diseases[161] and her apartment was wound up. From that time onwards she lived "as a boarder in one room"[162]. The bulk of her art collection was deposited at the Kunstmuseum Bern and, from September 1937 onwards, exhibited there – at least from time to time[163] – for one year.[164] Lily Klee reported:

> At the moment the entire K... collection of mrs Bürgi is hanging in 3 rooms in the Kunstmuseum in bern as a long-term loan – very beautiful & self-contained. Strong impression. Hanny bürgi is having a wretched time.[165]

According to Rolf Bürgi the collection aroused almost no interest at all.[166] This would explain why there were no notices in the press.

In the last year and a half of her life Hanni Bürgi suffered a number of setbacks to her health, from which she only ever temporarily recovered. On 16 August 1938 she died from arteriosclerosis in the Kantonale Heil- und Pflegeanstalt Waldau in Ostermundigen.[167] Paul Klee sent his condolences to Rolf Bürgi the next day from St. Beatenberg where he was taking a cure (facsimile letter on p. 258). On 19 August his wife Lily attended the funeral ceremony, which was followed by a silent cremation in the chapel of the Bürgerspital in Bern.[168] Obituaries appeared in the Bern daily paper *Der Bund* on 21 August,[169] in the *Frauen-*

Zeitung "Berna" on 9 September (excerpts reprinted on p. 259), and in the *Bulletin du Lyceum de Suisse* for September,[170] honouring the services of the late Hanni Bürgi to the cultural life in Bern, both in the visual arts and in music. Max Huggler, in *Bericht über die Tätigkeit der Kunsthalle Bern 1938* (reprinted p. 259), remembered the close links between the collector and the Kunsthalle Bern. Lily Klee bade farewell to her friend Hanni Bürgi in very personal and open terms in a letter to Will Grohmann (reprinted p. 257). On the second anniversary of Hanni Bürgi's death, Lily Klee's thoughts turned to her again in a card to Rolf Bürgi:

My dear Rolf, tomorrow on 16 August my thoughts are specially with you at the grave of your dear unforgettable mother. For tomorrow is the 2nd anniversary of her death. How quickly my husband followed her, with whom she had such a close spiritual friendship for decades. This year it is particularly painful to think of that day, when we lost so much with the passing away of Hanny Bürgi. But her personality lives on, in the work which she herself created from its very beginnings, her utterly unique collection. With it she established a memorial that will last forever.[171]

Acknowledgements

I should like to express my gratitude to Christoph and Dominique Bürgi and Vincent Bürgi for their very generous help with my researches for this article. They allowed me unlimited access to their extensive family archives. Moreover, Christoph and Dominique Bürgi suggested various improvements and additions to the text. I should also like to thank the following for their help, advice and information: Bernd Dütting, Galerie Beyeler, Basel; Christoph Ballmer, Öffentliche Bibliothek der Universität Basel; Daniel Brand, Bern; Martin Bürgi, Bürgi AG/Bauunternehmung, Bern; Violette Bühlmann-Müller, Lyceumklub, Bern; Nicole Aeby, Denkmalpflege des Kantons Bern; Claudine Girardin, Bern; Alexander and Anne-Marie Klee-Coll, Klee-Nachlassverwaltung, Bern; Eberhard W. Kornfeld and Christine Stauffer, Galerie Kornfeld, Bern; Eszter Gyarmathy, Kunsthalle Bern; Michael Baumgartner, Judith Durrer, Heidi Frautschi, Christian Rümelin, Eva Wiederkehr Sladeczek, Kunstmuseum Bern/Paul Klee Foundation; Peter Lauri, Photographer, Bern; Annemarie Bieri, Neue Mittelschule Bern; Alice Schwarz, Bern; Marco Iten, Schweizerischer Nationalfonds, Bern; Barbara Spalinger and Barbara Studer, Staatsarchiv, Bern; Mario Marti and Margit Zwicky, Stadtarchiv, Bern; Werner Strik, Universitäre Psychiatrische Dienste, Bern; Paul-André Jaccard, Lutry; Angela Rosengart, Galerie Rosengart, Lucerne; Conradin Mohr, Waldabteilung 5, Bern-Gantrisch, Riggisberg; Gladys Luginbühl-Surbek, Spiez; Vreni Glaus, Thun; Martin Ed. Gerber, Geologisches Gutachtenbüro, Üttligen. In my preparation of the text I drew on information supplied by the Paul Klee Foundation in the Kunstmuseum Bern.

[1] In 1938 Hanni Bürgi's Klee collection contained 66 works, which were listed and illustrated for the first time in the February 2000 issue of the journal *Du*. Only the collector and businessman Otto Ralfs in Braunschweig had a larger collection, with a total of 80 pictures.

[2] Letter from LK, St. Beatenberg, to GGr, 31.8.1938 (NFK).

[3] Cf. Klee's records of sales in his hand-written œuvre catalogue (KmB/PKS).

[4] Cf. Michael Baumgartner's lecture *Klee und seine frühen Sammler* at the International Paul Klee Symposium in Bern on 16/17.10.1998, which is due to be published soon by the Paul Klee Foundation along with the other papers from the symposium. I am grateful to Michael Baumgartner for allowing me to consult his typescript.

[5] Huggler 1939.

[6] For more on this see Schweiger 1994, p. 7.

[7] Dates of births and deaths of members of the Bigler family have been taken from the following documents: 'Heimatschein der Bürgergemeinde Bern', 22.3.1921 (ABB); E 2.2.1.0. 103, no. 143 (Stadtarchiv, Bern); 'Familienschein. Auszug aus dem Familienregister der Gemeinde Muri' (Zivilstandsamt Muri bei Bern).

[8] Information kindly supplied to the author by U. Münger, Residents' Registration Office, Bolligen, 10.12.1999. See also the entry '"Bigler-Siegenthaler, Wirth zur Waldeck", Gemeinde Bolligen', in: *Adressbuch für Stadt und Stadtbezirk Bern. 1881*, Bern 1881, and the entry '"Bigler-Siegenthaler, Wirth Altenbergbad" in Bern', in: *Adressbuch für Stadt und Stadtbezirk Bern. 1883/84*, Bern 1883.

[9] In the archives of the Neue Mittelschule, previously the Neue Mädchenschule, Bern, there are no records of Hanni Bürgi, see the pupil lists in the *Neue Mädchenschule. Promotionen, III Band. 1884–94* (Neue Mittelschule, Bern).

[10] The inn had existed since 1886, see *Adressbuch für Stadt und Stadtbezirk Bern. 1886/87*, Bern 1886.

[11] There is, for example, a photographic record of Albert Einstein's visit to the inn.

[12] Information kindly supplied by Alice Schwarz, Wabern/Bern.

[13] Dates of births and deaths of members of the Bürgi family as well as biographical details on the life of Alfred Bürgi are taken from the following documents and obituaries: 'Ortsburger E 2.2.1.0. 503', p. 82 (Stadtarchiv, Bern); Anonymous, '† Gemeinderat Alfred Bürgi', in: *Der Bund*, Bern, vol. 70, no. 2, 3.1.1919, Friday issue, p. 3; Anonymous, '† Alfred Bürgi', in: *Die Berner Woche in Wort und Bild. Ein Blatt für heimatliche Art und Kunst*, Bern, vol. 9, no. 3, 18.1.1919, 'Zweites Blatt', p. 35.

[14] See *Berner Adressbuch 1903-04*, Bern 1903.

[15] Information supplied to the author by Frau Obrecht, Registry Office, Lyss, 13.10.1999.

[16] See *Berner Adressbuch 1909–1910*, Bern 1909.

[17] They lived there from 1900 until at least 1912, see *Berner Adressbuch 1911–1912*, Bern 1911.

[18] See *Adressbuch für Stadt und Stadtbezirk Bern. 1899*, Bern 1899.

[19] See *Berner Adressbuch 1912-1913*, Bern 1912, and *Adressbuch der Stadt Bern 1920*, Bern 1920.

[20] See *Berner Adressbuch 1914*, Bern 1914.

[21] In 1880 – three years before the building of the Kirchenfeld Bridge and the development of the Kirchenfeld district – the land in this part of the town was amongst the most expensive in Bern; see *INSA. Inventar der neueren Schweizer Architektur 1850–1920. Städte Basel, Bellizona, Bern*, ed. by the Gesellschaft für Schweizerische Kunstgeschichte, Zurich 1986, p. 419.

[22] As a member of the Liberal-Democratic Party Friedrich Bürgi was a member of the Municipal Council of the city of Bern, the Regional Council of the Canton Bern, and of the National Council (1896–1908).

[23] Location of all sources: ABB.

[24] See Bürgi 1998, p. [3].

[25] The following details of the life of Hanni Bürgi are, unless otherwise stated, drawn from Bürgi 1998.

[26] PK to LK, 1.10.1908, in: Klee BF/2, p. 681.

[27] PK to LK, 11.11.1910, in: Klee BF/2, p. 762. See also PK to LK, 11.10.1910, in: Klee BF/2, p. 752.

[28] See Klee L, p. 107.

[29] Frey-Surbek 1938.

[30] See Bürgi 1947, p. 1.

[31] See letter from PK, Dessau, to MK, 21.10.1930 (ABB).

[32] See PK to LK, 13.11.1910, in: Klee BF/2, p. 763 and PK to LK, 18.11.1910, in: ibid., p. 764.

[33] Klee L, p. 107.

[34] See Bürgi 1947, p. 4.

[35] The company "F. & A. Bürgi" leased the Ostermundigen quarry from 1.1.1906, see *Bericht über die Staatsverwaltung des Kantons Bern für das Jahr 1905,* Bern 1906, p. 149. In *Bericht über die Staatsverwaltung des Kantons Bern für das Jahr 1910*, Bern 1911, p. 117, the company "F. & A. Bürgi" is recorded as lessee for the last time. Since subsequent reports of the Canton Bern ('Berichte über die Staatsverwaltung des Kantons Bern') contain no mention of the lessee, it is not possible to give a definite date for the end of the lease.

[36] Bürgi 1947, p. 4.

[37] In 1907 the company "F. & A. Bürgi" acquired the stone-cutting site in Waldeck and the administration block of the liquidated "Aktiengesellschaft für die Steinbrüche von Ostermundigen", see Karl Ludwig Schmalz, 'Die Ostermundigen-Steinbrüche', in: *Ostermundigen. Geschichte, Gemeindeentwicklung, Alte Ansichten*, ed. by the Einwohnergemeinde Ostermundigen, Ostermundigen 1983, p. 25.

[38] For more on Klee's periods of work in the Ostermundigen quarries, see PK to LK, 18.6.1909 and PK to LK, 22.7.1910, in: Klee BF/2, pp. 702, 745.

[39] It is no longer possible to say exactly in which year it was acquired. Since Klee notes the details of the work and its ownership in the same hand in his handwritten œuvre catalogue started in February 1911 (see Klee 1988, no. 895), he must have sold it before 1911.

[40] Thus the subtitle of the work as recorded in the œuvre catalogue.

[41] On *Gepflegter Waldweg*: "besitzt baumeister bürgi, bern" and on the Stockhorn watercolours: "Verkauf Herr Bürgi Baumeister Bern".

[42] Bürgi 1951, p. 3. See also Bürgi 1948, p. 25.

[43] Bürgi 1947, p. 3.

[44] In early 1917 Paul Klee thanked Hanni for a Christmas package, see postcard from PK, Munich, to HB, Bern, 19.1.1917 (ABB). For an account of a visit by Lily Klee and Felix to the Bürgis in summer 1916, see Klee L, p. 39.

[45] See Jakob Klaesi, 'Prof. Dr. med. h.c., Dr. med. Emil Bürgi, 19. April 1872 bis 30. Januar 1947', in: *Mitteilungen der Naturforschenden Gesellschaft Bern*, Bern, Neue Folge, vol. 5, 1948, pp. 61–63.

[46] See PK to LK, 13.7.1917 and 13.8.1918, in: Klee BF/2, pp. 874, 932.

[47] Klee had shown this with the title *Flottenrevue* in the *Ausstellung zur Eröffnung der Kunsthalle Bern*, Kunsthalle Bern, 5.10–3.11.1918, where it was marked not for sale.

[48] See Klee's record of sale in his hand-written œuvre catalogue.

[49] PK to LK, 28.6.1919, in: Klee BF/2, p. 957.

[50] After the death of her husband Hanni Bürgi owned at least the four properties at Länggassstrasse nos. 8, 75, 75a, 77; see *Adressbuch der Stadt Bern 1922*, Bern 1922.

[51] On the biography of Fritz Bürgi see Anonymous, '† Dr. med. Fritz Bürgi, Spiez', in: *Der Bund*, Bern, 19.2.1948.

[52] See Bürgi 1998, p. [3].

[53] The purchaser was the Federal Councillor Jean Marie Musy, see *Adressbuch der Stadt Bern 1922*, Bern 1922.

[54] See *Adressbuch der Stadt Bern 1921*, Bern 1921 and *Bulletin du Lyceum de Suisse*, Geneva, vol. 9, no. 80, May 1930, p. 5.

[55] Frey-Surbek 1938.

[56] Klee gave Hanni Bürgi a discount of at least 30% on each purchase, see PK to LK, 1.11. 1924, in Klee BF/2, p. 995.

[57] In addition, according to Bern 1931, the coloured sheets (*Föhn im Marc'schen Garten*), 1915,102; *Mystisches Stadtbild*, 1920, 149; *Bildnis O.*, 1924, 147; the drawings *Aussicht auf einen See (Neuenburgersee vom Mont Vully)* 1910,61; *Bern*, 1910,75; *Im Steinbruch unten*, 1910,104; *Südlich von München*, 1912,164.

[58] First mentioned in 1918, see PK to IK, 11.5.1918, in: Klee BF/2, pp. 919f.

[59] See § 4 of the 'Vertrag zwischen Paul Klee, München, und Hans Goltz, München, 1.10.1919' reprinted in: Kain et al.1999, p. 115.

[60] PK to MK, 4.1.1921, in: Klee BF/2, p. 967. The 'head' is probably a reference by Klee to the watercolour *Der Mond war im Abnehmen und zeigte mir die Fratze eines Engländers eines berüchtigten Lord's*, 1918,147.

[61] See letter from Emil Bürgi, Bern, to IK, Bern, 8.2.1921 (NFK).

[62] Bürgi 1948, p. 25. Bürgi erroneously gives the date of the visit to Weimar as 1922.

[63] Bürgi 1951, p. 6.

[64] See Bürgi-Lüthi 1987 and Lisbeth Herger, 'Mein Meisterwerk', in: *Das Magazin. Tages-Anzeiger und Berner Zeitung BZ*, Zurich, no. 42, week from 18–24.10.1997, p. 61.

[65] Klee L, p. 132.

[66] See Klee L, p. 163.

[67] Bürgi 1947, p. 5.

[68] See PK to LK, 25.7.1927, in: Klee BF/2, p. 1055. Hanni Bürgi had her passport (ABB) extended for three years on 16.9.1927.

[69] For example in July 1927, see PK to LK, 25.7.1927, in: Klee BF/2, p. 1055; in September 1928, see PK to LK, 15.9.1928, in: Klee BF/2, p. 1068; in December 1928, see PK to LK, 18.12.1928, in Klee BF/2, pp. 1068f. and entry in pocket diary, 18.12.1928, in: ibid., p. 1080; in July 1929, see letter from PK, Bern, to HB, 22.7.1929 (ABB); in September 1929, see PK to LK, 8 and 11.9.1928, in: Klee BF/2, pp. 1097f.; in October 1932, see PK to LK, 8.10.1932, in: Klee BF/2, p. 1189; in October 1933, see PK to LK, 9 and 13.10.1933, in: Klee BF/2, pp. 1236f.

[70] The sum of 6,000 RM was approximately the yearly salary of a Bauhaus teacher. In 1926 when Klee was paid off from the Bauhaus his salary was 7,000 RM, see Wolfgang Kersten, 'Paul Klee. Chronologische Biografie', in: Berlin 1985, p. 17. For more on the Klee Society see the following more recent articles: Stefan Frey and Wolfgang Kersten, 'Paul Klees geschäftliche Verbindung zur Galerie Alfred Flechtheim', in: *Alfred Flechtheim. Sammler, Kunsthändler, Verleger*, exh. cat. Kunstmuseum Düsseldorf, 20.9–1.11.1987; Westfälisches Landesmuseum für Kunst und Kulturgeschichte, Münster, 29.11.1987–17.1.1988, p. 75; Henrike Junge, 'Otto Ralfs. Sammler, Mäzen und Wegbereiter der Avantgarde in der Provinz', in: idem (ed.), *Avantgarde und Publikum. Zur Rezeption avantgardistischer Kunst in Deutschland 1905–1933*, Cologne/Weimar/Vienna 1992, pp. 246f.; Werner J. Schweiger,

'Vom Sammeln in der Provinz. Rudolf Ibach 1873–1940', in: ibid., pp. 168–171; Schweiger 1994, pp. 31f., 41f.

[71] In Paul Klee's records for the 'Account Mrs Hanny Bürgi' in the Klee Society, 15.5.1934 (fig. 10) deposits are listed from September 1925 onwards; however, a letter from PK, Dessau, to HB, 6.3.1931, refers to deposits from 1 October 1925 (reprinted in this catalogue on pp. 255f.).

[72] In the year of its founding, besides Hanni Bürgi, the Klee Society had five further members: Hermann Bode, Hanover (1925–?); Rudolf Ibach, Barmen (1925–?1928); Otto Ralfs, Braunschweig (1925–1935); Heinrich Stinnes, Cologne (1925–1932); Werner Vowinckel, Cologne-Marienburg (1925–1935). Later the following members also joined: Otto Baier, Cologne (1932–1934); Ida Bienert, Dresden (?1928–1933); Richard Doetsch-Benzinger, Basel (?1929–1940); Hermann Flesche, Braunschweig (?–?); Heinrich Kirchhoff, Wiesbaden (?1928–?1933); Adolf Rothenberg, Breslau (1929-1930); Hermann Rupf, Bern (1931–1932); Fritz Trüssel, Bern (1927–?1933).

[73] For her acquisitions as a member of the Klee Society, see fig. 10.

[74] The other works were: *abwandernder Vogel*, 1926,218 for 450 RM; *Vogel Pep*, 1925,197 for 400 RM; *Abenteurer zur See*, 1927,5 for 300 RM; *Orientalische Gartenlandschaft*, 1924,229 for 265 RM; *Heiss blühendes*, 1927,282 for 400 RM; *der Blumensäger*, 1926,73 for 400 RM.

[75] See the enclosure in the letter from PK, Dessau, to Dr. (Mrs) Trüssel, Bern, 13.12.1927 (private collection, Germany): 'Verzeichnis für Frau Dr. Trüssel Bern' (NFK).

[76] See PK to LK, 20.6.1930, in: Klee BF/2, pp. 1128f., and postcard from PK, Viareggio, to HB, Bern, 23.8.1930 (ABB).

[77] The second work she acquired was *Früchte*, 1930,132 for 500 RM.

[78] Hanni Bürgi must have given *Decoration für ein orientalisches Singspiel* back to the artist between 1931 and 1935, see Bern 1935, no. 171, where it is offered for sale at the price of 500 fr.

[79] With respect to the four drawings *Wiesenflora*, 1927,186 (cat. no. 95), *ihr habt hier eine Lumpenwirtschaft*, 1927,260 (cat. no. 97), *Sie entgegnet*, 1927,266 (cat. no. 98) and *Schwarze Gaukler*, 1928,39 (cat. no. 100), it is not clear whether Hanni Bürgi also acquired these in Dessau or at an earlier date from Klee himself.

[80] The other works were: *einsames*, 1928,80 for 335 RM; *Aufblühende Pflanze*, 1930,107 for 470 RM; *Überflutung*, 1931,259 for 335 RM. Hanni Bürgi gave *Aufblühende Pflanze* back to Klee in early 1933, see letter from OR, Braunschweig, to PK, Dessau, 18.2.1933 (NFK).

[81] In early 1933, Hanni Bürgi's account with the Klee Society was overdrawn by 1,040 Reichsmarks, see letter from OR, Braunschweig, to PK, Düsseldorf, 13.1.1933 and account details sent from OR, Braunschweig, to HB, Bern, 10.1.1933 (NFK).

[82] Doetsch-Benzinger made payments to Paul Klee until at least 1939, whether as a member of the Klee Society or as purely private financial assistance must remain an open question, see correspondence between PK/LK and Richard Doetsch-Benziger in the 1930s (NFK).

[83] Klee L, p. 2.

[84] On the relationship between Rupf and Klee, see note 4.

[85] Letter from LK, Bern to WG, 29.4.1935 (SS/AWG).

[86] See PK to LK, 14/17/21/27.6 and 3/10.7.1935, in: Klee BF/2, pp. 1251-1255.

[87] See card from WG&GG/PK/KB, Lucerne, to HB, Bern, 27. [illegible: 3.]1935 (ABB).

[88] See letter from LK, Düsseldorf, to HB, 17.11.1933 (ABB).

[89] On the course of her illness see the letters from Lily Klee to Will Grohmann, reprinted in this catalogue, pp. 256f.

[90] See letter from LK, Bern, to WG, 11.1.1935 (SS/AWG).

[91] Ibid.

[92] Letter from Fritz Bürgi, Spiez, to PK/LK, 26.12.1934 (NFK).

[93] See publisher's leaflet on the publication (NFK). Hanni Bürgi owned no. 17 of the luxury edition.

[94] See Joseph Gantner, 'Handzeichnungen von Paul Klee', in: Neue Zürcher Zeitung, Zurich, no. 409, 10.3.1935.

[95] Detailed information in Frey 1990, p. 112.

[96] Bern 1935, no. 107. After the 15% commission for the Kunsthalle Bern had been taken off, Klee was left with the net sum of 2,975 francs. Hanni Bürgi transferred this amount directly to Klee, see Klee's handwritten note on the letter from MH, Kunsthalle Bern, to PK, Bern, 10.5.1935 (NFK).

[97] As a matter of comparison: a middle-ranking civil servant such as a forestry official would have earned 7,300 francs in 1939.

[98] This was the same amount as fetched by the painting Büh-nenlandschaft, 1922,178, which Klee had always priced in the top range in exhibitions, see Wolfgang Kersten, 'Hoch taxiert: Paul Klees Ölbild ‹Bühnenlandschaft› 1922.178 – Versuch einer historischen Einordnung', in: Meisterwerke I. 9 Gemälde des deutschen Expressionismus, exh. cat., Galerie Thomas, Munich, 1.6–29.7.1995, p. 120.

[99] This work had been owned by Hanni Bürgi since at least 1935, see PK to LK, 14.6.1935, in: Klee BF/2, p. 1251.

[100] These three prints are not mentioned in Bern 1931; they are listed in Bern 1937 as nos. 2–4.

[101] Frey-Surbek 8/1938. On the occasion of the Künstler Bazar Bern 1911, Hanni Bürgi and her husband Alfred donated a woodcut by Hannah Egger, Vier Kinder, at the price of 35 francs to the "[Selling] exhibition of works of art to promote the building of a Kunsthalle in Bern", at the Kunstmuseum Bern, 21.5–11.6.1911, see the handwritten 'Kunsthalle-Bazar-Rechnung, samt Nachträgen und Bazar-Ausstellungs-Rechnung' (KhB). The Bern artist and drawing teacher Hannah Egger had known Paul Klee since at least 1904, see Klee BF/1, pp. 389, 398.

[102] Share certificate no. 149 (KhB), taken up between 1912 and 1917, see Leo Steck, Die Sektion Bern der GSMBA und die Gründung der Bernischen Kunsthalle, Bern 1930, p. 17.

[103] See Verein Kunsthalle Bern, Statuten, Reglement und Vorschriften für die Beschickung der periodischen Ausstellungen, Bern 1918, p. 2.

[104] See Verein Kunsthalle Bern, Mitglieder Verzeichnis, June 1919 (KHB), where Hanna Bürgi is listed with a share certificate for 100 francs and an annual ticket for 10 francs.

[105] Frey-Surbek 8/1938.

[106] See Bern 1931.

[107] It is not certain whether the works from Hanni Bürgi also included some owned by her brother-in-law Emil Bürgi.

[108] Sieest., 'Stadt Bern: Sonntagmorgen in der Kunsthalle', in: Neue Berner Zeitung, Bern, 27.1.1931.

[109] See Basel 1935, nos. 6, 89, 95, 120. Trinkender Engel, 1930,239 (cat. no. 112) was exhibited, but not listed in the catalogue, see postcard from LK, Bern, to the Kunsthalle Basel, 1.12.1935 (Staatsarchiv des Kantons Basel-Stadt).

[110] See Basel 1935, no. 74.

[111] See Paul Klee, Galerie Alfred Flechtheim, Berlin, 20.10–15.11.1929, nos. 15, 30, 57, 70, 71, 106.

[112] See letter from PK, Bern, to HB, 22.7.1929 (ABB) and PK to LK, 13.9.1929, in: Klee BF/2, p. 1099.

[113] See Will Grohmann, Paul Klee, Paris 1929, ill. p. 57, erroneously dated there as 1926, and René Crevel, Paul Klee ("Peintres nouveaux"), Paris 1930, ill. p. 28.

[114] Bern 1937.

[115] See 'Mitgliederverzeichnis vom 1. Januar 1932', in: C. von Mandach, Verein der Freunde des Berner Kunstmuseums.

[115 cont.] Zweiter Bericht 1926–1930, Bern 1932, p. 42.

[116] See Statuten des Vereins der Freunde des Berner Kunst-museums, 1.7.1920.

[117] Bern 1935.

[118] Letter from PK, Bern, to WG, May 1934 (SS/AWG).

[119] Meeting of the Board, 23.3.1935, in: 'Vereinsprotokoll', p. 150 (KmB). Die Meeresküste is the same as Klassische Küste, 1931,285, see Bern 1935, no. 57, sale price: 3,200 fr.

[120] See letter from MH, Kunsthalle Bern, to PK, Bern, 10.5.1935 (NFK).

[121] Hugo Wagner, in the introduction to the catalogue of the exhibition 50 Jahre Verein der Freunde des Berner Kunst-museums, Kunstmuseum Bern, 10–30.3.1970, p. 6.

[122] See Victor Loeb in the foreword to ibid., p. 4.

[123] See the entry in the book 'Die Donatoren des Kunst-museums (1871–1958)' (KmB). The other donors were: Dr. Wander, Bern, 3,000 fr.; Mr. Loeb, Bern, 1,000 fr.; Hermann Bürki, Bern, 50 fr. In Huggler 1939, Max Huggler thanks Hanni Bürgi for her support.

[124] Including Ad Parnassum the Kunstmuseum Bern only owned three works by Paul Klee. In 1931 the "Verein der Freunde des Berner Kunstmuseums" acquired the two coloured sheets Gerüst eines Neubaus, 1930,41 and Bildnis eines Kostümierten, 1930,84 for 735 RM directly from the artist, see 'Vereins-protokoll', pp. 113f., and letter from PK, Dessau, to the Kunst-museum Bern, 12.3.1931 (KmB).

[125] Huggler 1939.

[126] See [Max Huggler]: 'Er hatte in Bern wenig Erfolg, weil er Deutscher war' (Klee-Erinnerungen 8/Schluss), in: Berner Zeitung, Bern, 27.10.1987, and Huggler 1996, p. 101.

[127] Huggler 1936, p. 3.

[128] Invitation card to the opening of the exhibition Bern 1935 (SS/AWG).

[129] See postcard from Lisbeth Schmid-Blaser, Lyceum Club Bern, to MH, Kunsthalle Bern, 16.2.1935 (KhB).

[130] See letter from LK, Bern, to GG, 3.10.1934 (SS/AWG), and Bürgi 1951, p. 4.

[131] Huggler 1936, p. 3. It is not clear why, decades later, Hugg-ler revised his opinion on the success of the Klee exhibition of 1935, see Huggler 1969, p. 156.

[132] See the surviving fragments of correspondence between the collector and the artist (ABB).

[133] See 'Biographie', in: Alice Bailly. Werke 1908–1923, exh. cat., Galerie nächst St. Stephan, Vienna, 16.4-18.5.1985; Galerie Krinzinger / Forum für aktuelle Kunst, Innsbruck, 29.5–29.6.1985; Aargauer Kunsthaus, Aarau, 16.8–15.9.1985, p. 57. I am grateful to Paul-André Jaccard from Lutry, for de-tailed information on the relationship between Hanni Bürgi and Alice Bailly as well as on the works the collector acquired.

[134] Presumably purchased from the Weihnachts-Ausstellung Bernischer Künstler 1919, veranstaltet durch die Sektion Bern der Gesellschaft Schweiz. Maler, Bildhauer und Architekten, Kunsthalle Bern, 7.12.1919–4.1.1920, no. 8, sale price: 1,200 fr.

[135] See Elka Spoerri, 'Alice Bailly (1872–1937). Biographische Notizen zu den Bildern im Kunstmuseum Bern', in: Berner Kunstmitteilungen, Bern, nos. 128/129, July/October 1971, p. 9 (the previous owner is erroneously named here as Bürgi-Widmer instead of Bürgi-Bigler), ill. p. 5.

[136] 'Protokoll der 22. Direktionssitzung des Kunstmuseums Bern', 27.6.1939 (KmB).

[137] Paul-André Jaccard reports that there is no information as to the location nor an illustration of the oil painting that was sub-sequently made, La Passante à Berne (alternative title: La Passante).

[138] La Ville en fête, 1918, wool embroidery on canvas stretched

on card, 71 x 59 cm, private collection, presumably purchased at the exhibition *Alice Bailly / Sektion Aargau der Gesellschaft Schweizer Maler, Bildhauer und Architekten / Fritz Osswald, Paul Klee, A. Stockmann*, Kunsthalle Bern, 19.6–17.7.1921, no. 9, price: 1,500 fr.-; *Genève sous la neige*, 1919, wool embroidery on canvas stretched on canvas, 53 x 46 cm, private collection, presumably purchased at the exhibition *Les Tableaux-laine d'Alice Bailly*, Studio of Alice Bailly, Lausanne, 15–31.3.1930, see entry in 'Livre I. Renseignements sur mes œuvres', p. 21, no. 112 (Fondation Alice Bailly, Lausanne): "acquisé par Mme Bürgi en 1930"; information kindly supplied by Paul-André Jaccard.

[139] *Fleur dans la nuit*, 1918(?) and *Danseuse*, 1918, both in private collection. No details of medium or dimensions.

[140] *Croquis en couleurs (no 3)*, 1931, pencil and watercolour on paper, 47.3/47.5 x 32.3/32.6 cm, private collection.

[141] Huggler 1939.

[142] *Rolf B.*, 1920, original terracotta head, 30 cm, private collection; *Rolf B.*, 1924, original terracotta head, 36 cm, private collection; *Fredy Bürgi*,1927, head, technique unknown, 35 cm, private collection; *Max B.*, 1932, bronze head, private collection; *Stöffi*, 1939, original terracotta head, 19 cm, private collection; see the catalogue of works in: Wilhelm Stein (ed.), *Max Fueter*, Bern 1960, pp. 27–29, 31, 33.

[143] *Terrasse. Diemerswyl*, 1917, watercolour on paper on card, 22.6 x 27.1 cm, private collection; *Durchblick. Diemerswyl*, 1917, pencil and watercolour on paper on card, 22.6 x 27 cm, private collection.

[144] See *Bulletin du Lyceum de Suisse*, Geneva, vol. 2, no. 10, May 1923, p. 2.

[145] On the history and aims of the Lyceum Club, see *Lyceum Club*, ed. by the Association Internationale des Lyceum Clubs, Wemding 1986.

[146] See *Bulletin du Lyceum de Suisse*, Geneva, vol. 4, no. 28, March 1925, p. 6, and *Bulletin du Lyceum de Suisse*, Geneva, vol. 9, no. 77, February 1930, p. 9.

[147] See *Bulletin du Lyceum de Suisse*, Geneva, vol. 7, no. 58, March 1928, p. 6, and *Bulletin du Lyceum de Suisse*, Geneva, vol. 17, no. 156, January 1938, p. 10.

[148] See *Adressbuch der Stadt Bern 1929*, Bern 1929. On the biography of Moeschinger see Helene Ringgenberg, 'Albert Moeschinger (1897–1985). Das Leben', in: Falkner 1996, pp. 6f.

[149] See for example *Bulletin du Lyceum de Suisse*, Geneva, vol. 11, no. 105, December 1932.

[150] See letter from LK, Bern, to GG, 29.12.1935 and letter from LK, Bern, to GG, 25.1.1936 (SS/AWG).

[151] Information kindly supplied to the author by Vreni Glaus, Thun, former president of the Albert Moeschinger Foundation, 5.10.1999.

[152] Letter from LK, Bern, to GG, 29.12.1935 (SS/AWG).

[153] The Klees and Moeschinger met each other through their mutual friendship with Victor Surbek and Marguerite Frey-Surbek; information kindly supplied by Vreni Glaus, Thun. In 1933 Moeschinger dedicated to Paul Klee the piece *3 Humoresken für Violin & Klavier*, op. 37, see Falkner 1996, no. 226. In return the artist gave the composer the painting *dürre Pflanzen*, 1929,342, oil on card, 23 x 46 cm, private collection, Switzerland, with the dedication: "Für Albert Moeschinger freundlich-nachbarlich Bern, Sept. 1934 Klee".

[154] *Das Tierli-Rondo für Gesang & Klavier*, [no op.], 1932 (see Falkner 1996, no. 121), dedication on the sixth handwritten copy: "Frau Hanny Bürgi mit herzlichem Gruss"; *Ach! zu lieben für Gesang und Klavier*, incipit: "Ach! zu lieben und behüten", text: Albert Moeschinger[?], [no op.], 1933, dedication: "Für Frau Hanny Bürgi von Albert Moeschinger 27.XII.33" (not listed in Falkner 1996); *Liebeslied für Gesang und Klavier*, incipit: "Ich schlaf, ich wach, ich geh", text: unknown poet, [no op.], 1933, dedication: "Für Frau Hanny Bürgi Weihnachten 1933 von Albert Moeschinger" - no. 1 of *Zehn Lieder*, printed by Schott 1934 as Opus 36a (see Falkner 1996, no. 122), dedication on a copy of the first edition: "seiner lieben Frau Hanny Bürgi mit den besten Wünschen von Albert Moeschinger Bern, 16-11-34"; *Frage an das Schicksal*, short piano piece, [no op.], 18.12.1934, dedication: "für Frau Hanny Bürgi von Moe" (not listed in Falkner 1996). All manuscripts and printed music are in the Bürgi Archives, Bern.

[155] See Falkner 1996, no. 277. The manuscript is in the Albert-Moeschinger-Stiftung, Öffentliche Bibliothek der Universität Basel.

[156] See Bürgi 1998, p. 4.

[157] See *The New Grove. Dictionary of Music and Musicians*, ed. by Stanley Sadie, vol. 7, London 1980, pp. 364f.

[158] See Bürgi 1998, p. 4.

[159] Letter from LK (& PK), Montana, to WG, 18.9.1936 (SS/AWG).

[160] Letter from LK, Bern, to WG, 24.8.1936 (SS/AWG). During the last three years of her life Hanni Bürgi moved a number of times. There are records of the following addresses: 21 Alpenstrasse from April 1934 to November 1936; 18 Elfenstrasse from December 1936 to April 1937; 45 Schänzlistrasse from May 1937; Tillierstrasse 6, probably until August 1938; see the changes of address in the *Bulletin du Lyceum de Suisse*, Geneva, no. 120, May 1934, p. 2; no. 145, December 1936, p. 4; no. 150, May 1937, p. 2; no. 156, January 1938, p. 5.

[161] See letter from LK, Bern, to WG, 11.2.1937 (SS/AWG).

[162] Ibid.

[163] See letter from LK, St. Beatenberg, to GGr, 31.8.1938 (NFK).

[164] See the entry in the book 'Berner Kunstmuseum; Leihgaben' (KmB): "Nr. 297 / Eingangsdatum; 8. VII 37 / Autor: Klee u. Bailly / Gegenstand: 52 Blatt / Besitzer: Frau Bürgi / zurück an: 54 Blatt Rolf Bürgi / Ausgangsdatum: 10. X 38."

[165] Letter from LK, Ascona, to WG, 15.9.1937 (SS/AWG).

[166] See Bürgi 1951, p. 5.

[167] See 'Bestattungsprotokolle 1938; Nr. 17927' (Stadtarchiv, Bern) and the medical history of Hanni Bürgi's illness (Archiv der Universitären Psychiatrischen Dienste, Bern), summarised by Christoph A. Bürgi, Bern.

[168] See 'Announcement of Death', in: *Der Bund*, Bern, vol. 89, no. 381, 17.8.1938, evening edition, p. 8, and letter from LK (& PK), St. Beatenberg, to WG, 26.8.1938 (SS/AWG).

[169] Frey-Surbek 8/1938.

[170] Dora Dätwyler-Garraux, '† Frau Hanni Bürgi', in: *Bulletin du Lyceum de Suisse*, Geneva, vol. 17, no. 162, September 1938, p. 8.

[171] Card from LK, Bern, to RB, Bern, 15.8.1940 (ABB).

JOSEF HELFENSTEIN

MEETING PLACE: THE BÜRGI COLLECTION
PAUL KLEE'S LIFE AND WORK

1883–1910

The Bürgi collection is one of the few collections of works by Klee to cover the whole span of his artistic activities, from childhood drawings (cat. no. 1) to his last works made in May 1940, a few weeks before his death (*vermält*, 1940,363, cat. no. 150). Klee met Johanna Bürgi-Bigler between 1906 and 1908. A year younger than himself and with a keen interest in the arts, Hanni Bürgi was married to Alfred Bürgi, an owner of a construction company in Bern; she first met Klee long before he was established as an artist and when he had barely sold any works as yet.

The childhood drawing in the Bürgi collection is one of almost sixty surviving drawings Klee made between the ages of three and eleven years (1883–1890) (see *Catalogue Raisonné Paul Klee*, vol. 1, nos. 1–38). Later on he included eighteen of these in his œuvre catalogue. It is well-known that Klee is one of those artists who, from early on, refered programmatically to childhood as an ideal of artistic activity.

Having completed his school-leaving certificate in Bern, in October 1898 Klee travelled to Munich in order to train as an artist. In April of the same year he started to keep a diary which he persevered with until 1918, subsequently re-working and editing it on into the 1920s. In Munich he attended the private drawing school run by Heinrich Knirr from 1898 until 1900, to prepare himself for the Academy of Art. In 1900/1901 he studied for six months under Franz von Stuck at the Munich Academy of Art. After a six-month study trip to Italy (October 1901 until May 1902), Klee spent the next years in the seclusion of his parental home in Bern. Here, in the calm, bourgeois atmosphere of a provincial town, he systematically pursued his artistic training on his own. He embarked on a sober and extremely disciplined analysis and acquisition of the artistic means which he regarded as the foundations of his art. As he did so he was unremittingly self-critical of his own artistic progress. It was not until 1903, when he started on *Inventionen*, a series of etchings, that he felt he was working on his first works of any importance. In March 1905 he completed his *Inventionen*, and designated this series of ten etchings as his "opus one". In parallel with the etchings Klee also made studies from the figure: generally free inventions, often with elements of caricature about them. In these drawings, influenced by the life drawings of Rodin that he had seen in Rome in 1902, he used line more freely.

In summer 1905 he began to experiment with drawings scratched into black-

ened glass plates. In these he exploited the resistance of the unusual picture support in order to explore new possibilities of pictorial expression. These experiments led him to his technique of reverse-glass painting, which he continued to use off and on until 1912.

In September 1906 Klee married the pianist Lily Stumpf, and on 1 October of the same year he moved to Munich. After the birth of their son Felix Klee on 30 November 1907, Klee took care of the child while his wife supported the family by giving piano lessons. Klee continued to experiment; from 1907 onwards he made an increasing number of drawings from nature (1907–1910), striving to realise the same free, personal style of those earlier drawings which were not from nature (1903–1906).

During the first fifteen years of his artistic career Klee primarily and almost exclusively produced drawings. It was not until after 1914 that drawing lost its dominant status in his work. Up until approximately 1910 Klee was searching for his own personal style. In this sense, the drawings that use "broken" lines, showing scenes from nature in the countryside around Bern (1909/1910), mark a breakthrough in his work. Around 1907, using black watercolour paint, Klee had started to look at light/dark contrasts in an early exploration of colourist effects. In 1910 he started to apply to colours and colouration the lessons he had already learnt about tonality.

The year 1910 marks the end of Klee's early period, a phase in which he had worked in seclusion and solitude, developing a personal style. In August of that year, for the first time Klee came to public notice: the occasion was his first substantial solo exhibition at the Kunstmuseum Bern, which then toured to the Kunsthalle Basel and to a gallery in Winterthur. 1910 also saw the beginning of his friendship with Alfred Kubin, whose attention had been caught by Klee's work and who first bought a drawing of his in December 1910; from now on Klee's reputation grew slowly but steadily, and he started to form links with the artists of the European avant-garde.

In the Bürgi collection there are examples of almost all the different experiments, techniques and stages in Klee's early period: the *Inventionen* (cat. nos. 3–12), rarely seen in such numbers, are the first highlight of the collection. Reverse-glass paintings such as *belebter Platz vom Balcon aus*, 1908,62 (cat. no. 15) are in any case exceptional amongst Klee's works. The landscape drawings showing the district around Bern (from 1908 onwards) are another main focus of the Bürgi collection (cat. nos. 17–21, 24, 25), and come from the time around 1909 when Hanni Bürgi was taking her first steps as a collector.

Kinderzeichnung, fünf Geschwister darstellend.

1

Child's Drawing, Portraying Five Siblings, 1885–1889

Kinderzeichnung, fünf Geschwister darstellend, 1885–1889

2
Untitled, 1898
Ohne Titel, 1898

3
Virgin (dreaming), 1903
Jungfrau (träumend), 1903,2

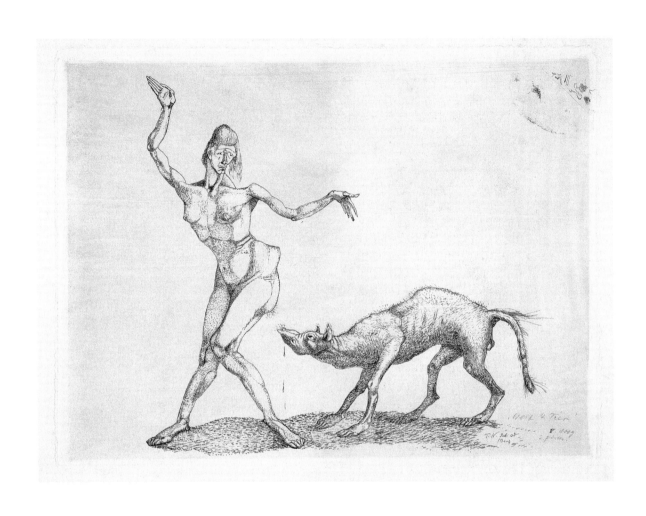

4
First Version "Woman and Beast", 1903
Erste Fassung "Weib und Tier", 1903

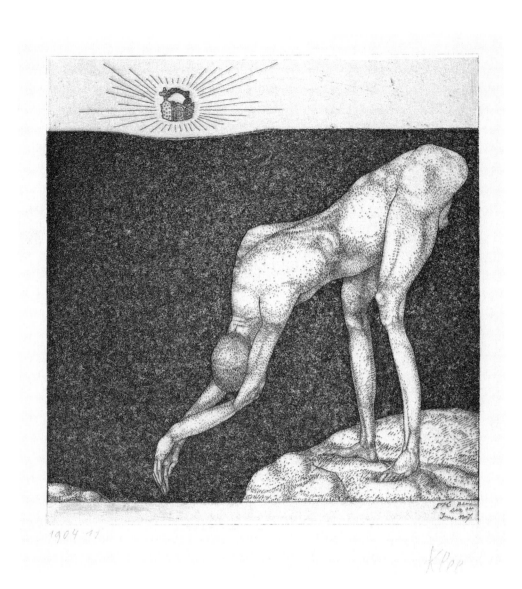

5
A Man Sinks down before the Crown, 1904
ein Mann versinkt vor der Krone, 1904,11

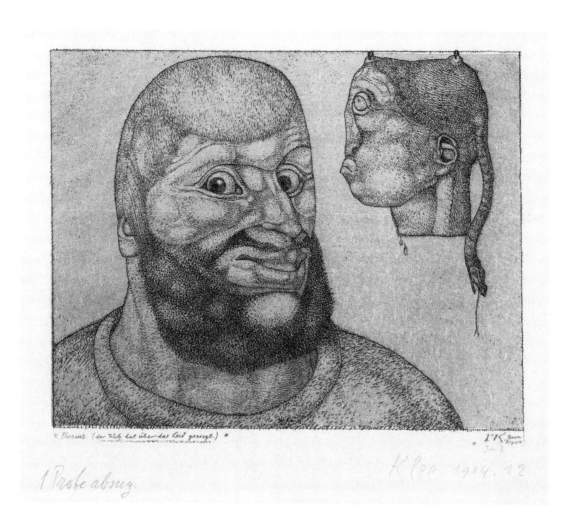

6
Perseus. (Wit has Triumphed over Grief.), 1904
Perseus. (der Witz hat über das Leid gesiegt.), 1904,12

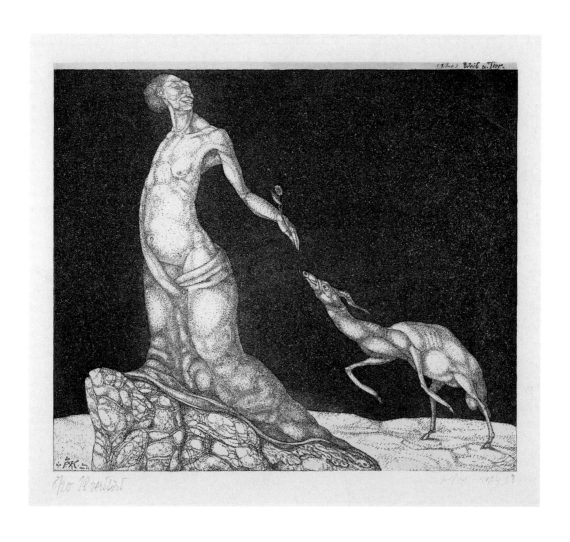

7
Woman and Beast, 1904
Weib u. Tier., 1904,13

8
Comedian. (Inv. 4), 1904
Komiker. (Inv. 4), 1904,14

9

Pessimistic Symbol of the Mountains. (Inv. 11.), 1904

Pessimistische Symbolik des Gebirges. (Inv. 11.), 1904

10
Aged Phoenix (Inv. 9), 1905
Greiser Phönix (Inv. 9), 1905,36

11

Menacing Head, 1905

Drohendes Haupt, 1905,37

45

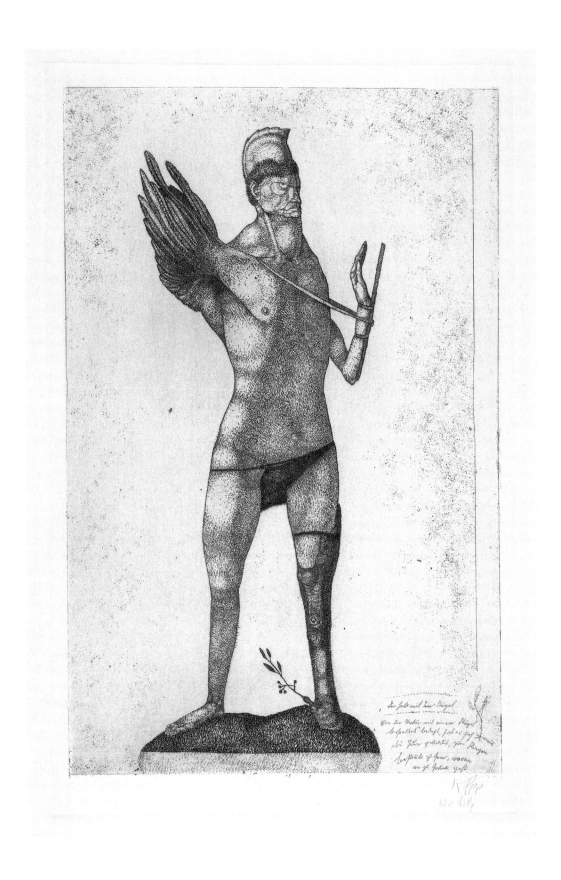

12
Winged Hero, 1905
Der Held mit dem Flügel, 1905,38

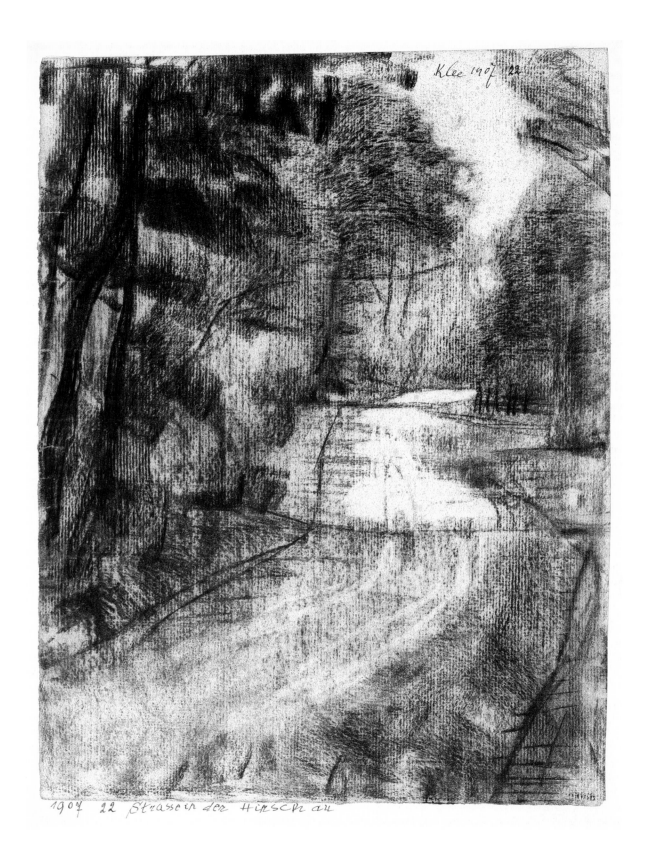

1907 22 Strasse in der Hirschau

13
Road in the Hirschau, 1907
Strasse in der Hirschau, 1907,22

14
Children on a Building Site, 1908
Kinder auf e. Bauplatz, 1908,44

15
Busy Square as Seen from the Balcony, 1908
belebter Platz vom Balcon aus, 1908,62

16
The Clock on the Sideboard, 1908
d Uhr auf d. Kredenz, 1908,69

17
Quarry of Ostermundigen, 1909
Osterm. Steinbruch, 1909,27

18
Deciduous Forest, 1909
Laubwald, 1909,42

52

19
Landscape with the Oak Tree, 1909
Landschft. mit d. Eiche, 1909,44

20
Bathing Place by the Aare, 1909
Aare-Bad, 1909,58

21
Well-Tended Forest Path, 1909
Gepflegter Waldweg, 1909,62

22
Avenue Lined with Young Trees, 1910
junge Allee, 1910,18

23
Lilacs, 1910
Flieder, 1910,25

24
Aare near Berne, 1910
Aare b. Bern, 1910,38

25
Mouth of the Gürbe, 1910
Gürbemündung, 1910,68

26
Houses in the Park, 1910
Häuser im Park, 1910,72

27
Crane in the Quarry, 1910
Radkrahn im Steinbruch, 1910,107

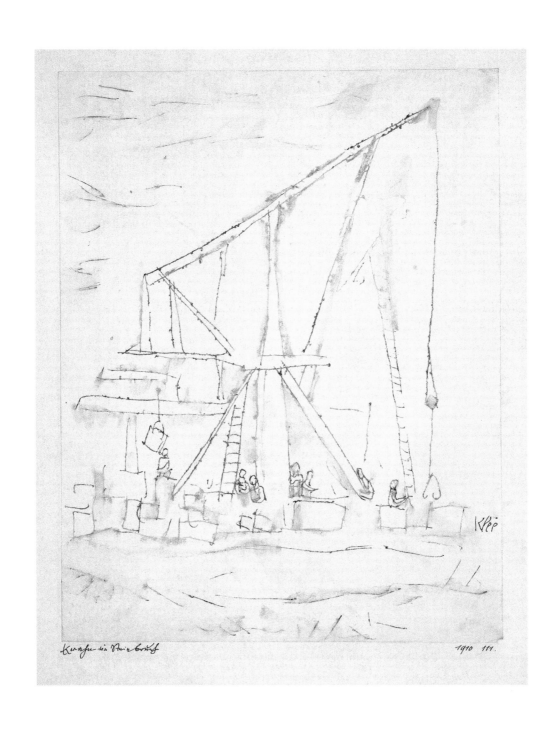

28
Crane in the Quarry, 1910
Krahn im Steinbruch, 1910,111

1911–1914

In January 1911 Kubin, an admirer of Klee's drawings, visited his colleague in Munich. In February of the same year Klee decided to compile a complete catalogue of all his works to date, including his childhood drawings. Thus he was in part creating an instrument for monitoring, classifying and ordering his artistic production – similar to the systematic record of his personal and professional development he had been keeping in his diaries since 1898. At the same time, this catalogue also meant evaluating what he felt to be of significance in his artistic development so far. Having started to catalogue his works in 1911, he continued to do so with meticulous care throughout his life.

In May 1911 Klee started a set of drawings illustrating Voltaire's novel *Candide ou l'Optimisme* (first published in 1759). In these drawings he created a new type of figure (see *Praecision zweier Candide-Figuren*, 1912,170, cat. no. 34). In this style of drawing, where the line is broken up by the "restlessness of the hand", the figures take on a schematic quality. Here the line is poised on the borderline between having a representational and an autonomous, non-representational function. Thus by the use of purely artistic means, Klee had captured the pessimistic undertone of Voltaire's novel, with which he himself identified on a personal level; at the same time, in his illustrations for *Candide* he also succeeded in advancing his own modernist conception of drawing which he had been working on for years. This translation of the novel with Klee's illustrations was not published until 1920 by the Verlag Kurt Wolff in Munich.

The years 1911 and 1912 brought with them encounters that were to have a decisive effect on Klee's artistic career. In 1911 he met August Macke and Wassily Kandinsky, in 1912 Robert Delaunay (in Paris), Hans Arp, Franz Marc, Alexei von Jawlensky and the Berlin art dealer Herwarth Walden. On his second trip to Paris in April 1912 Klee explored Cubism more thoroughly; his encounters with the members of Der Blaue Reiter strengthened his interest in children's drawings. He also established close contact with the avant-garde in Switzerland, who had formed the group Der Moderne Bund (with Hans Arp amongst its members). From 1911 onwards Klee participated regularly in their group exhibitions; in 1911 in the Galerie Thannhauser in Munich, the following year in the 2nd Exhibition of Der Blaue Reiter (in Munich), the International Exhibition of the Sonderbund in Cologne, the group exhibition of Der Moderne Bund in Zurich and in the Galerie Hans Goltz in Munich. With his participation in the Sonderbund exhibition in Cologne and in the *Erster Deutscher Herbstsalon* in the Berlin gallery Der Sturm in 1913, Klee's work was represented at the two largest and most important survey exhibitions on contemporary art that took place in Germany before the First World War. Thus within a short space of time Klee had become a firm member of the small group of increasingly confident, publicly active, avant-garde artists in Germany.

Klee's own new self-confidence is evident in the fact that for a time he was also active as an art critic and cultural commentator. For over a year, starting in November 1911, he regularly wrote reviews of exhibitions for the Swiss monthly *Die Alpen*, which was edited by his friend Hans Bloesch in Bern. In his reports from Munich he quite deliberately took the part of mediator and promoter of the new "expressionist" art.

In April 1914 Klee travelled with Louis Moilliet and August Macke to Tunisia. This two-week visit to North Africa sparked off one of his most fruitful periods of production. Klee documented the trip in detail in his diary, and celebrated it as his "breakthrough to colour". However, the declaration of war on 1 August 1914 initially put an end to contacts abroad and any hopes of success for the German avant-garde, including Paul Klee.

The years 1911 to 1914 which were crucial to Klee's career are not so strongly represented in the Bürgi collection as the years immediately previous to that. One major work is the self-portrait *Junger Mañ, ausruhend*, 1911,42 (cat. no. 30). In this work Klee's dialogue with the work of van Gogh, one of the most widely discussed artists in avant-garde circles in Munich, reaches a high point. From the works made in North Africa there is the watercolour *Blick zum Hafen von Hamañet*, 1914,35 (cat. no. 41). Klee, Macke and Moilliet stayed in Hammamet on 14 April, having travelled from Tunis. A day later they continued on to Kairuan. Klee showed this watercolour along with seven others in the first exhibition of the Neue Münchner Secession, which was opened on 30 May, shortly after his return.

JH

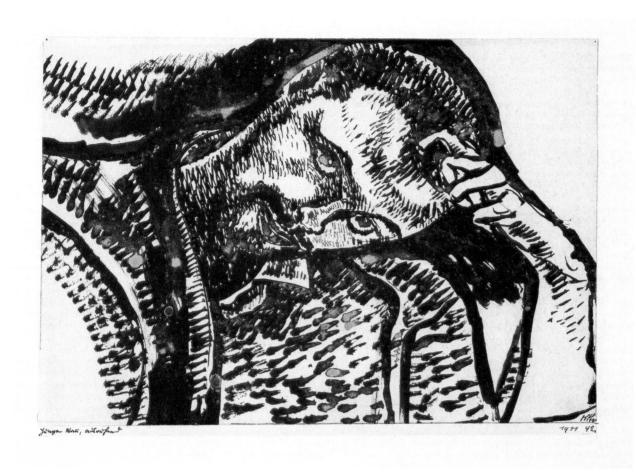

30
Young Man Resting, 1911
Junger Mañ, ausruhend, 1911,42

32
Factory Building by the Water (with the 4 Chimneys), 1912
Fabrikanlage am Wasser (mit den 4 Kaminen), 1912,24

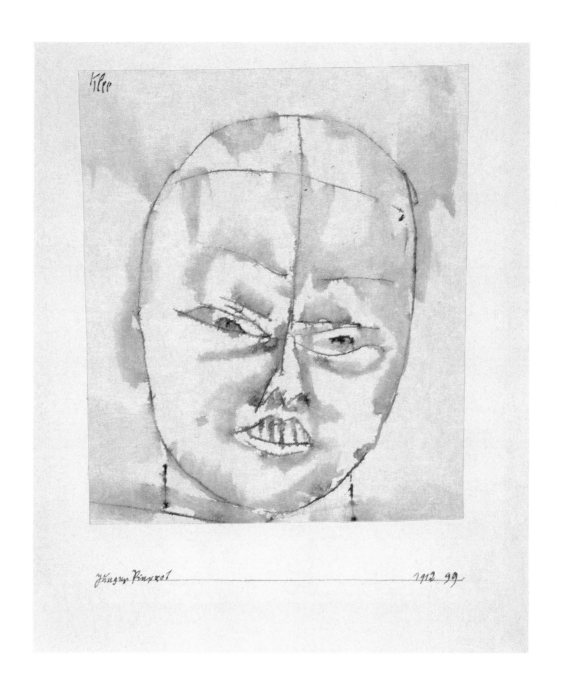

33
Young Pierrot, 1912
Junger Pierrot, 1912,99

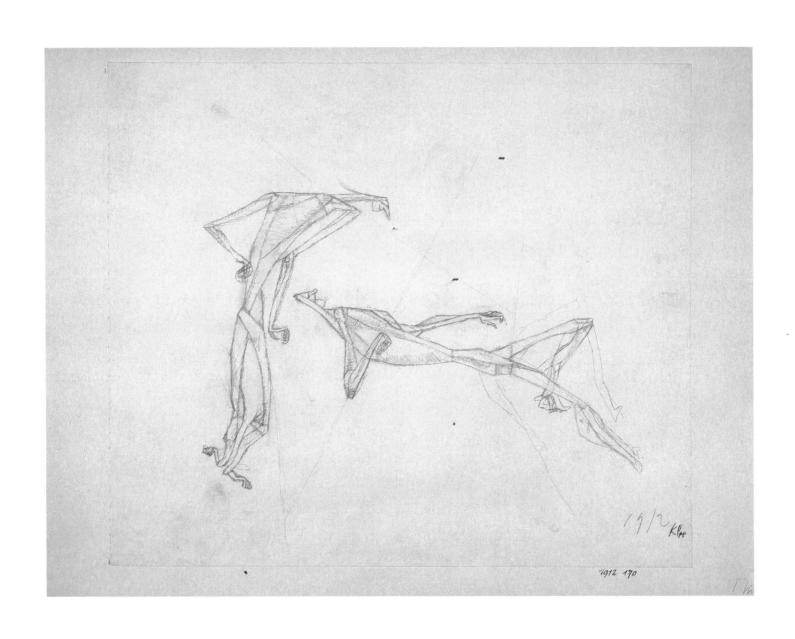

34
Precision of Two Candide Figures, 1912
Praecision zweier Candide-Figuren, 1912,170

36

A Creator's Grief, 1913

Kummer eines Schöpfers, 1913,103

37
Fighting with Beasts of Prey, 1913
im Kampf mit Raubtieren, 1913,144

39
On the Abyss, 1913
Am Abgrund, 1913,157

40

Medieval Town, 1914

Mittelalterl. Stadt, 1914,15

41
View Towards the Harbour of Hammamet, 1914
Blick zum Hafen von Hamamet, 1914,35

1914–1920

In contrast to many artists and intellectuals in Germany Klee did not share the widespread enthusiasm for war. Yet the outbreak of war did not stop him from painting with intense concentration. On the contrary, in his diary and in his correspondence with Franz Marc Klee described his deliberate, increasing withdrawal from the world as being directly related to the war and its cruelty and futility, which he wanted to keep at bay as far as possible. Not least as a result of the trip to North Africa, the years 1914 and 1915 became the most productive period in Klee's career so far. In his œuvre catalogue he listed a total of 475 works for these two years.

Klee continued to spend the summer months with his family in Bern and in the Bernese Alps. In October 1914, on his way to Munich he visited Wassily Kandinsky, who had fled to Goldach near Lake Constance with Gabriele Münter after the outbreak of war. In 1915 Klee met the poet Rainer Maria Rilke and the two remained on friendly terms in the years to follow.

On 11 March 1916, a few days after the death of Franz Marc at the front, Klee was called up to serve in the German army and recruited at Landshut near Munich. In August he was transferred from the infantry to the Reserve Flying Division in Schleissheim. After his transfer to the Royal Bavarian Flying School in Gersthofen in January 1917, which spared him from duty at the front, he was able to paint when he was off-duty in a room he had rented for the purpose.

During the war years Klee had his first commercial successes. While the exhibition in the Berlin gallery Der Sturm in March 1916 had gone well, in the Sturm exhibition in February 1917 Klee sold more than he had ever done before. But more important than this was the recognition he received in the press. In various reviews, most notably by the writer Theodor Däubler, Klee was celebrated as a major discovery. Even before the end of the war these successes led to plans for a monograph on Klee by the German art historian Wilhelm Hausenstein, although these only came to fruition in 1921.

When the war came to an end so, too, did Klee's entries in his diaries, although he did edit and partially re-work them on into the early 1920s. During the war Klee had already started to explore theoretical issues regarding pictorial composition. In 1918/1919 he wrote his first essay on the theory of art; this was then published in 1920 in the anthology *Schöpferische Konfession* (Creative Confession), edited by Kasimir Edschmid. After having been sent on leave in 1918 and demobilised in 1919 Klee rented a studio in the little Schloss Suresnes in Munich. Here for the first time he concentrated his attention on oil painting.

In spring 1919 Klee became actively involved in the cultural politics of the Munich Republic of Councils. After its collapse he fled to Switzerland in June to escape the military regime. Here he found Hans Arp and met Tristan Tzara and

other members of the Zurich Dada movement. The efforts of Oskar Schlemmer and Willi Baumeister to have Klee appointed to a chair at the Stuttgart Academy of Art fell through in autumn 1919. On 1 October 1919 Klee signed an exclusive contract with the Munich art dealer Hans Goltz. In terms of picture sales, 1919 was by far Klee's most successful year to date.

In 1920 the 40 year-old artist made the breakthrough to public recognition. In May his largest exhibition yet, with 363 works, was opened in the gallery "Neue Kunst – Hans Goltz" in Munich. With active support from Klee, Hermann von Wedderkop and Leopold Zahn published the first two monographs on him. In October Walter Gropius appointed Klee to a chair at the Staatliche Bauhaus in Weimar.

In the Bürgi collection there are only a few examples of Klee's output during the war years. This is partly due to the fact that from 1916 until the end of the war Klee could not travel to Bern, and consequently had less contact with Hanni Bürgi. At the same time, in 1916, 1917 and 1918 Walden sold numerous works in the Sturm exhibition. This greatly reduced the works available to collectors such as Bürgi, since Klee also kept back a number of works in order to avoid a "sell-out". The inclusion of the three-part sequence of watercolours of the lower and upper Lake Stockhorn (cat. nos. 44–46) shows the collector's continued interest in views of Bern and the surrounding areas. Typical examples of Klee's output during the war, which sold so well in Berlin, are the coloured works *Bildnis einer Rothäutigen*, 1917,112 (cat. no. 50) and *Schiffsrevue* 1918,9 (cat. no. 51). The drawing *Die Zahlenhölle*, 1918,145 (cat. no. 52) has an ironic, self-reflexive character in its reference to Klee's function as a clerk and cash officer in the German army. His output for 1920 is particularly strongly represented in the Bürgi collection with a total of seven works (cat. nos. 56–62).

JH

43
Untitled, 1914
Ohne Titel, 1914

44

A 1 Lower Stockhornsee, 1915

A 1 unterer Stockhornsee, 1915,164

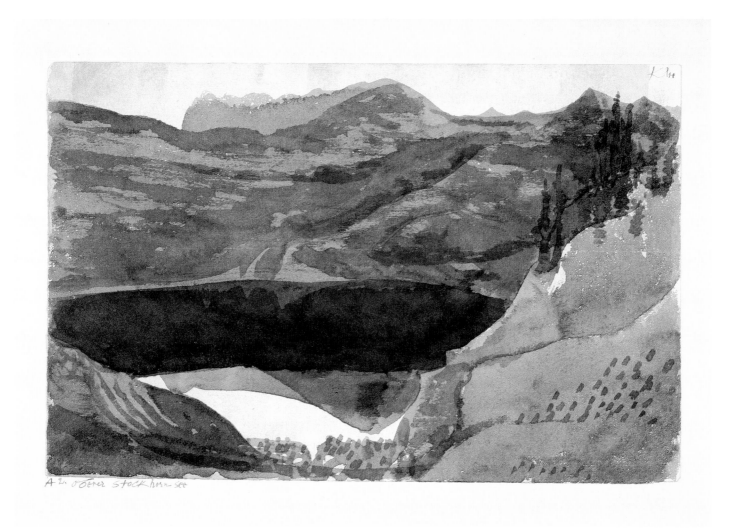

A 2. oberer Stockhornsee

45
A 2. Upper Stockhornsee, 1915
A 2. oberer Stockhornsee, 1915,165

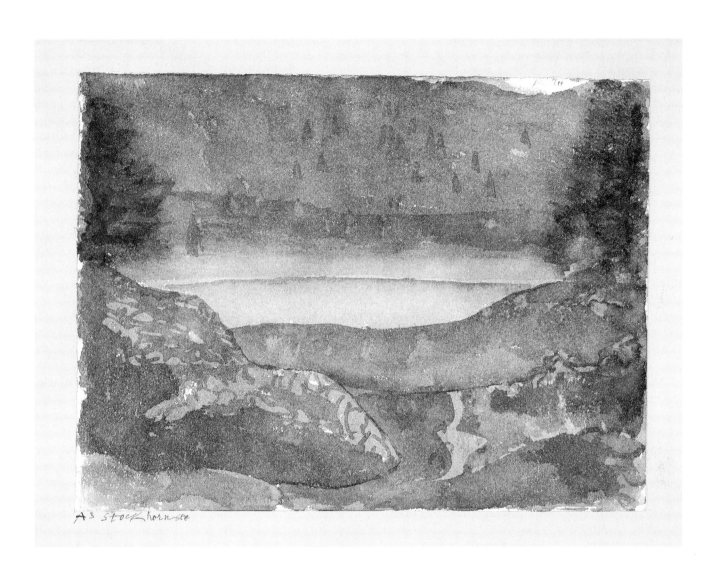

46
A 3 Stockhornsee, 1915
A 3 Stockhornsee, 1915,166

47
Untitled, 1915
Ohne Titel, 1915,211 doppelte Nummer

48
Destruction and Hope, 1916
Zerstörung und Hoffnung, 1916,55

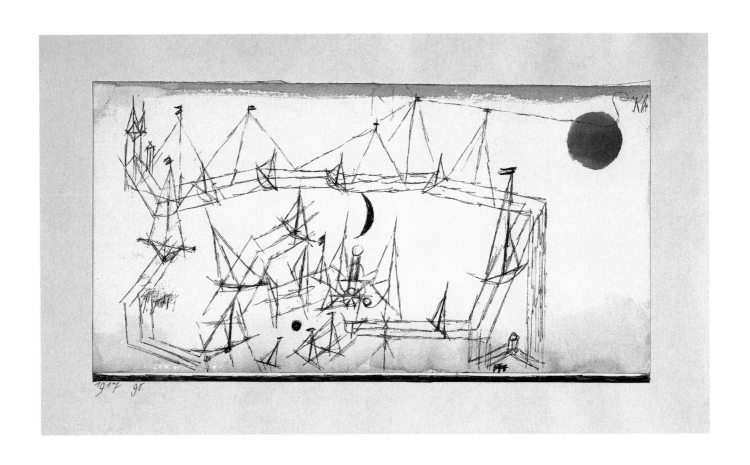

49

(Picture of a Harbour with the Black Half-Moon and the Indian Red Sun), 1917

(Hafenbild m. d. schwarzen Halbmond u. d. indischroten Sonne), 1917,90

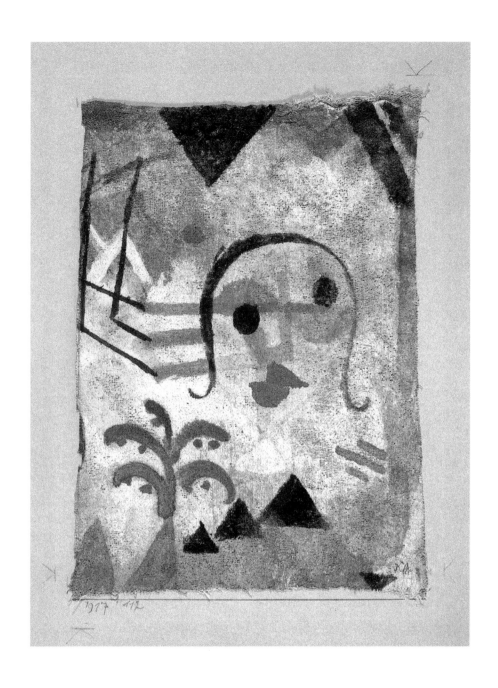

50
Portrait of a Woman with Red Skin, 1917
Bildnis einer Rothäutigen, 1917,112

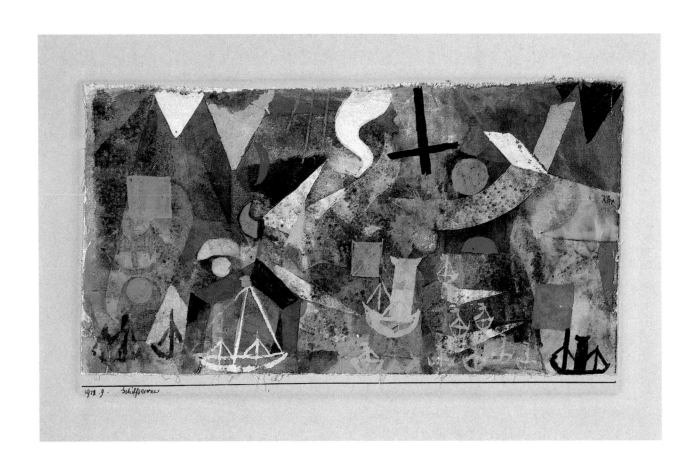

51
Review of Ships, 1918
Schiffsrevue, 1918,9

84

52
The Numbers Hell, 1918
Die Zahlenhölle, 1918,145

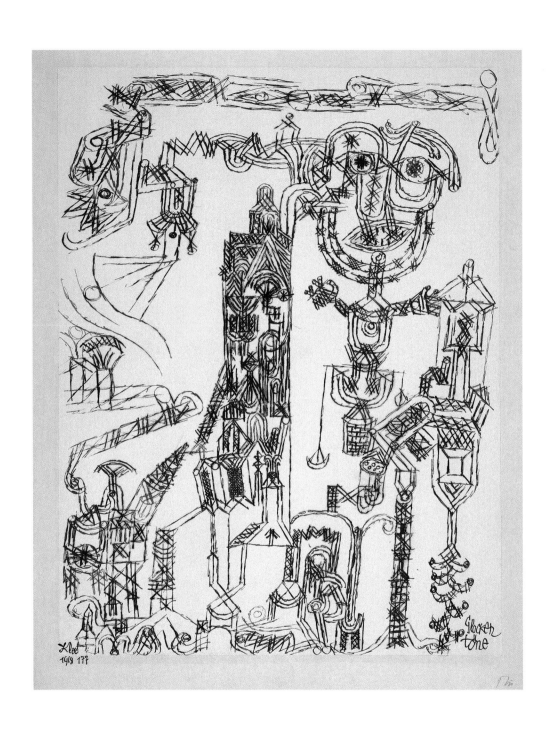

53
Sounds of Bells, 1918
Glockentöne, 1918,177

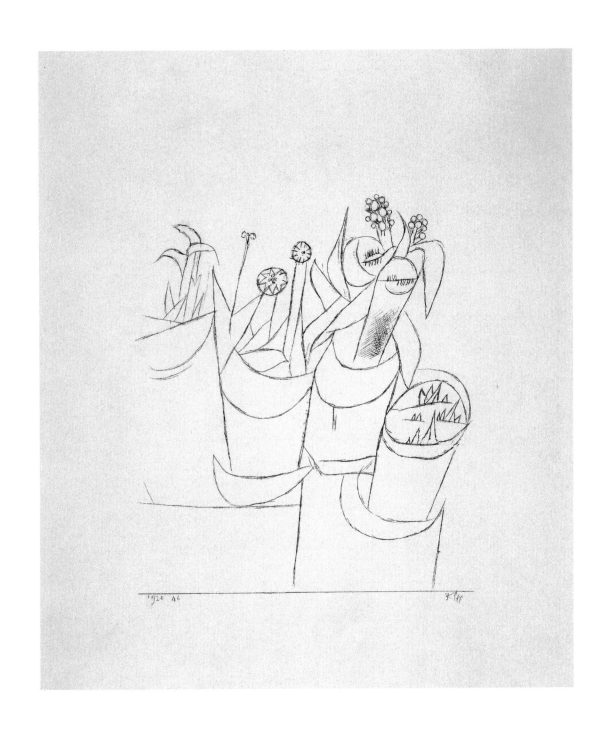

56
Pot Plants (after 1915,114), 1920
Blumenstöcke (nach 1915 114), 1920,46

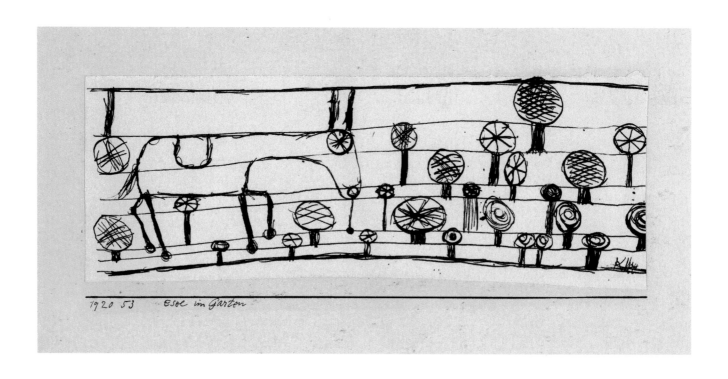

57

Donkey in the Garden, 1920

Esel im Garten, 1920,53

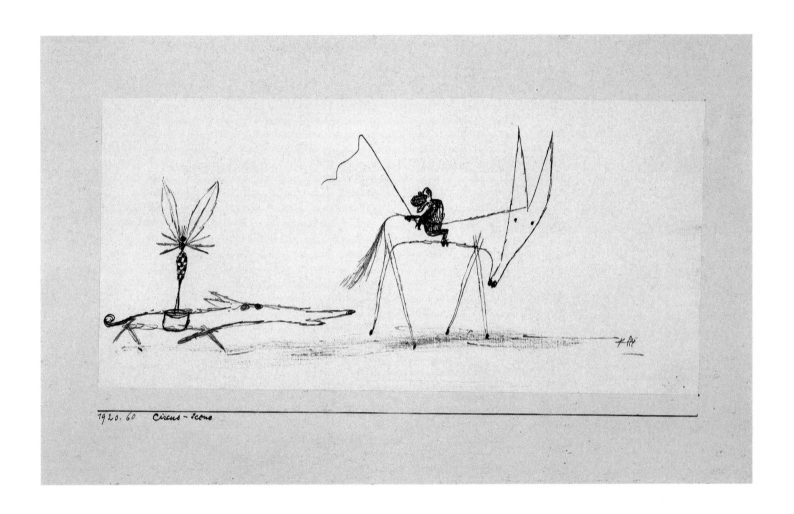

58
Circus Scene, 1920
Circus-Scene, 1920,60

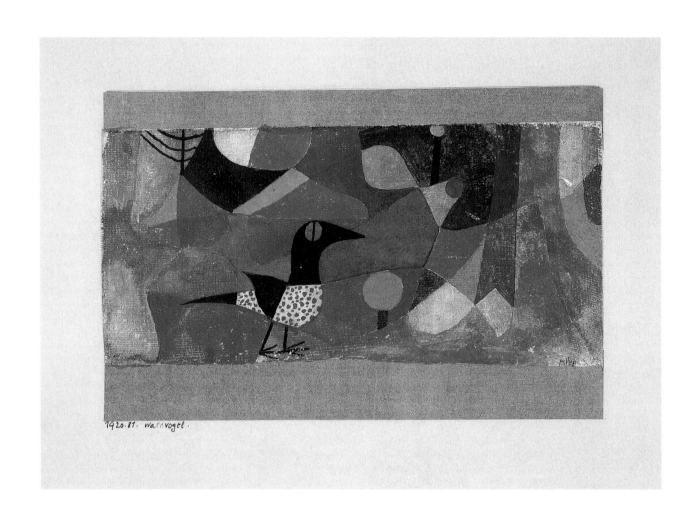

59
Forest Bird, 1920
Waldvogel, 1920,81

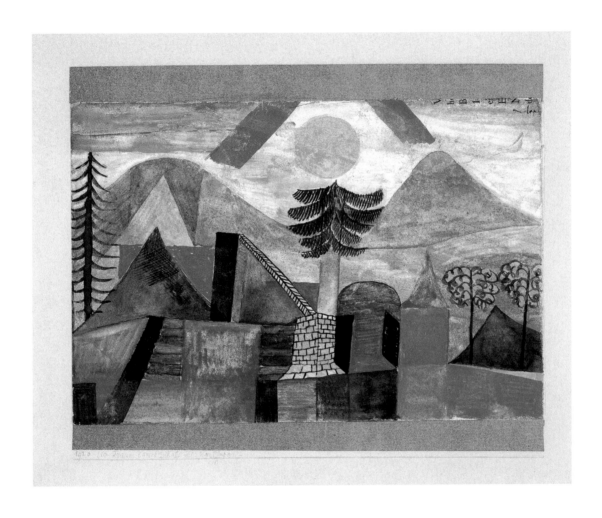

61
Dream Landscape with Conifers, 1920
Traumlandschaft mit Koniferen, 1920,110

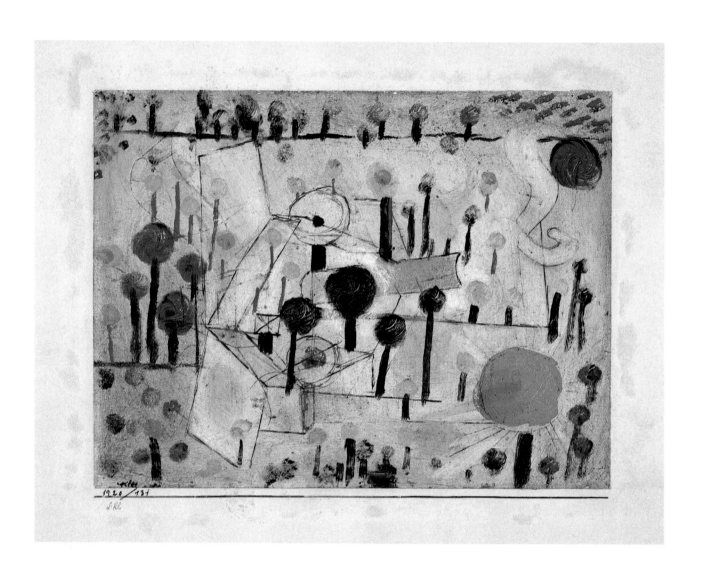

62
Abstract-Imaginary Garden, 1920
abstract-phantastischer Garten, 1920,131

1921–1924

With his appointment to the Bauhaus in Weimar, Klee found himself joining a group of leading contemporary artists. He took up his post on 10 January 1921. Before the family finally moved to Weimar in September 1921, he travelled there for a fortnight each month. His teaching consisted of morning lectures on the theory of form and composition and practical sessions in the afternoon. In mid-April Klee took over as master of form in the book-binding workshop; in 1922/1923 he was in charge of the glass-painting studio. The art training at the Bauhaus was intended to give students a precise understanding of the laws of form. During the time that he taught at the Bauhaus Klee concentrated on deepening and consolidating his experiences so far, above all looking at the methodology and theoretical foundations of his own artistic principles. At the same time as lecturing and teaching, Klee continued to work intensively on his own pictures.

In 1919 Klee had developed a process of transferring images, which allowed him to copy pencil, ink, and Indian ink drawings and to use these as the basis for coloured sheets (oil transfer drawings with watercolour). During his first years in Weimar (1921–1923) Klee made particularly intensive use of the new copying methods that were now technically and economically viable. An example of this in the Bürgi collection is the oil transfer drawing with watercolour *Bartolo: La vendetta, oh! la vendetta*, 1921,5 (cat. no. 64). The preparatory drawing is owned by the Paul Klee Foundation (*Zeichnung zu Dr. Bartolo 1921/5.*, 1921/40). Klee also began to make innovative use of his knowledge of oil transfer processes in his lithographs: *Hoffmaneske Märchenscene*, 1921,123, (cat. no. 65); *Narretei*, 1922,68, (cat. no. 67); *Vulgaere Komoedie*, 1922, 100, (cat. no. 68); *Der Verliebte*, 1923,91, (cat. no. 72); *Seiltänzer*, 1923,138, (cat. nos. 73, 74).

Klee's sales were growing but his earnings were largely wiped out by the consequences of the economic crisis and the soaring inflation rates at the time. 1921 saw the publication of Wilhelm Hausenstein's monograph *Kairuan oder eine Geschichte vom Maler Klee und von der Kunst dieses Zeitalters*. This book was to have a considerable influence on the reception of Klee's work. In summer 1922 Kandinsky was appointed to the Bauhaus. In summer 1923 Klee's essay 'Wege des Naturstudiums' (Ways of Studying Nature) was published in the catalogue of the first Bauhaus exhibition in Weimar.

On 26 January 1924, on the occasion of his exhibition at the Kunstverein Jena, Klee delivered his famous, posthumously published lecture *Über die moderne Kunst* (On Modern Art). In January/February of the same year, on behalf of the Société Anonyme in New York, Katherine Dreier organised the first exhibition of Klee's work in the USA. In 1924, together with Feininger, Jawlensky, Kandinsky and Klee, the German art dealer and promoter Emmy (Galka) Scheyer founded

the group "The Blue Four" with the aim of publicising their work in the USA. On 26 December 1924, having increasingly become the object of right-wing political attacks, the Bauhaus in Weimar was closed.

Kind an der Freitreppe, 1923,65 (cat. no. 71) and *Buchstabenbild*, 1924,116 (cat. no. 77) were the first oil paintings in the Bürgi collection. Both are in strikingly small formats, which may point to a preference on the part of the collector for particularly intimate works. *Buchstabenbild* is a complex work both in terms of its technique and content: a variety of geometrically shaped pieces of paper were first glued apparently randomly next to and over each other; a large sheet of paper, covering the whole surface of the picture, was then glued over these. This was coloured with watercolours before finally individual letters were added, again in watercolour. The picture support was nailed onto card with paper glued over its entire surface, the nailheads were painted brown-red and the whole was framed with simple wooden batons. The materials and techniques used for this laborious construction (roughened paper, paint partially scratched away) give the impression of a painting that has weathered with age and emerged out of the obscurity of some mysterious past. The seemingly meaningless letters strewn randomly across the picture surface lend weight to this sense of enigma.

JH

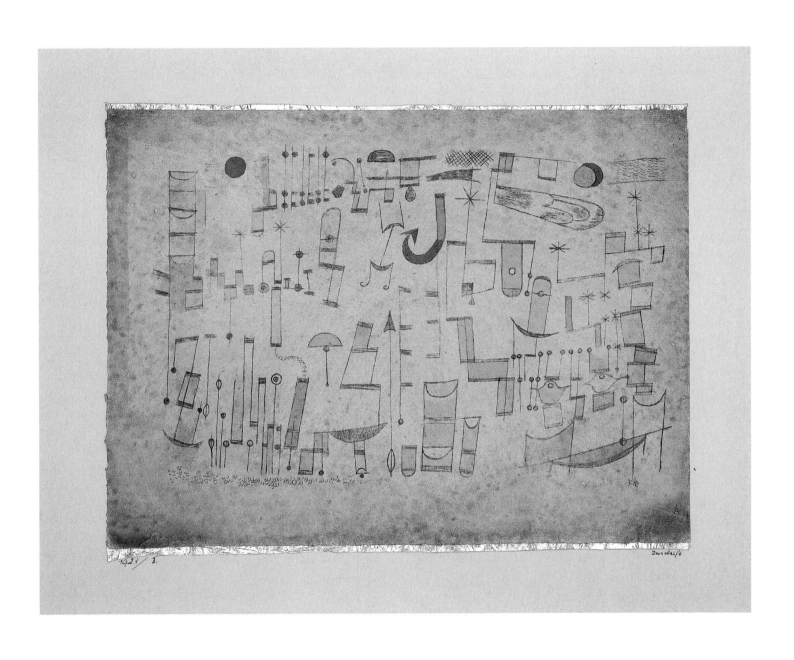

63
Inscription, 1921
Inschrift, 1921,3

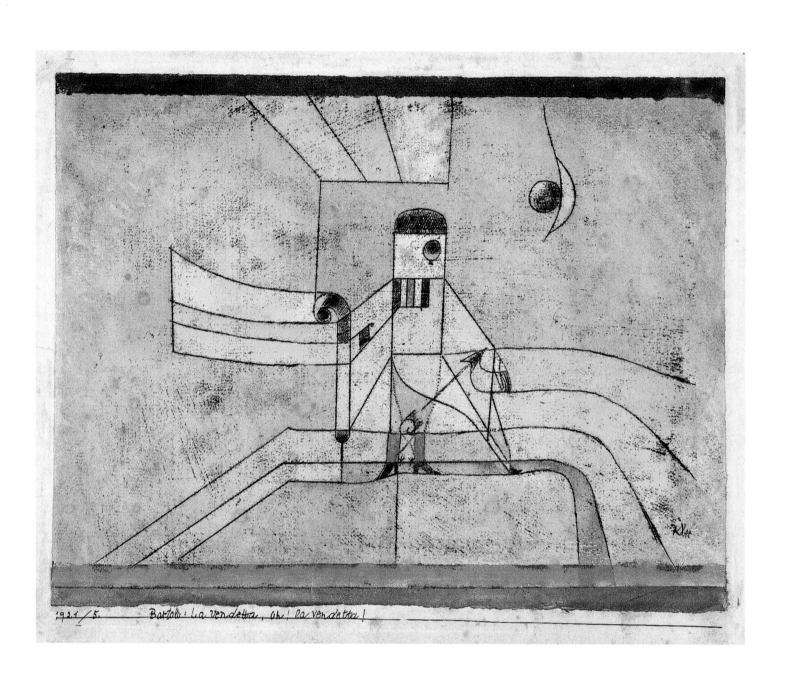

64
Bartolo: La vendetta, oh! la vendetta!, 1921,5

1921/123 Irdealzug von schwarze den Klee

65
Hoffmanesque Fairy-Tale Scene, 1921
Hoffmaneske Märchenscene, 1921,123

66
‹For 1922,130 Star Container›, 1921
‹zu 1922/130 Sternbehälter›, 1921,194

70

Postcard "The Sublime Aspect" for the Bauhaus Exhibition 1923, 1923

Postkarte "die erhabene Seite" zur Bauhaus-Ausstellung 1923, 1923,47

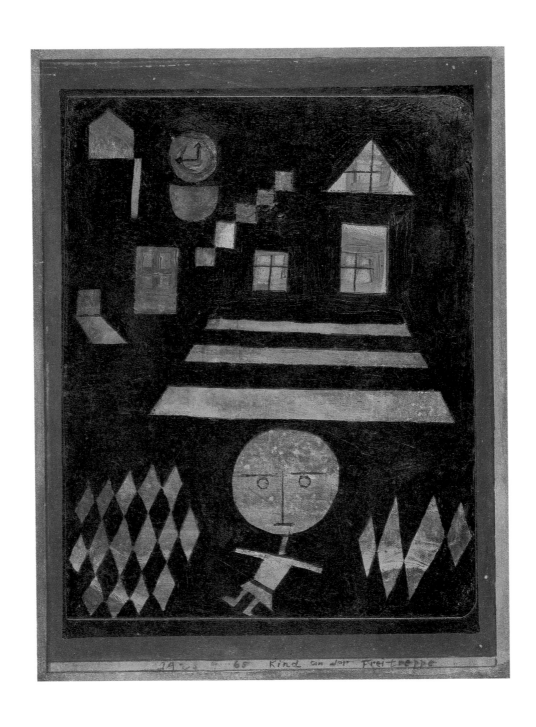

71

Child at the Front Steps, 1923

Kind an der Freitreppe, 1923,65

72
The Man in Love, 1923
Der Verliebte, 1923,91

73
Tightrope Walker, 1923
Seiltänzer, 1923,138

1924. 50.

Landschaft des Pferdchens

76
Landscape of the Pony, 1924
Landschaft des Pferdchens, 1924,50

77
Picture with Letters, 1924
Buchstabenbild, 1924,116

78
Oriental Cemetery, 1924
orientalischer Friedhof, 1924,174

79
Dune Landscape, 1924
Dünenlandschaft, 1924,194

80
Aquarium with Blue-Silver-Fishes, 1924
Aquarium mit Blausilberfischen, 1924,211

81

After an Impression of 1910 (View of the Neuenburgersee), 1924

nach einer Impression v. 1910 (Blick auf den Neuenb. See), 1924,227

1925–1931

The year 1925 was to be another one of important decisions and successes for Klee at home and abroad. In March the Dessau Municipal Council voted to take over the Bauhaus. After considerable hesitation Klee decided to continue in his post. However, he did not resettle in Dessau until 1926 when he and Kandinsky were able to move into one of the masters' houses built by Gropius. Klee and Kandinsky now ran a free painting class in Dessau.

In autumn 1925, Klee and Hans Goltz agreed to discontinue their exclusive contract. Thus, as before in 1919, Klee was now in charge of his own exhibition activities and sales, which meant working with a number of different dealers simultaneously. Up until 1933, Alfred Flechtheim, with galleries in Berlin and Düsseldorf, was the leading dealer for Klee's work in the international art world. In July 1925, even before the contract with Hans Goltz had been ended, the Braunschweig businessman and collector Otto Ralfs had set up the Klee Society, which remained in existence until the late 1930s and secured an additional monthly income for the artist from sales. Hanni Bürgi was amongst the founding members of the Society, which included the leading collectors of Klee's work in Germany and Switzerland.

In autumn 1925, Paul Klee's *Pädagogisches Skizzenbuch* (Pedagogical Sketch-book), a shortened version of his first semester lectures, was published as volume two of the series of Bauhaus Books. In October, the Galerie Vavin-Raspail in Paris presented Klee's first solo exhibition in France. In November the Surrealists included two works by Klee in their first group exhibition, in the Galerie Pierre in Paris. The Surrealists, above all René Crevel, Paul Eluard, Louis Aragon and Max Ernst, had been amongst Klee's greatest admirers for years.

At the same time as teaching at the Bauhaus, Klee continued to work regularly on his own pictures. During the vacations he made extended trips to Italy (1926, 1930), Porquerolles and Corsica (1927), Brittany (1928) and the Basque country (1929). In December 1928/January 1929, with financial support from the Klee Society, Klee was able to embark on a journey to Egypt that he had long been planning to make.

To mark Klee's fiftieth birthday, in late 1929 the Galerie Alfred Flechtheim in Berlin and in early 1930 the Galerie Neue Kunst Fides in Dresden each showed a survey of his work. Christian Zervos published a monograph, introduced by Will Grohmann, under his own imprint at Cahiers d'art in Paris. In 1930 René Crevel published a further monograph in French on Paul Klee.

In 1928 Klee's essay 'exacte versuche im bereich der kunst' (precise experiments in the realm of art) appeared in the journal *bauhaus*. In this essay Klee defended his concept of art against the rationalist tendencies emerging in the Bauhaus under the new director Hannes Meyer. In view of the political turmoil in

and around the Bauhaus, in 1928 Klee began to consider resigning his post. His teaching in Dessau had started to feel more and more like a duty to be performed, yet Klee could not bring himself to resign because of the financial implications this would have. In 1928 he discussed the possibility of a chair at the Städelschule in Frankfurt, but this came to nothing, and in 1929 he made contact with the Staatliche Kunstakademie (State Academy of Art) in Düsseldorf. Meanwhile there were a number of important Klee exhibitions at home and abroad: in 1930 at the Museum of Modern Art, New York, at the Galerie Flechtheim in Berlin and Düsseldorf, and at the Nationalgalerie Berlin (The Otto Ralfs Collection); in 1931 at the Kestner-Gesellschaft in Hanover, at the Düsseldorf Kunstverein, and at the Galerie Flechtheim in Berlin. Klee was now at the height of his success, and was counted amongst the artists of international repute working in Germany.

On 1 April 1931 Klee resigned from the Bauhaus and took up a chair at the Staatliche Kunstakademie in Düsseldorf. There was a mixed reaction in the press to this appointment.

Klee's output between 1924 and 1931 is particularly well-represented in the Bürgi collection. There are a total of 37 works from this period, spread evenly across the years. This reflects the increased intensity and the continuity in the new acquisitions for the collection from the mid-1920s onwards.

Klee thanked Hanni Bürgi for her loyalty to his art with numerous presents. Thus, in 1925 following her visit to Weimar, he gave her an early print of the lithograph *Kopf*, 1925,84 (cat. no. 84) and in late 1925 the coloured lithograph *die Sängerin der komischen Oper*, 1925,225 (cat. no. 88). In 1926 he gave her *Dorf*, 1925,122 (cat. no. 86), made using a palette knife and oil paint, for Christmas 1927 there was the reed pen drawing *nördliche Seestadt*, 1927,122 (cat. no. 94), in 1928 the etching *"Höhe!"* 1928,189 (cat. no. 101), and finally for Christmas 1930 the pen drawing *Uebungen*, 1929,286 (cat. no. 106).

JH

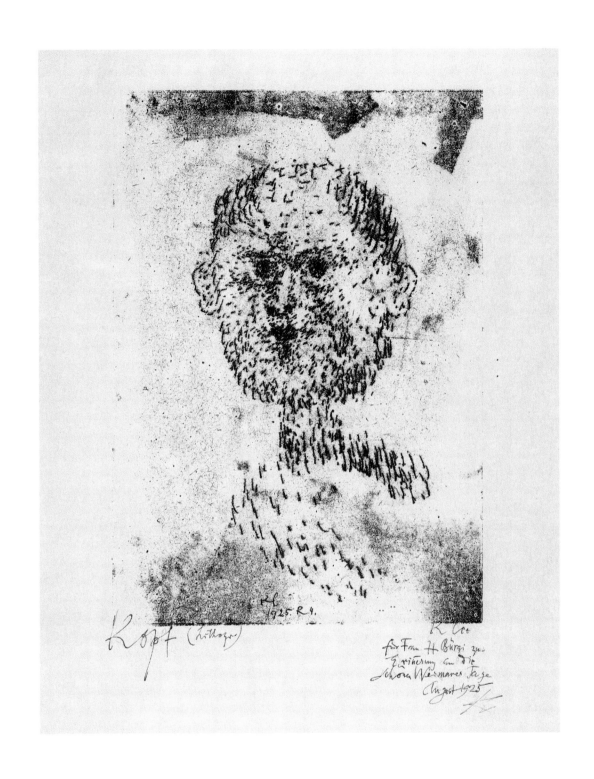

84

Head, 1925

Kopf, 1925,84

1925 A.8. rotgeflügelte Sumpfhühner. *

85
Red-Winged Moorhens, 1925
rotgeflügelte Sumpfhühner, 1925,108

86
Village, 1925
Dorf, 1925,122

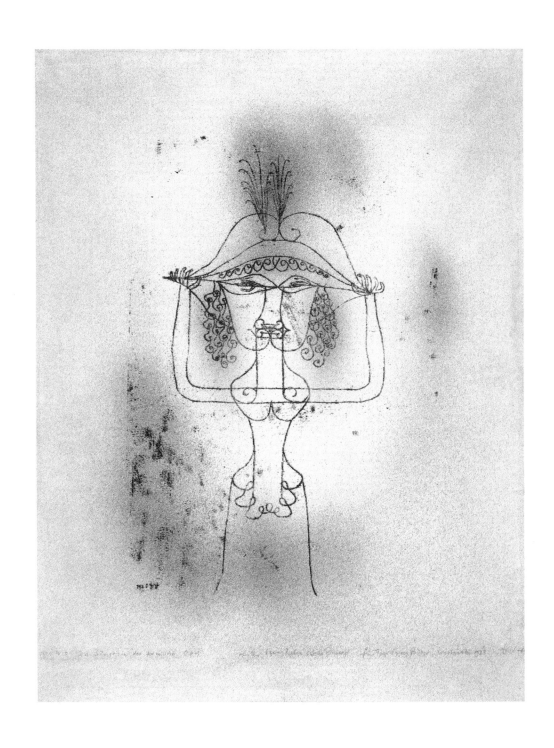

88

The Singer of the Comic Opera, 1925

die Sängerin der komischen Oper, 1925,225

89
Colourful Harmonious, 1925
buntharmonisch, 1925,256

90
Outing of the Menagerie, 1926
Ausgang der Menagerie, 1926,83

116

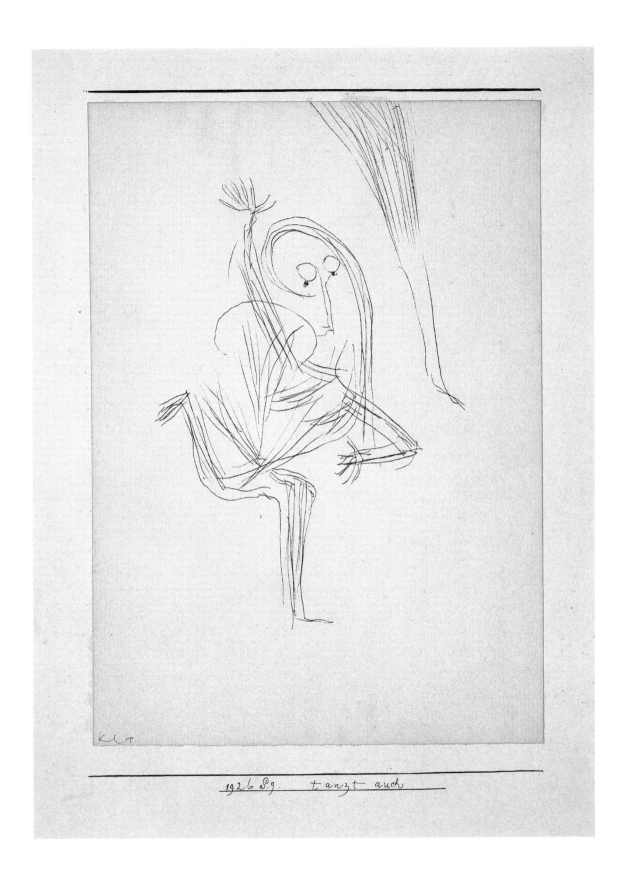

1926 S.9. tanzt auch

91
Dances as Well, 1926
tanzt auch, 1926,99

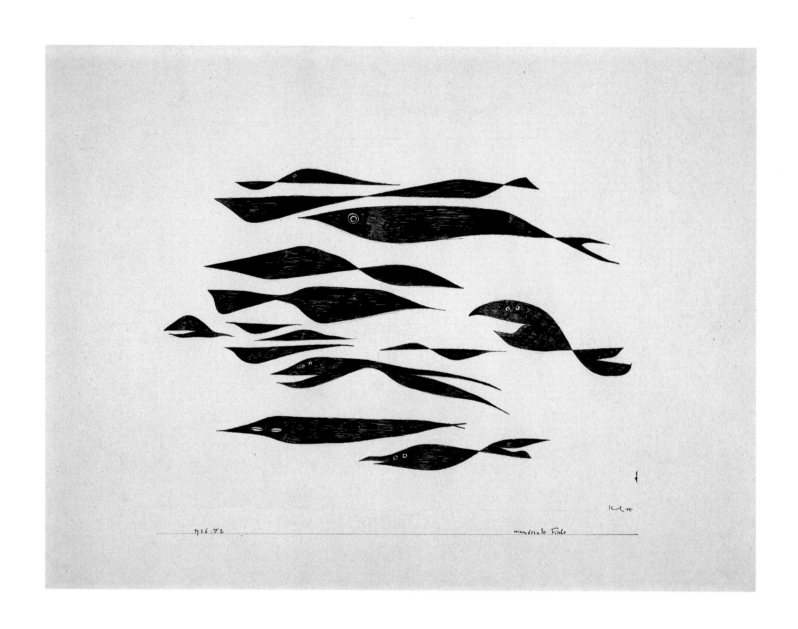

92
Migrating Fishes, 1926
wandernde Fische, 1926,212

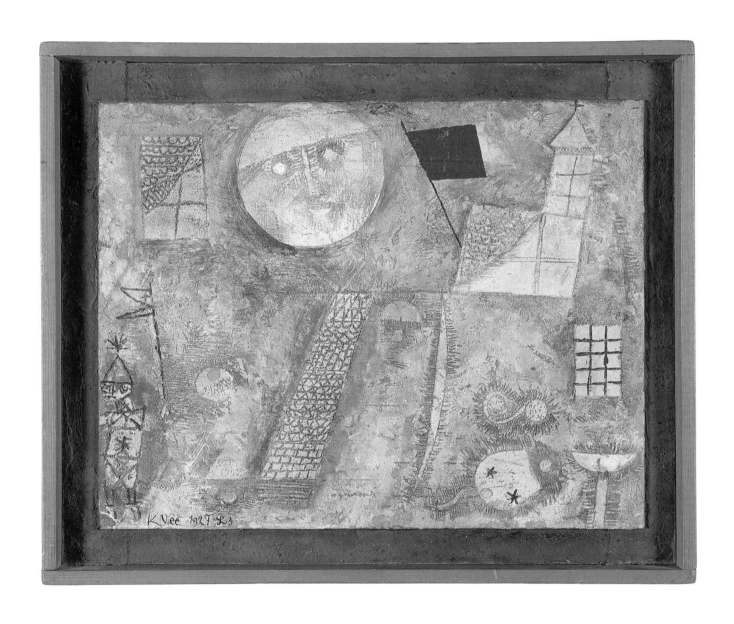

93
Full Moon, 1927
Vollmond, 1927,23

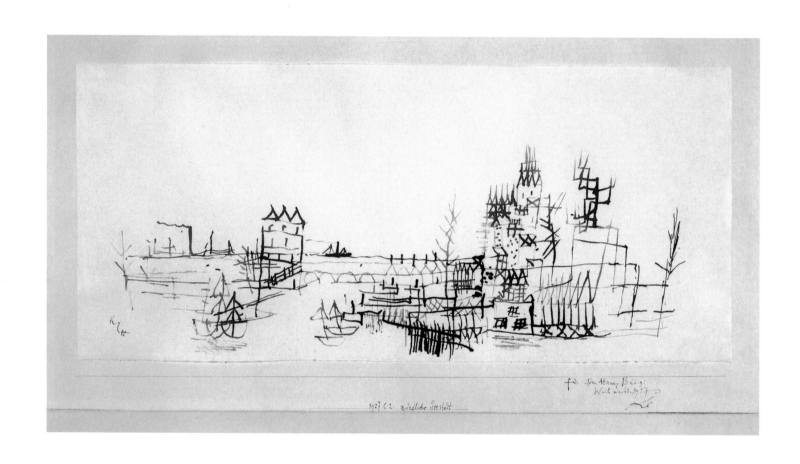

94
Northern Seaside Town, 1927
nördliche Seestadt, 1927,122

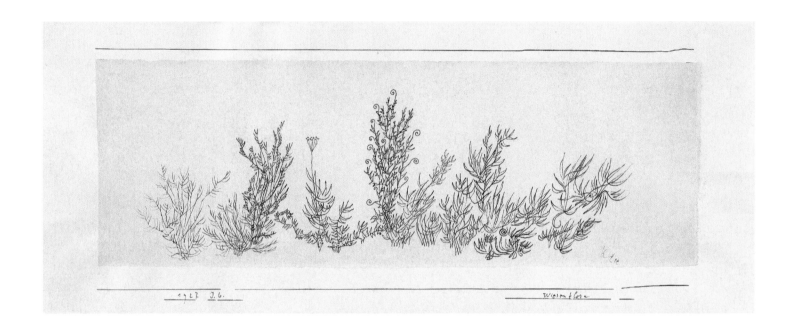

95
Meadow Flora, 1927
Wiesenflora, 1927,186

96
Refuge of the Ships, 1927
Zuflucht der Schiffe, 1927,251

97
What a Shambles, 1927
ihr habt hier eine Lumpenwirtschaft, 1927,260

98
She Retorts, 1927
Sie entgegnet, 1927,266

grosser Circus

1928 L.2

99
Circus Big Top, 1928
grosser Circus, 1928,22

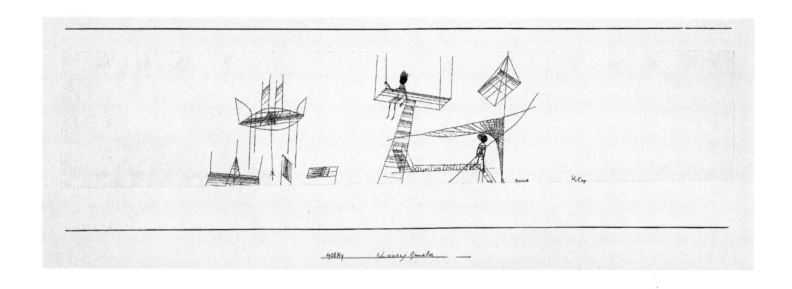

100
Black Jugglers, 1928
Schwarze Gaukler, 1928,39

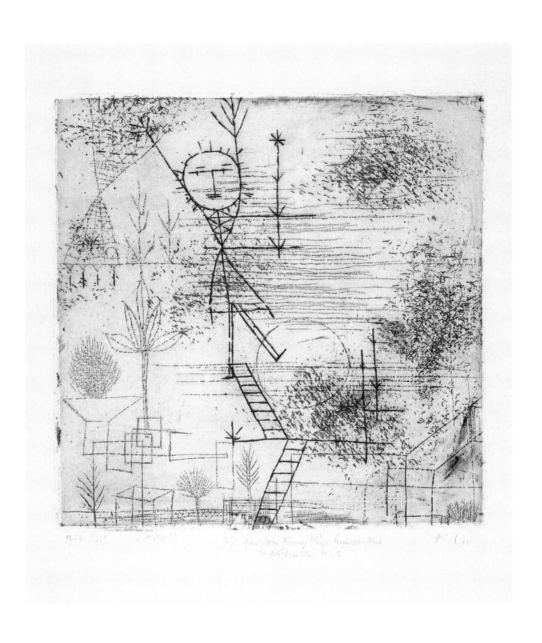

101
"Height!", 1928
"Höhe!", 1928,189

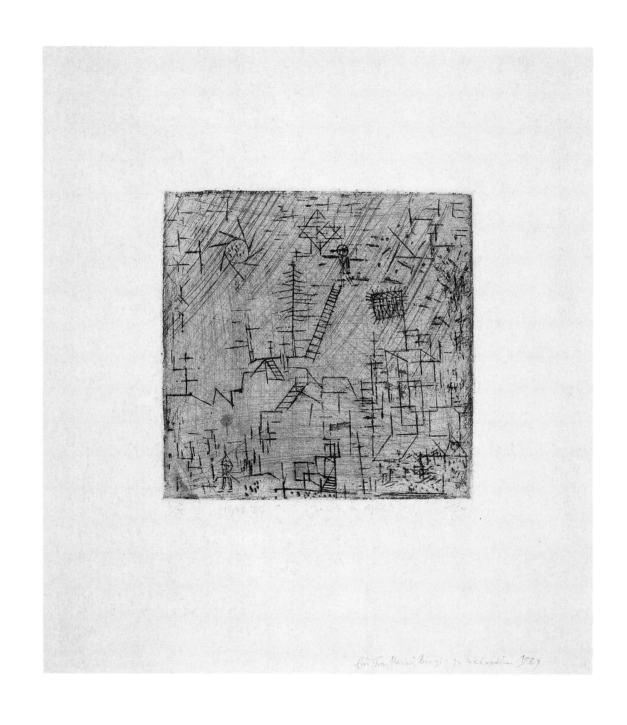

102
"Jugglers in April", 1928
"Gaukler im April", 1928,197

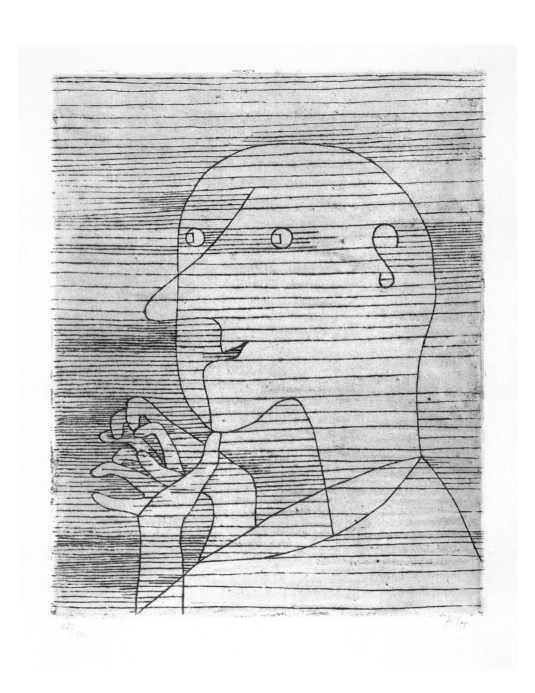

104
Old Man Counting, 1929
rechnender Greis, 1929,99

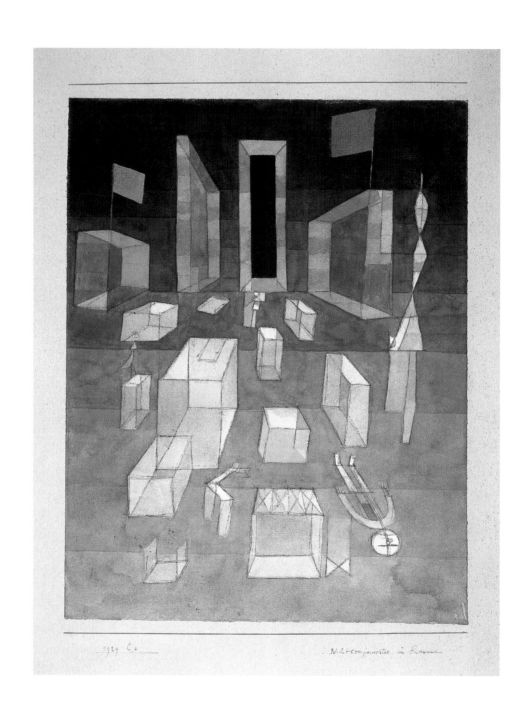

105

Uncomposed in Space, 1929

Nichtcomponiertes im Raum, 1929,124

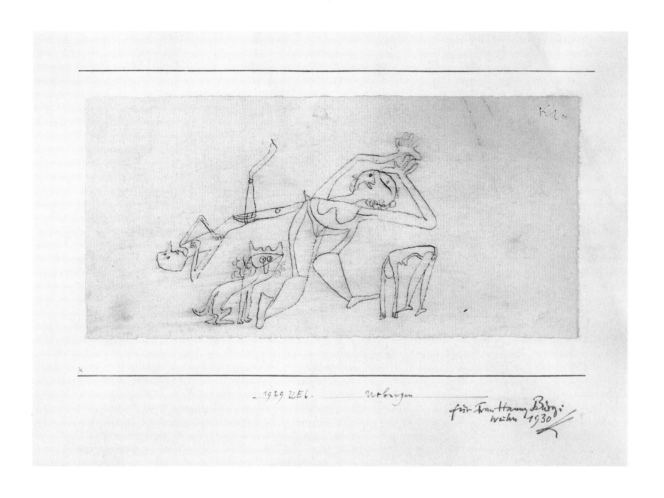

106
Exercises, 1929
Uebungen, 1929,286

108
Over-Exhilarated Ones II, 1930
über-beschwingte II, 1930,32

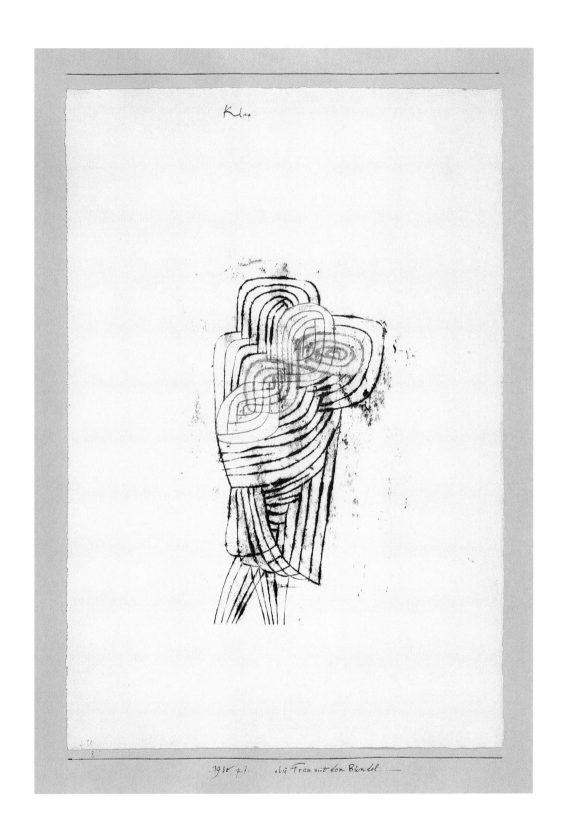

109
The Woman with the Bundle, 1930
die Frau mit dem Bündel, 1930,67

110
Spatial Study (no. IV.), 1930
räumliche Studie (Nr. IV.), 1930,112

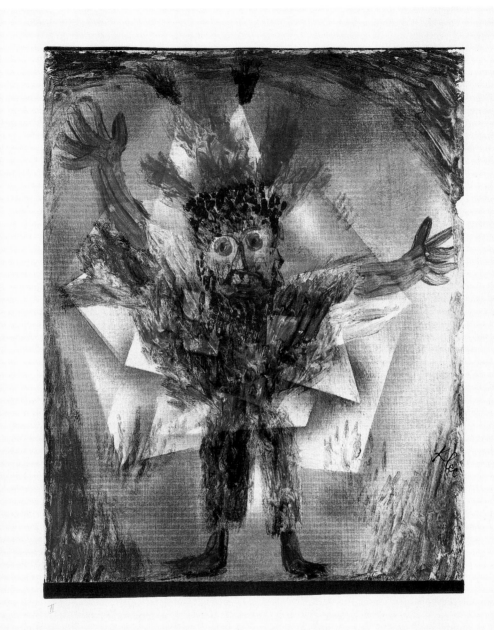

1930. d 3 Feuermann

111
Man of Fire, 1930
Feuermann, 1930,193

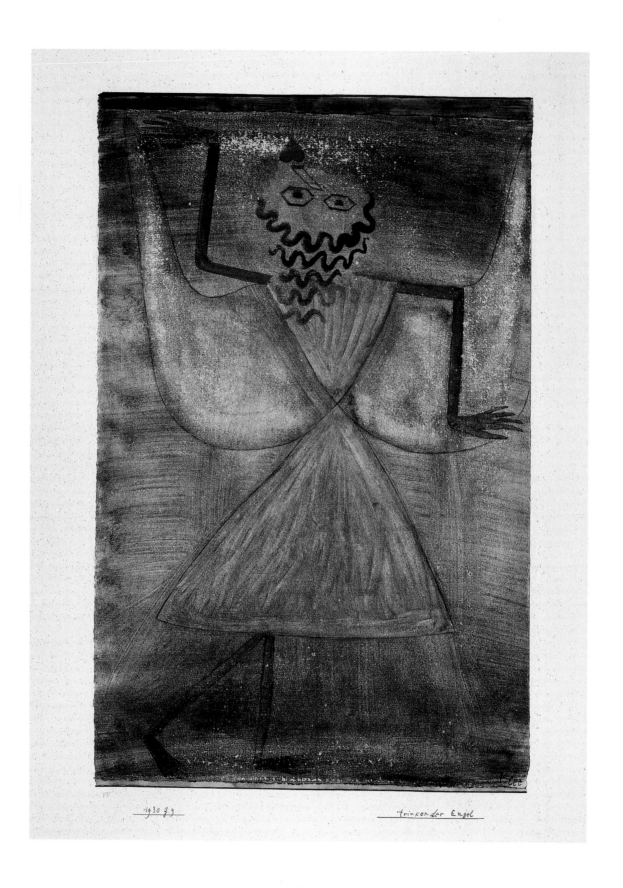

112
Drinking Angel, 1930
trinkender Engel, 1930,239

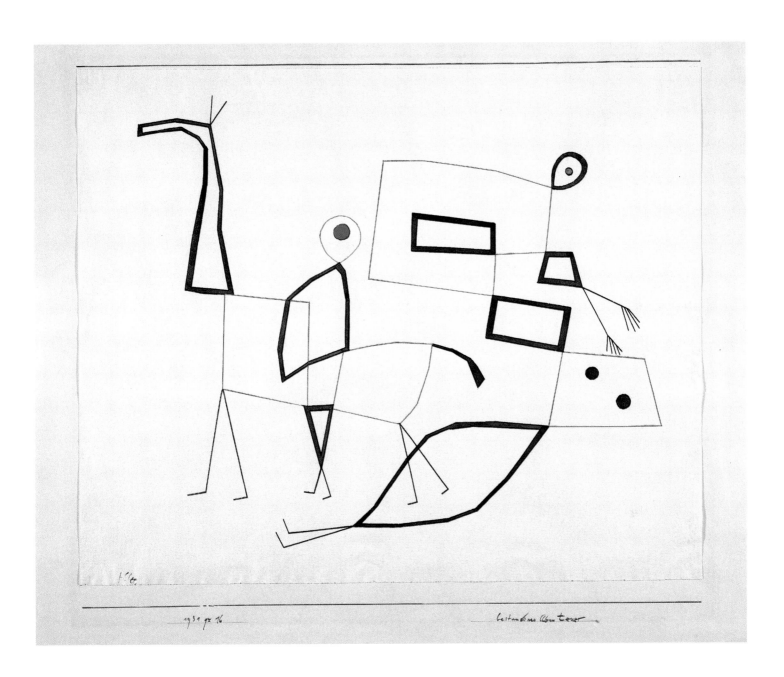

113

Endured Adventure, 1931

bestandenes Abenteuer, 1931,136

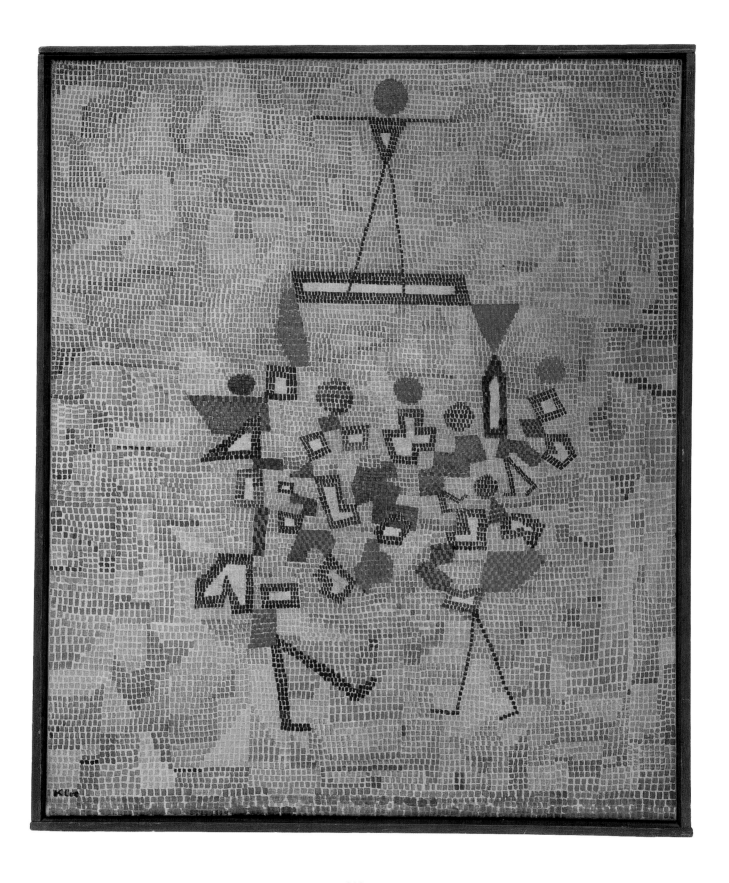

114
Spanned, 1931
Überbrücktes, 1931,153

1931–1933

Before taking up his post at the Staatliche Kunstakademie Düsseldorf, in summer 1931 Klee made another journey to Sicily. During the following two summers he again journeyed south: in 1932 to northern Italy and in 1933 to the Mediterranean coast in France.

In October 1931 Klee started teaching painting technique at the Academy in Düsseldorf, at first with a class of only four students. He rented a room in Düsseldorf, and kept his Dessau apartment until April 1933. He had a studio in each town, and painted in a different style in each. In Düsseldorf he worked intensively on his pointillist paintings and watercolours.

Even before he had been appointed to Düsseldorf there were signs of the ominous economic and political changes that were to lead Germany into a National Socialist dictatorship. In 1929 crashes on the New York Stock Exchange had sparked off a worldwide economic crisis, whose consequences, exacerbated by the acute political crisis, Klee was also to feel in the early 1930s. By 1932 the economic crisis and unemployment in Germany were at an all-time high. On 30 January 1933 Hitler was elected Chancellor of the Reich. The new ruling powers started to prohibit the sale of modern art, and left many artists and dealers no choice but to emigrate. In March the National Socialists searched Klee's Dessau apartment. Klee fled temporarily to Switzerland. On 21 April, even before he had moved from Dessau to Düsseldorf, Klee was given leave from his post "with immediate effect". In the autumn he was dismissed with effect from the end of the year. After the Klees' apartment had been searched by the police and the SA, Rolf Bürgi personally intervened and succeeded in having confiscated written material returned and in securing an exit permit for Paul and Lily Klee.

In view of the worsening economic and political situation Klee attempted to establish new contacts in the art market. After a vacation in the south of France, in late October he travelled to Paris. There he signed an exclusive contract with Daniel-Henry Kahnweiler, the owner of the Galerie Simon. The contract with Kahnweiler came about as a result of a recommendation from the Bern collector Hermann Rupf, who had been one of the first collectors, after Hanni Bürgi, to buy works from Klee in the 1910s. In Paris Klee found his friend Kandinsky, who was preparing to emigrate to France and who, like Klee, was re-shaping his professional future.

Even after his return to Germany Klee initially underestimated the threat that the new regime posed for him. It was not until 23 December that he emigrated to Switzerland, on his wife's insistence. Klee dealt with the political upheavals and the threat to his own existence by increasing his level of production. The year 1933 became his most productive to date. In his œuvre catalogue he recorded a total of 482 works, of which 314 were drawings.

Immediately after Hitler had seized power, the National Socialists intensified their offensive against modern art. Klee was one of those most frequently denounced in the press as representatives of "degenerate art". In 1933 his pictures were pilloried in the three so-called "Schandausstellungen" (exhibitions of shame) in Mannheim, Chemnitz and Dresden.

Between 1931 and 1933 Hanni Bürgi, now with her son Rolf, continued to enlarge the collection. Each year three or four new works came into the collection, including a particular rarity as a present from Klee in 1932, namely the trial proof from the inked stone of the lithograph *Seiltänzer*, 1923,138 (cat. no. 73). With the purchase of the 1931 oil painting *Überbrücktes*, 1931,153 (cat. no. 114) – albeit after the Second World War – another major work was added to the collection. *Überbrücktes* and *draussen buntes Leben*, 1931,160 (cat. no. 115) are amongst Klee's earliest works in a pointillist manner, of the kind he made from 1931 onwards in Düsseldorf in distinct contrast to his Dessau style.

1932 saw the arrival of *Ort der Verabredung*, 1932,138 (cat. no. 118), yet another painting whose enigmatic title might suggest an element of complicity between artist and collector. Against the background of the political events in Germany and Klee's flight in 1933, the implications of this title were all too real. Klee's production in that crucial year, 1933, is well represented in three small-format paintings *Kleiner BLAUTEUFEL*, 1933,285 (cat. no. 122), *Gelehrter*, 1933,286 (cat. no. 123), *KIND MIT BEEREN*, 1933,358 (cat. no. 124), and the two drawings *Ausgang*, 1933,165 (cat. no. 120) and *Schosshündchen N*, 1933,234 (cat. no. 121). The two drawings were presents from Klee and thus had a particular sentimental value for the collector.

JH

115
Colourful Life Outside, 1931
draussen buntes Leben, 1931,160

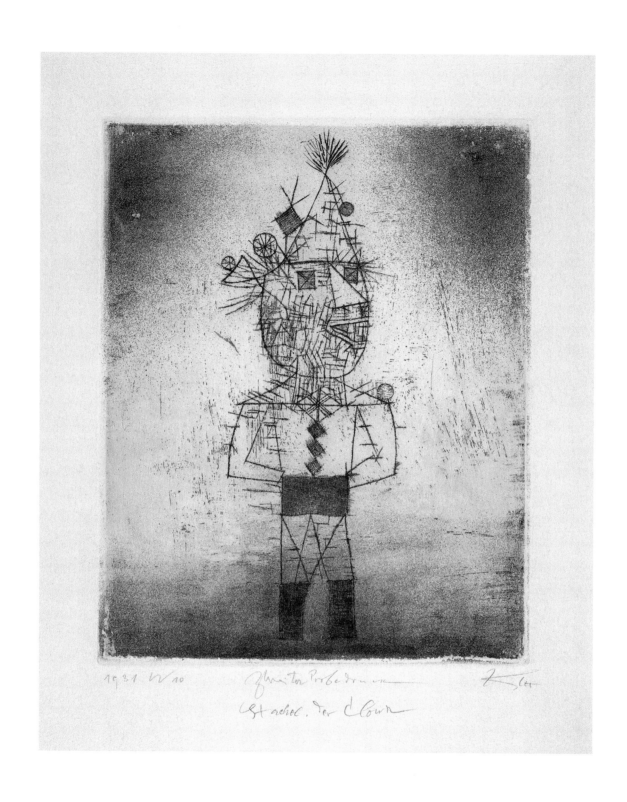

116
Thorn the Clown, 1931
Stachel der Clown, 1931,250

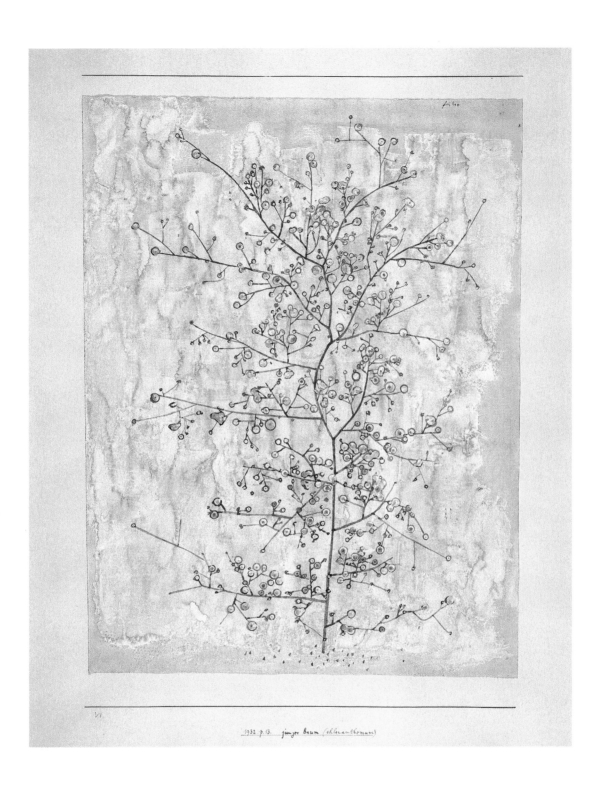

117
Young Tree (Chloranthemum), 1932
junger Baum (chloranthemum), 1932,113

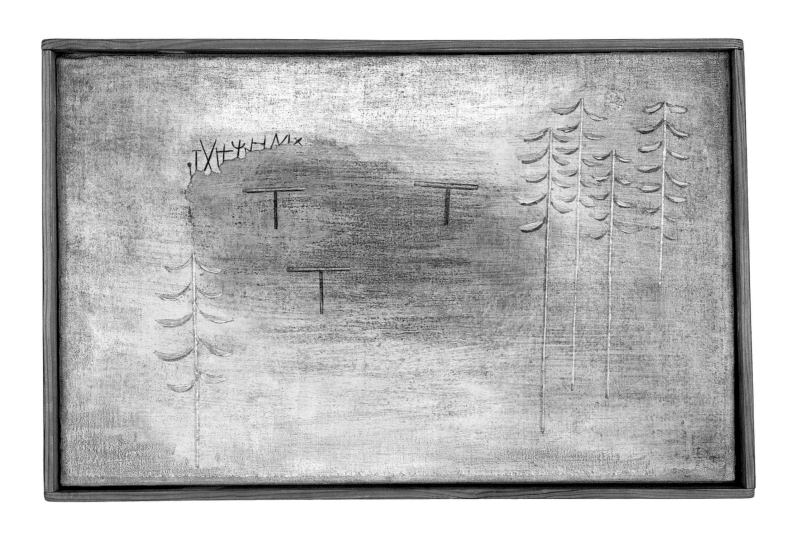

118
Meeting Place, 1932
Ort der Verabredung, 1932,138

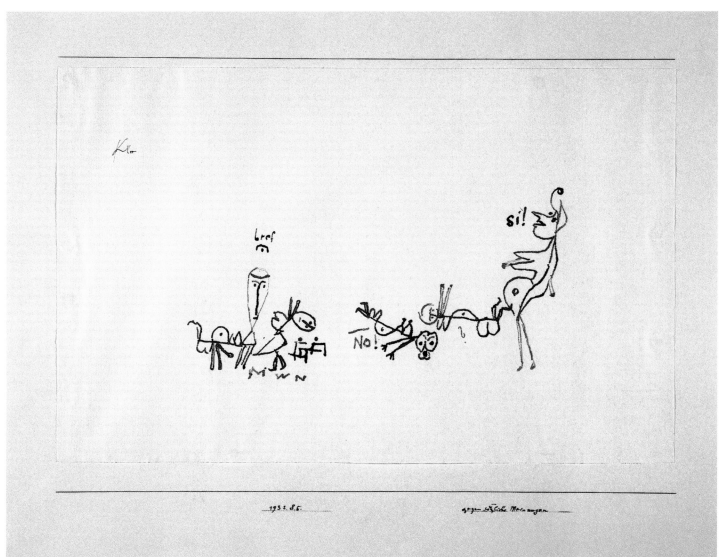

119
Opposing Views, 1932
gegensätzliche Meinungen, 1932,165

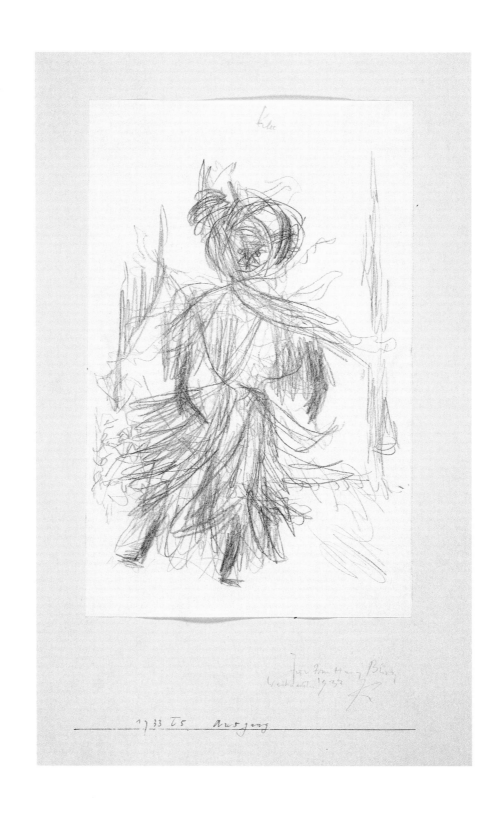

120
Going Out, 1933
Ausgang, 1933,165

121
Lap Dog N, 1933
Schosshündchen N, 1933,234

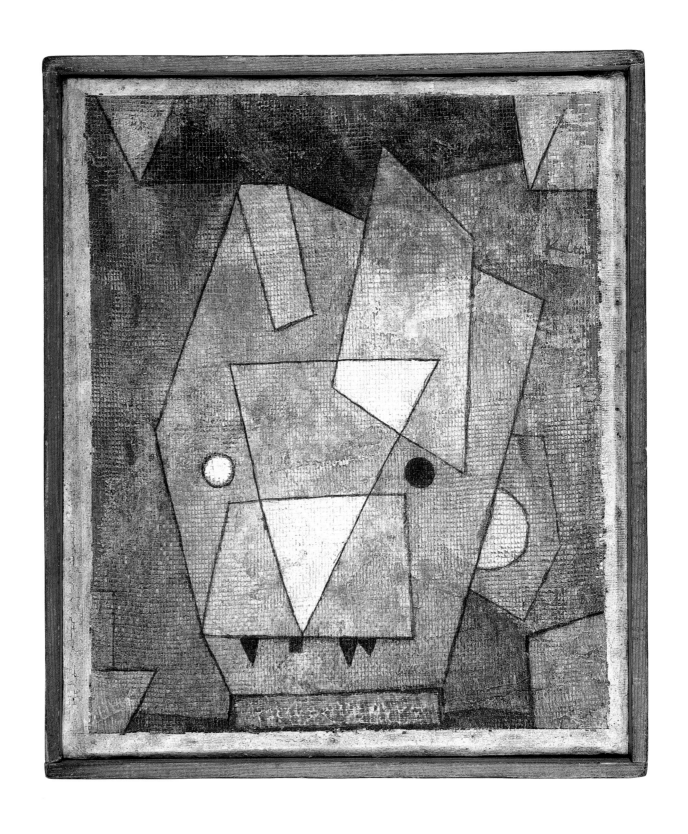

122
Little Blue Devil, 1933
Kleiner BLAUTEUFEL, 1933,285

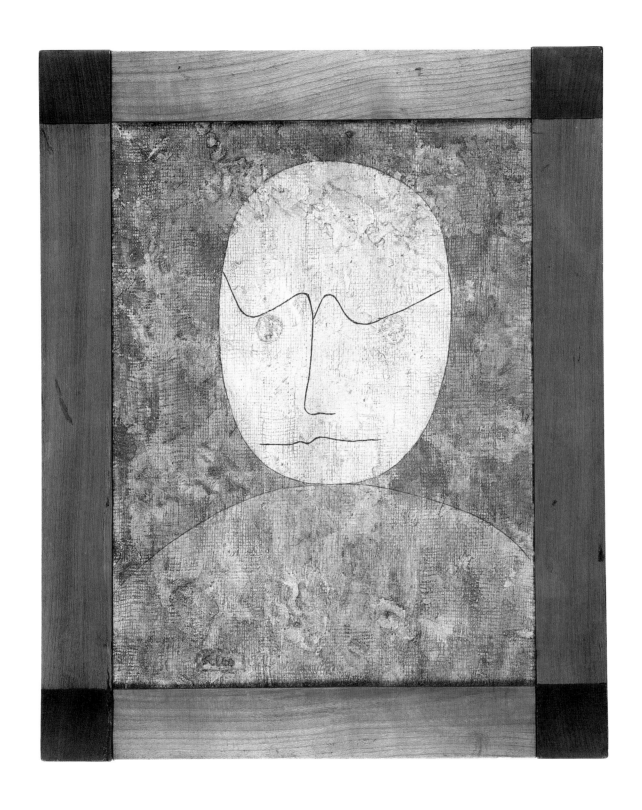

123
Scholar, 1933
Gelehrter, 1933,286

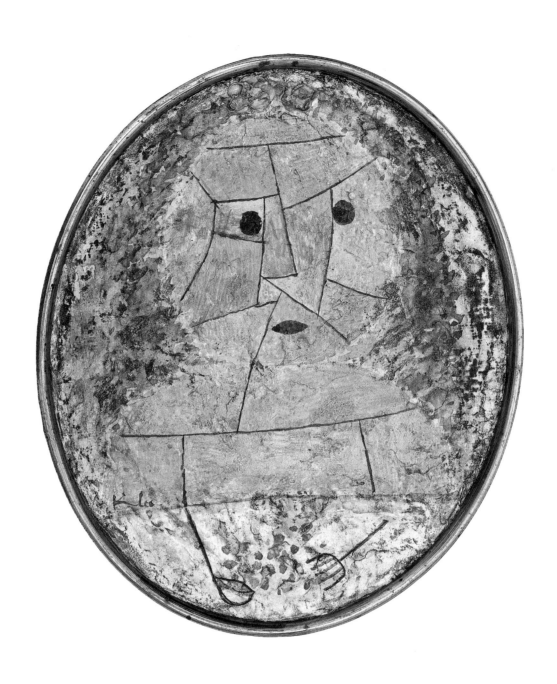

124
Child with Berries, 1933
KIND MIT <u>BEEREN</u>, 1933,358

1934–1936

Klee's return to Bern, in effect a combination of emigration and flight, was the severest setback of his life. Suddenly the internationally renowned artist found himself prey to increasing intellectual isolation in a provincial town with little cultural inspiration to offer. His contacts were now reduced to a small circle of art connoisseurs, collectors, and friends. These included the collectors Hermann Rupf and his wife Margrit in Bern and the Bürgis in Belp. Rolf Bürgi supported the Klees until Paul Klee's death by advising them on practical matters. After a hiatus of several months in his creativity, which can be attributed to his emigration and lack of permanent accommodation at first in Bern, in spring 1934 Klee embarked on a productive period in his creative work. However, from 1934 until 1936 there were growing signs that Klee was suffering a crisis in his art, which manifested itself in a decrease in production amongst other things.

In spring 1934, the first exhibition of Paul Klee's work in the United Kingdom took place at The Mayor Gallery in London, through the mediation of the art dealer Alfred Flechtheim who had by now emigrated to London. In June in the Galerie Simon, Kahnweiler presented his first solo exhibition of Klee's work. In Germany in autumn of the same year, Will Grohmann published his œuvre catalogue of Klee's drawings, *Paul Klee. Handzeichnungen 1921–1930*. However, after this was impounded by the National Socialists in April 1935, any further book projects in Germany on Klee's work would have been completely futile.

Before this blow, however, in February/March 1935 the Kunsthalle Bern had presented a major exhibition giving a survey of Klee's output from 1919 to 1934. The exhibition was shown again in autumn 1935 in a somewhat altered form in the Kunsthalle Basel and the reactions in the press in Switzerland and elsewhere in Europe were cautiously favourable. The sales in both exhibitions, however, were no more than modest. The economic crisis was having an increasingly detrimental effect on the art market throughout Europe and in the USA. Up until the end of 1937, Klee sold little in France, Great Britain, and the USA, although the USA seemed most promising in terms of future sales. Nevertheless, in 1936 substantial groups of works by Klee were shown at the Museum of Modern Art, New York, in the two most important survey exhibitions of the avant-garde in recent decades, *Cubism and Abstract Art* and *Fantastic Art, Dada, Surrealism*.

In autumn 1935 Klee became seriously ill. He was later diagnosed as having progressive sclerodermia, which completely halted any artistic work until spring 1936. In 1936 Klee took two extended cures in the Swiss mountains, which somewhat alleviated his condition. Despite this, however, his health remained very fragile. In 1936 his production sank to its lowest ever level with only 25 works.

The holdings of the Bürgi collection reflect this sequence of events. Three works represent Klee's output from 1934, one of which is the painting *Schlangen*

Wege, 1934,217 (cat. no. 127), a major work in the collection. In this Klee adapted his technique of layers of watercolour to suit oil paint on a larger-format canvas. The colour effects are much less differentiated than in the gleaming layers of watercolour he had created in 1929 (*Schwungkräfte*, 1929,267) or 1930 (*polyphon gefasstes Weiss*, 1930,140). The linear intertwining forms created by the particular distribution of areas of colour are answered on a narrative level by the motif of a snake slithering like an arabesque across almost the full width of the picture. The coloured sheets *trüb umschlossen*, 1934,74 (cat. no. 125) and *Zweig und Blatt*, 1934,165 (cat. no. 126) were presents to Hanni Bürgi from Klee for Christmas 1934 and 1935. There is only one work from 1935 in the collection: *Tor zum verlassenen Garten*, 1935,58 (cat. no. 129). In 1937 Klee gave the pencil drawing *Gras*, 1935,2 (cat. no. 128) to Hanni Bürgi as a present, having added a dedication with good wishes.

JH

125
Wrapped in Gloom, 1934
trüb umschlossen, 1934,74

126
Twig and Leaf, 1934
Zweig und Blatt, 1934,165

154

127
Snake Paths, 1934
Schlangen Wege, 1934,217

128
Grass, 1935
Gras, 1935,2

129

Gateway to the Deserted Garden, 1935

Tor zum verlassenen Garten, 1935,58

1937–1940

During the course of 1937 Klee's health stabilised. By the end of February he was able to start working again. This marked the beginning of his last, intense period of creative work, during which his productivity – although badly affected by his illness - constantly increased: in 1937 he completed 264 works, in 1938 there were 489, in 1939 the total rose to 1253, and in what remained to him of 1940 he produced 366 works. In his late period Klee developed a succinct graphic style that many of his admirers still found alienating years after his death.

In July 1937 the touring exhibition *Entartete Kunst* (Degenerate Art), organised by the National Socialists, opened in Munich. Around fifteen works by Klee were pilloried in this exhibition and subjected to defamatory comment. Amongst other things his pictures were reviled as "psychopathic art". In the wake of the wholesale confiscation of "degenerate art", in the summer and autumn of 1937 more than a hundred works by Klee were removed from German museums. Most of these were sold abroad for foreign currency. Thus many major works by Klee from before 1933, previously owned by German museums, found their way into collections elsewhere, above all in the USA. Klee tried to distance himself from distressing news of this kind, and to focus all the more on his creative work.

In September and October 1937 Klee and his wife took a cure in Ascona, where he worked with intense concentration. Here they met many friends and acquaintances, including Louis Moilliet and Marianne von Werefkin. Following this Klee took a number of extended cures to improve his health and well-being. Although his health meant that he lived a very withdrawn existence in Bern, in the last years of his life he still saw some leading artists of the time: in 1935 Jawlensky visited him, in 1937 Kandinsky came for the last time. In the same year Picasso came to see him in Bern. In 1939 he met Georges Braque.

In spring 1938 in Paris, Kahnweiler presented his second Klee exhibition with works exclusively from the artist's late period. From 1938 onwards, the gallery owner J. B. Neumann and the art dealers Karl Nierendorf and Curt Valentin – both of whom had emigrated from Germany – organised regular exhibitions of Klee's work in New York and in other cities in the USA. They were increasingly successful in their endeavours to promote Klee's art there.

After the outbreak of war on 1 September 1939 and the mobilisation of the Swiss Army, Paul and Lily Klee lived an even more withdrawn existence. Klee concentrated solely on his artistic work, his "main business", as he described it in a letter to his son Felix towards the end of 1939.

In February 1940, the Kunsthaus Zurich marked Klee's sixtieth birthday with a major exhibition of works from 1935 to 1940. It was the only presentation of Klee's late works which he himself conceived. Due to illness he was only able to visit the exhibition shortly before it closed. This last exhibition of Klee's work dur-

ing his lifetime generated a debate on his art in the Swiss press, during the course of which some commentators questioned his physical and mental health.

Klee continued to work until 10 May 1940. He felt that in his artistic work he was increasingly racing against time. The total of 366 works recorded in his œuvre catalogue for the leap year 1940 had a symbolic meaning: it was the literal evidence of his motto "nulla dies sine linea" (no day without a line). Klee died on 29 June 1940 while he was taking a cure in Locarno-Muralto. Within the year the Kunsthalle in Bern and Curt Valentin in New York had put on memorial exhibitions.

Klee's late work is well represented in the Bürgi collection with a total of twenty works. This focal point meant that for many decades the Bürgi collection was exceptional amongst larger private collections of Klee's works. On the one hand, Klee's move to Switzerland and the proscription of his art by the Nazis made it virtually impossible even for his most faithful collectors in Germany to continue their activities. On the other hand, his late works were less popular amongst collectors than his earlier productions. The late works remained largely in Klee's possession and after his death went to his estate, with many of these subsequently going to the Paul Klee Foundation.

Klee's main work from this period, which along with the self-portrait of 1911 (cat. no. 30) is the most exhibited work from the Bürgi collection, is the large-format painting *Feuer-Quelle*, 1938,132 (cat. no. 135, pp. 167f.). The group of three pictures of angels (*armer Engel*, 1939,854, cat. no. 140; *wachsamer Engel*, 1939,859, cat. no. 141; *Engel, übervoll*, 1939,896, cat. no. 142) reflect a particular preference on the part of the collectors. The large-format watercolour *Engel, übervoll*, was a present from Paul Klee to the young collectors Rolf Bürgi and his wife Käthi for Christmas 1939.

JH

IV

1937 K.J. neu angelegter Garten

130
Newly Laid Out Garden, 1937
neu angelegter Garten, 1937,27

131
Animals Perform a Comedy, 1937
Tiere spielen Komoedie, 1937,112

132
"Alas, oh alas!", 1937
"ach, aber ach!", 1937,201

133
Halves, the Clown, 1938
Haelften, der Clown, 1938,27

134
Garden Bed, 1938
Beet, 1938,113

136
Rainy Weather by the River, 1938
Regenwetter am Strom, 1938,200

Fire Source, 1938
Feuer-Quelle, 1938,132

[1] The works in question are *Vorhaben*, 1938,126; *rostende Schiffe*, 1938,127; *Früchte auf Blau*, 1938,130; *der Nachlass des Artisten*, 1938,133; *reicher Hafen*, 1938,147; *Insula dulcamara*, 1938,481. Besides the painting under discussion here, *rostende Schiffe* is the only other work owned privately. Of the others, three are in the collection of the Paul Klee Foundation, and there is one in the Kunsthaus Zurich and one in the Öffentliche Kunstsammlung/Kunstmuseum, Basel.

[2] Will Grohmann and Max Huggler also favoured this interpretation of the work. See Grohmann 1954, p. 328 and Huggler 1969, p. 181.

[3] See Huggler 1969, p. 181. The most blatant example of the work being used for a writer's own argument is de Lamater's interpretation of *Feuer-Quelle* as the depiction of a scene from Hindu cosmogony. See Peg de Lamater, *Klee and India: Krishna themes in the art of Paul Klee*, Ph.D. Dissertation, University of Texas, Austin 1991, pp. 232–234.

[4] In his contribution to the compendium *Schöpferische Konfession* (Creative Confession), 1920, Klee refers to the metaphysical dimension of fire in the creative process: "A certain fire, to create something, comes to life, passes through the hand, streams on to the panel, and on the panel, and as a spark, closing the circle, springs back to where it came from: back into the eye and on." Paul Klee, in: *Schöpferische Konfession* (Tribüne der Kunst und Zeit, Eine Schriftensammlung, ed. by Kasimir Edschmid, XIII), Berlin 1920, p. 34 (with thanks to Osamu Okuda for this information). Klee seems to take up this idea in the picture *Feuermann*, 1930,193 (cat. no. 111), which may be interpreted as a self-portrait of the artist.

In Klee's late period, during which he produced a considerable number of large-format works, a special position is occupied by *Feuer-Quelle*, 1938,132 (cat. no. 135), together with six other large landscape-format works also from 1938.[1]

The works are similar in terms of technique and form rather than content: the picture supports are of woven fabric (canvas or jute), to which Klee has glued newspaper before adding a ground. They are painted in oils or thick paste. Common to all is the use of heavy black lines which determine the linear design of the composition.

In *Feuer-Quelle* the central motif is a jagged black curve that returns in on itself. It circumscribes an elongated form that is open at the top. A blue disc with a black centre touches this form at its starting point (or finishing point), while a pink-rimmed, emerald green disc touches it between the two points on the far left. The colours of this second disc are echoed, via the pictorial diagonal, by two black-outlined forms in the lower right of the picture.

The restrained colours of the secondary pictorial elements and of the ochre-brown picture ground are in contrast to the intense orange-red concentrated in four areas along the other diagonal axis of the picture. Initially the viewer notices the two vivid areas within the main form, and it is only on closer observation that a small enclosed area in the upper right of the picture and the colour radiating from the bottom left corner make their presence felt as part of the composition.

In addition to the formal qualities of the picture, there is also the content of the title *Feuer-Quelle* (Fire source) to be taken into consideration. The imagination is excited by these verbal concepts and – as though reliving the creative process in reverse – looks for their confirmation in the different aspects of the picture. Seen in connection with the title, the intense red starts to "glow", the serrated form becomes a vessel with "fire" forcing its way out of its narrow opening. It is the linguistic paradox of the title that really unleashes the associative process: source evokes "water", and hence the other two elements as well, air and earth.

Klee's open pictorial signs present the ideal setting for the viewer to project associations of this kind. Thus we might see the blue disc as "water", we might see "air" in the "fire" emitting from the vessel, and "earth" in the ochre-brown pictorial ground.

In this web of associations, the fan-like figure on a green ground, which we read as a cipher of a plant, acquires meaning and becomes a symbol for vegetative growth, for life itself.[2] This is confirmed by the fact that we find the same glowing orange-red of *Feuer-Quelle* in another work which Klee listed two numbers later in his œuvre catalogue, namely *Pomona über-reif*, 1938, 134, where it represents the luscious richness of life.

Precisely because of their many possible readings, Klee's pictures seem to compel the viewer to make associations. Thus one commentator reads the inverted form, reminiscent of the figure "6", as a smoker's pipe, supposedly a reference to the use to which fire is put by humans.[3]

Speculations of this kind run the risk of distracting from the work of art. *Feuer-Quelle* owes its pictorial effect to the presence of the colour, the glowing orange-red which dominates all the others by its intensity. The red not only fills the vessel-like form to the brim, it also swamps the brown ground and reflects off the lower edge of the picture. But where does it originate, this "source"? If one takes the small glowing area in the lower left corner into account, yet another dimension opens up: the source of the red is not situated in the picture, but lies beyond it, in space. What we see is the reflection of a vast "cosmic" fire or flash of lightning, extending across the picture from lower left to upper right.

This interpretation is rooted in the picture itself, and is entirely in keeping with Klee's thinking – and yet it, too, is purely speculative.[4]

Michael Baumgartner

137
Untitled, ca. 1938
Ohne Titel, ca. 1938

135
Fire Source, 1938
Feuer-Quelle, 1938,132

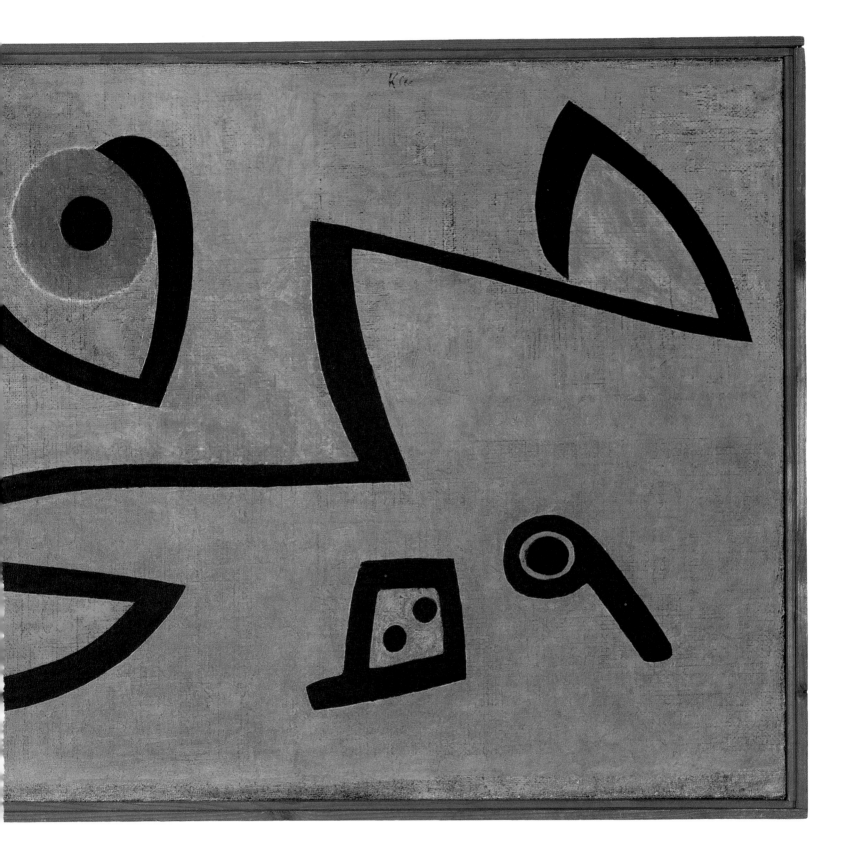

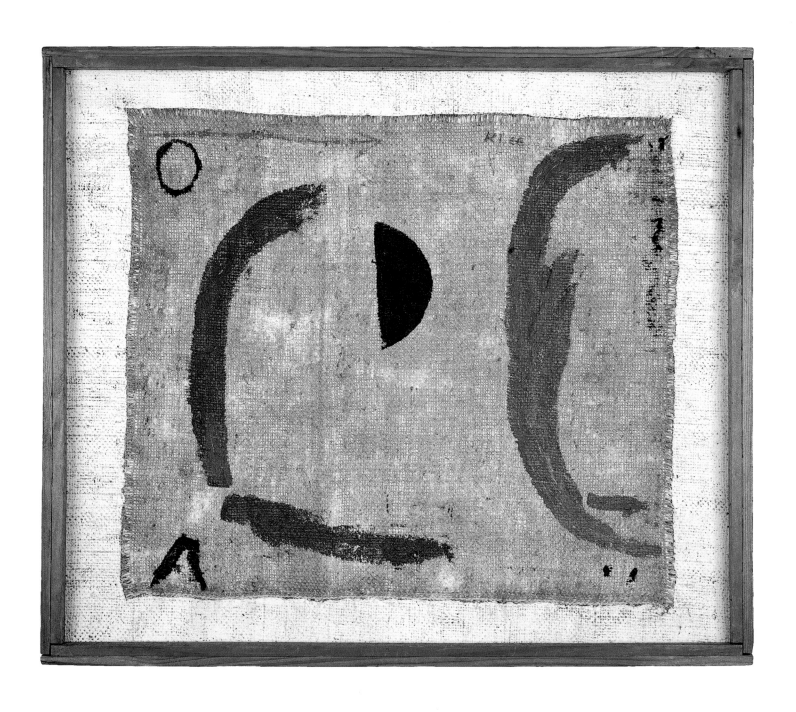

138
Snow-Storm-Spirits, 1939
Schnee-sturm-Geister, 1939,352

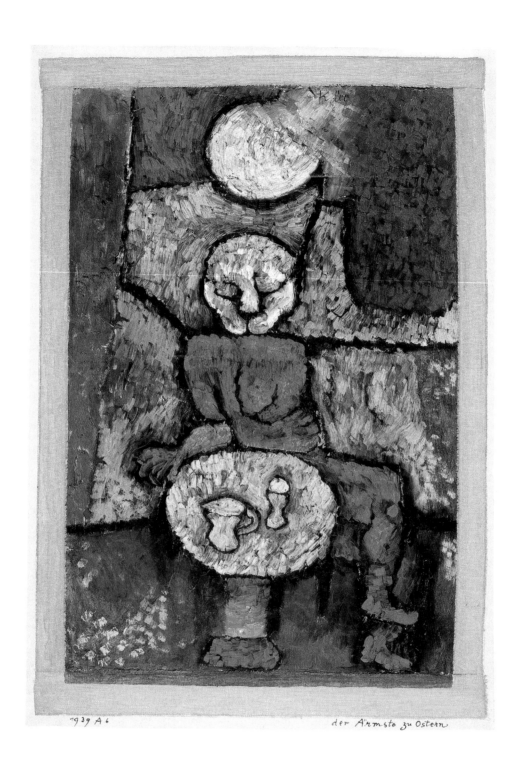

1939 A6

der Ärmste zu Ostern

139
The Poorest at Easter, 1939
der Ärmste zu Ostern, 1939,386

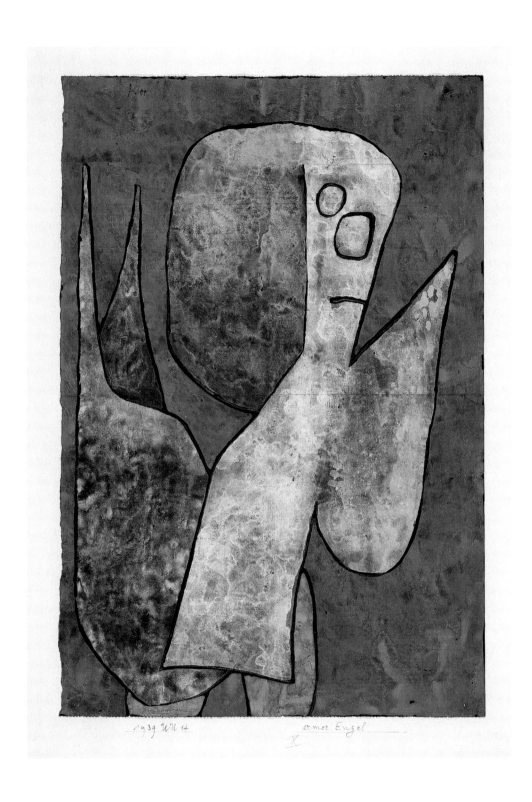

140
Poor Angel, 1939
armer Engel, 1939,854

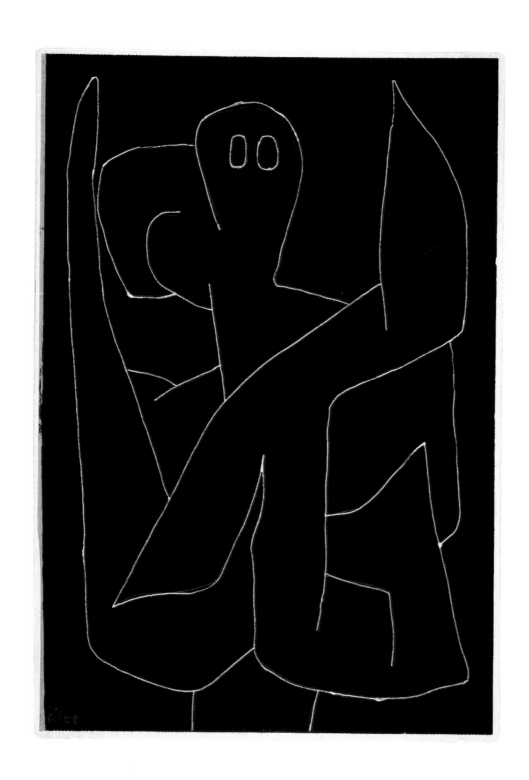

141
Vigilant Angel, 1939
wachsamer Engel, 1939,859

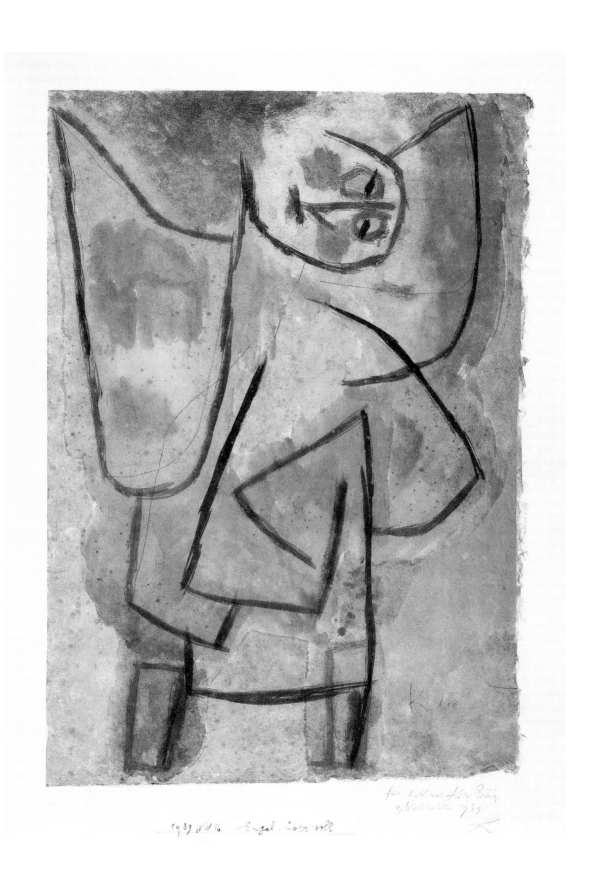

142
Angel, Brimful, 1939
Engel, übervoll, 1939,896

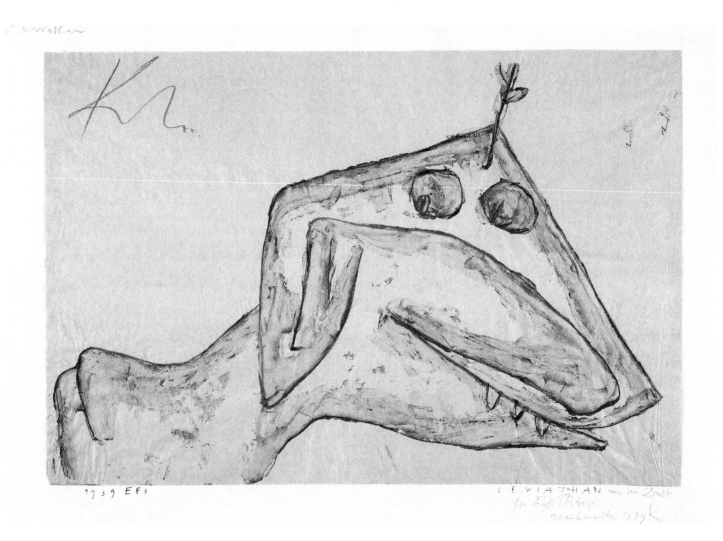

143
Leviathan of the Fair, 1939
LEVIATHAN von der Dult, 1939,1048

176

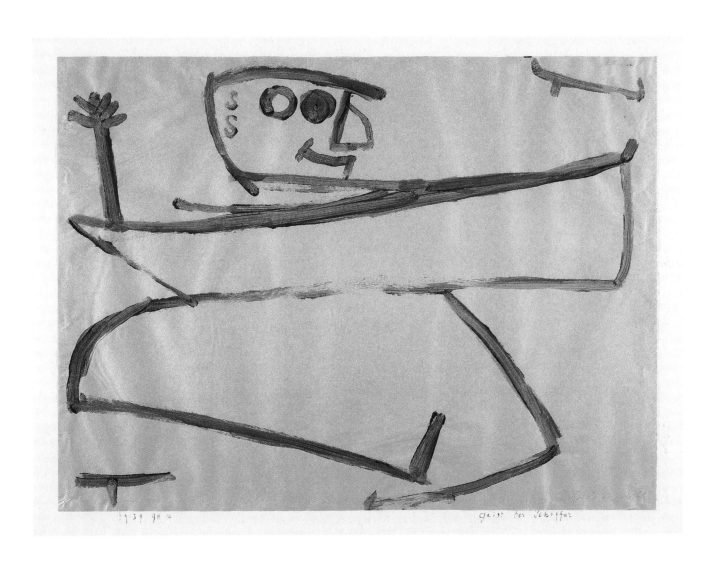

144
Spirit of the Navigators, 1939
Geist der Schiffer, 1939,1094

145
Untitled, ca. 1939
Ohne Titel, ca. 1939

1940. K7

Assel

148
Woodlouse, 1940
Assel, 1940,287

149

Horse by the Woodland Lake, 1940

Pferd am Waldsee, 1940,309

1940 E3 vermält

150
Married, 1940
vermält, 1940,363

NATHALIE BÄSCHLIN, BÉATRICE ILG, PATRIZIA ZEPPETELLA

PAUL KLEE'S PAINTING EQUIPMENT:
WORKING PROCESSES AND PICTURE SURFACES

Introduction

This essay on painting techniques used by Paul Klee concentrates on a small selection of works from the Bürgi Collection that were made between 1924 and 1933. A closer look at the surfaces of the paintings reveals unusual methods of applying paint and combining materials. The surfaces are rarely smooth, it is as though they have been modelled. The traces of the working process would seem to point to tools such as palette knife, spatula and brush. For the linear drawings, besides pen and brush Paul Klee also used stamps or lines incised into the paint or the ground. Large areas of the picture surfaces are incised, polished and sometimes over-worked to make them smoother or to create a glazed effect. In places fragmentary woven and paper textures dominate the appearance of the surface. Various commentators have referred to what looks like signs of patina, as on archaeological finds.[1]

The impulse for this special study of the traces of Klee's methods came from the artist's own collection of painting equipment that have survived. In December 1992 the Bürgi Family gave the Paul Klee Foundation, in the Kunstmuseum Bern, a large box of painting tools as an extended loan. The box probably went from the estate of the artist's widow, Lily Klee, to the Bürgi family sometime between 1946 and 1952, after the founding of the Klee Society.[2]

Paul Klee's attitude towards his painting tools is clear from the following quotation: "My main instruments, the sharp pencils and etching needles have been christened with the beautiful names Lupus, Füntzhart, Chrüttli, Nero, Judas, Rigoletto and Robert the Devil".[3] The paint pots, which Klee modelled himself and completed with shells and other found objects, not only fulfilled the function of practical utensils but were also, and still are, objects of interest in their own right (fig. 4).

The aim of this essay is to show in selected cases the versatility of the painting tools used by Klee, the traces they left and how they affected the picture surfaces.

In attempting to describe the surfaces – relief-like, many-layered and yet transparent – the German-speaking art conservator is faced with the question of how to arrive at a descriptive terminology for this purpose. The plastic formation of a picture surface or even the suggestion of a sculptural effect is often referred to in German in terms of "Struktur" and "Textur". "Struktur" (from the Latin struc-

tura: combination, order, mode of building) is a general term for "construction" and "set-up", often used metaphorically. In many disciplines in both the sciences and humanities, it has a number of more closely defined specialist meanings. "Textur" (from the Latin textura: weave, fabric) is used by the educated lay-person in a similar manner to "Struktur", that is to say also meaning "construction" or "make-up". However, in the sciences as a whole, "Textur" is used less frequently; the main areas where it does occur are biology and mineralogy.

Help is also at hand in the shape of the specialist terminology used for painting techniques. The terms that have established themselves in this connection predominantly focus on the technical process carried out by the artist, as in engraving and pastiglia. These refer to ways of treating a modelled picture ground, and are typically found in medieval panel paintings. Engraving refers to "the incising or tooling of drawings and patterns in a ground with an engraving tool. This technique is different from scratching in that it penetrates more deeply and removes more of the substance of the ground."[4] Pastiglia, on the other hand, does not involve material being removed. Instead, in order to create the effect of a relief, the ground is built up and modelled. Gold backgrounds were often made using a combination of these two techniques. Although related to the technical processes in Paul Klee's work, terms of this kind may not simply be applied unqualified to Klee's technique or to that of other artists in the 20th century.

Modelled Picture Surfaces – A Brief Glance at Earlier Techniques

Modelled picture surfaces in painting go back to the very earliest cultures. The combination of plastic layers and planar painting, as for instance in Neolithic art, is regarded as the transition from coloured reliefs to painting as a planar art in its own right.[5] The pastiglia so often used in medieval panel painting has its roots in ancient Egyptian art. Used together with engraving, incising and other ways of tooling a surface, it was a popular method of creating plastic pictorial effects, particularly in combination with decorative motifs on gold backgrounds. Pastiglia was also used to build up the edges of garments and halos. During the Renaissance sculpted detail on paintings fell out of favour. Pastiglia made a return in Baroque painting but only to a limited extent, primarily being used for the depiction of brocades, saints' halos and jewellery.[6]

If we turn our attention to the various methods of incising and the multifarious forms of layering in the field of wall painting, then it would seem that one of these techniques in particular, namely sgraffito, has in effect a close affinity with aspects of Paul Klee's own painting techniques. Sgraffito is described as the art of "incising, scratching and scraping". Layers (coloured and otherwise) of plaster and chalk were incised to reveal the contrasting colours of the underlayers. Sgraffito is closely related to print techniques and was revived to a certain extent in the 19th century for decorating façades.

A very different form of plasticity is also achieved in painting by the visibility of certain styles of brushwork. This is in itself determined by the type of brush

used, how the brush is handled by the artist and by the thickness of the paint. It gained importance in the painting of the 16th century, and was used in conjunction with the textural effects of the weave of the picture support.[7] A much-admired pictorial effect was achieved by the Impressionists with their impasto style and their highly individualistic, visible brushwork. Significantly, this aspect of Impressionist technique has been linked to the mechanised production of flat brushes.[8]

In the painting of the early 20th century, new materials from all imaginable sources established themselves alongside traditional artists' paints and painterly techniques. The conceptual principle of consciously using a material to make a specific statement was just as important as the rather more playful use of the inspiration found in materials and objects that often seem to be drawn from the personal surroundings of the individual making the work of art. The aforementioned traditional techniques of creating plastic picture surfaces were combined with new materials and often with new tools too.[9]

In connection with the plasticity of picture surfaces and the question as to how these are to be described, we will be well-served by looking briefly at another artist. Willi Baumeister was quick to discover – in the early 1920s – the particular effect of plastic techniques when used in painting. He worked with pastose paint substances and sand, as well as adding pre-formed, three-dimensional components.

Structures and Conglomerates

In his publications on this subject, Willi Baumeister went into some detail on the question of the terminology to be used to describe structured pictorial surfaces in paintings.[10] In his own words:

> Structure is the construction of a thing, which that thing needs in all circumstances [...]. The structure of water is a combination of H_2O [...]. If one throws a stone into water, then there will be modulations, waves, circles of waves. Wood has a particular structure from which it is formed. Yearly rings, bark are modulations [...] paint powder has its structure. One can achieve modulations with it.[11]

Baumeister was trying to narrow down the term "structure" that was otherwise so widely used for descriptions of the plastic formation of surfaces, and he introduced the term "modulation" to describe the "transformation of an essentially abstract plane into a rhythmic relief that could be registered by the senses"[12]. The term "modulation" (from the Latin modulatio: regular measure, rhythm) is mainly used in music. Baumeister was no doubt thinking of the corresponding gradation and regulation of the volume and colour of sounds, with his main interest being in the possibility of endowing the picture surface with rhythm by working it in a particular manner. The breaking-down of a surface into a number of "partial values" was described by Baumeister as "dispersion"[13]. The terms modulation and dispersion have not, however, generally been adopted in the description of materials and techniques used to form pictorial surfaces in paintings.

But let us return to the problems of terminology we have already touched on. In the literature on painting techniques, reference is made to structures, structuring and textures. As we have already indicated, these terms – at least in the German-speaking world – are generally used synonymously. Not so in the English-speaking world where a structured surface may be referred to in terms of "surface texture".[14] In the English-speaking world "structure" refers to the entire technical and material make-up of a work of art. German mineralogists frequently talk of "surface textures", using the term in a similar manner to the English-speakers' use of "surface texture" in art texts. Comparable with the English usage of the word "texture", German mineralogists also talk in terms of "surface textures". They differentiate the two German terms as follows; "Struktur" describes the arrangement of the components in toto, with the structure of the surface being closely related to the way the mineral has formed; it can be with or without direction, it can be uniform, with an even grain, or uneven. In keeping with the original meaning of the word, "Struktur" in mineralogy always implies an underlying order; accidents, as in conglomerates for instance, are out of the question. The term "Textur", with its derivation from "weave, fabric", generally involves regularity and direction in the way components relate to each other. It also includes – at least in mineralogy – more accidental forms, which are not necessarily characteristic of the composition of the material. A stone can, for instance, have a banded, cloudy or pearly texture, which is not connected with its inner structural make-up.[15]

This short digression shows that the question of finding an appropriate descriptive terminology for Paul Klee's paintings is of considerable interest. The mere attempt to differentiate the meaning of existing terms already opens up the volatile distinction between different traces of painterly methods, between the elements that clearly stem from particular painting techniques and tools, and elements that the viewer can scarcely interpret and which seem quite by chance to overlay painting and drawing.

In attempting to describe the surfaces of Paul Klee's paintings it seems most obvious to draw on the terminology used by mineralogists in German and English alike. Hence, we will take the "structuring of the surface" primarily to refer to work processes whose traces hypothetically allow the viewer to reconstruct the formation of the surface as it appears. We will take "surface texture" to refer to the qualities of the material itself – such as the fibre of the paper for instance – and also to refer to accidental surface effects that could not be reconstructed, or only with great difficulty. This being said, it is of course not possible to keep these terms strictly separate at all times.

Studio and Painting Equipment

In 1925 Rolf Bürgi accompanied his mother on a visit to Paul Klee in Weimar and later recorded what they saw:

> Klee's studio was like an alchemist's kitchen. In the middle there were several easels, one chair. He always used to work on several pictures at once, the formats were still small at that time. Everywhere paint powder, oils, little

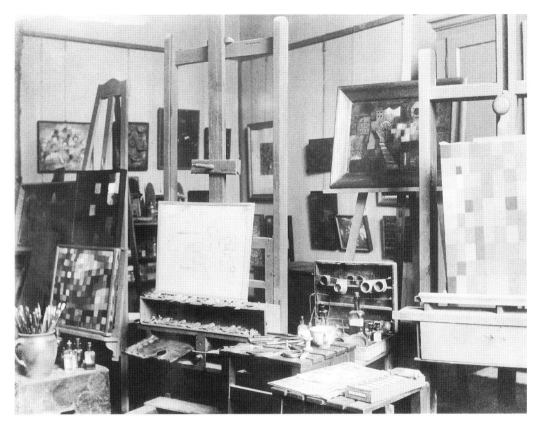

Fig. 1
Studio at the Bauhaus,
Weimar, 1925

bottles, little boxes, matchboxes. Whatever he needed for painting, he made himself. That paid off; I only know of one picture that did not last for technical reasons, and he painted a new one for the owner.[16]

Several photographs of Paul Klee's studios in Munich, Weimar, Dessau and Bern have survived. The pictures of these studios convey an impression of spaciousness and liveability. In some of these pictures Paul Klee may be seen sitting at a writing desk or working on a decorative frame.

The surviving photographs show various easels with paintings, all kinds of furniture: upholstered armchairs, ordinary chairs, stools, small tables, chests of drawers and bookshelves, with crowds of pots, bowls, cups, bottles and tins in different sizes standing on them. Brushes and painting tools stick out of drinking glasses, jugs and vases. A palette is lying on a stool, and on a small table next to the easel there is a paint box, stuffed with utensils and tubes of paint. Setsquares hang from the easel, a decorative frame and a palette are fixed to the door frame. On one of the shelves there are carefully arranged plaster objects and found objects. On the walls hang paintings, started, finished, framed and unframed, others are stacked on the floor while yet more lean against the easels (fig. 1).

In some of the shots of Klee's studios there are larger and smaller paintboxes to be seen. As mentioned in the introduction to this essay, in the Paul Klee Foundation, in the Kunstmuseum Bern, there is a large paintbox that belonged to the artist, with a wide variety of tools and painting utensils (fig. 2).[17] It contains a variety of screws and nails (some still in their original packets), drawing pins,

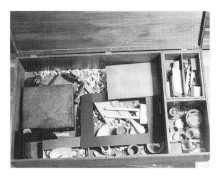

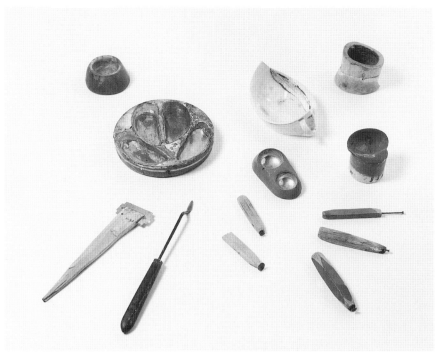

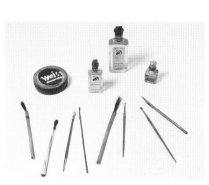

Fig. 2
Paul Klee's paintbox, as presented by the Bürgi Family as a loan to the Paul Klee Foundation, Kunstmuseum Bern, in 1992

Fig. 3
Utensils from Paul Klee's paintbox

Fig. 4
Tools, mixing trays and pots from Paul Klee's paintbox

metal rings, picture hooks and book rests; a round tin marked "white"; Egyptian Senoussi cigarette boxes and other tin boxes; wooden boxes marked "coloured lithographic crayons" and "stamps". The equipment includes a watercolour box by the English paint manufacturers Winsor & Newton, turpentine and painting mediums by Dr. Schönefeld & Co, Düsseldorf, and fantail blenders, watercolour brushes and flat brushes.[18] Paul Klee made many brushes himself by inserting animal hairs into a small bamboo tube or an old brush handle, and securing these with twine or metal wire (fig. 3). Klee used egg-cups or a broken tea cup for mixing bowls and pots. He embedded shells in modelling clay, painted them and used them as containers for paint and binding agents.

As well as this, the paintbox contains palette knives, spatulas, and tools for scraping, incising and stamping that the artist made himself (fig. 4). He also used ordinary everyday objects such as a dinner knife and instruments from a manicure set, which no doubt were useful for spreading, scraping and incising.

The drawing tools include coloured pencils and pencils, reed pens, pen holders and etching needles. Besides these there is also a rounded stick with a sharp, blackened point, that Klee presumably used like a pencil or a pen. In addition, the paintbox also contains a solid block of Asian black ink, an empty Indian ink bottle, various measuring instruments and instruments for constructing geometric figures such as a set of technical drawing instruments and compasses for working out the golden section, a protractor and a scratch gauge for marking parallel lines.

This list is by no means exhaustive, but it does give an insight into the quantity and diversity of Klee's painting tools. In his œuvre catalogue, besides technique and materials, Klee sometimes recorded the tools used for his paintings. He also mentions them in his diary and in letters to his family, for instance in a letter to Lily:

In the afternoons I am working successfully on white oil paint. I applied the paint with the knife and then, without applying any more paint, continued with three brushes. Thus subtleties emerge and it does not get dirty.[19]

Moreover in another letter he makes a drawing of a zinc-cutter[20] that Lily was to buy for him in Munich. Elsewhere he draws and describes a pantograph[21] in detail in his diary.

Treatises on painting, artists' biographies, guild contracts, letters, formulas and notebooks, artists' estates and inventories are the written sources that can tell us about painting materials and how they were made, about painting tools and how they were used.[22] Studio and academy pictures, portraits of painters and self-portraits, and – starting in the 19th century – photographs of artists and their studios all document the surroundings, the equipment, the painting and drawing tools used, as well as the working methods of the artist.

The studio equipment, the painting tools and materials as significant components in the estate of any artist should be meticulously catalogued and preserved, as for example in the inventories made of the contents of Albert Anker's studio[23] in Ins, and of Meret Oppenheim's studios[24] in Bern and Carona. In art-technological investigations painting tools may provide important information on the use of materials and techniques. Of the numerous art-technological investigations into the work of various artists[25] in recent years, the following two are of special interest here: during the course of investigations into Wassily Kandinsky's[26] and Paul Klee's[27] techniques, it was possible – on the evidence of binding agent components found in Kandinsky's Munich and Paris palettes and in Klee's paint pots - to come to a clearer understanding of otherwise problematic terms such as "tempera".[28]

Paul Klee's technique, the technical specifications he gives in his hand-written catalogue, his painting tools and observations regarding his paintings will now be discussed in relation to selected works from the Bürgi Collection.

Structured Surfaces, Textures, and Layerings –
A Short Description

Buchstabenbild, 1924,116 (cat. no. 77)

The surface appearance of this work is achieved by the juxtaposition and super-imposition of geometric paper-shapes in various sizes, glued to a cardboard picture support. Their seemingly random arrangement and distribution in fact follow a precise plan of black lines drawn on the cardboard picture support.[29] In the final form of the work, these lines are only visible in places. A sheet of paper the same size as the cardboard support covers the entire surface so that the linear plan and the paper shapes are concealed. The background to the letters floating in space is defined by the shadows and outlines of the rectangles standing and lying at all angles. The cut edges of the paper shapes are softened by the thickness of the adhered top sheet. The paint is applied in horizontal bands with a brush of at least two centimetres in width. The clearly visible brushstrokes enrich the existing multiple layers of the picture support (fig. 5). Significantly,

Fig. 5
Detail from *Buch-stabenbild*, 1924,116. The texture of the picture support is en-riched by horizontal bands of colour

Fig. 6
Detail from *Buch-stabenbild*, 1924,116 The aged paint layer reveals an area of fine craquelure and small paint losses which considerably affect the surface texture

during the work process, Klee also used abrasive tools, presumably a wooden stick or a bone folder, with which he partially scraped away the paint, thereby also roughening the paper. By this means he was able to emphasise or obscure existing layers of texture. While it was still wet, yet another modelling effect was created on the surface: a strongly textured piece of paper was laid on the paint in places and then lifted off again. This method of forming the surface together with the way paint has collected in the dips and along the edges of the paper shapes give the picture its spatial quality.

The ageing of the paint is apparent today in areas of very fine craquelure (fig. 6) that have with time and in conjunction with other factors[30] led to losses forming in certain places. These blemishes have created a new component in the texture of the surface, even if these are not yet in a very advanced stage.

Vollmond, 1927,23 (cat. no. 93)

The back of the cardboard picture support is fixed with nails to four strips of wood, which are in turn stabilised in the corners with wooden blocks and nails. These strips of wood not only strengthen the cardboard but form part of the frame of the work in that they are two-thirds visible from the front of the paint-ing. Last of all four orange batons are nailed to the outer edges of the inner frame. If we turn to the picture support itself we discover that the paint has been applied in a rich and varied manner.

The first layer on the cardboard picture support is a thin, white ground, which is followed by a thin pinkish-lilac paint layer. Klee then applied a thick, white

Fig. 7
Detail from
Vollmond, 1927,23.
Around the outline of
the goblet-like shape,
the paint substance
has been incised and
scratched away in a
sgraffito-like manner,
while the star-shaped
decorations have
been stamped from
short lines of equal
length

Fig. 8
Detail from
Vollmond, 1927,23.
The texture of the
window bars
stamped from a num-
ber of lines contrasts
with the incised
outer edge of the
window

layer to the coloured ground, smooth in places and crusty in others. Lines have been incised into this white layer, and the incisions have been picked out in dark colours. Other lines and small areas have been treated in a sgraffito-like manner, with paint being scraped and removed, revealing the pinkish-lilac paint layer that comes directly after the first ground (fig. 7). During the work process Klee reapplied white with a spatula in certain places, some of which are delineated as though they had been stencilled. In other places Klee left the irregular, grainy lines of incisions made with some blunt instrument just as they were.

The carefully worked and formed surface has a continuous, transparent glaze that seems to have been applied wet on wet. The contours of the figure in the lower left and the window spars at the far right have been stamped (fig. 8). Klee presumably used a small piece of card or some other moderately hard material for the stamp so that the lines would stand out clearly on the strongly structured surface. The lilac-coloured flag in the upper right of the composition is – in contrast to the continuous transparent layer of colour elsewhere – pastose, solid and has a slight sheen on its surface (fig. 9). The isolated pink spots evident in various places are reminiscent of the "applied" flowers in the hair of the *KIND MIT BEEREN*, 1933,358 (cat. no. 124).

The number and variety of the techniques and processes are a demonstration of the skills of an artist who early on was a master of drawing and who had a particular ability to employ techniques involving incising and scraping. In apparently random, easy-looking steps Klee was in fact drawing on his rich experience of countless materials and processes from classical painting techniques as well as from new materials.

Überbrücktes, 1931,153 (cat. no. 114)

Fig. 9
Detail from
***Vollmond**, 1927,23.*
Different binding
media not only deter-
mine the texture but
also the surface
sheen, as in the lilac-
coloured flag

Fig. 10
Detail from
***Gelehrter**, 1933,286.*
In places the gauze is
completely concealed
by smoothed patches
of gesso, in others
the gauze remains
visible, surrounded
by coarse gesso

Fig. 11
Detail from
***Gelehrter**, 1933,286.*
The eye is appliquéed
by means of small
pieces of gauze and
gesso ground, the
surface structured
with a stencil brush

"Now I am going to glue cotton fabric, fine-grained, onto a tightly stretched can-
vas of medium size, in order to use this fine material as a panel."[31] This state-
ment by Paul Klee could hardly fit the painting *Überbrücktes* better, which ac-
cording to the œuvre catalogue is made using "watercolours, varnished cotton
with canvas glued to stretcher, original batons".[32]

The fine, off-white, densely woven fabric is indeed glued to a robust, thicker
canvas and attached to an adjustable wooden stretching frame. The entire sur-
face of the cotton fabric is colour-glazed, with the image marked out in pencil.
The small squares are applied using a flat brush, roughly half a centimetre in
width, sometimes used flat and sometimes used on its narrow edge. The squares
are arranged next to each other in a pointillist manner, the dot-like effect is
under-pinned both by the matching texture of the fine fabric and the contrast-
ing structure of the heavier weave of the canvas. By taking advantage of differ-
ent material and technical factors Klee achieves a particular pictorial effect. The
rows of small areas of colour and the contrasting textures of the weaves create
a "flickering" sensation in this planar image. Klee takes this effect a stage fur-
ther when he uses sand as a paint substance – as in the painting *Ranke*, 1932,29,
where he applied a layer of sand to a pinewood panel and then added a thin
whitish layer and irregular spots of colour.

Gelehrter, 1933,286 (cat. no. 123)

The painting *Gelehrter* is painted on a rigid picture support, although Klee did not allow the texture of the wood to remain visible. Instead he created an alternating combination of a gauze texture and a structured gesso ground. In the œuvre catalogue Klee described it as "watercolours (waxed), old wood panel overlaid with gauze and gesso ground". After the gauze had been laid on the wood, Klee applied the ground with a brush and then worked it with a spatula. By means of this mechanical process, reminiscent of the lifting and smoothing involved in plastering a wall, in many places Klee distorted the weave of the gauze into a gently undulating net. On top of this, seemingly accidentally, there are islands of gesso – some grainy, some smooth – that completely cover the gauze (fig. 10). As in pastiglia work, where halos or the edges of garments were accentuated in places, Klee gave this figure its own three-dimensional "scholastic wreath" by subsequently applying daubs of gesso. The scholar's eyes were made from an additional application of gesso and small pieces of gauze, whose frayed edges Klee left as they were. The eyes were finished off with a stencil brush (fig. 11). Klee chose a similar method for his signature, although here the gesso was applied to the gauze with a knife and the signature was incised.

The watercolours are applied like a glaze, most probably with a brush. Presumably Klee removed some of the paint again by wiping it with a damp rag or a small sponge. This created a cloudy surface texture that is punctuated by areas where the paint has collected in the gauze and in the structured gesso ground. Last of all Klee painted the even lines of the drawing itself.

KIND MIT BEEREN, 1933,358 (cat. no. 124)

The surface effect of the panel *KIND MIT BEEREN* has a certain affinity with that of *Gelehrter*. The "mural character"[33] that Klee creates in other works too, is evoked primarily by the surface which has been worked with a knife or a spatula. The oval "solid gypsum panel"[34] strengthened with wire (fig. 12) is worked directly into the decorative brass frame, as is the wire hook on the top edge of the back of the picture support. A very thin, brownish layer of colour extends across the whole surface – sometimes transparent, sometimes opaque – bringing out its structure. Pools of colour accentuate the irregularities of the gesso layer, the grainy patches and the bubbles which are due both to the material used and the way it has been worked. Adjoining areas of colour, very thin and transparent, are divided by black painted lines. In this case the child's long hair is not formed from an additional working of the gesso layer; its texture is solely indicated by the areas of brown paint, both smooth and patchy, around the head (fig. 13) – in contrast to the lilac flowers on the child's head, made with a knife and set impishly on it like appliqués (fig. 14). What was merely a hint of a "scholastic wreath" in *Gelehrter* has taken on a considerably more sculpted form in *KIND MIT BEEREN*.

Before and after *KIND MIT BEEREN* in the œuvre catalogue for 1933 Klee listed

Fig. 12
The back of the painting *KIND MIT BEEREN*, 1933,358. Along the lower edge of the oval gypsum panel the wire mesh reinforcement shows through the surface. The wire for hanging the piece protrudes from the top where it is worked into the gypsum

Fig. 13
Detail from *KIND MIT BEEREN*, 1933,358. The hair of the child is made from a layer of brown paint, planar and patchily applied

Fig. 14
Detail from *KIND MIT BEEREN*, 1933,358. The appliqué-like small flowers on the child's head stand out from the gesso ground by virtue of their more plastic working

works in which he was exploring related depictions of children's heads. Black or dark lines give the forms a similarly schematic appearance, delineating and dividing areas of colour, but the techniques and picture supports are different.[35]

Conclusion

The examples in this short description of paintings by Paul Klee show combinations of traditional techniques and materials being developed and adapted to suit the artist's own demands, as well as his recourse to unorthodox materials. The same is true of his painting equipment. While Klee did indeed use traditional tools and brushes he changed them to suit his own purpose and also used instruments from very different areas. By this means he created layers of different textures, structuring substances by applying them repeatedly, adding appliqués, glazing, scraping, scratching and incising. He not only worked with the given properties of his materials, he also worked his materials, distorted woven textures, tore holes in smooth surfaces and incorporated the resulting grainy effects, lines and protruding frayed edges of cut fabric shapes. Construction lines, brushwork, traces of work processes, linear stamps and imprints of flat textures merge into one another to such an extent that it is often scarcely possible to distinguish them from each other visually. The qualities of the materials change during the work process and open up the possibility of different forms of treatment, for instance the incision in a damp chalk ground will leave a very different mark to an incision on a dry ground.

Paul Klee's thoughts on the structures of materials and their make-up are contained in a lecture he held in 1923 at the Bauhaus in Weimar.[36] Taking sound patterns as his starting point[37] – the patterns formed from the vibrations in fine sand strewn on a sheet of wood or metal plate when a violin bow is drawn across its

Thus, first there is the impulse to vibrate or the desire or the need for vitality, next this is transferred to a material episode, lastly there is the visible expression of this in layers of new matter.[38]

Klee was well aware of the importance of the tiniest particle in the overall creative process:

The particle is therefore to be formed so that it is capable of movement. And of being guided. [...] For the particle is not a thing in itself, but a cog in a greater purpose. It is a mediator, that is to say, an in-between part, which receives and relays. It serves an episode that has the capacity to evolve, it is the building block in a higher scheme; and conveys this in all directions, including the spatial.[39]

The tiny grain of sand, the groove in the picture ground, the scratch on the paint layer, the gauze fabric breaking through a layer of gesso, all these apparently accidental components and acts derive from the artist's ability to respond to the way the work is developing and to incorporate this in his subsequent forming of the piece. Thus the combinations of painterly techniques are not merely playfully superimposed layers and harmoniously placed lines, scratches and incisions – rather, the material takes on a more concentrated form through the exploitation of its own immanent, material characteristics; the accidental is anticipated and thereby becomes a concrete and consciously deployed building-block in the overall result. Wolfram Hogrebe discusses Paul Klee's notion of the "essentialisation of the accidental" in a philosophical and art-historical context in his essay 'Paul Klee im ästhetischen Muster der Moderne'.[40]

Klee's work as a creative artist starts with the smallest particles of his materials; his voyages of discovery into the macroscopic allowed him to explore the possibilities of these particles in smaller and greater contexts alike.

These elements form the basis – as Klee put it in his lecture – of "livelier forming" and open up the way to higher realms:

The power of the creative cannot be named. Ultimately it remains mysterious. Yet it would be no mystery if it did not shatter us to the core. We ourselves are charged with this power right to our tips. We cannot describe its being but we can approach the source as far as possible. Whatever the case, we have to reveal this power in its functions, as it is revealed in ourselves. Probably it is itself a form of matter, only not perceivable with the senses in the same way as the more familiar kinds of matter. But it must reveal itself in the familiar kinds of matter. It has to function in unity with these. In permeating matter it has to take on a living, real form. Thus matter acquires life and from its tiniest particles upwards is ordered by underlying rhythms right through to higher schemes. The particles resonate with the original impulse. They resonate, be it in the simplest way or in combined patterns.[41]

The construction of Paul Klee's complex paintings is far removed from the classical methods of academic composition that we know from the 19th century. The image in Klee's works is not created purely by painterly means; instead carefully worked textures and surface forms – which are not an imitation of the existing or the given – become the bearers of a personal language of forms. Meticulously worked surfaces, that are no less light and spontaneous, give rise to new possibilities of expression, which are fitting in the sense that the material is given its

bilities of expression, which are fitting in the sense that the material is given its own meaning, for it is not pretending to be something it might be. The existing and the given are not imitated; instead Klee's personal language of modulation evokes feelings and associations in the viewer.

If we, as viewers, want to maintain our access to this artistic creativity then it is essential that we do not damage the substance of the artefacts and hence their authenticity. It is only thus that we will learn of the "power of the creative" and of Klee's different, magical world.

Acknowledgements

We should like to express our gratitude to the Bürgi Family for allowing us unrestricted access to their collection, where we were able to research the works of Paul Klee in the most beautiful, inspirational surroundings. We are also grateful to Dr Stefan Wülfert, Bern, for reading the text and making valuable comments.

[1] See Kersten/Trembley 1990, pp. 77–91; Haxthausen 1998; Bäschlin/Ilg/Zeppetella 1998.

[2] Information kindly supplied by Christoph Bürgi and Stefan Frey. See Frey 1996, pp. 175–181.

[3] Klee 1988, no. 589.

[4] Rolf E. Straub, 'Tafel- und Tüchleinmalerei des Mittelalters', in: Reclams Handbuch der künstlerischen Techniken, vol. 1, 2nd ed., Stuttgart 1988, p. 168.

[5] See Albert Knoepfli and Oskar Emmenegger, 'Wandmalerei bis zum Ende des Mittelalters', in: Reclams Handbuch der künstlerischen Techniken, vol. 2, Stuttgart 1990, p. 116.

[6] See Manfred Koller, 'Das Staffeleibild der Neuzeit', in: Reclams Handbuch der künstlerischen Techniken, vol. 1, 2nd ed., Stuttgart 1988, pp. 306, 353.

[7] The new individual painting methods of the Venetians of the seicento led to new concepts such as "impasto", "macchia" and "docco sprezzante". See ibid., p. 381. Outside Italy there was also a widespread move towards artists developing their own individual painting methods. One need only call to mind Rembrandt's idiosyncratic technique, see Ernst van de Wetering, Rembrandt. The Painter at Work, Amsterdam 1997.

[8] See Bomford et al. 1990, p. 93. See also Cornelia Peres, 'An Impressionist Concept of Painting Technique', in: A Closer Look. Technical and Art-Historical Studies on Works by Van Gogh and Gauguin, Cailler Vincent 3, Rijksmuseum Vincent van Gogh, Zwolle/Amsterdam 1991, pp. 25–38; Lulu Welther, Die Geschichte und die Herstellung des abendländischen Künstlerpinsels, Diploma dissertation at the Institut für Technologie der Malerei der Staatlichen Akademie der bildenden Künste Stuttgart, ed. by the Institut für Museumskunde, Stuttgart 1992.

[9] An overview of avant-garde artists' attitudes to materials may be found in: Vivian van Saaze, 'Betekenis en houdbaarheid van sokken, vet en fruit. Een onderzoek naar de waarde van de materiaaliconologische methode voor de moderne kunst', Dissertation, Faculty of Cultural Studies, University of Maastricht, typescript, 1998.

[10] Beerhorst 1992, p. 56. See also Sonya Schmid, 'Vom Sand in der Kunst ... Sand als Gestaltungsmittel in der modernen Kunst', Diploma dissertation, Schule für Gestaltung, Bern,

Fachklassen für Konservierung und Restaurierung HFG, typescript, 1996.

[11] Willi Baumeister, "[...] ein Arbeiten ins Unbekannte hinein [...]", as quoted in Beerhorst 1992, p. 56.

[12] Ibid.

[13] See, Willi Baumeister, Das Unbekannte in der Kunst, Cologne 1960, p. 92: "If a colour is applied inexactly, dispersions will appear on the surface (indeterminate clouds in watercolours). If these dispersions (where the colour is broken down into a number of partial values) or modulations are systematised, so that the transitions between dark and light are given a continuous direction – course, equal shading – then a virtual body or virtual area will appear on the picture surface. Thus elementary means are extended into illusion."

[14] See Bomford et al. 1990, pp. 91–98.

[15] See Friedrich Müller, Gesteinskunde, Ulm/Donau 1984, p. 46.

[16] Bürgi 1948, p. 25,

[17] A complete inventory of the tools and painting utensils, compiled by Stefan Frey, is available in the Bürgi Archives, Bern.

[18] On the various types of brushes used in art and the applied arts, see Carl Koch, Grosses Malerhandbuch, ed. by idem, painter and teacher, Kassel, and Heinrich Killinger, Nordhausen am Harz, 1936, pp. 675–690.

[19] Klee BF/2, p. 680.

[20] Klee BF/1, p. 640.

[21] Klee 1988, p. 299. The pantograph or "stork's beak" is used for enlarging or reducing drawings.

[21] See Cornelia Peres, 'Materialkundliche, wirtschaftliche und soziale Aspekte zur Gemäldeherstellung in den Niederlanden im 17. Jahrhundert', in: Zeitschrift für Kunsttechnologie und Konservierung, vol. 2, part 2, 1988, pp. 263–296.

[23] See Isabell Dettwyler, 'Inventaire de l'atelier d'Albert Anker', Diploma dissertation, Schule für Gestaltung Bern, Fachklassen für Konservierung und Restaurierung HFG, typescript, 1994.

[24] Various painting materials from the Bern studio were donated to the Kunstmuseum Bern by Dominique Bürgi.

See Beatrice Zahnd, 'Meret Oppenheim', Diploma dissertation, Schule für Gestaltung Bern, Fachklassen für Konservierung und Restaurierung HFG, typescript, 1996.

[25] See, amongst others, Beerhorst 1992, p. 66; Anna-Barbara Lorenzer, 'Studien zur Maltechnik von Otto Dix in der Schaffenszeit von 1910–1933', in: *Zeitschrift für Kunsttechnologie und Konservierung*, vol. 3, part 1, 1989, p. 140; Jens Baudisch, 'Studien zur Maltechnik von Otto Dix in der Schaffenszeit von 1933–1969', in: *Zeitschrift für Kunsttechnologie und Konservierung*, vol. 3, part 2, 1989, p. 345.

[26] H. Rudolf Wackernagel, '"Ich werde die Leute [...] in Öl und Tempera beschwindeln [...]". Neues zur Maltechnik Wassily Kandinskys', in: *Zeitschrift für Kunsttechnologie und Konservierung*, vol. 11, part 1, 1997, pp. 119f.

[27] Bäschlin/Ilg/Zeppetella 1998.

[28] See Eva Reinowsky-Häfner, 'Tempera. Zur Geschichte eines maltechnischen Begriffs', in: *Zeitschrift für Kunsttechnologie und Konservierung*, vol. 8, part 2, 1994, pp. 297–317.

[29] The under-drawing is visible with the aid of an infra-red reflectogram.

[30] First and foremost the climatic influence, due to variations in temperature and relative humidity.

[31] Klee BF/2, p. 1119.

[32] Paul Klee, 'Œuvre-Katalog 1930–1933', manuscript (Paul Klee Foundation, Kunstmuseum Bern).

[33] For example *Dame Dämon*, 1935,115. The entry in the handwritten œuvre catalogue reads: "Dame Dämon, watercolour, oil paints, mural character, jute on stretcher".

[34] The entry for *KIND MIT BEEREN*, 1933,358 in the handwritten œuvre catalogue reads: "watercolours waxed / solid gypsum plate, elliptical form".

[35] Examples from the handwritten œuvre catalogue: *Namens Elternspiegel*, 1933,357, "watercolours waxed, cardboard, partly glued with handkerchief"; *noch unentschlossen*, 1933,370, "Lithographic crayon, paper (Dokumenten-Canzleipapier)"; *ungläubig lächelnd*, 1933,384, "paste with knife, paper (Dokumenten-Kanzleipapier)".

[36] PN, pp. 13–21.

[37] Ernst Chladni, German physicist (1756–1827), worked on acoustics and discovered the sound patterns named after him that are generated on vibrating membranes when these are strewn with fine sand. The sound patterns make the position of the oscillation nodes and loops visible. (Concepts from wave theory; stationary waves.) Information kindly supplied by Dr. Daniel Lukas Bäschlin, Locarno.

[38] PN, pp. 13f.

[39] PN, p. 16.

[40] Wolfram Hogrebe, 'Paul Klee im ästhetischen Muster der Moderne', in: *Paul Klee in Jena 1924. Der Vortrag*, ed. by Thomas Kain, Mona Meister and Franz-Joachim Verspohl (Minerva. Jenaer Schriften zur Kunstgeschichte, vol. 10), Jena 1999, p. 78: "[...] once the realm of success has been reached, the products of the entirely subjective efforts of the artist seem to free themselves from these efforts, to detach themselves from those who have helped at their birth, and to embark on an existence of their own. [...] It is only in this consolidation phase of the initially wholly chance act that the essentialisation of chance, required by Klee, takes place. This consists in allowing an element of coercion to influence the creative process of contingencies, an influence that, as trans-subjective chance, has the character of an event. Precisely this is what constitutes the successful forming of a work, and the artist may well sense it, but is helpless in the face of it despite his efforts."

[41] PN, p. 20.

STEFAN FREY

ROLF BÜRGI'S COMMITMENT TO PAUL AND LILY KLEE
AND THE CREATION OF THE PAUL KLEE FOUNDATION

Rolf Bürgi, the son of the collector and art patron Hanni Bürgi, was more closely involved with Paul and Lily Klee during the last years of their lives than anyone else in their circle of friends in Bern. He also supported them as a friend and adviser in practical and business matters. After the death of Paul Klee, he took over the administration of the estate on behalf of his widow and their son Felix. In this capacity he had a decisive influence on the future of the work Paul Klee left to posterity. How many are still aware that it is thanks to the efforts of Rolf Bürgi that a large part of the estate of one of the most outstanding artists of the 20th century was kept together and is now housed in Bern?

This essay[1] outlines some of the important moments in the history of the artist's estate up until 1952 and presents the relevant documents in full.[2]

Rolf Bürgi and the Klees in the Early 1930s

Right from the outset the ties between Hanni Bürgi and her husband Alfred and Paul and Lily Klee also included their sons – Rolf Bürgi and Felix Klee –, a fact which Rolf by no means took for granted: "The real and deep friendship my mother felt towards the Klee[s] was also shared by me, and I was proud to feel that it was reciprocated by the much older Paul Klee."[3] Over more than two decades an unshakeable bond of trust developed between the Klees and Rolf Bürgi which was to form the basis of their personal and business relations in the 1930s and 40s.

Rolf Bürgi took a degree in business at the Ecole supérieure de commerce in Neuchâtel, and consolidated his studies between 1927 and 1932 with traineeships in Hamburg, Brussels and Bern.[4] In January 1935 he was appointed head of the main office for the Canton of Bern of the Eidgenössische Versicherungs-Aktien-Gesellschaft (Federal Insurance and Shares Company). In 1941 he became director of the considerably larger main office in Bern of the Schweizerische National-Versicherungs-Gesellschaft (Swiss National Insurance Company).[5] In 1950 he transferred to a special branch caring exclusively for the larger and corporate clients of the Schweizerische National-Versicherungs-Gesellschaft where he remained director until his death in 1967.[6] In keeping with family traditions, Rolf Bürgi also made a career in the Swiss army, where he rose to the rank of colonel.

Fig. 1
The wedding couple
Rolf and Käthi Bürgi-
Lüthi, Thun, 1.9.1934

In early October 1931 Paul Klee asked the future businessman Rolf Bürgi to invest a sum of 70,000 francs on his behalf.[7] The funds for this came from a clandestine savings account which the artist had probably opened with the Cantonal Bank of Bern immediately after the First World War, and which his sister Mathilde had administered until 1934 because of the strict German currency regulations. Profits from picture sales in Switzerland, and later on in Germany and in the USA had gone into this account.[8] In the name of Paul Klee and also in his own name Rolf Bürgi purchased bonds to the value of 67,000 francs, which he managed on behalf of the artist.[9] Questions regarding capital investments were only ever discussed in conversations between himself and Klee during the latter's visits to Bern. In view of the looming danger of inflation caused by the precarious political and economic situation in 1933, Rolf Bürgi cashed in a good third of the bonds, and invested the return of around 25,000 francs in property. On 2 May 1933, on the account of Paul Klee but in his own name he purchased an apartment house from his uncle Hermann Bürgi at 47 Jubiläumsstrasse in Bern[10] which he then also administered.

House Search in Dessau and Emigration from Düsseldorf to Bern

In mid-March 1933, following a raid on the house in Dessau while the Klees were absent, the police and the SA[11] confiscated three washing-baskets of documents, including papers relating to the account in the Cantonal Bank of Bern.[12] Since Paul Klee feared arrest for breaking currency regulations he immediately left for Switzerland where he went straight to Rolf Bürgi in his office. On the request of the artist, Rolf Bürgi went to the aid of Lily Klee in Dessau. By intervening personally he managed to secure the return of the documents, unexamined, from

Fig. 2
Wedding party (left to right: Fritz and Gertrud Bürgi-Morgenthaler with their sons Peter and Max, unknown, Paul Klee, unknown, Lily Klee and two unidentified guests), Thun, 1.9.1934

the relevant authorities. Together with Lily Klee he went through the papers and destroyed anything incriminating.[13] In early April, immediately after returning from Tessin, where he had been awaiting the outcome of Bürgi's intervention, Paul Klee wrote from Düsseldorf to his wife: "The fact that I sent Rolf to you was partly to reassure you and partly to reassure myself. We wanted to be as meticulous as possible."[14]

Publicly branded as a "degenerate artist", robbed of his most important dealer as a result of the closure of the Galerie Alfred Flechtheim, and since 21 April 1933, given leave of absence "with immediate effect" as a teacher at the Staatliche Kunstakademie in Düsseldorf, Paul Klee was forced to rethink completely his financial situation. His wife was pressing him to emigrate from Germany. But this was a step that had to be well prepared. The returns from his bonds and from the heavily mortgaged apartment house acquired in Bern in May were not enough to live on. Paul Klee had to secure the necessary income by finding a new dealer. On 24 October he signed an exclusive contract with Daniel-Henry Kahnweiler who owned the Galerie Simon in Paris, to start on 10 February 1934. Although the critical economic situation at the time meant that this did not guarantee him the "ideal case" of a minimum yearly income,[15] he told Rolf Bürgi a few days later that he had decided "to tackle the move to Bern"[16]. Consequently Bürgi submitted an application to the immigration authorities for a residence permit for the Klees.[17] On 18 December he informed the Klees in Düsseldorf that their residence permits had been granted;[18] two days later Lily Klee arrived in Bern and her husband followed on 24 December. The works by Klee that were transported to Bern in May 1934 were stored for a time at the construction company Hermann Bürgi & Co, which belonged to Rolf Bürgi's uncle.[19]

In the years to come, Rolf Bürgi not only administered the income of the artist and his wife, but also advised them on tax matters and supplied them with cash. From time to time he used his own account to pay bills sent to the Klees – from

the tax authorities for instance –, to have the apartment house renovated, and to send Lily a regular sum for housekeeping.[20] By this means, over time Paul and Lily Klee used up the sum that had been invested in the apartment house at 47 Jubiläumsstrasse, so that this then fell to Rolf Bürgi as outright owner.[21]

Meeting Place: Schlössli Belp

On 1 September 1934 Rolf Bürgi married Käthi Lüthi (1914–1995), the daughter of Albert Lüthi, a surgeon in Thun and a former classmate of Paul Klee (fig. 1).[22] The Klees were amongst the wedding guests (fig. 2);[23] at the wedding in the church at Scherzligen near Thun Paul Klee played violin pieces by J. S. Bach.[24] For three years the young couple lived in an apartment of their own in the same house as Hanni Bürgi at 21 Alpenstrasse – later in 1936 at 19a Alpenstrasse in 1936[25] – where their first son Alfred – called Fredi – was born in July 1935. In November 1937[26] Rolf and Käthi Bürgi rented the lower floor of Schlössli Belp, a noble country residence built in the 18th century (fig. 9). Their second son Christoph was born there in December 1937. After the war the family occupied the entire house.

Paul and Lily Klee were in regular contact with Rolf and Käthi Bürgi, which became all the closer due to their shared concern for Hanni Bürgi's health. "[we love] Rolf & Käthi as our own children," wrote Lily in 1936, "Rolf is very close to us. He is & always has been like a son to us & a real friend."[27] The Klees were often invited to Schlössli Belp. The families frequently celebrated big occasions such as Christmas[28], Easter and birthdays together[29] – Paul Klee's sixtieth birthday for instance, as Lily reported:

> On the 1st evening the young bürgis put on a charming party for my husband in Schlößli belp (of course collected by car[)]. Only our closest, artistically active friends got together there en petit comité.[30]

Rolf Bürgi and his wife also occasionally invited Paul Klee to a concert or to a performance at the Circus Knie[31], and often collected him for a drive in the car[32] or for an outing with the horse and carriage[33]. Following the onset of serious illness in autumn 1935, from which Paul Klee was never fully to recover, he very much enjoyed these excursions, for they brought him a change of scenery and inspiration without his having to exert himself physically. Käthi Bürgi also accompanied the artist to exhibitions.[34] In early June 1939[35], for instance, they went together to the preview in the Galerie Fischer in Lucerne for an auction of works confiscated by the Nazis from German museums.

When Paul Klee died on 29 June 1940 while he was taking a cure in Locarno-Muralto, Rolf Bürgi – on active service at the time – travelled a few hours later to see Lily Klee in Tessin. There he relieved her of all the necessary tasks to be performed and later organised the funeral service with her in Bern.[36] Lily Klee thanked him afterwards for his support at this difficult time: "May what you have done and do for me in memory of my husband & of your mother, dear Rolf, never be forgotten as long as you live & forever."[37]

At the age of nineteen Rolf Bürgi purchased directly from Paul Klee a watercolour to be paid for in instalments (see p. 18), thereby laying the foundations of his later collection, to which the Klees added a series of presents. In late 1932, to thank Rolf Bürgi for his efforts in administrating his finances, Klee gave him the coloured sheet *exotischer Park*, 1932,257[38] (fig. 2, p. 256), and in 1939 expressed his gratitude for an outing with the horse and carriage with the ink drawing *Landschaft des Pferdchens*, 1924,50[39] (cat. no. 76). For Christmas 1939 Klee put *Engel, übervoll*, 1939,896 and *LEVIATHAN von der Dult*, 1939, 1048 (cat. nos. 142, 143) on the presents-table as gifts for Rolf and Käthi. There are no records of the present that he gave them for their wedding, at which he and Lily will certainly not have arrived empty-handed.

For Christmas 1941, "in grateful recognition of many services"[40], Lily Klee gave Rolf Bürgi the oil painting *Stadt im Frost*, 1926,114 (fig. 3) and in June 1945 the Indian ink drawing *grosser Circus*, 1928,22[41] (cat. no. 99). Rolf also bought from Lily the drawing *Stachelfrucht*, 1925,229 for 250 francs[42] in 1941, and the watercolour *Wildwasser*, 1934,16 for 500 francs[43] in 1945. There are no records of when he acquired the prints *Zerstörung und Hoffnung*, 1916,55 (cat. no. 48), *Hoffmaneske Märchenszene*, 1921,123 (cat. no. 65) and *Gestrüpp*, 1928,196[44] although it is highly likely that he also bought them from Lily Klee. Since the records the Klees kept of their private sales between 1934 and 1946 are very patchy and Rolf Bürgi also kept no accounts of his purchases, it is not possible to be specific about the contents of his collection.[45]

Rolf and Käthi Bürgi's interest also extended to four of Klee's artist friends, of whom they knew Wassily Kandinsky in person.[46] On 26 October 1938[47], Käthi Bürgi bought the gouache *La Tension double* (fig. 4) when she, Will Grohmann and his wife visited Kandinsky in Neuilly-sur-Seine. Since the Grohmanns' involvement in the Klee exhibition at the Kunsthalle Bern in 1935 (see pp. 24 and 222), Will Grohmann and his wife Gertrud had become good friends of the Bürgis, as may be seen from Rolf and Käthi Bürgi's guest book (fig. 5). It is possible that the Dresden art historian also paved the way for their purchase of the oil painting *Abstrakter Kopf*, 1928 (fig. 6) by Alexei von Jawlensky, for he had already used his influence in various ways on behalf of Jawlensky who was not in good health and whose finances were in trouble.[48] In an auction at Gutekunst & Klipstein in Bern on 4 December 1940, Käthi Bürgi bought Lionel Feininger's pen, ink and watercolour drawing *Rennen in Deep*, 1929[49] (fig. 7) for 110 francs. There are no records of how and when Franz Marc's tempera sheet *Pferde in d. Schwemme*, 1910 (fig. 8) came to the Bürgi collection.

After the death of Hanni Bürgi in summer 1938, just a few of her pictures went to her son Fritz.[50] Rolf Bürgi took over the rest of the collection, which he then hung in his own home with Paul Klee apparently positioning some of the works himself.[51] Thus Schlössli Belp became the prime destination for those who wanted to acquaint themselves with the work of Paul Klee. From the point of view of the artist, who had no opportunity in his simple studio to give visitors an overview of his works, it was ideal that a large number of his works should be on permanent view in a private location, as he himself said to Rolf Bürgi:

I am happy that all those who are interested are granted access to your collection in the home of your wife and yourself in Belp, since my pictures have so far not found approval in the museums. For me it is much more pleasurable to look at my pictures in an old Bernese house than to see them in a museum.[52]

Up until the Paul Klee Foundation was installed at the Kunstmuseum Bern in 1952, Schlössli Belp remained the "focal point for everything regarding Paul Klee"[53] and, even after 1952, a visit to the Bürgi Collection was still an unforgettable experience for art lovers from the world over and for artists, such as Hans Arp, Alexander Calder, Marc Chagall, Marino Marini, Joan Miró and Henry Moore.[54]

Lily Klee and the Artistic Estate of Paul Klee (1940–1946)

After the death of her husband Lily Klee administered his artistic estate as his sole beneficiary. Her only son Felix, born in 1907 in Munich, had remained in Germany in 1933, where he had established his own life both professionally and privately. He had begun his training as a theatre director in 1926, he married the Bulgarian singer Efrossina Greschowa in 1932, and the following year was engaged for five years as a director and actor at the Stadttheater Ulm. After that he accepted an engagement at the theatre in Wilhelmshaven. In 1940 Alexander – called Aljoscha – was born in Sophia, the only child of Felix and Efrossina.

Felix Klee travelled from Wilhelmshaven to Bern for his father's funeral on 4 July 1940. He spent a month in Bern, amongst other things organising the matter of his inheritance. In the Contract of Inheritance (reprinted on p. 260) he renounced his "inheritance claims in respect of his father's estate in favour of his mother" and agreed to her right to sell pictures from his father's estate. In return Lily Klee agreed to help her son and his family with a monthly allowance as needed – of approximately the same amount that she and her husband had previously provided –, thereby releasing Felix from the "obligation to support her in any way in the future". After her death her entire property was to go to her son or to his legal heirs. In the event of any disputes, Lily and Felix Klee agreed to abide by any judgement made by Rolf Bürgi as mediator. On 29 July Felix Klee issued Rolf Bürgi with a power of attorney by notary that "the latter should be endowed with the legal power to attend to all his affairs for him and in his name, whatever these might be"[55].

During the last six years of her life, Lily Klee supervised, ordered and cared for the works and writings left by Paul Klee. By assisting with publications and the organisation of several major solo exhibitions[56] she actively promoted the dissemination of his works and teachings. "A small circle of friends, younger people with an interest in art, have helped me, so that I did not have to face this onerous task entirely on my own"[57], as she wrote in summer 1945. Besides Rolf Bürgi, these friends included the businessman Hermann Rupf, the publisher Hans Meyer-Benteli and the architect Werner Allenbach. Hermann Rupf had known Paul and Lily Klee since he first bought one of Klee's works in 1913. Hans Meyer-Benteli had first made their acquaintance in January 1935 in Bern[58] and had

Fig. 3
Paul Klee, *Stadt im Frost*, 1926,114, oil and watercolour on paper on card, original frame 30×35 cm, private collection, Germany

regularly purchased pictures by Klee ever since. Allenbach had met Lily Klee after the death of the artist, and had also become a Klee collector.

Lily Klee supported herself with moderate sales from the estate, which provided her with a yearly income of between 8,000 and 11,000 francs.[59] She sold pictures to the museums in Bern, Basel and Zurich, as well as to private individuals, especially to the four Bern collectors Allenbach, Bürgi, Meyer-Benteli, Rupf, the Basel wholesale merchant Richard Doetsch-Benziger and the eye-specialist Othmar Huber in Glarus. In response to requests from various private galleries in Switzerland she made works available for sale in exhibitions.[60] She also made extended loans of major works from her collection to the museums in Basel and Bern,[61] and she privately lent paintings to individuals such as Max Huggler, the director at the Kunstmuseum Bern.[62]

Rolf Bürgi supported Lily Klee by carrying out the duties of a private secretary and advising her in many of her business transactions. In doing so he was fulfilling the wishes of Paul Klee who had expressed his concern for his wife and his artistic estate in 1938, as Rolf Bürgi reported:

He was particularly preoccupied with the question of how, at the very least, his most important, as yet unsold works could be kept together as an intact collection. He asked that I personally should assist his wife in all her financial affairs, oversee the artistic estate and specifically take over the transactions with the art dealers.[63]

By the end of 1940 he was already negotiating with the Kunsthalle Bern as "sole representative of Prof. (Mrs) Klee"[64] on the organisation of Klee's memorial exhibition (*Gedächtnisausstellung Paul Klee*). In April 1941 he brokered an agreement between Lily Klee and Werner Allenbach and Hans Meyer-Benteli regarding the preparation of a publication on the diaries, letters and other writings left by Paul Klee.[65] Of all that he had written, only the Jena lecture of 1924 was published in 1945 by the Benteli Verlag Bern with the title *Über die moderne Kunst* (On modern art).[66]

In October 1941 Rolf Bürgi and Lily Klee came to an open-ended agreement regarding their business relations (reprinted on p. 260). Henceforth Rolf Bürgi had the right, with the agreement of the artist's widow, to negotiate sales, endowments, gifts and the loan of works from the estate of Paul Klee and had charge of the reproduction rights for the works. Furthermore, and again with the agreement of Lily Klee, he had the right of disposal over the entire written legacy of the artist. His expenses would be covered by payment of a 5% "of all proceeds from his works".

The double load of his own job and active military service meant that until 1945 Rolf Bürgi was not able to assist Lily Klee in her sales negotiations and exhibition projects to the extent that he would have wished. It was only after the demobilisation of the Swiss army that he had the time to take a greater interest in the business affairs of the artist's widow. He considered his "main task" to see to it "that Klee's work should be made known abroad as soon as the war was over"[67]. With a good word from the British Envoy Clifford Norton (a personal friend who, like many diplomats from the Western powers, was a regular visitor to Schlössli Belp) and with the support of the art historian and collector Douglas Cooper, Rolf Bürgi succeeded in negotiating a Klee exhibition in London. "For the late artist Paul Klee it was a particular honour to have his work shown in the National Gallery in London, the first foreigner since the end of the war"[68], as he commented on this success, adding that "for commercial reasons he had recommended that the pictures exhibited should not be for sale. In this matter my view was, as ever, that deliberate, pronounced restraint in the matter of sales would raise and stabilise the prices"[69].

Once it was possible to travel abroad again – even if in difficult circumstances – in March and April 1946 Rolf Bürgi re-established contact with the leading dealers from the pre-war period by meeting Daniel-Henry Kahnweiler in Paris and Karl Nierendorf in New York; since 1938 Nierendorf had been Klee's exclusive dealer in the USA. On the one hand Rolf Bürgi had to set about locating works that had been on commission and investigating various assets of Lily Klee's that had accrued, partly in blocked accounts, from sales of commission works during the war by Nierendorf and Kahnweiler. On the other hand, it was also necessary to reorganise the sale of works from Paul Klee's estate. By raising the prices and entering into exclusive agreements with a small number of dealers, Rolf Bürgi sought to increase sales returns and to reduce the amount of administration involved. To this end, "with his powers of attorney on behalf of the heirs of Paul Klee", he signed a new contract with Karl Nierendorf, which guaranteed the Nierendorf Gallery sole representation for North and South America. Nierendorf agreed to take works from the estate of the artist for the sum of at least 24,000 francs net annually.[70] The fact that Bürgi's business strategy was recognised by onlookers is clear from a letter from the artist Otto Nebel, living in Bern, to Hilla von Rebay, adviser to the museum-founder Solomon R. Guggenheim, in which he says: "He [Rolf Bürgi] conducts Lily Klee's business affairs with great perspicacity and energy and has very skilfully turned Klee's circle of friends into a 'trust'."[71]

The Founding of the Klee Society

In October 1945 Lily Klee made her last will and testament (reprinted on p. 261), in which she laid down that a committee should oversee the estate of the artist Paul Klee. Besides her son Felix, its members were to be Hermann Rupf, the Zurich art historian Carola Giedion-Welcker, Werner Allenbach, Rolf Bürgi and Hans Meyer-Benteli. She specified particularly that after her death "all functions relating to my husband's artistic legacy, such as sales and the fixing of sale prices, exhibitions, loans and negotiations concerning publications etc." should pass to the committee. Lily Klee made sure in advance that those individuals, living in Switzerland and chosen for the committee would perform their duties as honorary members.[72] However, she died before she was able to set out in writing her "special wishes and instructions regarding my husband's artistic legacy" or the "regulations […] with provisions on rights and obligations" of the committee.

Fig. 4
Wassily Kandinsky, *La Tension double*, 1938, gouache on paper on card, 49.5×32.2 cm, private collection; dedicated on the card, verso: "Frau Kathi Burgi zur freundl Erinnerung Kandinsky" (To Mrs Kathi Burgi in fond memory Kandinsky)

Despite these gaps in the detail of her wishes, it may be assumed that Lily Klee laid out her own will in order to fulfil the "last will" of her husband. In the last years of his life, Paul Klee had frequently said in conversation with friends that he wanted "to bequeath a Swiss museum a body of work that was not to be sold. He was not sure whether it should be Basel or Bern, and was waiting for the outcome of his naturalisation application to the city of Bern"[73]. Thus it was still undecided on his death what form a bequest of works from his estate to a Swiss museum should take – a gift, a foundation, or a deposit. Born in Switzerland as the son of a German father and a Swiss mother he died in 1940 as a German, despite his efforts to obtain Swiss citizenship.[74] Thus his wife Lily also remained a German citizen, and her own application for citizenship in the 1940s did nothing to alter this.[75] Already in spring 1945, all German assets held in Switzerland were frozen in accordance with a ruling by the Federal Government. In August 1945 Lily Klee complied with a demand from the Swiss Compensation Office in Zurich to disclose the value of her assets in Switzerland.[76] Since Switzerland had signed the Allies' Washington Agreement on 27 June 1946 (excerpts of this are reprinted on p. 262), there was a real danger that after Lily Klee's death the artistic estate of Paul Klee would be impounded, sold, and scattered throughout the world, because Lily's heirs lived in Germany. The agreement provided for the liquidation of assets in Switzerland which belonged to Germans living in Germany. After all German theatres had been closed on 1 September 1944 in preparation for "total" war, Felix Klee had been draughted to serve in a heavy artillery division, and at the beginning of 1945 had been sent to the eastern front in Poland. At the end of the war he was taken prisoner by the Russians in Czechoslovakia, and for a long time was recorded missing in action. He returned in mid-September 1946 from a Russian prisoner-of-war camp to Sommerhausen am Main, where his wife and six year-old son had been sent as evacuees from Würzburg.[77]

Having learnt from Rolf Bürgi of the implications of the Washington Agreement – the fate of the Kirchner estate in Switzerland was a salutary warning[78] – Lily Klee earnestly implored the latter

to do all he could to realise her wishes for the estate of Paul Klee. She specif-
ically explained to me that she would unquestioningly agree with anything

*I should propose that would lead to the implementation of her intentions as
described in her will and which I was already aware of* [79].

On 11 September 1946 Rolf Bürgi and Lily Klee further refined the detail of their
business relationship in a new five-year contract (reprinted on p. 262), which re-
placed their agreement of 28 October 1941 (reprinted on p. 260). Lily Klee made
over to Rolf Bürgi the "sole agency in respect of the works of Prof. Paul Klee
worldwide with the exception of Switzerland" and also granted him the right to
enter into contracts with art dealers and publishers. Rolf Bürgi promised to

*conduct all negotiations in connection with the sale of the works and the pub-
lication of the legacy of Prof. Klee in the best possible interests of Mrs Klee,
handle all the related correspondence and deal with all paperwork in general.*

To this end he set up, as agreed, a permanent office in Bern. As payment for his
efforts he claimed 15% of the net profits, which was less than half of the usual
commission taken by art dealers.

During the months leading up to the signing of the contract, Lily Klee was al-
ready in poor health. She wrote to Othmar Huber that the "endless upsets, wor-
ries & distress on account of my missing son" had taken such a toll of her men-
tal health in May/June 1946, that she had to

*submit to medical treatment. [...] On 13 July the 1 news arrived here [in Bern]
of my d. son Felix through the Moscow red cross, dated 1 June 1946. It was
as though I was stunned & nonplussed & at first incapable of joy. For 1³/₄ years
he had been missing [...]* [80].

On 16 September Lily Klee suffered a stroke and died, without regaining con-
sciousness, on 22 September 1946.[81] "The news of Felix's return to his wife and
his son shook Lily so deeply that she was not able to withstand the consequences
of this turmoil", as Rolf Bürgi put it in his funeral address for Lily Klee (reprinted
on p. 266).

In order to avoid the threatened liquidation of Paul Klee's estate, shortly be-
fore Lily Klee died Rolf Bürgi started to make enquiries, first discussing the mat-
ter with Karl Nierendorf who was staying with him at the time:

*Nierendorf suggested buying the estate for the "Paul Klee Society" in New
York. The price was initially set at $120,000 [= approx. 480,000 francs], but
was then reduced to $90,000 [= approx. 360,000 francs] to be paid in five
yearly instalments.* [82]

Rolf Bürgi, however, put off signing the contract which had been arranged with
the Paul Klee Society[83] on 16 September because he was still hoping to find a
better solution. He approached the industrialist and art collector Emil Georg
Bührle in Zurich-Oerlikon, whom he knew personally. He summed up the nego-
tiations as follows:

*I offered Mr Bührle the Klee estate initially for 360,000 Swiss francs, but then
reduced the price to 240,000 francs. [...] Mr Bührle declined without making
me a counter offer. It may interest some to know that he explained this by say-
ing my evaluation was too optimistic [...] The judgement of this great patron
and collector, who had also taken advice in this matter from the internation-
ally renowned art dealer Dr Nathan showed me the direction I should take.* [84]

After this refusal, on 20 September 1946,[85] two days before Lily Klee's death, Rolf
Bürgi offered the entire estate of Paul Klee[86] including printing and publication

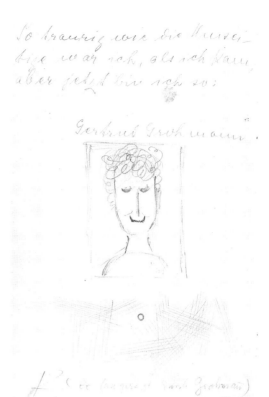

Fig. 5
Guest book of Rolf
and Käthi Bürgi:
entries on the first
two pages from Will
Grohmann (p. 1),
Gertrud Grohmann
and Paul Klee (p. 2),
27.2.1935

rights and the artist's library to the collectors Hermann Rupf and Hans Meyer-Benteli in Bern:

At first I thought it might be possible to agree on 180,000 francs. However, both gentlemen were clearly convinced that they could not take on such a large risk. We finally agreed on a price of 120,000 francs.[87]

The agreed sum, which was later judged to be "appropriate" by Max Huggler,[88] was transferred to a blocked account to the benefit of Felix Klee.[89] The sales contract (reprinted on pp. 262f.) was approved retrospectively by the Swiss Compensation Office in Zurich which was responsible for administering the Washington Agreement in Switzerland.[90]

On 24 September 1946, Hans Meyer-Benteli and Hermann Rupf together with Rolf Bürgi and Werner Allenbach founded the Klee Society (see the Partnership Agreement on p. 263) and transferred the estate of Paul Klee into the Society's possession.[91] The work of administering the estate was then divided between the members as follows: Hermann Rupf took charge of the accounts and represented the Klee Society as its president; Werner Allenbach made an inventory of the holdings of the estate; Rolf Bürgi was responsible for selling designated works and Hans Meyer-Benteli was responsible for publications and questions concerning publishing rights. The Partnership Agreement laid down in more detail the duty already formulated in the sales contract of 20 September "to gift an appropriate collection from the acquired legacy to the Kunstmuseum Bern and the Kunstmuseum Basel" and "to set aside […] a closed and unsaleable collection" which would represent Klee's work. In addition the agreement also stipulated that it was the duty of the Society's members to support Felix Klee and his aunt Mathilde Klee.

The Creation of the Paul Klee Foundation

Fig. 6
Alexei von Jawlensky,
Abstrakter Kopf,
1928, oil on plywood,
41.7×32.1 cm, private
collection

The Klee Society temporarily deposited the estate at the Kunstmuseum Bern,[92] and after a first thorough examination divided it into three groups: works that were not for sale (at least 3,200 works), works that were to become gifts (at least 30 works) and works that were for sale (around 2,500 works). Following this, in accordance with advice from Markus Feldmann, Cantonal Director of Education and a member of the Cantonal Government,[93] on 30 September 1947 the Klee Society founded the Paul Klee Foundation with its seat in Bern, and endowed it with the following holdings from the group of works that were not for sale: 40 panel paintings, 150 coloured and 1,500 monochrome sheets, one copy each of the extant prints, a number of reverse-glass paintings and sculptures, some of Paul Klee's writings and his library[94] (see the Deed of Foundation on p. 264). Three years later the Klee Society added a further 1,500 works[95] to the Foundation's holdings, mainly designs and sketches classified as not for sale, "that are less important to the public than to scholarly research"[96]. Besides monochrome sheets, the Klee Society members above all contributed the representative group of coloured works to the Foundation which Paul Klee had already chosen for his estate. In 1950 Mathilde Klee also gave some of her brother's pictures to the Klee Society to pass on to the Paul Klee Foundation, "since she feared that these works of art might be realized as German property after her death"[97].

The seven members of the Board of the Foundation were: the four Klee Society members with Hermann Rupf as president and Rolf Bürgi as secretary, the Cantonal Director of Education and member of the Cantonal Government Markus Feldmann to represent the Government of the Canton of Bern, Max Huggler representing the Kunstmuseum Bern and the Zurich art historian Carola Giedion-Welcker, whom Lily Klee had named in her will.

With the setting up of the Paul Klee Foundation, the Klee Society pursued the objective of establishing an unsaleable stock of works, that could be displayed in retrospective exhibitions at home and abroad, and which would be capable of demonstrating the importance of Paul Klee. It also created an archive for serious research into Paul Klee, the man and the work (see the Deed of Foundation on p. 264). Max Huggler and the Board of the Kunstmuseum Bern recognised the unique opportunity to offer the Foundation a home in their institution, thereby preventing it from going to Zurich or Basel.[98] Therefore, in response to Rolf Bürgi's suggestion,[99] in early 1948 the Kunstmuseum proposed to the board of the Paul Klee Foundation that they should "permanently install the Paul Klee Foundation at the Kunstmuseum Bern", with the Museum taking over the insurance costs of the holdings, and setting aside space at the Kunstmuseum

> *for the permanent display of the collection, with a separate work-room for the holdings not on display such as the library, manuscripts etc, stored in a fitting manner and with access for those interested in conducting scholarly research*[100].

In mid-1948 the board of the Paul Klee Foundation voted unanimously for the solution proposed by the Kunstmuseum Bern;[101] the transfer of the entire holdings of the Foundation to the Museum was completed by the end of 1952.[102] This addition to the holdings of the Kunstmuseum Bern laid the foundations of its international reputation.

Fig. 7
Lionel Feininger,
Rennen in Deep, 1929,
pen with Indian ink and
watercolour on paper,
composition:
16.7/18.1×25.7/26 cm,
private collection

Fig. 8
Franz Marc, *Pferde in d.
Schwemme*, 1910,
gouache on paper on
card, 10×15.3 cm,
private collection

In the first four years of its existence, the Paul Klee Foundation showed a selection of its holdings in an exhibition that toured to numerous venues at home and abroad: 1947 in Bern, 1948 in Paris, Brussels and Amsterdam, then in a slightly reduced form in Zurich and Basel. Following this the number of works from the Foundation was reduced yet further, but works from private collections in North America were added and the whole was divided into two sections. Organised as a joint venture between the gallery director Curt Valentin and the Paul Klee Foundation, the exhibition now toured during 1949 and 1950 to fifteen towns and cities in the USA.[103] In the eyes of Will Grohmann "this major exhibition tour by the Paul Klee Foundation in the United States of America […made] Klee into a world artist"[104].

The Activities of the Klee Society

With donations to the Öffentliche Kunstsammlung Basel and the Kunsthaus Zurich in early 1948[105] – each received two panel paintings, three coloured and six monochrome sheets – the Klee Society fulfilled another commitment written into the Sales Contract.

Between 1947 and 1952 the Klee Society probably sold around three fifths of the 2,500 works designated for sale. The main purpose of these sales was to pay off the bank loan of 120,000 francs taken out to buy the estate, and also to cover the costs of administering the estate and setting up the Paul Klee Foundation. Rolf Bürgi carried out the sales negotiations mainly in Schlössli Belp, at times occupying the entire first floor apartment for this purpose.[106] He sent works to the Nierendorf Gallery in New York (until 1947), the Buchholz Gallery run by Curt Valentin (from 1948)[107] and the Galerie Rosengart in Lucerne[108]. Around eighty percent of the pictures went to the USA, either through the dealers Nierendorf and Valentin, or via sales to American tourists in the Galerie Rosengart.[109] Rolf Bürgi sold some dozens of pictures directly to museums or to established and new Klee collectors in Switzerland, above all to Richard Doetsch-Benziger. In addition the individual members of the Klee Society also added pictures from the estate to their own collections. Thus the Bürgi Collection increased more rapidly around 1950 than at any other time.

The Klee Society, under its own name, put on various solo exhibitions of Paul Klee's work, above all in Germany.[110] Together with the concurrent touring exhibition of works from the Paul Klee Foundation that were not for sale, which the Society sent to six German and fifteen American towns and cities, these exhibitions marked the first high point in the emergent, carefully targeted worldwide reception of Klee's work after the war: during 1948 and 1949, including the exhibitions of the works for sale in the galleries supplied by the Klee Society, there were more solo exhibitions of the artist's work than at any other time. The publicity strategy that the Klee Society had been pursuing in their presentation of unsaleable works from the Paul Klee Foundation was intended both to popularise Klee's art and to stimulate the demand for works in precisely these other selling exhibitions.[111] Rolf Bürgi was in no doubt:

> *Without the sale of Klee's estate in 1946 and without the setting up of a Foundation and without the possibility of profiting from the market [...] Klee's work would have suffered the same fate as Kirchner's, it would have sunk into obscurity.[112]*

The heavy demands made on Rolf Bürgi in his work for the Klee Society and the Paul Klee Foundation meant that he "drew noticeably ever further away from his original business"[113]. Thus the directors of the Schweizerische National-Versicherungs-Gesellschaft in Basel suggested to him in 1950 that he "should from now on take on a smaller work load for them"[114]. This accounts for his move from the main office to the branch specialising in the care of their larger and corporate clients.

Felix Klee Claims his Inheritance[115]

Rolf Bürgi and the Klee Society supported Felix Klee and his family with food parcels for two years, for which Felix Klee expressed his gratitude in October 1948: "[I] should like to thank you once again most sincerely for the generous help that you have extended to us so far, and which we would have been lost without."[116] On the invitation of the Klee Society, on 13 November 1948 Felix Klee, with his wife and child, was at last able to set out on the longed-for journey from Sommerhausen am Main to Bern.[117] The Klee Society also funded his stay in Bern at first.[118] However, the Society withdrew its financial assistance when tensions arose between its members and Felix Klee. With the assistance of a lawyer, before the end of 1949 the sole heir of Paul and Lily Klee laid claim to the entire estate and the copyrights, by challenging the validity of the sales contract entered into by Rolf Bürgi with Hermann Rupf and Hans Meyer-Benteli, and the legality of the setting up of the Paul Klee Foundation:

> *The "sale" on 20 September 1946 was only a simulated legal transaction. It was carried out for the purpose of protecting the estate of Paul Klee as such from the Washington Agreement and in order to be able to declare a much too low sale-price to the Swiss Compensation Office so that this could be blocked rather than the estate itself. [...] The Klee Foundation too [...] has no legal basis, since the late Mrs Klee determined according to paragraph 7 of her will and testament that such a foundation should only be set up if her son and grandson should die before her.[119]*

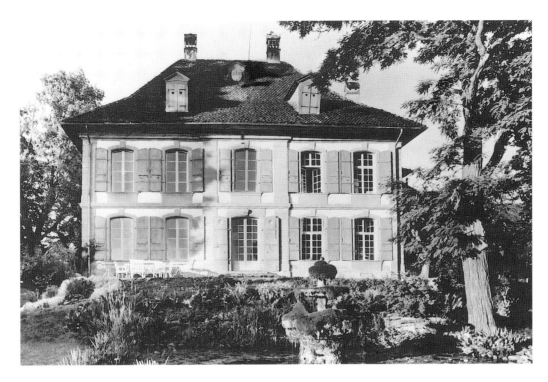

Fig. 9
Schlössli Belp, north-
east façade, ca. 1950

The Klee Society countered this accusation of a fake transaction through their lawyer:

> The sale of the artistic estate took place in accordance with the wishes of Mrs Lily Klee in order to realise her husband's desire that a foundation should be set up. Mrs Klee was aware that if this sale did not take place, after her death the estate of Paul Klee would suffer the same fate as that of Kirchner which today is open to the highest bidder with no account taken of artistic considerations.[120]

Following this the Society received the following communication from the Joint Commission which, together with the Swiss Compensation Office, was responsible for the implementation of the Washington Agreement in Switzerland:

> Even if the Klee Society had not stepped forward as purchaser, the Klee estate would still have had to be liquidated. Felix Klee must come to terms with this fact.[121]

A four-year legal battle ensued between Felix Klee and the Klee Society, which, through the mediation of the Swiss Compensation Office, was settled out of court in late December 1952 with the following conditions: The Sales Contract of 20 September 1946 was annulled; Felix Klee recognised the legality of the Paul Klee Foundation and, as the sole heir of his parents, received from the Klee Society the artistic estate of Paul Klee plus the concomitant rights and duties; each member of the Klee Society gave him ten works that they had acquired from the estate around 1950,[122] and the Klee Society wound its affairs up on 31 December 1952.[123]

A separate agreement was reached between Felix Klee and the Paul Klee Foundation (reprinted on p. 265): Felix Klee agreed that the Paul Klee Foundation should continue to exist and recognised the holdings of the Foundation as

these had existed in 1947; of the 1,500 works that came to the Foundation in 1950, Felix Klee received all the panel paintings and coloured sheets plus a third of the monochrome sheets, the reverse-glass paintings, the prints and the sculptural works.[124] The Paul Klee Foundation was granted copyright for all the works by Paul Klee in its holdings, as well as the most important writings by Paul Klee and the art-historical section on Paul Klee from the library. Werner Allenbach, Rolf Bürgi and Hans Meyer-Benteli left the Board of the Foundation at the end of 1952; Felix Klee joined the board, and following the death of Hermann Rupf, chaired the board from 1963 until 1990.

The president of the Paul Klee Foundation, Hermann Rupf, and the treasurer, Max Huggler, sent the following letter expressing their gratitude to Rolf Bürgi, after he had resigned from the board:

> We are well aware that your efforts and work above all brought the Foundation into being. At the time the initial impulse came from you and you took the necessary steps to set up a memorial to the great artist whose home was in Bern, the like of which few other artists can boast. Thus you brought to a close the work begun by your mother Hanny Bürgi, whose name will also remain forever linked with the œuvre of Klee and the Foundation dedicated to his work.[125]

[1] The following account of the history of the artistic estate of Paul Klee is an extended version of sections of the following essay by the author: Frey 1996, pp. 175–184.

[2] In 1960 Felix Klee published a number of documents on the setting up of the Paul Klee Foundation and on the history of the collection in the estate he inherited, see Klee 1960, pp. 271–275. For more on the history of the artistic estate of Paul Klee, see also: Klee-Gesellschaft 1947, pp. 3–6; W. Wartmann, [Introduction], in: *Paul Klee-Stiftung*, exh. cat. Kunsthaus Zurich, 22.9–17.10.1948, pp. 10f.; Grohmann 1954, pp. 89f.; wb [Wolfhart Friedrich Bürgi], 'Paul Klee. Die Ausstellung in St. Gallen', in: *National-Zeitung*, Basel, no. 86, 21.2.1955, p. 3; Felix Klee, 'Foreword', in: *Tagebücher von Paul Klee 1898–1918*, ed. and introduced by idem, Cologne 1957, pp. 6–8; Klee 1966, unpaginated; Ewald Rathke, 'Kleestiftung als Expertenbüro. Berner Tempo', in: *Artis. Das aktuelle Kunstmagazin*, Constance, vol. 23, no.12, Dec. 1971, pp. 28–31; Hugo Wagner, 'Introduction', in: Glaesemer 1973, pp. 3f.; Kuthy 1979, pp. 1–64; Felix Klee, 'La Fondation Paul Klee, ses origines, son expansion, ses activités', in: *Hodler, Klee. Chefs-d'œuvre du Musée des Beaux-Arts de Berne*, exh. cat. Musée Cantonal des Beaux-Arts, Lausanne, [29.10.1981–3.1.1982], pp. 3–5; John Richardson, 'A Cache of Klees', in: *Vanity Fair*, New York, vol. 50, no. 2, Feb. 1987, pp. 78–83, 108–110; Stefan Frey, 'Erläuterungen zum Verzeichnis der Werke des Jahres 1940', in: *Paul Klee. Verzeichnis der Werke des Jahres 1940*, publ. by the Paul Klee Foundation, Kunstmuseum Bern, ed. by Stefan Frey and Josef Helfenstein with assistance from Irene Rehmann, Stuttgart 1991, pp. 23f.; Stefan Frey and Josef Helfenstein, 'Der ‹Werkkatalog von Paul Klee› – Zu einem laufenden Projekt', in: *Paul Klee (1879–1940). Gemälde, Aquarelle, Zeichnungen, Graphik*, exh. cat. Wolfgang Wittrock Kunsthandel GmbH, Düsseldorf, 9.2–6.3.1993, unpaginated.

[3] Bürgi 1951, p. 6.

[4] See certificate of employment of the Speditions- und Versicherungsgesellschaft Richard Wolff, Hamburg, to RB, 15.5.1928 (ABB); Bürgi 1998, p. 5; certificate of the Kantonale Bernische Handels- und Gewerbekammer, Bern, 16.1.1932 (ABB).

[5] See the certificate of the Eidgenössische Versicherungs-Aktien-Gesellschaft, Bern, 1.5.1941 (ABB).

[6] See -n-, '† Oberst Rolf Bürgi', in: *Der Bund*, Bern, vol. 118, no. 149, 19.5.1967, p. 17.

[7] See RB – MK, 26.4.1933.

[8] See PK to MK, 10.8.1919, in: Klee BF/2, p. 961; PK to FK, 12.7.1927, in: ibid., p. 1052; PK to LK, 27.5.1930, in: ibid., p. 1125; receipt from MK, Bern, 3.5.1933 (ABB).

[9] On his trusteeship from 1931 onwards, see also the letter from KF, Bern, to RM, Zurich, 30.3.1950 (ABB).

[10] See RB – MK, 26.4.1933 and entries in the Land Registry Office, Bern.

[11] See letter from the Magistrat, Dessau, to the lawyer, Heine, in Dessau, 8.6.1933 (copy: ABB).

[12] See Bürgi 1947, p. 7 and Bürgi 1951, p. 7. For general information on the biography of Paul and Lily Klee in the 1930s, see Frey 1990, pp. 111–132.

[13] See ibid.

[14] PK to LK, 3.4.1933, in: Klee BF/2, p. 1233.

[15] See letter from PK, Paris, to HB, Bern, 26.10.1933 (ABB), reprinted p. 256.

[16] Letter from PK, Düsseldorf, to RB, Bern, undated [between 27.10 and 6.11.1933] (ABB).

[17] See, ibid.

[18] See letter from RB, Bern, to PK, Düsseldorf, 18.12.1933 (ABB).

[19] See letter from LK, Bern, to the Kunsthaus Zurich, 24.7.1936 (Kunsthaus Zurich: document "Ausstellung Künstler").

[20] See the various accounts sent by Rolf Bürgi for the attention of Paul and Lily Klee (ABB).

[21] Rolf Bürgi sold the property on 25.3.1942, see entry in the Land Registry Office, Bern.

[22] See Bürgi-Lüthi 1987.

[23] See letter from LK, Bern, to WG, 11.1.1935 (SS/AWG).

[24] See Bürgi 1947, p. 8.

[25] See *Adressbuch der Stadt Bern 1935*, Bern 1935 and *Adressbuch der Stadt Bern 1936*, Bern 1936.

[26] See postcard from LK (& PK), Bern, to WG, Dresden, 12.11.1937 (SS/AWG).

[27] Letter from LK (& PK), Bern, to WG, 24.10.1936 (SS/AWG).

[28] See card from LK/PK, Bern, to RB/KB, 31.12.1938 (ABB).

[29] See Bürgi-Lüthi 1987.

[30] Letter from LK, Bern, to GGr, 1.1.1940 (NFK).

[31] See letter from LK/PK, Bern, to WG, 9.6.1935 (SS/AWG).

[32] See PK to LK, 31.5.1939, in: Klee BF/2, p. 1292.

[33] See PK to LK, 18.7.1935, in: Klee BF/2, p. 1256.

[34] See card WG&GG/PK/KB, Lucerne, to HB, Bern, 27. [illegible: 3.]1935 (ABB) and PK to LK, 6.5.1939, in: Klee BF/2, p. 1288.

[35] See PK to LK, 31.5 and 5.6.1939, in: Klee BF/2, pp. 1292, 1294.

[36] See letter from LK, Bern, to WG, 7.7.1940 (SS/AWG).

[37] Card from LK, Bern, to RB, Bern, 15.8.1940 (ABB).

[38] See letter from PK, Dessau, to HB, 22.12.1932 (ABB), and letter from HB, Bern, to PK, 2.1.1933 (NFK), reprinted p. 256.

[39] See Bürgi 1948, p. 26, reprinted p. 268.

[40] Deed of donation from LK, 25.12.1941 (ABB).

[41] See 'Notizheft des Jahres von Lily Klee' (ABB).

[42] See ibid.

[43] See 'Agenda 1945 von Lily Klee' (ABB).

[44] See letter from RB, Bern, to Kunstmuseum [sic!], Zurich, 18.7.1946 (carbon copy: ABB).

[45] In a note written in 1940, Paul Klee names Rolf Bürgi as the future owner of a number of works; see Kain et al. 1999, p. 318. So far, however, it has not been possible to establish whether Rolf Bürgi did in fact take ownership of these works.

[46] On Rolf Bürgi's first contact with Wassily Kandinsky, see Bürgi 1948, p. 25, reprinted p. 267.

[47] See 'Agenda 1938 von Käthi Bürgi' (ABB).

[48] This work cannot have come to the Bürgi Collection in 1928 (see Maria Jawlensky, Lucia Pieroni-Jawlensky and Angelica Jawlensky, *Alexej von Jawlensky. Catalogue Raisonné of the Oil Paintings. Volume Two 1914–1933*, Munich 1992, no. 2311), but only after 1934, since it is entered in the 'Cahier noir' for January 1934, having previously been in the artist's studio (information kindly passed on to the author by Angelica Jawlensky Bianconi, Alexej-von-Jawlensky Archiv, Locarno, Nov. 1999). On Grohmann's support for Jawlensky, see for instance Stefan Frey, '"Blaue Vier? In Deutschland kannte man sie bisher kaum" – Zur Blaue Vier-Ausstellung, Galerie Ferdinand Möller, Berlin, October 1929', in: *Die Blaue Vier. Feininger, Jawlensky, Kandinsky, Klee in der Neuen Welt*, exh. cat. Kunstmuseum Bern, 5.12.1997–1.3.1998; Kunstsammlung Nordrhein-Westfalen, Düsseldorf, 28.3–28.6.1998, p. 253.

[49] Information kindly passed on to the author by Christine Stauffer, Galerie Kornfeld, 23.11.1999.

[50] Fritz Bürgi took ownership of the following works by Paul Klee: *Bern*, 1910,75; *der Blumensäger*, 1926,73; *treuer Hund*, 1930,147; all illustrated in *Du*, Zurich, February 2000, pp. 54

and 56. It is not possible to establish whether the wash and Indian ink drawing *Hannah*, 1910,78 is also from Hanni Bürgi's Collection.

[51] See Bürgi 1998, p. 8.

[52] Bürgi 1951, p. 8.

[53] Ibid.

[54] See the entries in the Bürgi's guest book (ABB).

[55] See 'Vollmacht von Felix Klee an Rolf Bürgi', Bern, 29.7.1940 (ABB).

[56] See the list of exhibitions organised by Lily Klee on p. 269 in this catalogue.

[57] Lily Klee, 'Lebenslauf', Bern/Vitznau, 4.8.1945, p. 3 (typescript: ABB).

[58] See letter from LK, Bern, to WG, 11.1.1935 (SS/AWG).

[59] See letter from RB, Bern, to Max Blumenstein, Bern, 31.8.1945 (ABB).

[60] See the list of exhibitions organised by Lily Klee on p. 269 in this catalogue.

[61] Loaned to the Kunstmuseum Basel from 1941, some until 1946: the paintings *Reicher Hafen*, 1938,147 by Paul Klee and *Entwurf 1 zu Komposition VII*, 1913, by Wassily Kandinsky as well as five oil paintings by Alexei von Jawlensky (see letter from RB, Bern, to Georg Schmidt, Kunstmuseum Basel, 1.4./13.5.1941, carbon copies: ABB, and letter from Georg Schmidt, Kunstmuseum Basel, to RB, Bern, 14.2.1947; ABB). Loaned to the Kunstmuseum Bern: *Insula dulcamara*, 1938,481 (see MH, Kunstmuseum Bern, to RB, Bern, 11.2.1947; ABB).

[62] *Harmonie*, 1923, und *Fröhliches Spiel*, 1933,310, see MH, Kunstmuseum Bern, to RB, Bern, 11.2.1947 (ABB).

[63] Bürgi 1951, p. 9.

[64] Letter from RB, Bern, to MH, Kunsthalle Bern, 18.11.1940 (carbon copy: ABB).

[65] See 'Vereinbarung zwischen Frau Prof. Klee und Herrn Felix Klee, vertreten durch Herrn Rolf Bürgi, einerseits und den Herren Werner Allenbach und H. Meyer-Benteli andererseits', Bern, 2.4.1941 (ABB); see also Kersten 1999, pp. 72f.

[66] See ibid.

[67] Bürgi 1951, p. 20.

[68] Letter from RB, Bern, to M. Blumenstein, Bern, 26.4.1946 (carbon copy: ABB). On the exhibition *Paul Klee 1879–1940*, Tate Gallery in the National Gallery, London, [22] December 1945–February 1946, see the essay by Richard Calvocoressi in this catalogue, pp. 229–245.

[69] Bürgi 1951, p. 21.

[70] See 'Vertrag zwischen Karl Nierendorf, New York, und Rolf Bürgi, Bern', 17.7.1946 (ABB).

[71] Letter from Otto Nebel, Bern, to Hilla von Rebay, 21.4.1946 (Solomon R. Guggenheim Museum: Archives).

[72] See letter from LK, Bern, to Carola Giedion-Welcker, 1.11.1945 (photocopy: NFK).

[73] 'Ansprache des Herrn Hermann Rupf anlässlich der Eröffnung der Ausstellung "Paul Klee" im Kunstmuseum Bern, 11.8.1956', unpaginated (typescript: KmB).

[74] On Klee's nationality and his efforts to acquire Swiss citizenship, see J. O. Kehrli, 'Weshalb Paul Klees Wunsch, als Schweizer Bürger zu sterben, nicht erfüllt werden konnte', in: *Der Bund*, Bern, vol. 113, no. 6, 5.1.1962; Stutzer 1986, pp. 109–136; Frey 1990.

[75] See letter from LK, Bern, to HR, 26.7.1945 (KmB). So far it has not been possible to establish whether Lily Klee's application for Swiss citizenship was refused or still pending on her death.

[76] See letter from the Kantonalbank of Bern to LK, Bern, 18.8.1945 (ABB) and letter from RB, Bern, to the SV, Zurich, 31.8.1945 (carbon copy: ABB).

[77] For details on the biography of Felix Klee, see Klee 1966, unpaginated.; 'Curriculum Vitae von Felix Klee über Felix Klee', in: *Keimlinge der großen Kunst. Kindheits- und Jugendwerke des Felix Klee*, exh. cat. Kinder- und Jugendwerke-Museum in Halle/Westfalen, [20.11.1988–31.3.1989], pp. 7–42; *Felix. Arbeiten auf Papier. Bilder von Felix Klee 1913–1921*, exh. cat. Hans Thoma-Gesellschaft/Kunstverein Reutlingen, 3–31.3.1991, p. 83.

[78] After the death of Erna Kirchner the Swiss Compensation Office took over the administration of the Kirchner Estate. Only intervention by Georg Schmidt prevented the precipitous sale of the estate's holdings; see Eberhard W. Kornfeld, *Ernst Ludwig Kirchner. Nachzeichnung seines Lebens*, Bern 1979, pp. 327–330.

[79] Bürgi 1951, p. 24.

[80] Letter from LK, Vitznau, to Othmar Huber, 21.7.1946 (fragment: ABB). The surviving fragment of this letter breaks off directly after the quoted passage.

[81] See letter from RB, Bern, to Irene Groth-Karst, Weimar, 8.3.1947 (carbon copy: ABB). On the death of Lily Klee, see also the different account by Heinz Berggruen, *Hauptweg und Nebenwege. Erinnerungen eines Kunstsammlers*, Berlin 1996, pp. 90f.

[82] Bürgi 1951, p. 24.

[83] See letter from RB, Bern, to Karl Nierendorf, New York, 16.9.1946 (fragmentary copy: NFK).

[84] Bürgi 1951, p. 25.

[85] See Klee 1960, p. 273.

[86] In 1946 the Paul Klee estate may have had over 300 panel paintings, as Klee described his paintings – and around 5,500 monochrome and coloured sheets, as he called his drawings and watercolours. It comprised unsold works - largely from his youth and the time between 1933 and 1940 – as well as a collection of works that the artist had intentionally kept back for himself. On Klee's own collection for his estate, see Frey 1996, p. 176.

[87] Bürgi 1951, p. 25.

[88] See letter from MH, Kunstmuseum Bern, to RB, Bern, 20.3.1947 (photocopy: ABB).

[89] See letter from the SV, Zurich, to RB, Bern, 21.9.1948 (ABB), and letter from RB, Bern, to the SV, Zurich, 23.9.1948 (carbon copy: ABB).

[90] See letter from the SV, Zurich, to Rolf Bürgi, Bern, 26.4.1947 (photocopy: ABB).

[91] See 'Klee-Gesellschaft: Protokoll Nr. 6 der Sitzung vom 28. Januar 1947' (KmB).

[92] See letter from the K-G, Bern, to MH, Kunstmuseum Bern, 25.11.1946 (carbon copy: ABB).

[93] See Rupf 1951, p. 5.

[94] See Klee-Gesellschaft 1947, p. 6. In exh. cat. *Ausstellung der Paul Klee-Stiftung*, Kunstmuseum Bern, 22.11–31.12.1947, the panel paintings and the coloured sheets are listed in full, of the monochrome and the printed sheets only a selection are listed by title.

[95] See the list in Klee 1960, p. 274.

[96] 'Klee-Gesellschaft: Protokoll Nr. 55. Sitzung vom 4.9.1950' (KmB).

[97] Letter from KF, Bern, to RM, Zurich, 14.11.1950 (carbon copy: ABB).

[98] See 'Protokoll der 96. Direktions-Sitzung des Berner Kunstmuseums, 15.1.1948', excerpts reprinted in Kuthy 1979, p. 44. The museums in Zurich and Basel were also interested in taking over the Paul Klee Foundation. Both institutions had supported Paul Klee in the past to varying degrees. The Kunsthaus Zurich presented the last comprehensive solo exhibition of Klee's work before his death (*Paul Klee. Neue Werke*, 16.2–25.3.1940). While Paul and Lily Klee were still alive, the Kunstmuseum Basel

and above all the Kunsthalle Basel had done a great deal to promote Klee's art and had instigated
important purchases for the Öffentliche Kunstsammlung. Their exhibitions encouraged various Basel collectors to acquire works by Klee.

99 From 1947 until 1967 Rolf Bürgi was a member of the Board of the Kunstmuseum Bern; from 1947 until 1959 he held the office of keeper of the accounts.

100 Letter from the Board of the Kunstmuseum Bern, to the Paul Klee Foundation, Bern, 16.1.1948 (carbon copy: KmB).

101 See letter from K-G, Bern, to the Board of the Kunstmuseum Bern, 11.8.1948 (KmB).

102 Kuthy 1979, p. 47.

103 See the list of exhibitions organised by the Paul Klee Foundation on p. 269 in this catalogue.

104 [Expert opinion] from Will Grohmann, 3.4.1951 (ABB).

105 See letters from K-G, Bern, to the Kunstmuseum Basel and to the Kunsthaus Zurich, 29.1.1948 (carbon copies: ABB). The works for Basel are listed in: *Paul Klee (1879–1940). Gemälde. Aquarelle, Zeichnungen, Druckgraphik*, exh. cat. Kunstmuseum Basel, 2.10–28.11.1976, nos. 53, 78, 80, 88, 91, 93, 97, 100, 104, 105, 107.

106 See Bürgi 1951, p. 32.

107 After the death of Karl Nierendorf (25.10.1947), in February 1948 the Klee Society put the sole representation for the work of Paul Klee for North America in the hands of the art dealer Curt Valentin.

108 In 1947, the Klee Society appointed Siegfried Rosengart, the owner of the Galerie Rosengart in Lucerne "[…] as the only art dealer in Switzerland with the right to sell pictures from the Paul Klee estate (outside the USA)", letter from RB, Bern, to Siegfried Rosengart, 21.4.1947 (carbon copy: ABB). Marie-Suzanne Feigel of the Galerie d'art moderne in Basel had also been interested in selling Klee's pictures in Switzerland, see letter from RB, Bern, to Marie-Suzanne Feigel, Basel, 7.5.1947 (carbon copy: ABB).

109 See Bürgi 1951, p. 29.

110 See the list of exhibitions organised by the Paul Klee Foundation on p. 269 in this catalogue.

111 See Rupf 1951, p. 2.

112 Bürgi 1951, p. 30.

113 Ibid., p. 31.

114 Ibid., p. 32.

115 Most vividly portrayed in Klee 1960, pp. 271–275, specially pp. 273f.; Klee 1966, unpaginated.

116 Letter from FK, Sommerhausen, to RB, Bern, 15.10.1948 (ABB).

117 See letter from RB, Bern, to FK, Sommerhausen, 9.11.1948 (carbon copy: ABB).

118 See letter from Werner Allenbach, Bern, to Federal Councillor Ed. von Steiger, Bern, 17.3.1950 (carbon copy: ABB).

119 Letter from RM, Zurich, to K-G, Bern, 14.3.1950 (copy: ABB).

120 Letter from KF, Bern, to RM, Zurich, 23.7.1949 (ABB).

121 Letter from RB, Bern, to the Gentlemen of K-G, 2.11.1949 (photocopy: ABB).

122 See 'Verzeichnis der von der Kleegesellschaft gemäss Ziff. 2 des Auseinandersetzungsvertrages an die Schweizerische Verrechnungsstelle zuhanden von Herrn Felix Klee herauszugebende Bilder, 31.12.1952' (NFK).

123 See 'Vereinbarung [agreement between Felix Klee and the Klee Society] vom 31.12.1952' (KmB).

124 Felix Klee received from the Paul Klee Foundation a total of 20 panel paintings, 224 coloured sheets, 461 monochrome sheets, 47 prints, 13 reverse-glass paintings, 4 sculptures, 2 reliefs.

125 Letter from HR and MH, Bern, to RB, Belp, 16.12.1952 (ABB).

OSAMU OKUDA

"RETURN TO OLD HAUNTS":
THE PAUL KLEE EXHIBITION AT THE KUNSTHALLE BERN
IN 1935

*Pauvres gens! Spirit and humour have left you [the Swiss] and you are
the poorer for it. Spirit and humour are in exile.*
(Carl Albert Loosli)

Driven out of Germany by the National Socialists, Paul Klee and his wife Lily
had been living as exiles in his native city of Bern since late 1933. From 23 Feb-
ruary until 24 March 1935 there was an exhibition at the Kunsthalle Bern to mark
his "return to old haunts"[1]. The exhibition presented an overview of Klee's work
from 1919 until 1934, with a particular focus on his work of the last five years.[2]
Besides pictures by Klee there were also small sculptures by his boyhood friend
Hermann Haller (fig. 1).[3]

Fig. 1
Poster for the double
exhibition *Paul Klee /
Kleinplastiken von
Hermann Haller*,
Design: Otto Tschumi

The following factors show that this exhibition occupies a special position in
Klee's career as an exhibiting artist:

1. Klee only exhibited works from his own collection, thereby distancing him-
self from the art market as such.[4]

2. A lecture at the opening was given by the art critic and connoisseur of Klee's
work Will Grohmann, for whom Klee had a high regard, as he also did for Carl
Einstein.

3. The idea for the exhibition had originally come from Klee's patron Hanni
Bürgi, and she was actively involved in the subsequent purchase of the picture
Ad Parnassum, 1932,274 (fig. 2) by the Verein der Freunde des Berner Kunst-
museums (The Friends of the Kunstmuseum Bern).

4. Hanni Bürgi also took this opportunity to buy a major work by Klee, his
painting *Botanisches Theater*, 1934,219 (fig. 3). This purchase was a high point
in her activities as a collector of Klee's works.

Accounts of this exhibition elsewhere in the literature on Paul Klee are in-
complete.[5] For instance, the part played by Hanni Bürgi has been entirely ig-
nored. So far there has been no analysis of Klee's selection of exhibits, and no
research has as yet been undertaken on the drawings he made in 1933, which
were shown in the exhibition.

Without claiming to be exhaustive, this essay sets out to fill some of the gaps
in current research and, by focusing on the exhibition at the Kunsthalle Bern, to
examine Klee's situation in the early days of his exile at home. At the same time,
a case will be made showing the influence of Honoré Daumier's art on Paul Klee,
which allowed the latter to express his own underlying satirical attitude to history.

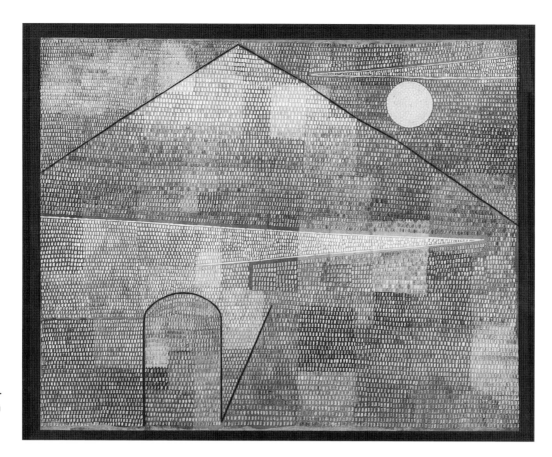

Fig. 2
Paul Klee, *Ad Parnassum*, **1932,274, oil on canvas, 100×126 cm, Kunstmuseum Bern**

The Part Played by Hanni Bürgi

As early as 1931, there was a Klee exhibition at the Kunsthalle Bern with works owned privately in Bern. A total of 108 works were shown, including 53 pictures belonging to Hanni Bürgi.[6] As we know from Klee's lecture at the Bauhaus in Dessau, the collector visited the artist in Germany in late 1930:

Yesterday Mrs Bürgi from Bern was here (in Dessau). Mrs Bürgi is a woman of unusually good taste. Even her clothes are always very carefully matched, down to the last detail. Nothing showy, nothing loud. She was a pupil of my father's and at that time was already collecting paintings and drawings, now it gives her pleasure that they are so valuable and that she has a private collection. She will shortly be showing her private collection at the Kunsthalle Bern. She is one of the most sensitive of all collectors and no-one has such a fine memory for cataloguing.[7]

Klee's praise for Hanni Bürgi is surprising, in that he never once mentions her in his extensive diaries (1898–1918) although the collector was already active early on promoting the work of the young, unknown artist. Evidently Klee was not entirely at ease with Hanni Bürgi's bourgeois milieu, as may be seen from certain turns of phrase in his letters to Lily. In 1910 he wrote: "Mrs Bürgi has fixed Thursday evening for us, not precisely comfortable, but what can you do."[8] And in 1919 he remarked: "This evening we are to go to Mrs Bürgi. It will be no pleasure and I am so defenceless."[9]

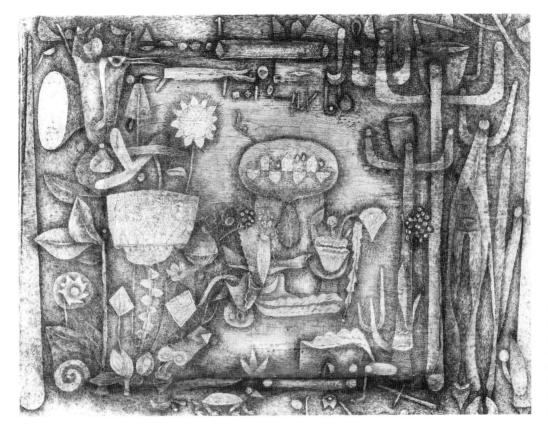

Fig. 3
Paul Klee, *Botanisches Theater*, 1934,219, oil and watercolour on card on wood, 50×67 cm, Städtische Galerie im Lenbachhaus, Munich

During the 1920s Klee grew rather friendlier to the bourgeoisie; for these were the people most likely to buy his works. Max Huggler, director of the Kunsthalle Bern at the time, remembered that shortly after Klee's return to Switzerland, Hanni Bürgi came up with the idea of a major exhibition of Klee's work:

> It was early in January 1934 that I became personally acquainted with Paul Klee: Mrs Hanny Bürgi had brought him to see me at the Kunsthalle. [...] Her main concern was that a Klee exhibition should come about as soon as possible – as the most fitting welcome to the artist in his new home.[10]

Huggler also documented Hanni Bürgi's active role in the realisation of the Klee exhibition of 1935 in the yearly report of the Kunsthalle:

> As the most determined champion of Paul Klee's art she was the inspiration behind the Klee exhibition at the Kunsthalle in 1935, and so effectively supported its realisation[11] that it was an immense success both for the artist and for the Kunsthalle.[12]

By 1932 at the latest Hanni Bürgi had become a member of the Verein der Freunde des Berner Kunstmuseums, and was on the Friends' Board from 1935 onwards. Together with the chairman of the Board, Fritz von Fischer, and the director of the Kunstmuseum Bern, Conrad von Mandach, she visited the Klee exhibition at the Kunsthalle Bern in March 1935.[13] It seems likely that Hanni Bürgi successfully recommended that the Friends should buy the painting *Ad Parnassum* – particularly since she may have remembered a postcard that Klee sent her

Fig. 4
Paul Klee, *das Kunst-werk*, 1933,154, pencil on paper, 23.8×19.8 cm, private collection, Switzer-land

Fig. 5
Paul Klee, *Krieger mit Narben*, 1933,412, pencil on paper, 33×21 cm, location unknown

from Luxor for the New Year in 1929 when he was on his trip to Egypt. On the front of the card is a photograph, *Cairo – Tempel of the Sphinx* which may have been a source of inspiration for both the composition and the content of the painting (fig. p. 255). In the 1935 Klee exhibition, Hanni Bürgi purchased for her own collection the oil painting *Botanisches Theater*, 1934,219 (fig. 3), which Klee had been working on since 1924 and which Otto Nebel reported he had finished on 10 July 1934.[14] The painting was listed in the catalogue at 5,000 Swiss francs – one of the most expensive works in the exhibition – but Klee sold it to her at the lower price of 3,500 francs.[15]

The Lecture by Will Grohmann

In view of the "concrete thought processes" of the Bern public, Huggler had already asked Grohmann in early February 1935 "to avoid broader – psycholog-ical and art-historical – reflections"[16]. Despite Huggler's warning, in his opening lecture Grohmann discussed the significance of Klee's art with allusions to Berg-son, Jung, Freud, Klages, Joyce and others. He put Klee's work in a wider cultural context and described it in art-historical terms, drawing partly on the language of Carl Einstein.[17] This elicited the following prompt comment from the *Berner Tagblatt*: "The informative lecture by Dr. Grohmann conveyed much that was fas-cinating about Klee's art, but by taking theory rather than the pictures as its start-ing point it was less than entirely convincing."[18]

Exhibits

The selection that Paul Klee made for the exhibition in Bern would in itself be worthy of a comprehensive essay. Suffice it to say here that – as has hitherto been ignored – Klee showed 22 items from a group of works from 1933, which Alexander Zschokke, a colleague from the Düsseldorf Academy of Art, described as depictions of the "National Socialist revolution"[19]. The works on show included drawings such as *das Kunstwerk*, 1933,154 (fig. 4), *Gefesselter Sclave*, 1933,182, *Haus-sclave*, 1933,183 and *Krieger mit Narben*, 1933,412 (fig. 5). There is no record of the reaction of the Bern public to these works; in the numerous reviews there is no specific reference to these drawings. The figures are drawn in a hectic manner, and their themes are in part reminiscent of the caricatures of Honoré Daumier. In terms of style they are also surprisingly close to Daumier's drawings.[20] In the drawing *eitler Pädagoge*, 1933,335 (fig. 6), which was not shown in the exhibition, Klee even makes a direct reference to a lithograph by Daumier of 1866 (fig. 7). Klee knew Daumier's caricature *The Toughening of Youth* from the book *Daumier und der Krieg* (Daumier and the War) which had been published in Leipzig in 1926. He himself owned a copy.[21] The caption under the lithograph reads: "'You just need to pick up the new gun, press once, and you've killed ten times as many people as with the old system.' – 'Is that what is called progress, Papa?'" Klee's version of Daumier's critical image, made in the year that Hitler came to power implies that, while alluding to an established role model in art history, his actual subject was the educational concepts of the National Socialists.[22] In view of this, the entire series of drawings made in 1933 ought perhaps to be re-interpreted.[23]

Resonance

As Werckmeister and Hopfengart show, the reaction in the press to the exhibition was "by and large not unfriendly".[24] A closer reading of the reviews does, however, shows that the positive response was not without a subtext. The reviewer in the Bern newspaper *Der Bund*, Walter Adrian, described Klee's situation in Bern at the time as follow:

> So here is an unbernian inhabitant of Bern, who has made his name far from here, who cares not a jot for our views. It is not easy to approach this phenomenon from the firm ground of lives founded on reality. "I am not to be understood in this world. For I would be as well off amongst the dead as amongst the unborn…": thus a diary entry of his which I have seen published somewhere.[25]

Sensing that reactions of this kind might be forthcoming, Huggler had stressed Klee's links with Bern in his foreword to the catalogue. Instead of referring to his artistic career in Munich, Weimar, Dessau and Düsseldorf, the director of the Kunsthalle spoke of the time he spent abroad. In the reviews there is no mention of the fact that Klee had been driven out of Germany by National Socialism. The only exception was in a review of the exhibition *These, Antithese, Synthese* which took place in Lucerne at the same time as the Klee exhibition in Bern, and in-

cluded works by Klee. This review briefly refers to the cultural-political reasons behind Klee's exile:

Even though the major works by this German [Klee] with Bernese roots are on show together in a major survey exhibition in Bern (where the artist, accused of "cultural Bolshevism", has had to live for some time now) [...].[26]

Significantly, a harsh review of the Klee exhibition was published in the *Berner Tagwacht*, the official organ of the Social Democratic Party of Switzerland:

Klee is not a name, behind which a mortal toils. Klee is a concept. A concept that international art historians and critics use like a mathematical formula. Woe betide any who should "deconceptualize" this concept! The laboriously cobbled-together orienteering device could collapse like a house of cards! [...] Prices that are strictly intended for bourgeois aesthetes, gourmets and those with capital to "invest". Prices that positively debar tailors' apprentices from feeling "kleeish". [...] Of course art-things can never be valued in terms of money, but is it not possible that many simple minds at the present time will draw the line at these thousands? Is it not possible that the fantastic level of these figures lay the attitude and morality behind them open to question?[27]

As a matter of interest: contrary to the positive estimations by Huggler[28] and Grohmann[29], the 1935 Klee exhibition in Bern with its 1,993 visitors[30] was an extremely modest success.

In Switzerland in 1935, Klee's art was really only accepted by a few bourgeois patrons of the arts and by some free-thinking critics and art historians on the political left, including Georg Schmidt and Konrad Farner. The younger generation moving in avant-garde art circles, such as Max Bill[31] and Willy Rotzler[32], did not make their voices heard until 1939/1940. In an often quoted review of the 1935 Klee exhibition in Bern, the critic Georg Schmidt, who had consistently pleaded Klee's cause in the *National-Zeitung* in Basel since 1921, put his own sensitive response into words:

The main drive behind Klee's art is a psychic reaction to certain experiences, and the picture is like a seismographic record of this reaction. At times these symbols are just used for some wider game, at others they are deflected into irony, and at yet other times, and this applies more than any other, they emerge with all the signs of the fearful. In Klee's garden grow many in no way harmless poisonous plants! I think that anyone who could read all Klee's symbols would see the whole horror of our decayed times under the picture surfaces which are so uncommonly pleasurable in purely aesthetic terms [...]. And one almost feels a sense of exhilaration in the presence of Klee's art.[33]

It is also worth mentioning the observation by the reviewer in the *Luzerner Tagblatt*. He noted

that this [Klee's] spiritual art is also high-spirited art, often it is inspired levity – "cheerful science" along the lines of Goethe's: "O children of wisdom, make fools of the fools, as one should!" Such jokes by Paul Klee lift up our hearts[34].

In 1936, the Marxist art critic Konrad Farner in Lucerne took up the above-mentioned comment by Georg Schmidt:

This new inward manner, which is ground-breaking and points the way forward, may be understood through Klee's output as a whole. His pictures are not just a depiction of the processes of the outer and the inner world, they

Fig. 6
Paul Klee, *eitler Pädagoge*, 1933,335, pencil on paper, 44.8 × 27.3 cm, Paul Klee Foundation, Kunstmuseum Bern

Fig. 7
Honoré Daumier, *[The Toughening of Youth]*, lithograph, first printed in: *Charivari*, 8 August 1866

are the closest one can get to accounts of illustrations of reality – to use Lenin's words. They offer the most precise seismographic record of the tremors that human society is currently suffering. And as such they are the plainest revelations of the needs and terrors as well as of the monstrous knowledge of human beings today, or more precisely of European human beings in late capitalist society.[35]

Somewhat later Klee indirectly legitimised Schmidt's and Farner's views. In summer 1939 the artist was sent a questionnaire by the Carnegie Institute, Department of Fine Arts, in Pittsburgh. In response to the question: "Quel sont les maîtres modernes qui ont eu sur vous le plus d'influence et que vous admirez le plus?" Klee surprisingly replied: "J'admire Daumier, mais il n'y a pas d'influence visible"[36].

Klee's esteem for Daumier, the militant chronicler of capitalist society in 19th century France, is an indication that Klee, in his own way, was striving to create an artistic account of his own times.[37] It was not without reason that in 1939 he linked his own art with that of Daumier to the benefit of the North American public. Since 1938 Klee had been commercially successful in the USA, having been recognised as an exile and victim of the repressive cultural politics of Nazi Germany. In the questionnaire he presented himself, even if with some restraint, as a satirist alive to social and political issues, as a critical artist. Klee

research would do well at some future date to bring to light the "invisible" influence of Daumier on Klee's art and to illuminate this in the context of its own times.[38]

Acknowledgements
I should like to express my sincere gratitude to Rachel Kessler and Reto Sorg for their kind support.

[1] Letter from Paul Klee to Will Grohmann, Bern, May 1934, as quoted in Gutbrod 1968, p. 78.

[2] See Bern 1935.

[3] The poster for this joint exhibition was designed by Otto Tschumi, whom Klee had first met in Bern in 1934. See Stefan Paradowski, 'Otto Tschumis gedruckte und nur geplante Gebrauchsgraphik', in: *Otto Tschumi*, exh. cat. Kunsthalle Nürnberg, 24.4–21.6.1987; Kunstmuseum Bern, 3.7–30.8.1987; Musée des beaux-arts, Mulhouse, 12.9–15.11.1987, p. 21.

[4] Paul Klee reported on the exhibition to Grohmann in early December 1934: "The exhibition itself will be extraordinary in that there will be no art dealers. I am showing everything that I have of importance, in order to show it and to see it myself. I am exaggerating, I don't want to cast aspersions on exhibitions with art dealers. But one really will sense a new tone. It used to be a little like that at Justi's, but not any more. For the Düsseldorf exhibition showed a great deal from private collections in the Rhineland, and through its very distinctive style the whole had a different accent..." (Letter from Paul Klee to Will Grohmann, Bern, 2.12.1934, as quoted in Gutbrod 1968, p. 79). In January 1935 Klee requested The Mayor Gallery in London to send the following sixteen paintings directly to the Kunsthalle Bern, to be included in his exhibition (according to the handwritten list by Paul Klee, KhB): *Kiosk*, 1920,121 (cat. no. 5); *Perspektivische Figuration*, 1925,D2 (cat. no. 23); *Kreuzblumenstilleben*, 1925,K1 (cat. no. 24), *Pastorale*, 1927,K10 (cat. no. 35); *Fundstelle*, 1927,L7 (cat. no. 36); *Ein Blatt aus dem Städtebuch*, 1928,N6 (cat. no. 39), *Eingezäuntes*, 1928,Qu4 (cat. no. 40); *Fliehender Geist*, 1929,D1 (cat. no. 42); *Heitere Gebirgslandschaft*, 1929,D4 (cat. no. 43); *Die Schlange auf der Leiter*, 1929,3H48 (cat. no. 45); *Schwebendes*, 1930,S10 (cat. no. 51); *Siesta der Sphinx*, 1932, A9 (cat. no. 60); *Die Frucht*, 1932,Y4 (cat. no. 71); *Wege am Dorfrand*, 1933,A7 (cat. no. 74); *Frauenmaske*, 1933,Ae2 (cat. no. 76), *Mai*, 1933,Z4 (cat. no. 84). In January 1934 these works, together with nine others, had been shown at The Mayor Gallery, and in December of the same year in the exhibition of the Society of Scottish Artists in Gallery III of the Royal Scottish Academy, Edinburgh (see David Foggie, 'Paul Klee's Work. A Criticism', in: *The Scotsman*, 15.12.1935).

[5] See Glaesemer 1984, p. 425; Werckmeister 1985, pp. 29f.; Stutzer 1986, pp. 133f.; Hopfengart 1989, pp. 113–115.

[6] See Bern 1931. The nine works, nos. 101 to 108, were offered for sale by Klee from his own collection.

[7] Petra Petitpierre, 'Aus der Malklasse von Paul Klee. 1930–1931–1932, Bauhaus Dessau + Staatl. Kunstakademie Düsseldorf', unpublished typescript, p. 70 (the original is owned by Simone Müller-Petitpierre, Minusio/Switzerland).

[8] Letter to Lily Klee, 18.11.1910, in: Klee BF/2, p. 764.

[9] Letter to Lily Klee, 16.6.1919, in: Klee BF/2, p. 953.

[10] Huggler 1996, p. 101.

[11] Hanni Bürgi contributed for instance to the finances for the lecture by Will Grohmann at the Kunsthalle (information kindly supplied by Stefan Frey).

[12] Huggler 1939.

[13] See minutes of the meeting of the board, 23.3.1935, in: 'Vereinsprotokoll', p. 150. Information kindly supplied by Stefan Frey.

[14] See '"Es ist frei und einfach beim Meister Klee." Unveröffentlichte Tagebuchauszüge von Otto Nebel (1892–1971)', selected and introduced by Therese Bhattacharya-Stettler, in: *Berner Almanach*, vol. 2: Literatur, ed. by Adrian Mettauer, Wolfgang Pross and Reto Sorg, with assistance from Sabine Künzi, Bern 1998, p. 303: "10.7.1934 (III, 11) The evening at Klee's. Paul Klee has just finished a picture that he has been working on for years. It has turned out wonderfully. He has christened it: 'Botanisches Theater'".

[15] See letter from Max Huggler to Paul Klee, 10 May 1935 (KhB): "Payment for the sale of cat. no. 107 Botanisches Theater goes to you, and you will therefore allow us to subtract the sales commission to the sum of 525 fr. (on the sale price for the work of 3,500 fr.)".

[16] Letter from Max Huggler to Will Grohmann, Bern, 2.2.1935 (SS/AWG).

[17] See Wolfgang Kersten, 'Textetüden über Paul Klees Postur – "Elan vital" aus der Gießkanne', in: *Elan vital oder Das Auge des Eros*, exh. cat. Haus der Kunst, Munich, 20.5–14.8.1994, p. 56.

[18] p.h., 'Kunsthalle. Paul Klee - Hermann Haller', in: *Berner Tagblatt*, vol. 47, no. 94, 26.2.1935, 'Abendblatt', p. 2.

[19] Alexander Zschokke, 'Begegnung mit Klee', in: *Du*, vol. 8, October 1948, pp. 74–76. See Glaesemer 1984, pp. 343–348, Werckmeister 1985, pp. 109f., and Werckmeister 1987, pp. 44–46.

[20] See Erich Klossowski, *Honoré Daumier*, Munich 1908, plates 81–83. In the library of Lily and Paul Klee there is a copy of the book with a dedication from Lily to Paul Klee on the title page: "Paul Klee. Meinem geliebten Paul von seiner Lily. 24. Dez. 08". Werckmeister is of the opinion that Klee's drawings from 1933 are "at variance with established modern forms" and "significant for this very reason". (See Werckmeister 1987, p. 44) He has, however, not taken into account that, in view of the "National Socialist revolution" Klee was returning to an earlier phase of socially critical Modernism. Of interest in this connection is the article 'Revisions Honoré Daumier' published by Christian Zervos in 1928 in the journal *Cahiers d'Art* (no. 6, pp. 181–184). In this Zervos makes the argument for Daumier's actuality with respect to abstraction: "Plus que tout autre peintre français du XIXe siècle, Daumier a compris le sens exact de l'abstraction picturale qui préoccupe au plus haut point la vraie peinture d'aujourd'hui. [...] Daumier a compris que le premier pas vers l'abstraction consiste à avoir des véritables impressions devant le réel..." (p. 182).

[21] Hans Rothe (ed.), *Daumier und der Krieg*, Leipzig 1926, V. 24. Library of Lily and Paul Klee, Bern (NFK).

[22] In the exhibition at the Kunsthalle Bern in 1935, Klee showed the picture *Gross-Wanderung*, 1934,196. The image depicts a caravan, an entire people on the move. In his work on this picture Klee reflected on his experiences from 1933. He may well have been alluding to Daumier's work on this subject, as in the painting *The Fugitives* (Collection Oskar Reinhart, Winterthur).

See Juerg Albrecht, *Honoré Daumier*, Reinbeck bei Hamburg 1984, pp. 110f.

[23] Josef Helfenstein's suggestion that these drawings from 1933, along with Klee's art as a whole between 1932 and 1940, may be explained in the light of the historical pessimism that was widespread in avant-garde culture in Europe at the time, seems problematic to me. See Josef Helfenstein, 'Die Thematik der Kindheit im Spätwerk von Klee', in: Jonathan Fineberg (ed.), *Kinderzeichnung und die Kunst des 20. Jahrhunderts*, Ostfildern Ruit bei Stuttgart 1995, pp. 102–112. For the counter-argument see Kersten/Okuda 1995, pp. 217–221.

[24] Hopfengart 1989, pp. 114, see also Werckmeister 1985, p. 30.

[25] W. A. [Walter Adrian], 'Paul Klee', in: *Der Bund*, vol. 86, no. 101, 1.3.1935, evening edition, pp. 1f.

[26] oe, 'Abstrakte Kunst im Kunsthaus Luzern', in: *Luzerner Tagblatt*, vol. 84, no. 62, 13.3.1935, p. 9.

[27] E. H. St., 'Ausstellung in der Kunsthalle. II. Klee – sein "Begriff" und seine Preise', in: *Berner Tagwacht*, vol. 43, no. 58, 11.3.1935, supplement, also reprinted with the title: 'Für und wider Paul Klee' in: *Der Bund*, vol. 86, no. 117, 11.3.1935, evening edition, pp. 2f. See also h. gr., 'Kunst in Basel', in: *Neue Zürcher Zeitung*, no. 2018, 19.11.1935: "Klee has almost become the fashion today. Some cannot do enough to praise this artist, to whom they already pay homage as a great master. We admit that we cannot share in this sentiment. In our view Klee is an unusual, subtle and very sensitive artist, but an artist of limited creative powers."

[28] See Huggler 1939. Later, however, Huggler no longer judged the exhibition to have been a success; see Huggler 1969, p. 156: "The exhibition which the Kunsthalle Bern presented to welcome the artist met with little recognition; composed of works from Klee's own collection, carefully preserved documents of each stage of his artistic career, this remarkable exhibition touched painting in this country as little as art associations and artists' groups and other cultural institutions had taken notice of the personal presence of the artist."

[29] See Will Grohmann, 'Klee-Beitrag für Württemberg. Almanach', typescript, undated (SS/AGW).

[30] See Jean-Christophe Ammann and Harald Szeemann, *Von Hodler zur Antiform. Geschichte der Kunsthalle Bern*, Bern 1970, p. 173. The comparison may be made with visitor numbers at other exhibitions at the Kunsthalle: *Albert Anker-Gedächtnisausstellung*, 15.9–18.11.1928, 14,136 visitors; *Ernst Kreidorf*, 22.1–19.2.1933, 13,886 visitors; *Französische Meister des 19. Jahrhunderts, V. van Gogh*, 18.2–2.4.1934, 5,340 visitors; *H. Hubacher, F. Traffelet*, 20.1–17.2.1935, 2,544 visitors; *Ferdinand Hodler*, 9.5–12.7.1936, 12,069 visitors; *Cuno Amiet*, 27.3–1.5.1938, 4,476 visitors. The memorial exhibition for Klee, which took place from 9.11. until 8.12.1940 in the Kunsthalle Bern, only attracted 1,286 visitors. On the number of visitors see ibid., pp. 169–179.

[31] See Max Bill, 'Paul Klee. Zu seinem 60. Geburtstag', in: *Neue Zürcher Zeitung*, vol. 160, no. 2140, 17.12.1939, Sunday edition, sheet 5; idem, 'Paul Klee', in: *Das Werk*, vol. 27, part 8, 1940, pp. 209–216.

[32] See Willy Rotzler, 'Ein Träumer unserer Zeit. Zum Tode des Malers Paul Klee', in: *'Zeitglocken. Beilage zum Luzerner Tagblatt*, vol. 19, no. 14, 1940, pp. 53f.

[33] dt. [Georg Schmidt], 'Paul Klee, Ausstellung in der Berner Kunsthalle', in: *National-Zeitung* [Basel], vol. 93, no. 134, 21.3.1935, 'Abendblatt', pp. 2f.

[34] E.T., 'Paul Klee in Basel', in: *Luzerner Tagblatt*, vol. 84, no. 285, 30.11.1935, p. 2.

[35] Konrad Farner, 'Vortrag über Paul Klee im Kunstmuseum Luzern, 23. Mai 1936', typescript, Estate of Konrad Farner, Thalwil, pp. 33f., as quoted in Otto Karl Werckmeister, '"Ob ich je eine Pallas hervorbringe?!"', in: *Paul Klee – In der Maske des Mythos*, exh. cat. Haus der Kunst, Munich, 1.10.1999–9.1.2000; Museum Boijmans Van Beuningen, Rotterdam, 19.2–21.5.2000, p. 161.

[35] Questionnaire by the Carnegie Institute, Department of Fine Arts, Pittsburgh, 27.7.1939 (NFK).

[36] At the time Klee was reading the Daumier monograph recently published in Paris by Jacques Lassaigne in which the author stresses Daumier's contemporary relevance. The book is in the library of Lily and Paul Klee, Bern (NFK).

[37] The author will shortly publish a discussion of Daumier's influence on Klee's late work.

Fig. 1
Herbert Read,
London 1933

KLEE'S RECEPTION IN SCOTLAND AND ENGLAND 1930–1945

Herbert Read

Paul Klee's first and most articulate champion in Britain was Herbert Read (fig. 1). Poet, scholar, critic and educator, Read's books *The Meaning of Art* (1931) and *Art Now* (1933) helped introduce modern art to an unfamiliar and largely sceptical English-speaking readership. Klee is featured in both publications.

The Meaning of Art (fig. 2) began life as a series of articles for *The Listener*, the weekly magazine of the B.B.C, which throughout the 1930s became the principal platform for Read's wide-ranging ideas on art and design, aesthetics and literature. In 1931, the year the book was published, Read, aged thirty-eight, was appointed Professor of Fine Art at the University of Edinburgh. In his inaugural lecture he argued forcefully for the inclusion of contemporary art in the university syllabus: "We cannot fully participate in modern consciousness unless we can learn to appreciate the art of our own day"[1]. Although his term at Edinburgh was to last only two years, from the outset Read tried to open his students' eyes to recent developments in continental modernism. This was unheard of in art history teaching in Britain before the war. Read's revolutionary course of lectures (attended also by students from Edinburgh College of Art) followed loosely the format of *The Meaning of Art* where Picasso, Chagall, Klee and Henry Moore appear at the end of the book representing crucial tendencies in modern art. But Read went much further in his lectures, discussing and illustrating work by Munch, Matisse, Derain, the Cubists, Severeni, de Chirico, Ernst, Arp, Zadkine, Brancusi, Giacometti and Barbara Hepworth; one lecture was devoted to contemporary architecture, with particular reference to Le Corbusier.[2]

Read's more conservative colleagues were in the habit of putting his slides in the projector upside down.[3] Others in 1930s Edinburgh were more sympathetic to his internationalist outlook. The College of Art, under its progressive Principal, Hubert Wellington, regularly awarded students of both painting and architecture scholarships to travel in Europe. Stanley Cursiter, Director of the National Galleries of Scotland, whose lectures and writings on art education echoed those of Read, campaigned throughout the 1930s for the establishment in Edinburgh of a museum of modern art that would show not only modern art but also craft and industrial design; there would also be facilities for film, performance and sound, and a circulating exhibitions department. Although this ambitious and innovative project was never realised, Cursiter commissioned a young Scottish architect

Fig. 2
Herbert Read,
The Meaning of Art,
London 1931, showing
reproduction of Klee's
*The Twittering
Machine*, 1922,151

to draw up plans, in an international-modern style, and even found a private benefactor to finance it.[4] Read himself in 1932 had tried to raise money to set up a "Bauhaus" in Edinburgh, no doubt concerned at the deteriorating political situation in Germany.[5]

The Scottish public's knowledge of contemporary German and Scandinavian art was enriched during the 1930s by a series of exhibitions, the most significant of which were devoted to Munch (1931), Klee (1934), German sculpture (1936), Max Ernst (1937) and *Modern German Art* (1939). The Munch, Klee and Ernst exhibitions were all organised by the Society of Scottish Artists as part of its annual exhibition at the Royal Scottish Academy in Edinburgh, where the exhibition of German sculpture in 1936 also took place. *Modern German Art*, which opened in March 1939 at the McLellan Galleries in Glasgow (the city's main exhibiting space), was a reduced version of the *Twentieth Century German Art* exhibition shown at the New Burlington Galleries in London in the summer of 1938, one of whose organisers was Herbert Read. The purpose of this show, in which Klee was represented by fifteen works (ten of them for sale), was not only to educate an ignorant or indifferent public to the forms and preoccupations of German art but also to offer moral and financial support to artists suffering persecution as a result of the Nazis' *Entartete Kunst* show which had opened in Munich the previous year.

The 1931 Munch exhibition in Edinburgh – his first in Britain, with twelve pictures selected by the artist – was reviewed by Read for BBC radio.[6] He drew attention to the nordic qualities in Munch's art, which he felt would strike a

chord with Scottish artists. For Read, Munch was the father of German Expressionism who had rescued German art from the unhealthy influence of France. There was a lesson here for the Scots, whom Read saw as belonging to a northern European, as opposed to a Latin, tradition. Read's advocacy of modern German art, inspired by his reading of Worringer and his friendship with Max Sauerlandt (to whom he dedicated *Art Now*), should be viewed partly in this context.[7] English art, too, belonged to the northern tradition but it had "grown feeble in a quite unnatural attempt to follow the French lead".[8] We can sense here the first signs of Read's irritation with the critical dominance of Roger Fry, whose insistence on the superiority of "significant form" over representational content led him to promote French, and virtually ignore German, art.[9]

By the time the Klee exhibition took place in Edinburgh – the artist's first in a public gallery in Britain – Read had resigned his professorship and had gone to live in London. But there is little question that he would have given it his unqualified backing. In *The Meaning of Art* and *Art Now* he had singled out Klee for being the most individualistic of contemporary artists, independent of school or movement (including Surrealism), and had praised him for his supreme draughtsmanship and for creating a self-contained world that was "fantastic", "witty" and "metaphysical":[10] "Klee's world is […] an intellectual fairyland […] quite different from any conceived by a Latin imagination […] a Gothic world".[11] Read later modified his picture of Klee as a northern artist, while continuing to insist on his distance from Surrealism and what he called "the macabre exploitation of the Freudian unconscious".[12] More precisely, it was the "preconscious", "the great reservoir of verbal images or memory residues from which an artist like Klee draws his fantasy".[13]

Twenty-five Klees ranging in date from 1913 to 1933 were shown in the Society of Scottish Artists' Forty-First Annual exhibition (1 December 1934–12 January 1935). They were hung in Gallery III of the Royal Scottish Academy, together with works by Scottish artists, a couple of Picassos, a portrait by Derain and a painting by Tchelitchew. It was the SSA's policy to exhibit "examples of the most distinguished Masters of various times and schools for the education more particularly of the rising artists and the public in general".[14] The Derain and one of the Picassos were lent by Sir Michael Sadler, who had been Vice-Chancellor of Leeds University while Read was a student there (1912–1915). Sadler was the owner of a remarkable collection of modern art, including works by Kandinsky (he translated *Über das Geistige in der Kunst* into English), Klee, Marc and Münter; he was also the first collector to buy Francis Bacon's work, most famously *Crucifixion* 1933, illustrated in Read's *Art Now*.[15]

Shortly before the SSA exhibition opened, at a meeting of its Council, two new Honorary Members of the society were elected: Edvard Munch and Hubert Wellington, Principal of Edinburgh College of Art.[16] All the Klees were for sale, at prices ranging from £35 to £300, and two works are known to have been bought. One of these, *Drohender Schneesturm* – called at that time "Approaching Snowstorm" –, a watercolour and ink drawing of 1927, was purchased by R. K. Blair, an Honorary Vice President of the SSA, whose family bequeathed the work in his memory to the National Galleries of Scotland in 1952; it now forms part of the collection of the Scottish National Gallery of Modern Art (fig. 3).

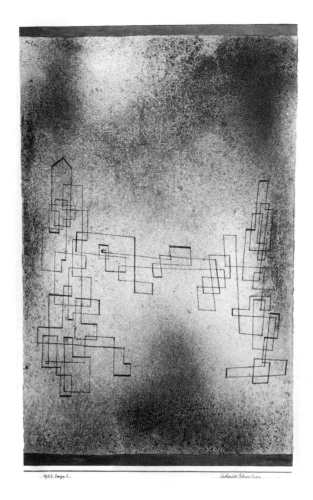

Fig. 3
Paul Klee, *Drohender
Schneesturm*, 1927,291,
bought from Klee's
exhibition at the
Society of Scottish
Artists in Edinburgh
in 1934, and bequea-
thed to the National
Galleries of Scotland
in 1952

Public interest in the exhibition was intense, resulting in higher attendances than usual, a demand that it should travel to the northern city of Aberdeen, and a lively correspondence in the newspapers. A few writers attributed the novelty and strangeness of Klee's art to the social and economic upheavals affecting Germany. Others discussed his complex relationship to primitive and child art (as Read had done in *The Meaning of Art*).[17] A significant number interpreted Klee's pictures as an expression or visualisation of the Freudian concepts of free association and the unconscious: to these commentators Klee was the artist of "inner vision"[18], of "the invisible intangible something that is at the centre of us"[19]. Not everyone, however, subscribed to this psychological view of Klee. His most persistent critic, the painter David Foggie, a member of the Royal Scottish Academy, derided Klee's technical virtuosity for its "misguided cleverness" and questioned Herbert Read's championship of the artist.[20] Another painter, R. H. Westwater, a member of both the selection and hanging committees of the SSA, one of whose paintings hung with Klee's in Gallery III, was more tolerant.[21] The most mature assessment of Klee's work and of the controversy surrounding the exhibition – less extreme, admittedly, than the reaction to Munch's paintings three years earlier – is contained in an article in the magazine *The Modern Scot* for January 1935. Quoting Read approvingly, the anonymous author's defence of Klee against those who had dismissed his art as ugly story-telling is an implicit criti-

MAYOR GALLERY
THE MAYOR GALLERY LTD

18 CORK STREET LONDON W.1

A SURVEY OF CONTEMPORARY ART
ARRANGED IN CONNECTION WITH

"ART NOW" (FABER & FABER 12/6 NETT)

by **HERBERT READ**

OCT. 11—NOV. 4
OPEN FROM 10-6
SATURDAYS 10-1

PRIVATE VIEW
WEDNESDAY
OCTOBER 11, 1933

THE MAYOR GALLERY
EIGHTEEN CORK STREET W.1

PAINTINGS BY

PAUL KLEE

PRIVATE

FIRST ENGLISH EXHIBITION

VIEW TUESDAY JANUARY 16

Fig. 4
Invitation card for
Art Now exhibition,
The Mayor Gallery,
London, October 1933

Fig. 5
Invitation card for
Klee's first one-man
show in Britain, The
Mayor Gallery,
London, January 1934

cism of Roger Fry and the importance given to formal values, at the expense of representational content, in the appreciation of a work of art. The writer goes on to reflect more generally on Klee's achievement.

He is [...] a painter, a technician of high accomplishment, so that even if one were to feel it a pity that he is preoccupied with subject-matter that must lack the universal appeal of all the greatest art – which we are apt to forget has been produced at rare intervals – one feels that it is a superb colourist and most sensitive linear artist who is immersed in this infernal contemporary flux [...] The beauty of much of Klee is undubitable: its value may be open to doubt. But even if we decide with our intelligence that objectivity, the extraverted qualities that Klee's works do not possess, are good things, we have to create circumstances, bring design into the modern chaos, before the artist can comprehend it with his entire being and give it forth in his works. Klee is a product of his generation. The Nazis want to turn the artists' eyes outwards, and have routed out the Klees; but the causes for introspection remain. We have still need of the fancy-free Klee, Ernst, Miró and Masson.[22]

The Mayor Gallery and Alfred Flechtheim

All twenty-five Klees were lent to the SSA by The Mayor Gallery in London, where two-thirds of them, including *Drohender Schneesturm,* 1927,291 (Approaching Snowstorm), had been shown in Klee's one-man exhibition a year earlier (January-February 1934) (fig. 5) – his first in a commercial gallery in Britain. It was this show that gave David Foggie RSA the opportunity to launch his attack on Klee, in a letter to *The Listener* complaining about an article by Herbert Read predominantly on Klee's technique. Foggie particularly objected to Read's phrase "the delicate sensibility of [...] line", of which he could find no evidence in the work by Klee used to illustrate Read's article.[23] (At this stage Foggie knew Klee's work only from reproduction; he did not travel to London to see the exhibition.) Foggie's letter,

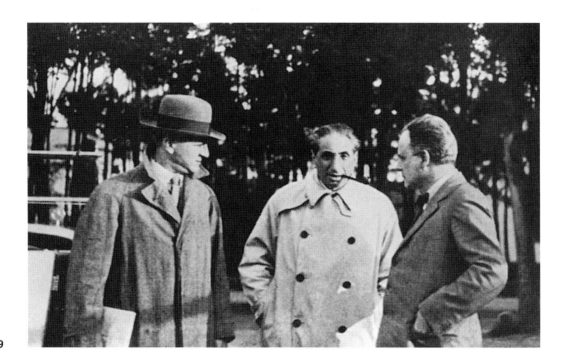

Fig. 6
Alfred Flechtheim
with George Grosz
(left) and Paul Klee
(right), Dessau, 1929

and Read's reply, sparked off a heated correspondence in *The Listener*, in which the chief supporters of Klee, and of Read's position, were three prominent writers on art – Geoffrey Grigson, Adrian Stokes and Hugh Gordon Porteus.[24] Grigson had already published an ecstatic piece in *The Bookman* praising Klee's "infinitely varied mythology" and "Northern calligraphy", and calling him "one of the most important artists alive".[25] Press reviews were on the whole more cautious, although *The New Statesman* and *Glasgow Herald* enthusiastically welcomed Klee's first exhibition in Britain.[26]

Klee's association with The Mayor Gallery might not have come about had it not been for a meeting between Freddy Mayor, the Gallery's founder and one of its directors, and Alfred Flechtheim in Paris in the autumn of 1933. Flechtheim was one of the most gifted German-Jewish dealers in modern French art, especially Picasso and Cubism, which he had helped introduce to Germany. He also exhibited Klee's work on numerous occasions throughout the 1920s at his various galleries in Germany. But he was experiencing serious difficulty transferring his business to Paris following the Nazi accession to power, in spite of good contacts, most notably with his old friend Daniel-Henry Kahnweiler, director of the Galerie Simon. Kahnweiler, who at the time was an important source for The Mayor Gallery's stock, almost certainly introduced Flechtheim to Freddy Mayor. The consequence of this meeting was a three-way contract between Flechtheim, Mayor and Kahnweiler, which led to The Mayor Gallery's first two exhibitions for 1934: *Paul Klee* and *20th Century Classics*.[27] The second of these should have given Flechtheim cause for optimism, since the great names of modern French art were well represented – Picasso, Braque, Gris, Léger, Matisse, Derain, Utrillo, Masson – in addition to de Chirico, Chagall, Klee, Ernst and Carl Hofer. The show was favourably reviewed by David Gascoyne (soon to publish his pioneering *A Short Survey of Surrealism*), who mentioned that the majority of works came

"from the collection of exiled Alfred Flechtheim, of Berlin" – the only occasion Flechtheim's contribution appears to have been recognised in the British press before his death in London in March 1937. Yet to Flechtheim's disappointment The Mayor Gallery failed to sell a thing. The prospects for modern German art were even worse, although from Klee's first exhibition at The Mayor Gallery the previous month three watercolours out of a total of 29 works had been sold. These works came partly from Kahnweiler and partly from Alexander Vömel, Flechtheim's associate in Düsseldorf, although the ultimate source for some of them may have been Flechtheim himself.[29] A George Grosz exhibition at The Mayor Gallery in June 1934, which Flechtheim (fig. 6) also organised from his own collection or stock, resulted in not a single sale.

The Mayor Gallery had reopened in April 1933, after a gap of seven years, in striking new premises at 18 Cork Street designed by the young modernist designer Brian O'Rorke. During its first year the gallery was arguably the most avant-garde in Britain, with one-man exhibitions of Ernst, Miró and Klee, and group shows devoted to the latest developments in contemporary art, both British and continental. In June 1933 the English artist Paul Nash announced in *The Times* that The Mayor Gallery had become the headquarters of an experimental group of modernist architects, painters and sculptors called Unit One; it held its one and only exhibition at the gallery the following April, accompanied by an illustrated book introduced and edited by Herbert Read. From the beginning, The Mayor Gallery was committed to showing German art. Its opening show, *Recent Paintings by English, French and German Artists*, included work by Ernst, Klee and Baumeister. (Ernst, incidentally, was classified by the London art critic of *The Scotsman* as "a German Parisian with a haunted mind"[30].) Mayor told the *Daily Mail* that "all the artists are of advanced tendencies, and […] the Germans will be the great novelty, as none of their works has been seen in England before".[31] Klee was also represented, by one work, in the exhibition held at the gallery in October 1933 to mark the publication of Read's *Art Now* (fig. 4 and 7). Both exhibition and book were widely reviewed in the British press – even previewed. Geoffrey Grigson, for example, informed his readers in *The Bookman* that:

> *"Art Now" will be the only general and reasoned survey of the evolution of contemporary art. Professor Read will outline the empiric and philosophic basis of modernism from Vico and Fechner to Bergson and Croce; and will illustrate his book with reproductions ranging from work of the German Expressionists, such as Kirchner, Schmidt-Rotluff, Emil Nolde, to work of Surréalistes such as Ernst, Miró, Giacometti and Salvador Dalí and of various members of Unit One. Unit One will also be prominent in "Art Now" at the Mayor Gallery, which will represent some forty artists by exhibits mostly carried out since 1931. Exhibitors will include Picasso, Braque, Miró, Kandinsky, Klee, Léger, Lurçat, Marcoussis, Hans Arp, Barbara Hepworth, Henry Moore, Ben Nicholson, Edward Wadsworth and other painters of Unit One, as well as Ivon Hitchens and Tristram Hillier. George Grosz, the brilliant, savage satirist of "Die Neue Sachlichkeit", who is now in New York teaching and helping to run "Americana", an illustrated paper of fierce political satire, will also be exhibited.*
>
> *No one concerned with contemporary art, no one anxious to satisfy himself*

Fig. 7
Herbert Read, *Art*
Now, **London 1933,**
with reproductions of
works by Klee and
Kandinsky

about the orderly evolution and coherence of an apparent chaos, should absent himself from Cork Street.[32]

Edward Crankshaw, reviewing the exhibition for *The Weekend Review*, agreed: "Nobody who has read the book can afford to miss this show; and everybody who visits the show should go home and read *Art Now*."[33]

Douglas Cooper

The book was reprinted three times before the end of the decade and revised and updated by Read in 1936. In the Acknowledgements, Read thanked a certain "Douglas Cooper" for helping him with the illustrations:[34] significantly, several works were reproduced by permission of the Galerie Flechtheim, Berlin,

Fig. 8
Douglas Cooper and
Alfred Flechtheim,
mid-1930s

the Galerie Simon, Paris, or The Mayor Gallery. Cooper (fig. 8), a rich art historian in his early twenties, was the principal backer of The Mayor Gallery and one of its three directors – "a group of knowledgeable young men who live partly in London, partly in Paris", according to *Vogue*.[35] He would gradually form one of the finest collections of Cubist art in the world; he also acquired works by Klee and Miró. In 1934–1935, during the period of his involvement with The Mayor Gallery, Cooper bought four Picassos and a work each by Léger, Gris and Klee, from Alfred Flechtheim. He would eventually own some eighteen works by Klee.[36]

Cooper's relationship with The Mayor Gallery lasted only a few years, from 1933 to 1937 or 1938, but in that period he organised a number of exhibitions there himself, including Klee's second one-man show (fig. 10), and served as secretary of Unit One. Cooper corresponded with Klee after his first Mayor show in 1934 and, again, before the second in June 1935.[37] The latter consisted mainly of watercolours, with a handful of oils, all obtained from Kahnweiler in Paris. 33 works were shown, of which four were bought, either then or later, by Roland Penrose[38]. The moving spirit behind the controversial *International Surrealist Exhibition* (fig. 9) in London the following year, Penrose was as important to the collecting of Surrealism as Cooper was to Cubism.[39] Fifteen Klees were included in the 1936 Surrealist show, even though Herbert Read, another of the organisers, had reservations about categorising Klee as a Surrealist – despite illustrating four of his works in the book of essays on Surrealism which appeared after the exhibition and which he edited and introduced.[40]

Klee's second Mayor exhibition was well received by the press. The art critic of *The New English Weekly* went so far as to call Klee "the most magical artist

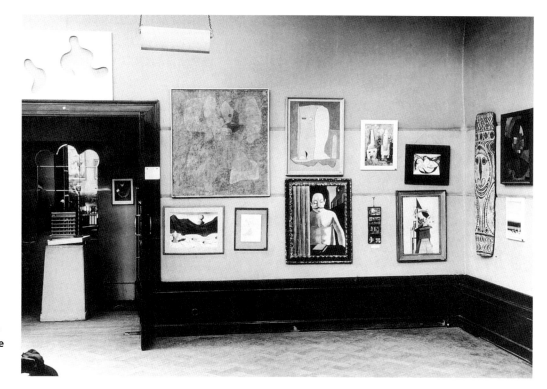

Fig. 9
The International Surrealist Exhibition, New Burlington Galleries, London, 1936: installation view showing three works by Klee (including the large painting to the right of the door)

alive", regretting that "not one-thousandth part of the great romantic snobbish dilettante art-loving public will trouble to see these superb works".[41] Others expressed concern at the effects of the new political situation in Germany on her artists. "Herr Paul Klee", wrote the reviewer for *Apollo*, "is no longer the *persona grata* he used to be in his native country, perhaps because he too clearly reveals the emotional irrationality which for the moment prevails in the country of Grimm's *Märchen*".[42] *The New Statesman's* critic suggested that:

> *If Klee were a Frenchman his first exhibition in London would probably have been opened by the French Ambassador. For he has been generally recognised as the most distinguished living painter his country has produced. But the Germans have no longer any sense of what mere foreigners can find to admire in their culture.*[43]

As if taking a hint from *The New Statesman*, The Mayor Gallery next showed Klee in a mixed exhibition of works by *French and English Artists* (May, 1936), an experiment they repeated the following year (February, 1937). The definition of "French" was stretched to incorporate, besides Klee, Picasso, Gris, Miró and de Chirico, though admittedly only Klee had not lived and worked in Paris for any length of time. The inclusion of several Klees in a Christmas exhibition of *Inexpensive Pictures* at The Mayor Gallery in 1936 (fig. 11) was probably indicative of the Gallery's lack of success in selling his work, in spite of favourable mentions in the press: for example, "Klee's works are as precious as Sung porcelain".[44]

The suppression of Klee's German identity and his appropriation by the Surrealist movement, however, gradually contributed to his growing recognition in Britain. In March 1939 the London Gallery, by then a stronghold of Surrealism, showed a selection of Klee's watercolours and oils. Somewhat larger (44 works) was the exhibition

PAUL
KLEE
EXHIBITION

JUNE, 1935
EIGHTEEN CORK STREET, W.1

THE MAYOR GALLERY LTD.

The honour of your company is requested
at the private view of

INEXPENSIVE PICTURES

BY

KEITH BAYNES PIERRE BONNARD
ROY DE MAISTRE DUNCAN GRANT
MAX JACOB PAUL KLEE
JOAN MIRÓ GEORGES ROUAULT

on

Tuesday the 8th December, 1936.

NINETEEN CORK STREET, W.1.

Fig. 10
Catalogue cover of
Klee's second one-
man show at The
Mayor Gallery,
London, June 1935

Fig. 11
Invitation card for
Inexpensive Pictures
exhibition,
The Mayor Gallery,
London,
December 1936

at the Leicester Galleries in March 1941, nine months after Klee's death, with a catalogue introduction by Herbert Read. But for his apotheosis – Klee's total, unqualified acceptance by the British art establishment – the artist had to wait until after the war.

The Tate Gallery Exhibition and Rolf Bürgi

The story of *Paul Klee 1879–1940*, organised by the Tate Gallery and shown at the National Gallery in London from December 1945 to February 1946, is particularly relevant to the present exhibition because it could not have happened without the close involvement of Rolf Bürgi. On 1 May 1945 John Rothenstein, Director of the Tate Gallery, wrote to Douglas Cooper agreeing to the latter's proposal for an exhibition of about 75 works by Klee, to be selected by Cooper from the collection of Klee's widow, at an unspecified date after the official declaration of peace. Rothenstein added:

His [Klee's] work is inadequately represented in the Gallery and I have no doubt that, if we could have such a collection here, I should want to submit examples from it to the Trustees for purchase, whose wish it also is that Klee's art should be better shown here.[45]

By late September 1945, Rothenstein was writing to Rolf Bürgi confirming arrangements for an exhibition of "approximately 100 works, with about 15 drawings, to be chosen by you on the basis of the photographs which you kindly supplied". He asked Bürgi to write a short foreword to the catalogue and thanked him and Douglas Cooper for their "valuable and welcome help".[46] Bürgi replied on 12 October, saying that 100 watercolours, drawings and sketches, and 15 oil paintings, would be ready for dispatch from the Kunstmuseum Bern on 15 October. Most works belonged to Lily Klee, although a handful would be lent by other collectors. The selection had been made by Lily Klee, Cooper and Bürgi himself. Mrs Klee regretted that, owing to poor health, she would not be able to

come to London for the opening.[47] Rothenstein wrote to her on 31 October, thanking her for her "generosity in lending such an important proportion of fine works from your own collection" and expressing his sorrow that she would be unable to attend the opening. He ended on an optimistic note.

Paul Klee is a famous artist both in this country and on the continent, but his work has been insufficiently shown in London and I know that our exhibition will be a great success and will appeal particularly to the younger generation of British artists.[48]

By now it had been decided to hold the exhibition in the annexe of the National Gallery – three rooms which had been placed at the Tate's disposal pending completion of repairs to its bomb-damaged building on Millbank. The arrangements from the Tate's end were taken care of by Robin Ironside, one of Rothenstein's assistants, who corresponded regularly with Bürgi throughout the autumn of 1945 on such details as transport, insurance, mounting and framing, and the catalogue.[49] The Bürgis were invited to the opening.

The exhibition opened to the public a few days before Christmas, 1945. Of the 137 works finally hung, 101 belonged to Lily Klee. Rolf Bürgi was the next biggest lender with fourteen works, followed by Douglas Cooper (six), Freddy Mayor and Roland Penrose (three each), Rodney Phillips of the Leicester Galleries (two) and the Bloomsbury critic Raymond Mortimer (one). The Tate lent a gouache, *Der Schlossberg von S.,* 1930,72 (The Castle Mountain of S.), which it had been given by the Contemporary Art Society in 1941. Apart from Lily Klee and Rolf Bürgi, the other Swiss lenders were Richard Doetsch-Benziger from Basel (three works), Mathilde Klee, the Kunstmuseum Basel and the Kunstmuseum Bern (one each). About a quarter of the work shown came from the last decade of Klee's life.

The exhibition was, as Rothenstein wrote later to Bürgi, "a quite exceptional success".[50] After it had been open for only a fortnight, *The Daily Telegraph* reported that it was "drawing nearly as large crowds as the Picasso and Matisse works at the Victoria and Albert Museum"[51] – a reference to the joint exhibition organised by the Arts Council of Great Britain in the winter of 1945–1946. The 25 Picassos on show dated from the dark period of the Nazi occupation and provoked considerable hostility among visitors. Critics occasionally bracketed Klee with Picasso, so that Douglas Cooper was compelled to defend both artists in the columns of *The Times*, while pointing out the differences between the two exhibitions and questioning the decision to show such a narrow selection of Picasso's work. Cooper's letter is interesting not least because he now felt justified in presenting himself as an authority on Klee.

[...] unlike most of your correspondents, I have known both Picasso and Klee for a number of years, have lived among their paintings, and have made a conscientious study of their work.[52]

Most people, fortunately, did not need convincing of Klee's importance. By mid-January 1946 some thirteen thousand copies of the catalogue had been sold.[53] Philip James, Director of Art at the Arts Council, wrote to Bürgi asking if it would be possible to tour all or part of the exhibition to provincial cities in Britain:

We shall shortly be taking the Picasso Matisse Exhibition to Glasgow and

[13] *The Meaning of Art*, p.147.

[14] Quoted by Edwin Muir in 'Fifty Years', *Society of Scottish Artists' Jubilee Exhibition 1894–1944*, exh. cat., Edinburgh 1944, p.ix.

[15] Sadler's collection was featured at the time in the avant-garde art periodical *Axis*, no. 2, April 1935, p. 24. See also Michael Paraskos, 'Herbert Read and Leeds', in *Herbert Read: A British Vision*, op. cit., pp. 30f.

[16] Minutes of the SSA Council Meetings, 23 October and 26 November 1934 (Archive of the Scottish National Gallery of Modern Art).

[17] Reviews, articles and letters published in the Scottish press are preserved in the press cuttings albums of The Mayor Gallery for the years 1933–1937, along with similar material from the English press.

[18] 'The Modernist's Creed: Klee and Picasso', *Scottish Education Journal*, 14 December 1934.

[19] D. B. MacDonald, 'Paul Klee', letter to *The Scotsman*, 24 December 1934.

[20] David Foggie RSA, 'Paul Klee's Work: A Criticism', *The Scotsman*, 15 December 1934.

[21] R. H. Westwater, 'Paul Klee: Another View', *The Scotsman*, 9 January 1935.

[22] S. B. Y., 'Fancy Free; Paul Klee's *Surréalisme*', *The Modern Scot*, vol. V., no. 4, January 1935, pp. 269f.

[23] Read's article was published in *The Listener* on 17 January 1934, Foggie's letter a week later on 24 January.

[24] Letters to *The Listener*, 7, 14 and 21 February 1934, respectively. Porteus later illustrated a work by Klee in an article on drawing, 'A Few Lines', in *Axis*, no. 7, autumn 1936, p.19.

[25] 'Paul Klee', *The Bookman*, January 1934.

[26] 'Paul Klee', *The New Statesman*, 20 January 1934; 'Pictures with Lines', *Glasgow Herald*, 16 January 1934.

[27] Flechtheim's championship of Klee, and the complex business relationship between Flechtheim, Kahnweiler and Mayor, are explored in two recent exhibition catalogues: *Alfred Flechtheim: Sammler, Kunsthändler, Verleger*, Kunstmuseum Düsseldorf and Westfälisches Landesmuseum, Münster, 1987, especially the essay by Cordula Frowein, 'Alfred Flechtheim im Exil in England', pp. 59–63, and the lengthy chronology of Flechtheim's life; and Dorothy M. Kosinski, *Picasso, Braque, Gris, Léger: Douglas Cooper Collecting Cubism*, Museum of Fine Arts, Houston, 1990, pp.1–10.

[28] 'Some Recent Art Exhibitions', *The New English Weekly*, 15 March 1934. Kosinski believes that "much of [Flechtheim's] gallery stock and many items from his important personal collection were sent either to the Mayor Gallery in London or to Kahnweiler's Galerie Simon in Paris" (*Picasso, Braque, Gris, Léger*, op. cit., p. 8).

[29] Christian Rümelin, 'Klee und der Kunsthandel', unpublished essay for the Paul Klee Foundation, Bern. See also Kosinski, op. cit., p. 10 and note 39 (pp. 50f).

[30] *The Scotsman*, 23 April 1933.

[31] *Daily Mail*, 13 April 1933.

[32] 'Unit One, Herbert Read, and The Mayor Gallery', *The Bookman*, October 1933.

[33] *The Weekend Review*, 21 October 1933.

[34] *Art Now*, London 1933, p. 9.

[35] 'Second Ceiling: First Show', *Vogue*, 17 May 1933. A more detailed account of Cooper's brief directorship of the Mayor Gallery can be found in Kosinski, op. cit, pp. 1–4.

[36] Kosinski, p. 10.

[37] See *Alfred Flechtheim: Sammler, Kunsthändler, Verleger*, op.cit., pp. 90f; and Kosinski, p. 10, and note 41 (p. 51).

[38] *Brother and Sister* 1930 (cat. 29), *The Town on the Hill* 1929 (cat. 30), *Town and Sun* 1928 (cat. 31) and *Portrait of an Artiste* 1927 (cat. 32).

[39] Penrose also owned some superb Cubist Picassos and later wrote the first English biography of the artist. Cooper became jealous of Penrose when the latter was asked by the Arts Council to organise the first major Picasso exhibition in Britain, at the Tate Gallery in 1960. (Correspondence in the Archive of the Scottish National Gallery of Modern Art).

[40] *Surrealism*, London 1936, plates 42–45.

[41] *The New English Weekly*, 27 June 1935.

[42] *Apollo*, August 1935.

[43] *The New Statesman*, 15 June 1935.

[44] Ibid., 12 December 1936.

[45] Letter from John Rothenstein to Douglas Cooper, 1 May 1945 (Bürgi Archives, Bern).

[46] John Rothenstein to Rolf Bürgi, 21 September 1945 (Bürgi Archives, Bern).

[47] Bürgi to Rothenstein, 12 October 1945 (Bürgi Archives, Bern).

[48] Rothenstein to Lily Klee, 31 October 1945 (Bürgi Archives, Bern).

[49] Correspondence in Bürgi Archives, Bern. Ironside was also in touch with Douglas Cooper who in October 1945 was based at the British Embassy in Bern (Bürgi Archives, Bern). Ironside published an article on Klee in the December 1945 number of the literary and artistic review *Horizon*. Six works were illustrated, including *Sie beissen an,* 1920,6, one of the group of three acquired by the Tate Gallery from Lily Klee the following year.

[50] Rothenstein to Bürgi, 13 March 1946 (Bürgi Archives, Bern)

[51] 'Swiss Artist's Lurid Colours: "Back to Cave-Men Standards"', *The Daily Telegraph*, 5 January 1946. Press cuttings relating to the Tate exhibition are kept by the Estate of the Klee Family, deposited in the Paul Klee Foundation, Kunstmuseum Bern.

[52] Douglas Cooper, letter to The Editor, *The Times*, 9 January 1946.

[53] Frances Spalding, *The Tate: a History*, London 1998, p. 90.

[54] Philip James to Bürgi, 9 January 1946 (Bürgi Archives, Bern).

[55] Bürgi to Rothenstein, 11 February 1946 (Bürgi Archives, Bern).

[56] James to Bürgi, 6 March 1946 (Bürgi Archives, Bern).

[57] Plaut and Daniel Cotton Rich, Director of the Art Institute of Chicago, visited Belp in June 1947 (Bürgi Guestbook, Bürgi Archives, Bern).

[58] Rolf Bürgi, 'Foreword', in *Paul Klee 1879–1940*, Tate Gallery, London 1945, p. 1.

[59] Herbert Read, 'Paul Klee', *The Listener*, 3 January 1946, pp. 20f.

[60] Letter from Rolf Bürgi to Dr M. Blumenstein, 26 April 1946 (Bürgi Archives, Bern). See also John Richardson, *The Sorcerer's Apprentice, Picasso, Provence and Douglas Cooper*, London 1999, p. 39.

[61] Rothenstein to the Bürgis, 9 August 1946 (Bürgi Archives, Bern).

[62] *The Sorcerer's Apprentice*, op.cit., pp. 35–39, 75f. Richardson says that Bürgi sold Cooper "a number of very fine Klees very reasonably", and that Cooper had dinner with Lily Klee in Bern the night before she died. Correspondence in the Bürgi Archives indicates that at least some of Cooper's Klees were (according to Cooper himself) a gift from Lily Klee. This seems to be confirmed by Kosinski, op.cit., p. 45. Cooper later fell out spectacularly with Rothenstein, whose running of the Tate he persistently criticised. Richardson's account (pp.160f.) of

Alan Davie and Eduardo Paolozzi. Gear, a Scot (as are Davie and Paolozzi), had seen the Klee exhibition in Edinburgh in 1934–1935 while a student at the College of Art and was greatly stimulated by his rediscovery of the artist's work a decade later at the National Gallery in London.[76] By chance, Davie saw the Arts Council's touring exhibition when he was passing through Stoke-on-Trent in July 1946. This was the first time he had seen Klee's work at first-hand and he described it as a revelation.[77] Paolozzi was similarly impressed by the Klee retrospective which he saw a couple of years later, in early 1948, at the Musée National d'Art Moderne in Paris.[78]

What these artists saw in Klee was different from the romantic, "literary" figure portrayed by Read and others before the war. A new emphasis on the formal qualities of Klee's work – particularly the late work – revealed a concern with the way forms develop, one mark leading intuitively to another in a process analagous to natural growth. The first to articulate this fresh perception of Klee, drawing attention to the "all-overness" of his late work, was the critic David Sylvester, in an article published in December 1948. He wrote:

The last works of Klee [...] are ideograms of movement in nature [...] pictures without focal point. In journeying through a Klee you cultivate it. It grows because it is an organism, not a constructed form [...] a picture by Klee goes on becoming not only while he cultivated it but while you cultivate it [...] To look at a Klee over a period of time is not to acquire a deeper understanding of a finished thing but to observe and assist in its growth.[79]

The concept of art as essentially dynamic and developmental informed Klee's teaching at the Bauhaus as much as it did his own work. Through artist-teachers such as Pasmore and Hamilton, Klee's example contributed in no small measure to the reform of art education in Britain after the war.[80]

I am indebted to Stefan Frey for providing me with a list of publications on Klee in English and a chronology of exhibitions of the artist's work in England; and for supplying copies of material in the Bürgi Archives and Klee Family Bequest, Bern, relating to the 1945–1946 Tate Gallery/National Gallery Klee retrospective. For making available their press cuttings albums for the years 1933–1937, I am grateful to The Mayor Gallery, London. I would also like to thank John Richardson for sending me a proof copy of *The Sorcerer's Apprentice* (see note 60) and for allowing me to quote from it; and Dr Christian Rümelin, project director of the Klee catalogue raisonné at the Paul Klee Foundation, for showing me his unpublished essay on Klee's dealers, 'Klee und der Kunsthandel'.

[1] Herbert Read, *The Place of Art in a University*, Edinburgh and London 1931, p. 25.

[2] Typescript of Read's lectures (collection Benedict Read). In May 1933 Read gave four lectures on 'The Aesthetic Basis of Modern Art' at the Courtauld Institute of Art in London, where (according to *The Yorkshire Post*, 27 April 1933) *The Meaning of Art* was recommended to students as "'stimulating', but a book to be used 'with caution'".

[3] See Benedict Read and David Thistlewood (ed.), *Herbert Read: A British Vision of World Art*, exh.cat., Leeds City Art Galleries, 1993, p.152.

[4] Sketch plans and a model for this project, together with related notes and correspondence, are in the Archive of the Scottish National Gallery of Modern Art, Edinburgh.

[5] As note 3.

[6] On 28 November 1931. Read's talk was reviewed in *The Scotsman* (30 November) and published in *The Listener* (2 December).

[7] See the essay by Andrew Causey, 'Herbert Read and the North European Tradition 1921–33', in *Herbert Read: A British Vision of World Art*, op.cit., pp. 38–52; and *A Tribute to Herbert Read 1893–1968*, exh. cat., Bradford Art Galleries and Museums, 1975, p. 20.

[8] 'Edvard Munch', *The Listener*, 2 December 1931, p. 962.

[9] See Causey, loc. cit., p. 51.

[10] *The Meaning of Art*, London 1931, pp.145–148.

[11] *Art Now*, London 1933, pp. 142f. Read repeated these phrases in his introduction to 'Peter Thoene' (Oto Bihalji-Merin), *Modern German Art*, Penguin Books, Harmondsworth, 1938, p.10, published to coincide with the exhibition of *Twentieth Century German Art* at the New Burlington Galleries, London.

[12] "Klee has nothing in common with the macabre exploitation of the Freudian unconscious; his vision is more childlike and innocent, and of a singular gaiety. Nor is there anything particularly Germanic about his spirit." ('Paul Klee', *The Listener*, 17 January 1934, p.109).

"Peter", had founded the London Gallery in Cork Street in October 1936. With Gropius, Moholy-Nagy, Bayer and Breuer on its advisory council, the gallery's exhibiting policy was not surprisingly slanted towards abstract and constructivist art. However, in March 1938 "Peter" Norton, who had left London for Warsaw where her husband had been posted as Counsellor in the British Embassy, sold the gallery to Roland Penrose. Under the new directorship of E.L.T. Mesens, who started the *London Gallery Bulletin*, it became the headquarters of the Surrealist movement in Britain, although it also showed non-Surrealist art. Penrose later described "Peter" Norton as "eccentric, incredibly energetic [...] a rare kind of patron" who was "in touch with the arts abroad and had made a small but well chosen collection which included works by Klee, Arp, Miró, Kandinsky and many young English artists".[64] When the Nortons were forced to flee Warsaw in 1939 following the Nazi invasion of Poland, she left behind paintings, including 43 works by Jawlensky, prints, rugs and a complete set of *Cahiers d'Art* given to her by Gropius for the London Gallery (which had a lending library).[65]

Whilst in Bern the Nortons became close friends with the Bürgis and often visited Belp. After the war, when foreign travel was possible again, they would bring British guests to the house to see the Klees. Others made their way to Belp independently. Between July 1945 and September 1951 the following signatures are recorded in the Belp guestbook: Cyril Connolly,[66] Peter Watson (twice),[67] Julian Huxley,[68] Herbert Read, John Craxton, John Rothenstein, Ashley Havinden,[69] Douglas Cooper and John Richardson (twice), Henry Moore, Richard Wollheim[70]. The painter John Craxton, who stayed at Belp for about a week in April 1946, recalls:

It was Käthi Bürgi who introduced me to Peter Norton, and took me on numerous occasions to visit Madame Klee who kindly gave me free rein to search through their immense collection of Klee's paintings and drawings. It was an indelible experience. Of course the Bürgis had their walls thick with wonderful things as well as Klee's sketchbooks which they had on loan from Madame Klee. The whole episode was for me a rare moment [...].[71]

Postwar

The impact of Klee on postwar British art is outside the scope of this essay.[72] But there is no doubt that the London retrospective of 1945–1946 confirmed the predictions of both Herbert Read ("This exhibition is an event from which our own artists may learn much"[73]) and John Rothenstein ("our exhibition [...] will appeal particularly to the younger generation of British artists"[74]). Read's monograph on Klee was published in 1948 by Faber & Faber who the same year brought out an English translation of Klee's theoretical treatise *On Modern Art*. The following year saw the publication of Douglas Cooper's monograph in the Penguin Modern Painters series – one of only three non-British artists to be featured. During and after the war the Polish emigré Jankel Adler, who had occupied a studio next to Klee at the Düsseldorf Academy in 1931–1933, helped introduce Klee's idiosyncratic graphic and printmaking techniques to fellow artists in Glasgow and London.[75] The list of British artists who were influenced by Klee at this time includes such eminent names as Victor Pasmore, Richard Hamilton, William Gear,

Manchester and I am sure that if it were known that the Klee drawings were available we should get many requests for them.[54]

On 11 February Bürgi told Rothenstein that, having discussed the idea with Lily Klee, 30 works could be kept back for a touring show.[55] In early March James asked Bürgi if this figure could be increased, pleading: "We are becoming inundated with requests for a Klee Exhibition".[56] Eventually 48 pictures were retained, including one from the Bürgi Collection, *Vogel Pep,* 1925,197 (Bird Pep); they were shown in six cities (Norwich, Sheffield, Stoke-on-Trent, Aberdeen, Liverpool and Manchester) between May and October 1946. Bürgi received a further request to tour the London exhibition round six American cities, including Boston and Chicago, from James S. Plaut, Director of The Institute of Modern Art in Boston.[57]

The British public's willingness to be seduced by Klee's "magic" was partly due to his reinvention as a reclusive Swiss artist. In his biographical foreword to the Tate catalogue, Rolf Bürgi calls Klee a "quiet, retiring philosopher and painter-musician". He omits all mention of Klee's German nationality, as well as the fact that he had served in the German army in World War One. There is a clear implication that the virtues Bürgi ascribes to Klee's art – "musical effects [...] profound sensibility and [...] spiritual richness" – are Swiss virtues.[58] Not a single review of the Tate exhibition referred to Klee's German background – not even Herbert Read in *The Listener*.[59] Bürgi, of course, had a perfectly legitimate reason for wanting to play down Klee's German identity: the Klee estate was in danger of being confiscated by the Allies as German property.[60]

Meanwhile, Rothenstein, on behalf of the Tate, was negotiating with Bürgi the purchase of three Klees from the artist's estate: *Sie beissen an,* 1920,6 (They're Biting) ; *Komödie,* 1921,108 (Comedy); and *Abenteuer eines Fräuleins,* 1922,152 (Young Lady's Adventure). The acquisition was concluded, on terms very favourable to the Tate, in May 1946. Rothenstein visited the Bürgis at Belp later that summer, thanking them afterwards "for giving me the opportunity of seeing the remainder of your Klee collection".[61]

Douglas Cooper's role as intermediary between Bürgi and Lily Klee on the one hand and Rothenstein on the other ultimately stemmed from his position at the end of the war as an agent in the Monuments and Fine Arts Division of the Allied Control Commission for Germany. This took him frequently to Switzerland in pursuit of works of art looted by the Nazis and sold to Swiss collectors. There he renewed his friendship with Lily Klee and met and became friendly with Rolf Bürgi, with whom he stayed at Belp. This lesser-known aspect of Cooper's life is recounted in John Richardson's recent memoir of Cooper.[62]

"Peter" Norton

In spite of Cooper's participation, however, Rolf Bürgi later emphasised that the 1945 Klee exhibition in London took place on the specific recommendations of Sir Clifford and Lady Norton.[63] Clifford Norton was Minister at the British Embassy in Bern from 1942–1946, before being appointed Ambassador in Athens; he was knighted in 1946. His wife Noël, known for some reason as

Cooper's dealings with Rothenstein over the Klee exhibition and acquisitions – unflattering to Rothenstein – appears to be slightly at odds with material in the Bürgi Archives.

[63] Bürgi to Monsieur Bastion, Département politique fédéral, Bern, 16 January 1948 (Bürgi Archives, Bern).

[64] Roland Penrose, *Scrapbook 1900–1981*, London 1981, p. 144. "Peter" Norton was a supporter and benefactor of the Institute of Contemporary Arts, which Penrose, Herbert Read and others founded in London in 1948. Penrose wrote Norton's obituary for *The Times* (5 August 1972) where he also referred to "her gallantry during the war in Poland, the indefatigable services she rendered to thousands of escaping prisoners of war in Switzerland and her charitable work in Greece".

[65] "It would have been so easy to pick up these few treasures and put them in the car. Perhaps it is a nobler side of man that comes to the surface in these crises when he forgets personal belongings in anxiety for the fate of human beings!" (letter from "Peter" Norton to Roland Penrose, 2 March 1971, Archive of the Scottish National Gallery of Modern Art). Norton is reputed to have brought out with her in the car Polish employees of the British Embassy (information from Christoph Bürgi).

[66] Founder and editor of *Horizon* (1939–1950).

[67] Art editor and financier of *Horizon*; co-founder of the I.C.A. in 1948 with Penrose and others; collector of modern art.

[68] Eminent biologist and first director-general of UNESCO (1946–1948).

[69] Commercial artist, typographer, and abstract painter; designed stationery for the London Gallery; friend of "Peter" Norton.

[70] Philosopher and writer on aesthetics; friend of John Richardson.

[71] Letter to the author, November 1999.

[72] The reader is referred to Anna Plodeck, 'A line on a walk – Paul Klee and England', unpublished MA dissertation, Courtauld Institute of Art, London 1998. This invaluable piece of research looks at the changing perception of Klee in Britain from the 1930s to the 1950s. It covers some of the same ground as my essay here but in greater depth and from a more theoretical perspective.

[73] 'Paul Klee', *The Listener*, 3 January 1946, p. 21.

[74] Rothenstein to Lily Klee, 31 October 1945 (Bürgi Archives, Bern). This is echoed by Richardson (b.1924): "To my generation, who had seldom seen a Klee in the original, the show had been a revelation" (*The Sorcerer's Apprentice*, pp. 160f).

[75] See Frances Carey and Antony Griffiths, *Avant-Garde British Printmaking 1914–1960*, exh. cat., British Museum, London 1990, pp.148, 152f. Adler published his 'Memories of Paul Klee' in *Horizon*, October 1942, pp. 264–267.

[76] See Keith Hartley, *Scottish Art since 1900*, exh. cat., Scottish National Gallery of Modern Art, Edinburgh, 1989, p. 29.

[77] *Alan Davie Drawing*, exh. cat., Scottish National Gallery of Modern Art, Edinburgh, 1996, p.12.

[78] Winfried Konnertz, *Eduardo Paolozzi*, Cologne 1984, p. 49.

[79] A. D. B. Sylvester, 'Auguries of Experience', *Tiger's Eye: on Arts and Letters*, vol.1, no. 6, December 1948, pp. 48–51. Sylvester's article, published in an avant-garde New York review, was written in Paris in 1948 in response to the Klee retrospective at the Musée National d'Art Moderne. It is reprinted in David Sylvester, *About Modern Art*, London 1996, pp. 35–38. Sylvester had also seen the exhibition at the National Gallery, London in 1945–1946 (ibid., p. 13). In contrast to Sylvester and others, an awareness of the process of organic, "self-creative" form in Klee is virtually absent in pre-war criticism in English, with the exception of Will Grohmann, 'Klee at Berne', *Axis*, no. 2, April 1935, pp. 12f., a review of Klee's retrospective at the Kunsthalle Bern.

[80] See, for example, David Thistlewood, *A Continuing Process: The New Creativity in British Art Education 1955–65*, exhibition catalogue, I.C.A., London 1981, especially pp. 8, 18.

WOLFGANG KERSTEN

PAUL KLEE: THE *BÜRGI SKETCHBOOK*, 1924/25
INTRODUCTION TO AN ANALYSIS OF HIS TECHNICAL METHODS

Keeping a sketchbook has proved itself, and will continue to do so.
(Paul Klee, card to Felix Klee on 28 July 1918)

An Unknown Work

The *Bürgi Sketchbook* (cat. no. 82), occupies a unique position in the work of Paul Klee. All that has survived from Klee's youth and his student days are one early sketchbook from 1899/90, another nine sketchbooks from 1892–1898 and a folio with *Studien und Scizzen bei Knirr* (1899);[1] these contain mainly landscape drawings and townscapes, studies for nudes and portraits, and are for the most part still traditionally illustrative, that is to say, academic in their style (figs. 1, 2). By contrast, the *Bürgi Sketchbook* is the only extant workbook from the mature Klee, the modern master; it dates largely from the time around 1924/25, when Klee was teaching at the Bauhaus in Weimar and Dessau as well as producing pictures independently for the middle-class art market.

In 1950, this landscape-format gem, measuring 10 × 14 cm, passed from the Klee estate administered by the Klee Society to Rolf Bürgi's Klee collection, and has been preserved there in its original state. On fifteen sheets of the seventy-page sketchbook there are outstanding drawings and paintings which are as yet entirely unknown to scholars and researchers, and which up to now have never been seen in any exhibition (figs. 3, 4). Thus there is a pressing need to make this document publicly available in as authentic a form as possible. The ideal solution must surely be a facsimile edition.[2] The art-historical significance of this document will only become apparent by analysing the way it was produced; this essay sets out some fundamental considerations and hypotheses towards achieving this.

A Glimpse into the Artist's Workshop

Since the 15th century at the latest and more than almost any other medium employed by the individual artist, sketchbooks and oil sketches have been linked to the cardinal question of the "prima idea".[3] Faced with finished, self-contained works of art, popular curiosity and the necessary scholarly interest

almost always seek to discover more about the different stages in the creative process, to have a glimpse into the artist's workshop. Consequently facsimile publications of sketchbooks with accompanying commentaries[4] as well as less extravagantly published specialist studies[5], have a long tradition in art history. This tradition continues to this day and is nowadays nurtured and advanced by experts who are equally aware of their responsabilities to publishing as they are to the critical interplay of ideological views and scholarly standards and values.[6] This would not be worthy of comment in the present context if the art historians working in the field of Klee research were part of this, which is, however, by no means the case.[7] Therefore it seems appropriate to start here with a relatively broad overview of the present level of knowledge pertaining to Klee's working methods, and to follow this with questions, based on the current state of awareness, as to the function and significance of the sketches, plans and studies in Klee's production as an artist.

The Materialist Phase in Klee Research

Although over the last twenty years a small number of Klee specialists across the world have made the breakthrough to an historical approach in their research, the literature on Paul Klee is still predominantly monadic in its attitude to the artist. Thus the impression emerges that in the history of modernist art Klee is an isolated phenomenon, beyond the reach of the methods traditionally employed in art-historical writings. For decades now there have been accepted standards of basic scholarly research which apply to art-historical texts on more recent art as on the art of the Middle Ages (particularly with respect to the critique of historical sources, bibliographic responsibility and technical precision in the description of objects); of all things it is these standards that have been – and still are – widely avoided in research into Klee's work.[8] This state of affairs is all the more serious in view of the fact that in 1995 a conceptual exhibition in the Kunstsammlung Nordrhein-Westfalen and in the Staatsgalerie Stuttgart demonstrated not only to specialists in the field but also to a wider public that the customary straight interpretations of Klee's pictures – no matter what theoretical and methodological premises they adhere to – can only be provisional and are built on precarious foundations as long as the physical shape, make-up and state of a painting or a drawing have not been subjected to empirical examination.[9] As far back as 1990 the move towards a materialist phase in Klee literature had already been introduced in principle, with the intention that pictorial analyses should be technically founded and psychologically refined in terms of perception.[10] Yet, in exegetic commentaries on Klee's work the view still prevails that enough is known of his creative working methods thanks to the extensive body of writing he left behind. What is reproduced each time, however, is a preconceived, organologically constructed ideal of artistic creativity, without any critical evaluation of all the available sources – writings and pictures alike. What insights may be gained, even indirectly, from a photograph of his studio has been demonstrated in an analysis of Klee's own photograph of his workplace in Munich in 1920.[11]

Fig. 1
Paul Klee, *Der Vier-waldstättersee (Urn-ersee) und der Uri-Rot-stock*, 1893, pencil, 11.5×8.7 cm, Sketch-book III, fol. 6, Paul Klee Foundation, Kunstmuseum Bern

Fig. 2
Paul Klee, *Untitled*, 1899, pencil, 32.5×20.7 cm, 'Studien und Scizzen bei Knirr', fol. 1, Paul Klee Foundation, Kunstmuseum Bern

A Diagnosis of an Artist's Work

There are a number of other shots of Klee's studios that are equally in need of thorough examination. In addition, for a diagnosis of various stages in Klee's creative work, first a number of more or less unusual working methods and comparable written statements would have to be taken into account.[12] Broadly speaking, the investigations would have to consider the following categories:

1. Cut-up or dissected and re-combined works; intitial studies have already been undertaken on these, as previously mentioned.[13]

2. Coloured works which consist of a number of layers or of a combination of different grounds and/or picture supports (gauze, gesso, paper, canvas, jute, and so on); a particularly memorable example of this is the oil transfer and water-colour drawing *Luftschloss*, 1922,42.[14]

3. Over-painted and thus conceptually altered paintings, such as *Akt*, 1910,124, or *Übermut*, 1939,1251.[15]

4. Compositions that are rotated, during their making, by 90° or 180°; an outstanding example of this is the work *Teppich der Erinnerung*, 1914,193.[16]

5. Coloured works and drawings on the backs of pictures, which may at one time have been the front of the work, as in the case of the oil painting *Blühendes*, 1934,199.[17] At an estimate, there are close on 380 works in Klee's œuvre that have an image on both sides.[18]

6. Rejected (scored through) paintings and drawings; these include, amongst others, the scored-through self-portrait marked "ungültig" (not valid) on the reverse of *Astern am Fenster*, 1908,53.[19]

7. Drawings on letters, postcards and in diaries; numerous examples of these are illustrated in the edition of the family's letters, published by Felix Klee in 1979.[20]

8. Drawings on sheets of papers, often in the standard sizes used in drawing

pads and sketchbooks of the time, but which Klee later mounted on card as independant works.[21]

9. Notes on technical details of Klee's own work processes in his writings, which give specific information on sketches, studies, designs, rejections, overworked items, variants, experiments, and so on. Thus in the fair copy of his first diary, for instance, Klee reports that in 1899 he took "lightning oil sketches" and a "humorous sketchbook" from Burghausen to Bern.[22] And in Klee's letters to his family, there are comments in 1904, 1905 and 1918 which clearly state that the artist filled a whole number of sketchbooks, not only in his youth, but also in later years, although it seems that these have not survived.

10. Pictures that Klee marked above the title on the work or above the title in his œuvre catalogue as sketch, preparatory drawing, experiment or variation. The word "Skizze" (sketch) occurs in his œuvre catalogue 92 times in conjunction with titles of works, and particularly often – 23 times – in conjunction with portraits.

The *Bürgi Sketchbook*

Alone from the last two points referring to the work yet to be done, four basic approaches emerge for an analysis of the technical methods in the *Bürgi Sketchbook*.

1. Function: What was the function of this sketchbook in Klee's production of art? – As the opening of this essay indicates, it is by no means enough to view it as an historic document together with the other sketchbooks of Klee's that have survived, and simply to accord it outstanding and singular significance within the overall output of the artist. The technical make-up of the document initially confirms the impression that this is a sketchbook: it is a robust little book with a loop for a pencil, bound in hard-wearing raw linen; the thirty-five sheets of drawing paper, made by Fabriano, are firmly sewn together; strong endpapers secure the inner book and the covers; two labels on the front inside cover name the maker, Pietro Miliani, and Klee's supplier in Munich, Adrian Brugger.

2. Circumstances: What circumstances in Klee's working methods could have caused him to start a sketchbook? Working first from the front and then from the back, making drawings and paintings, what led him to note down some arthistorical thoughts on the last page, and yet to leave most of the pages blank at the end? The fact that it comes from a Munich supplier indicates that Klee may well have bought the sketchbook before 1921 – that is to say before he moved from Munich to Weimar – at a time when he particularly valued the work that could be done with sketchbooks. On 28 July 1918 Klee wrote to his son Felix: "Keeping a sketchbook has proved itself, and will continue to do so".[23] The individual works in the sketchbook are generally dated according to the month; it would seem from these dates that Klee used the book from January 1924 until at least August 1925. Why did it lie unused for such a long time, assuming it really was from the time of the First World War? Whatever the various reasons might be, with the closure in 1924/25 of the Bauhaus in Weimar and the move to Dessau, Klee's life underwent crucial changes. It is possible that the conse-

quent change in the location of his workplace led him once more to appreciate for a while the advantages of a sketchbook that is not dependent on any particular place. Some of the works in the sketchbook may also have been made during Klee's trip to Sicily in summer 1924.

3. Procedures: Are the works in the *Bürgi Sketchbook* more or less fully worked-out studies or are they independent, finished pictorial works? On page 15 there is a drawing that initially looks like a conglomeration of various human, plant, animal, landscape and abstract figurations. On closer examination it is possible to make out two formally and stylistically distinct compositions, and to see that Klee rotated the sketchbook by 90° between finishing one and starting on the next (figs. 4 and 5). Both drawings are echoed two years later in related works (figs. 6 and 7), so that the question as to whether these are sketches can be answered positively by comparing them to the later pictures. At the same time, the gesticulating, schematic human figures with minimal internal lines and outlines, are reminiscent of Klee's development of an apparently childlike figure language before and during the First World War.[24] Thus we seem to be dealing here with a return to a past phase in Klee's creative work. – However, precisely the opposite may be seen in the brush drawing on the first page of the sketchbook (fig. 3). This comparatively realistic, carefully executed image of an interior with a figure at the left edge is untypical for the date that Klee himself gave it, January 1924; indeed it is untypical for his work at any time in the 1920s. It was not until 1932 that the artist made two related drawings of studios, using a brush and black Indian ink, *Atelier mit Stehleiter*, 1932,311, and *Bewegung in der Werkstatt*, 1932,312.[25] In view of this, the first work in the *Bürgi Sketchbook* would have to be regarded as a sort of precursor. What we have before us is neither a sketch nor a study, but a small, solitary work of art, that belongs to Klee's personal fund of images. This leads us to our first conclusion: The *Bürgi Sketchbook* is not a traditional, homogenous work, but a workbook in which the artist looks back, works on present issues, and looks forward to the future, in a to and fro that involves success and failure to an equal degree. It is an unfinished artist's

Fig. 3
Paul Klee, *Untitled*, 1924, Indian ink, 10×14 cm, Bürgi Sketchbook, fol. 1, private collection

Fig. 4
Paul Klee, *Untitled*, ca. 1925, Indian ink, 10×14 cm, Bürgi Sketchbook, fol. 15, private collection

Fig. 5
Fig. 4 rotated by 90 degrees to the right

Fig. 6
Paul Klee, *Drei Hexen*, 1927,111, pencil, erased, and pen on paper with spots of glue on card, 14×31.5 cm, private collection, Canada

Fig. 7
Paul Klee, *pflanzlich-schlimmes*, 1927,119, pen on paper with spots of glue on card, 23.5×31 cm, San Francisco Museum of Modern Art. Extended loan, Carl Djerassi

book, that came from the private thoughts of this master of Modernism, and was never intended for sale. As a document of an artist's pictorial output, it refutes the notion of a linear continuum, with Klee steadily stepping from one work to the next – an impression that Klee assiduously fostered in the account he kept of his work in the handwritten œuvre catalogue.[26]

4. Hierarchies: If Klee used the *Bürgi Sketchbook* both for drawings that are readily identifiable as sketches, and for more or less unique, generally carefully executed works, then our – for the moment – final question is rather obvious: which of the works listed by Klee in his œuvre catalogue can thus properly be regarded as major works, fully finished, the result of complex artistic working methods and thought processes?

1 Reproduced in: Cat. Rais. vol. 1, pp. 52–54, 59–131, 158–168; the nine sketchbooks and the folio of studies were first illustrated in full and subjected to art historical scrutiny in: Glaesemer 1973, pp. 20–102.

2 To be published in autumn 2000 by ZIP (Zürich Interpublishers).

3 See for instance a standard work on the theme: Paul Wescher, *La Prima Idea. Die Entwicklung der Ölskizze von Tintoretto bis Picasso*, Munich 1960.

4 At least three, more or less randomly chosen examples: [Roas Maria Subirana], *Picasso. Carnet de Paris*, facsimile and commentary in two volumes, Graz 1994; Marie Ursula Riemann-Reyher, *Ein Skizzenbuch. Blick auf sieben Jahre Arbeit und Leben des jungen Menzel*, Berlin 1996; *Le Corbusier, Album La Roche*, with an essay by Stanislaus von Moos, Milan/Paris 1996.

5 See for instance Marc Fehlmann, 'Géricault's Zurich Sketch-book. Its Contents and some Observations', in: *Georges-Bloch-Jahrbuch des Kunstgeschichtlichen Seminars der Universität Zürich*, Zurich, vol. 2, 1995, pp. 86–107.

6 See also the particular responses to the "Hamburg facsimile debate", documented by Michael Diers, 'Kunst und Reproduktion: Der Hamburger Faksimilestreit', in: *Idea. Werke, Theorien, Dokumente. Jahrbuch der Hamburger Kunsthalle*, Hamburg, vol. 5, 1986, pp. 125–137.

7 Klee's early sketchbooks have been reproduced (see note 1), but they have neither been published as facsimiles nor examined as such; similarly there has been no in-depth research into the significance of the sketch in Klee's artistic output; the main points of reference for an art-historical assessment have been in place since 1985, in: Werner Busch, *Die notwendige Arabeske. Wirklichkeitsaneignung und Stilisierung in der deutschen Kunst des 19. Jahrhunderts*, Berlin 1985, pp. 256–306.

8 In 1978 Otto Karl Werckmeister was already attempting to draw attention to basic misapprehensions in research into Klee's work, in: 'Die neue Phase der Klee-Literatur', in: *Neue Rundschau*, vol. 89, no. 3, 1978, pp. 405–420. Concrete cases and their consequences have most recently been described by Hans-Ernst Mittig, 'Über das Nichtverstehen von Bildern, besonders im Falle Paul Klees', in: *Radical Art History. Internationale Anthologie. Subject: O. K. Werckmeister*, ed. by Wolfgang Kersten, Zurich 1997, pp. 356–373, and Kersten 1997. (Mittig, however, did not take into account how much more refined Klee research has become over the last twenty-five years.) – Most recent opposing opinions from Klee-researchers in Jena in: *Paul Klee in Jena 1924. Der Vortrag*, ed. by Thomas Kain, Mona Meister and Franz-Joachim Verspohl (Minerva. Jenaer Schriften zur Kunstgeschichte, vol. 10), Jena 1999; on the problem of the critique of historical sources, see Kersten 1999.

9 See Kersten/Okuda 1995, p. 11. – Two informative studies deserve special mention: Otto Karl Werckmeister, 'Klee vor den Toren von Kairouan', in: *Paul Klee. Reisen in den Süden. "Reisefieber praecisiert"*, exh. cat. Gustav-Lübcke-Museum, Hamm, 26.1–13.4.1997; Museum der bildenden Künste, Leipzig, 8.5–13.7.1997, pp. 32–50; Mari Komoto, 'Repentirs de Klee. La fonction autocritique du collage dans les œuvres découpées et re-composées', in: *Histoire de L'Art*, vol. 44, June 1999, pp. 35–47.

10 Kersten/Trembley 1990; Wolfgang Kersten, Osamu Okuda, 'Die inszenierte Einheit zerstückelter Bilder. Paul Klees Gebrauch der Schere im Jahr 1940', in: Bern 1990, pp. 101–109. (Closely linked both thematically and personally: the diploma dissertation by Patrizia Zeppetella, 'Beobachtungen zur Maltechnik im Spätwerk von Paul Klee', unpubl. typescript, Bern 1989.) A particularly significant chapter in the analysis-cum-destruction of the substance of Klee's works goes back as far as 1945. In the history of restoration and conservation is an early case: *Urnenstätte der Familie Ochsenfrosch*, 1922,182, see Cat. Rais. vol. 3, no. 3006. – When Susanne Deicher, suggesting that technical analysis may well be superfluous even before it has been undertaken, and remarks, in a rarefied notion which she attributes to the Bern Klee Symposium, that, in anticipation of the technical analysis of his works, Klee "'simulated' this in advance, both in the spirit of parody and with the intention of influencing the work's reception", in: *Kunstchronik*, part 9/10, Sept./Oct. 1999, p. 458, she can hardly have meant this seriously.

11 Kersten/Okuda 1995, pp. 161–172; see also Otto Karl Werckmeister, 'Die Porträtphotograhien der Zürcher Agentur Photopress aus Anlaß des sechzigsten Geburtstages von Paul Klee am 18. Dezember 1939', in: Bern 1990, pp. 39–57.

12 It will only be possible to determine the current state of the research when the proceedings of the Bern Klee Symposium of 1998 are published.

13 See Kersten/Okuda 1995; individual examples already in, amongst others, Glaesemer 1973, and in Margarete Benz-Zauner, *Werkanalytische Untersuchungen zu den Tunesien-Aquarellen Paul Klees*, Frankfurt a.M./Bern/New York 1984.

14 Kersten/Trembley 1990, pp. 83-84; see also Katharine Bütikofer, Stefan Frey, Katharina Nyffenegger, *zum Beispiel: Paul Klee. Wir entdecken Kunst*, Solothurn 1992.

15 Okuda 1997, pp. 374–397, here pp. 379–390; Wolfgang Kersten, *Paul Klee. Übermut. Allegorie der künstlerischen Existenz*, Frankfurt a.M. 1990 (2nd revised edn. 1994).

16 Okuda 1997, pp. 390–395.

17 Kersten 1997.

18 The Paul Klee Foundation in the Kunstmuseum Bern has been kind enough to provide me with an unpublished list of these works; the verso pages will be illustrated in sequence in the *Catalogue Raisonné Paul Klee*.

19 Otto Karl Werckmeister, 'Von der Revolution zum Exil', in: *Paul Klee. Leben und Werk*, exh. cat. Kunstmuseum Bern, 25.9.1987–3.1.1988, pp. 31–55, here pp. 45–46.

20 Klee BF/1, Klee BF/2.

21 In his handwritten œuvre catalogue Klee usually noted details of types of paper used; it is hence all the more regrettable that in volumes 1–3 of the *Catalogue Raisonné Paul Klee* these paper-types are listed in a glossary, but not in an index.

22 Klee 1988, no. 70.

23 Klee BF/2, p. 928.

24 See Glaesemer 1973, pp. 184-224, and Otto Karl Werckmeister, *Versuche über Paul Klee*, Frankfurt a.M. 1981, pp. 143–151.

25 Illustrated in Berlin 1985, pp. 110 and 111.

26 See Okuda 1997, p. 376.

APPENDIX

COMPILED BY STEFAN FREY

The Collector Hanni Bürgi-Bigler

Note on the transcription of the texts:

The English translations of these texts reflect slight variations in spelling and punctuation in the original German. A forward slash '/' indicates a new line. Editorial notes are marked by square brackets.

Fig. 1
Postcard from Paul Klee, Luxor, to Hanni Bürgi, Adelboden, 1.1.1929

Excerpts from the correspondence between Paul Klee and Hanni Bürgi between 1929 and 1933

"Warm greetings, everything is just as I expected, ie. different of course, but just as beautiful. A hell of people a paradise of plants. After a few days in Cairo I am now in upper Egypt. I hope you are spending some pleasant days in Adelboden / warmest regards to you and Rolf / yours Klee"

Postcard from Paul Klee, Luxor, to Hanni Bürgi, Adelboden, 1.1.1929 (Bürgi Archives, Bern)

"Dear Mrs Bürgi! / many thanks for your good wishes for my fiftieth. It was a splendid day an aeroplane dropped presents for me amongst other things, the roof [insert: the flat roof] broke and the gifts fell right into the studio. I was very surprised and the exercise achieved its purpose / very best wishes for the festive season! yours Klee"

Letter-card from Paul Klee, Dessau, to Hanni Bürgi, 22.12.1929 (Bürgi Archives, Bern)

"Dear Mrs Bürgi. / Best greetings from the south, where it is hot and beautiful and where there is an ocean. Unfortunately no-one here can tell me your new addr. (but perhaps the old one will do the trick!) / yours Klee"

Postcard from Paul Klee, Viareggio, to Hanni Bürgi, Bern, 23.8.1930 (Bürgi Archives, Bern)

"Dear Mrs Bürgi! / my sincere thanks for your efforts regarding the Bern exhibition at the Kunsthalle[1]; and it was especially nice that it was through you that such a novelty as a telephone conversation with Bern took place! / Being fully informed of the price structure, I can declare my agreement. Basic net-price, expressed in Swiss currency plus the sales commission for the Kunsthalle is the correct way to calculate the prices. / Because what is nearest seems most pressing, please don't lose sight of the exhibition at the museum in Basel[2]! I hope my other good friends in Bern are also thinking of this very real opportunity. / With best wishes for your health (specially for the hawk-eye) and with greetings to you and your family, I remain yours Klee"

Letter from Paul Klee, Dessau, to Hanni Bürgi, 21.1.1931 (Bürgi Archives, Bern)

"Dear Mrs Bürgi! / many thanks for your kind letter. I have not needed the remaining items from the folder up until now. If you send it as a registered package, then it is not necessary to declare the full value, that would be too expensive. Even an insurance value of 100 Swiss francs is quite enough to make the package very precious to the postal service. I have checked your account, Mr Ralfs, probably because of a mistake in his addition, has overcharged you by 1000 RM. Before your last purchase on Dec. 30 you owed 2545 RM, this was then increased before your departure from Dessau by 1000 RM for the two watercolours *Früchte*[3] and *trinkender Engel* [cat. no. 112], which made a total owed of 3545 RM.

[1] Bern 1931.
[2] *Paul Klee. Gemälde, Aquarelle und Zeichnungen*, Öffentliche Kunstsammlung, Basel, 11.1–22.2.1931 (no catalogue).
[3] Col. ill. in: *Du*, Zurich, no. 2, 2000, p. 56.

Fig. 2
Paul Klee, *exotischer Park*, 1932,257, indelible pencil and chalk on chalk ground on paper on card, 20.5 x 33 cm, location unknown

Fig. 3
Paul Klee, *auf-blühende Pflanze*, 1931,107, water-colour, paste and chalk on paper on card, 59.7 x 43.2 cm, The Art Institute of Chicago

Fig. 4
Paul Klee, *Blumen in Gläsern*, 1925,10, oil on paper on card, 52.5 x 41.5 cm, private collection, Switzerland

On the other hand, you have your credit of monthly contributions, starting on 1 Oct 1925, that is to say 600 RM annually. 5 years up until 1 Sept. 1930 (inclusive) = 3000 RM plus the contributions paid since then, so far 6 à 50 RM = 300 RM. Thus your credit is 3300 and your debt is 3545 RM, thus for me today there is a shortfall of 245 RM. This debt is not worthy of the name and you can purchase a new work whenever you like. / I shall inform Mr Ralfs, and I apologise most sincerely on his behalf. / I was very happy to hear good news of your family. And the same goes for your positive impression of the Basel exhibition. / With warm greetings, from my wife too / yours Klee"

Letter from Paul Klee, Dessau, to Hanni Bürgi, 6.3.1931 (Bürgi Archives, Bern)

"Dear Mrs Bürgi! / The quiet feast days cast all kinds of lively and time-consuming and breathtaking shadows before them, and unfortunately I can find neither the internal nor the external peace to write to you as I would like to. I hope you liked the Christmas print[4]. I did not have the time to design or make a special print, so I collected together tasteful singles and curiosities. / I should like to give dear Rolf a watercolour as a present. It would be nice if he could choose something from this year's touring selection. If so, he should just help himself. Although I don't know if it is already,: still, or: no longer with you. / All the very best to you, and your sons / yours Klee"

Letter from Paul Klee, Dessau, to Hanni Bürgi, 22.12.1932 (Bürgi Archives, Bern)

"Dear Mr Klee! / Thank you very much for your frdl. lines and the charming print[5], which is now a valuable addition to my collection. In the quiet and loneliness of Christmas Eve they were doubly welcome. / To you too my very best, heartfelt wishes for 1933! I hope with all my heart that your wife will at last fully regain her health, so that you may embark on a more peaceful life together in Düsseldorf. / Rolf has taken great pleasure in accepting your frdl. offer to choose something from the folder, and I think that with: *exotischer Park* [fig. 2] he has made a happy choice. I myself have chosen: *Überflutung*,[6] *junger Baum* [cat. no. 117] and *auf-blühende Pflanze* [fig. 3]. I fear that I have rather exceeded my credit, and I would be grateful if you could orient me in this matter. But there is no hurry. Now I have another request to make of you. Could I perh. exchange *aufblühende Pflanze* if I should see something

in your atelier which I might possibly like better? Probably it seems strange to you that I have kept the picture; but it interested me so greatly that I simply could not put it back in the folder. As well as that there is another picture that remains in my mind: *eine Blume im Glas* [fig. 4], it left me with an unforgettable impression. Might you still have it? That would be a reason for visiting you in Düsseldorf in spring. / Warmest regards yours H. Bürgi"

Letter from Hanni Bürgi, Bern, to Paul Klee, 2.1.1933 (Estate of the Klee Family, deposited in the Paul Klee Foundation, Kunstmuseum Bern)

"Dear Mrs Bürgi / very many thanks for the ingenious way that you put me in possession of the card from Flechtheim, and also for your kind letter which you included. I have come to a promising agreement with the Galerie Simon here, even if the ideal solution of a financial guarantee was not possible because of the crisis. But that does leave me with complete freedom in what I do on Swiss soil. The separation from Flechtheim took place perfectly openly and harmoniously so that the new era can begin with a blank sheet / With warm greetings to dear Rolf too / yours Klee"

Letter from Paul Klee, Paris, to Hanni Bürgi, 26.10.1933 (Bürgi Archives, Bern)

Hanni Bürgi in excerpts from letters written by Lily Klee to Will Grohmann

January 1935: "re mrs Bürgi we are very anxious. Immediately after her youngest son's wedding on 1 September (at which we were also present), her health worsened, which has been somewh. fragile for yrs & she suffered serious heart attacks, which were rapidly repeated & she was in danger of her life. Therapy & weeks of lying in bed have now somewh. stopped these attacks. They now recur every 2 to 3 weeks. After the most recent occurrences she has recovered notably faster & at the moment is comparatively much better & happier. But the sword of Damocles is always hanging over her, unimaginable for this vital woman with such a hunger for life. On advice of the Drs & her friends she is continuing with her life, natur. within certain limits: for to be in a state of perpetual ill-health is unbearable for this woman, who has always been hard on herself & never spared herself. It has cast her into a deep depression."

Letter from Lily Klee, Bern, to Will Grohmann, 11.1.1935 (Staatsgalerie Stuttgart / Will Grohmann Archives)

[4] Seiltänzer, 1923,138 (cat. no. 73).
[5] As note 3.
[6] Col. ill. in: *Du*, Zurich, no. 2, 2000 p. 57.

June 1935: "We regularly spend time with Hanny bürgi. Recently she was here for the evening with her nephew Dr. W. bürgi & his charming wife Leni. First we played Bach's 3rd violin sonata & then on Hanny's request we played the sonata by César franck, which we hadn't played for at least eight years.[…] Then looked at the new works. / Hanni B.'s condition very changeable. Bad attacks leaving her with an alarmingly weak heart. The Drs are always trying out new methods with her. terrible suffering! But she never complains. Yesterday we met her as she was coming home from the town, extremely elegant, so smart & the height of fashion. She looked delightful still.

Letter from Lily and Paul Klee, Bern, to Will Grohmann, 9.6.1935 (Staatsgalerie Stuttgart / Will Grohmann Archives)

March 1937: "A very sad piece of news is that Hanny Bürgi suffered a stroke on Monday evening (to the brain) with one-sided paralysis, impairment to the speech centre. On Thursday she felt better. Today less so again. She is very weak. It is not possible to say yet what will become of this. Recovery is definitely not out of the question, but it is very serious. She has a nurse day & night. Apart from the children no-one may see her. I regularly speak on the telephone with Käthi. We are very upset by it. […] (Hanny had heart attacks every day during the week before the stroke. The last time I saw her (a week ago today) she was relatively wel full of all sorts of plans."

Letter from Lily Klee, Bern, to Will Grohmann, 20.3.1937 (Staatsgalerie Stuttgart / Will Grohmann Archives)

May 1937: "Sometimes I visit Hanny B. She is in much better health, even if the heart attacks still return from t. to time. But she is a completely broken vessel physically & above all mentally. Poor soul! She will doubtless never be able to run her own household again. The move was not the problem. It is the gradual progress of her unstoppable suffering. Sometimes it stops for a while but then it gives another jolt."

Letter from Lily (and Paul) Klee, Bern, to Will Grohmann, 15.5.1937 (Staatsgalerie Stuttgart / Will Grohmann Archives)

August 1938: "On 16 August our dear friend Hanni Bürgi was released from her sore suffering. She only reached the age of 57. I need not tell you what she achieved by the strength of her character, her temperament & her strong personality. The results are still evi-

dent. Apart from that, through sorrow & joy she was a faithful friend to us for decades. That is a rarity because one has very few true friends. So our loss is truly irreplaceable. To share her suffering for years and to see her gradual decline was immensely painful for us. Many difficulties, things that were hard to understand can be attributed to the advance of her nervous disease. Rolf & Käthi have been through hard times. Not to the detriment of Käthi's inner development. These times have led to a true friendship between us. And so we stood together in deep mourning by the coffin. / It has been a great blow to us & we are still in that shadow. – Hanni's death has thrown us badly. We are glad to be here [in Beatenberg] under the soothing influence of nature in all its vastness.

Letter from Lily (and Paul) Klee, St. Beatenberg, to Will Grohmann, 26.8.1938 (Staatsgalerie Stuttgart / Will Grohmann Archives)

Hanni Bürgi in Lily Klee's memoirs

"Hanny Bürgi started to collect pictures & works by Paul Klee very early on. She was one of the first to collect his art, gifted with the finest visual understanding of the colours & the quality of a picture. She was also very critical by nature. She already owned watercolours by Paul Klee when her husband was still alive, whom she lost so suddenly during the terrible flu epidemic in 1919; I particularly remember the three watercolours by Paul that he painted on the Stockhorn Mountain […] She had acquired a number of important coloured sheets since then […] Hanny Bürgi, my dear husband & I were united by a very beautiful & close friendship. Between her & my husband there was a close spiritual affinity through her deep understanding of his work. We first met Hanny Bürgi in my father-in-law's house. She was his singing pupil. It was ca 1910. Her children (3 sons) were still small at the time. She was an elegant woman, as beautiful as a picture. In her whole appearance she looked like a picture. How many pleasant evenings & hours we spent together in Alfred & Hanny Bürgi's beautiful, welcoming house on Wildhainweg & later in Hallerstraße. In those days I often accompanied Hanny as she sang with her melodious mezzo voice: Ganymed by Schubert or 'dark as dark['] by J. Brahms. Which was one of her favourite songs. We often made music together in the Bürgi's house on Wildhainweg in Bern."

Lily Klee, Memoirs, manuscript, from 1942, pp. 105–107 (Copy: Estate of the Klee Family, deposited in the Paul Klee Foundation, Kunstmuseum Bern)

**Fig. 5
Hanni Bürgi with her daughter-in-law, Käthi Bürgi, Thun, 1.9.1935**

Fig. 6
Letter of condolence from Paul Klee, St. Beatenberg, to Rolf Bürgi, 17.8.1938

Letter of Condolence

"Dear Rolf Bürgi, / we understand with particular clarity how sad recent times were for your poor mother, for you and for all of us, now that she has been released by death from immense suffering, for one finds oneself inclined to feel some comfort in this release. If only the mystery of death were not so ambiguous! And not less so is the mystery of life, and one asks oneself how splendour and things of beauty could be connected to the torments of recent times. / We need distance in order to overcome our last impressions, then for certain much that is comforting will replace these harsh blows. One has to hope that we will soon succeed in reaching that position. / I myself as an artist already today know a path that will take me there, namely: to connect your dear mother with a significant part of my œuvre, and to see an immense positivum in this part, which belongs to us both. / For you and your brother of course the path is not so simple, my wish for you is that the pain should be soothing and bring release. / I take your hand and that of your dear wife in affection / yours Klee"

Letter from Paul Klee, St. Beatenberg, to Rolf Bürgi, 17.8.1938 (Bürgi Archives, Bern)

Marguerite Frey-Surbek, 'Rückblick auf eine Persönlichkeit' [Look Back at a Personality], in: *Frauen-Zeitung "Berna". Organ des Bernischen Frauenbundes. Blatt für bernische und allgemeine Fraueninteressen,* Bern, vol. 40, no. 5, 9.9.1938, p. 38:

"[...] At first Mrs Hanni Bürgi approached the musical sphere with some trepidation, but was then completely caught up by it, and like most of those who studied with Hans Klee – a maestro who made no concessions – she learned to understand the endlessness of this territory, which in itself preserved her from dilettantism, and her intensive vocal studies did not lead to 'production' but to heightened musicality; anyone who heard her singing Brahms or Schubert in those days, did not find themselves – critically or pleasurably – at a concert, but at a short consecration – a consecration at which she gradually took on the role of listener, as there were increasingly long interruptions to her own singing. The heaviest of losses befell her, threatening her inner equilibrium. But then there was a rare occurrence, which is the subject of these lines: having awakened to her own artistic leanings whilst fully enjoying the blessings of family life – when many come to a halt in blinkered complacency – now her artistic interests became a pressing need, a woman in torment opened herself up, and her gratitude became a constant source of inspiration for creative artists. Torn apart by pain at the loss of her husband and son, she sought refuge in things that were not within the grasp of her husband, or only with difficulty, for it was in her indomitable nature to elicit sparks even from despair, which in turn released energies in her surroundings, giving the creative artist strength in his search [...] – First out of fellow-feeling, then drawn on a purely spiritual level, a circle formed around her which encouraged and cultivated mutual influences for over a decade; it would be hard to say which side received or gave more. What she had learnt of music and painting in the Klee house was extended and developed, sculpture and architecture were included in her field of interest, passionately observed and explored. No exhibition was left unvisited; favour and criticism sometimes took rather extreme forms – but how gladly the Kunsthalle finds itself at the centre of battles of opinion! – While Hanni Bürgi became something of a patron of the arts through her Klee collection, the real driving force sweeping her along was her burning interest in what was going on in the arts in general – and she did not specialise in any way, she was as open to the old as to the new. And that was the spirit in which she led the music section of the Lyceum Club, which she did so successfully until just a few years ago. Unaffected by the weight of refined tradition, for her family was part country folk part bourgeoisie, Hanni Bürgi's unique instinct led her to reject anything shallow, her naïve directness drew her to the true and the genuine in any art form - whatever proved to be so, became part of her inner being. [...]"

Max Huggler's Obituary for Hanni Bürgi in: *Bericht über die Tätigkeit der Kunsthalle Bern 1938,* Bern 1939, p. 3:

"The year of this report saw the death of Mrs Bürgi, who was one of the diminishing number of our oldest members. Through her support for artists, Mrs Bürgi played a personal part in the cultural life of the town. As the most determined champion of Paul Klee's art she was the inspiration behind the Klee exhibition at the Kunsthalle in 1935, and so effectively supported its realisation that it was an immense success both for the artist and for the Kunsthalle. But Mrs Bürgi also directed her interest and efforts towards other artists: when we think of the events in the Kunsthalle we remember her assistance with the exhibitions of the work of Ernst Ludwig Kirchner and of Alice Bailly; for the latter she had earlier smoothed the path to the friends of art in Bern. – The encouragement, edification and support of the private collector and the closest possible collaboration with the collector is one of the most important tasks of the Kunsthalle. For despite the increased public promotion of the arts, the collector actively involved in purchasing works and on a personal level is an indispensible requirement for the development of art. Mrs Bürgi remains in our memories as the ideal, with no interest in material gain whatsoever, an art lover with the greatest capacity for artistic joy and enthusiasm."

Documents relating to the Paul Klee Legacy, the Klee Society and the Paul Klee Foundation

Contract of Inheritance

between **Mrs Karolina Sophie Elisabeth Klee-Stumpf** and

Mr Felix Paul Klee

Following the death of their husband and father, Prof. Paul Klee, his heirs hereby conclude, pursuant to a last will expressed to them orally, the following agreement which is set out in greater detail in the paragraphs below:

§1 Mr Felix Paul Klee hereby renounces his inheritance claims in respect of his father's estate in favour of his mother, Mrs Karolina Sophie Elisabeth Klee-Stumpf.

§2 Mrs Karolina Sophie Elisabeth Klee shall have the right to sell the paintings from the legacy of the deceased.

§3 Mr Felix Klee shall have the right to be informed of any sales which are effected.

§4 For her part, Mrs Karolina Sophie Elisabeth Klee undertakes to give to her son and his family a monthly living allowance, to the best of her ability and where such need arises. Where possible, that allowance shall be maintained at the same level as the amounts which his parents paid to him hitherto.

§5 Mrs Karolina Sophie Elisabeth Klee hereby releases her son from the obligation to support her in any way in the future.

§6 Upon the death of Mrs Karolina Sophie Elisabeth Klee her entire property shall pass to her son, Felix Paul Klee, and upon his death to his legal heirs.

§7 In the event of any disputes which may arise from this Contract, the Contracting Parties hereby agree that such disputes will be resolved following oral or written consultation by Mr Rolf Bürgi – and upon his death Dr Wolf Bürgi – and that they will accept his judgment.

§8 This Contract has been drawn up in triplicate, one copy each for the Contracting Parties and a third for Mr Rolf Bürgi.

§9 Each Party shall stamp its copy itself.

Bern, 20 July 1940

[signed] Mrs Karolina Sophie Elisabeth Klee-Stumpf [signed] Felix Paul Klee

(Bürgi Archives, Bern)

Agreement

between Prof. Karolina Klee, née Stumpf, as representative of the heirs of Prof. Paul Ernst Klee,

and Mr Rolf Bürgi

§1 The great interest which has arisen in the work and legacy of Prof. Paul Ernst Klee following his death appears to necessitate the conclusion between the heirs and Rolf Bürgi, as trustee, of a written agreement to ensure that proper care is taken of the work and legacy of Prof. Paul Klee.

§2 This Agreement shall be concluded on condition that amicable agreement is reached on all points between all the Contracting Parties.

§3 Negotiations on the hand-over of works by the late Prof. Paul Klee – sale, endowment, gift, loan etc. – shall be conducted by Rolf Bürgi. He shall set the prices and lay down all conditions.

§4 International negotiations concerning works by Prof. Paul Klee in connection with the art trade shall be determined by Rolf Bürgi in consultation with Mrs Klee.

§5 All reproduction rights in respect of the works of Prof. Paul Klee shall be subject to authorisation by Rolf Bürgi.

§6 Rolf Bürgi alone shall have right of disposal over the entire written legacy – diary, letters, teaching notes, poems etc. – in consultation with Mrs Klee.
 An effort shall be made to prevent the legacy being damaged or dispersed. Rolf Bürgi shall ensure that the documents are kept in safekeeping and that only true and exact copies are given to third parties.

§7 On the death of Mrs Klee the Contract shall devolve to her son Felix Klee or his heirs together with all rights and obligations.

§8 In return Rolf Bürgi shall receive from the heirs of Prof. Paul Ernst Klee a 5% share of all proceeds from his works.

§9 This Agreement shall be concluded for an indefinite period. It may be terminated by either Party on 31 December by giving one-year's notice.

§10 This Agreement has been drawn up and signed in duplicate, one copy for the heirs of Prof. Paul Ernst Klee and one copy for Rolf Bürgi.

§11 In other respects the relevant provisions of the Swiss Federal Code of Obligations shall apply.

Each Party shall stamp its copy of the Contract itself.

Bern, 28 October 1941

[signed] Mrs Lily Klee [signed] R. Bürgi.

(Bürgi Archives, Bern)

Last Will and Testament of Lily Klee

Last Will and Testament

Being of completely sound mind I hereby order as follows in the event of my death:

1.) If I die before my son, Felix Klee, my entire estate shall pass to him, subject to the following provisos:

2.) If my sister-in-law, Miss Mathilde Klee, in Bern, and my sister Mrs Marianne Klinger-Stumpf, in Munich, survive me, I hereby order that the following pensions shall be paid after my death:

to Miss Mathilde Klee in Bern, 100 francs a month.

to Mrs Marianne Klinger-Stumpf in Munich, 100 francs a month.

3. To my godchild Gabriele Bach, the daughter of Rudolf and Carola Bach-Wagner (formerly in Augsburg but whose present whereabouts are unknown to me), born on 27 December 1930, I hereby bequeath 2,000 francs.

4. With regard to my husband's artistic legacy I hereby set up a Committee. The following shall belong thereto: my son Felix Klee, in so far as he is able, and

Mr Hermann Rupf in Bern,
Dr Carola Giedion-Welcker in Zurich,
Mr Werner Allenbach in Bern,
Mr Rolf Bürgi in Bern, and
Dr Hans Meyer-Benteli in Bümpliz.

I hereby entrust to that Committee as a whole, in an honorary capacity, the exclusive administration and supervision of my husband's entire artistic legacy, both in artistic and financial terms.

With complete confidence in the abovementioned members of the Committee I hereby request that they ensure that my husband's artistic legacy remains in the public eye and has a beneficial effect, while at the same time safeguarding the financial interests of my descendants. In that respect the Committee shall decide what may and may not be sold.

Where a member retires from the Committee, the Committee shall select a suitable new member. Upon my death the Committee which I have set up shall immediately take over the exclusive administration and care of my husband's entire artistic legacy. While I am still alive I hope to create the following documents as the basis for that administration:

a. A complete inventory of all the works of Paul Klee, insofar as they are in my possession.

b. My special wishes and instructions regarding my husband's artistic legacy.

c. In collaboration with the Committee, the regulations thereof with provisions on rights and obligations so that the Committee can continue to work in my spirit after my death.

In any event I now provide as follows: After my death all functions relating to my husband's artistic legacy, such as sales and the fixing of sale prices, exhibitions, loans and negotiations concerning publications etc., shall pass to the Committee.

For the time being a fund of up to 10,000 francs shall be set up from the sales to cover all expenses and charges. Amounts exceeding that 10,000 francs shall go to my heirs or, where applicable, the Foundation (see paragraph 7).

5.) If I should survive my son and die before my daughter-in-law and my grandson, three quarters of my estate shall pass to my grandson, Alexander Klee, and one quarter to my daughter-in-law Efrossina Klee-Grejova. With regard to my husband's artistic legacy, I wish a Committee to be set up as provided for in paragraph 4.) and the relevant rules to be laid down. My daughter-in-law shall, insofar as she is able, be a member of the Committee instead of my son.

6. If I survive my son and my daughter-in-law and only my grandson remains, my estate shall pass to him.

With regard to my husband's artistic legacy, I wish a Committee to be set up as provided for in paragraph 4.) and the relevant rules to be laid down.

My grandson Alexander Klee shall, insofar as he is able, be a member of the Committee.

7.) If my son and my grandson should die before me and only my daughter-in-law, Mrs Efrossina Klee, should remain, I shall grant her usufruct over my property. If that usufruct is insufficient to support her, the capital may be drawn on.

With regard to my husband's artistic legacy, I require a Committee to be set up as provided for in paragraph 4.) and the relevant rules laid down.

Following the death of my daughter-in-law the remaining capital shall be used for a Paul Klee Foundation. The statutes, purpose and desired effects of that foundation shall be laid down by the Committee which I provided for in paragraph 4.).

8. If I survive my son, my daughter-in-law and my grandson, the Committee which I provided for in paragraph 4.) shall establish the Paul Klee Foundation after my death.

My instructions in respect of my husband's artistic legacy shall enter into force as provided for in paragraph 4.). In that case any sale proceeds shall go to the Foundation. The fund of 10,000 francs shall not be set up and the Foundation shall meet all expenses and charges.

This last will and testament is consistent with my personal will and I would ask all those involved to respect it.

I hereby appoint notary Mr Otto Wirtz in Bern as executor.

Bern, 14 October 1945.

[signed] Mrs Carolina Lily Klee

(Copy: Bürgi Archives, Bern)

Note:

'Tax inventory of the late Mrs Carolina Lily Klee, Bern, 14.12.1946' (Bürgi Archives, Bern): "On 2 October 1946 the Town Clerk of Bern opened this last will and testament pursuant to Article 557 of the Civil Code and entered it verbatim into the Register of Wills of the municipality of Bern No. 42, on page 61."

Extracts from the 'Bundesbeschluss betreffend die Genehmigung des in Washington abgeschlossenen Abkommens. (Vom 27. Juni 1946.)' [Federal Order concerning the approval of the Agreement concluded in Washington. (of 27 June 1946)], in: *Eidgenössische Gesetzessammlung. Amtliche Sammlung der Bundesgesetze und Verordnungen,* vol. 62, 1946, Bern 1947, pp. 661f. and 666:

[The relevant passages in respect of the rules governing the Paul Klee Legacy read as follows:]

§1(1) The Swiss Compensation Office shall expand and continue its investigations concerning assets located in Switzerland belonging to Germans in Germany or controlled by such persons and realise those assets. This provision shall also apply to persons of German nationality who are to be repatriated.

§1(2) The Germans affected by these measures shall be reimbursed in German currency for the proceeds of their assets realised in Switzerland.

§2(1) Fifty percent of the revenue from the realisation of the assets located in Switzerland to which Germans in Germany are entitled shall go to Switzerland and the same percentage shall be made available to the Allies for the purpose of rebuilding allied countries destroyed or impoverished by the war and to feed starving populations.

Annex

§2(F) The Compensation Office shall, at the request of the Joint Commission, lay down the provisions and conditions governing the sale of German assets in general or with regard to specific cases, in which case reasonable account shall be taken both of the national interests of the undersigned governments and the interests of the Swiss economy and the desirability of obtaining the maximum proceeds from the realisation of the assets and having regard to freedom of trade. Only persons of non-German nationality who provide the necessary guarantees shall be permitted to acquire the assets in question and all measures shall be taken to prevent the subsequent repurchase of those assets by German nationals.

Agreement

between **Prof. (Mrs) L. Klee-Stumpf**, of 6 Kistlerweg, Bern, and

Mr Rolf Bürgi, of 2 Christoffelgasse, Bern,

1. Prof. L. Klee hereby transfers to Mr Rolf Bürgi sole agency in respect of the works of Prof. Paul Klee worldwide with the exception of Switzerland.

The sole agency in respect of the works of Prof. Paul Klee shall include the exclusive right to conclude with art dealers and publishers contracts relating to the sale of the posthumous works of Prof. Klee and the publication of his legacy. Mrs Klee undertakes to hold at Mr Bürgi's disposal the works of Prof. Klee and his written legacy so as to allow him to implement those agreements.

2. Mr Bürgi undertakes to conduct all negotiations in connection with the sale of the works and the publication of the legacy of Prof. Klee in the best possible interests of Mrs Klee, handle all the related correspondence and deal with all paperwork in general. He shall set up a permanent office in Bern for that purpose.

3. Pursuant to paragraphs (1) and (2) of this Agreement, Mr Rolf Bürgi shall conclude with art dealers contracts of sale relating to paintings from the legacy of Prof. Paul Klee. The sale prices of those paintings shall be fixed jointly by Mrs Klee and Mr Rolf Bürgi.

Mr Rolf Bürgi undertakes to monitor the contracting parties' compliance with the contracts and safeguard Mrs Klee's interests in respect of the implementation of the contracts.

4. Mr Rolf Bürgi shall provide Mrs Klee with duplicate copies of all contracts which he concludes in his capacity as sole agent in respect of the works of Prof. Paul Klee.

5. Exhibitions of works by Prof. Paul Klee shall be organised by Mr Rolf Bürgi or, in consultation with him, by art dealers with whom he has concluded contracts.

6. Every six months, commencing on 31 December 1946, Mr Rolf Bürgi shall render Mrs Klee an account of the receipts stemming from the contracts which he has concluded.

7. By way of recompense for his endeavours Mr Rolf Bürgi shall receive fifteen percent of all receipts stemming from sales to art dealers and publishing contracts.

This Agreement shall enter into force on 1 September 1946 and be concluded for a fixed period of five years. Unless notice of termination is given six months beforehand, it shall be renewed on each occasion for a further three years.

Bern, 11 September 1946.

B/Hu

[signed] Prof. L. Klee [signed] R. Bürgi

(Bürgi Archives, Bern)

Contract of Sale

between Mr Hermann Rupf, of 27 Brückfeldstrasse, Bern, and
Dr Hans Meyer-Benteli, of 1 Peterweg, Bern-Bümplitz, as the Purchasers, and

Mr Rolf Bürgi, of 2 Christoffelgasse, Bern, as the sole agent of Prof. (Mrs) L. Klee in Bern, as the Vendor.

1. Mr Rolf Bürgi hereby sells, as the sole agent of Prof. L. Klee, the entire artistic legacy of the painter Paul Klee, which on 16 September 1946 was held at the flat at 6 Kistlerweg,

by various art dealers as goods for sale on commission,
by Mr Rolf Bürgi in Belp, on loan at various locations,
and the library of the deceased artist

to Mr Hermann Rupf and Dr Hans Meyer-Benteli.

The purchase price shall amount to Sfr 120,000 (one hundred and twenty thousand Swiss francs) and be payable in four installments of Sfr 30,000 (thirty thousand Swiss francs) on 1 February 1947, 1 February 1948, 1 February 1949 and 1 February 1950 respectively.

2. The Purchasers undertake to gift an appropriate collection from the acquired legacy to the Kunstmuseum Bern and the Kunstmuseum Basel.

3. The Purchasers undertake to set aside from the acquired legacy a closed and unsaleable collection.

4. The Purchaser shall agree with Mr Rolf Bürgi the choice of the paintings intended for the two museums referred to in paragraph (2) and the collection referred to in paragraph (3).

5. Pursuant to this Contract the Purchasers shall simultaneously acquire all printing and publication rights relating to the work of Paul Klee.

This Contract was put in writing and drawn up in triplicate by prior oral agreement on 20 September 1946.

Bern, 20 September 1946.

[signed] R. Bürgi [signed] H. Meyer-Benteli

As agent of Mr Herm. Rupf: [signed] H. Meyer-Benteli

(Copy: Bürgi Archives, Bern)

Partnership Agreement

1. On this date an ordinary partnership within the meaning of Article 530 et seq. of the Law of Contract was set up for an indefinite period under the name of the "Klee Society, Bern".

2. The following persons, who were friends of the deceased painter Paul Klee, shall be members: Hermann Rupf, as chairman of the partnership, Rolf Bürgi, H. Meyer-Benteli and Werner Allenbach.

3. The purpose of the Partnership shall be to:

a. purchase paintings by Paul Klee at home and abroad, in particular the artistic, literary and educational legacy of the painter, including copyrights, and all personal effects which may serve as a reminder and indication of Paul Klee's personality.
b. look after, protect and promote his complete work in accordance with the will of the painter as known to the members.
c. preserve permanently that part of the art stock which is not intended for the general public so that it remains accessible only for serious artistic research.
d. create a permanent and unsaleable exhibition stock capable of demonstrating Klee's importance in all countries.
e. gift individual paintings to museums which Paul Klee wished properly to represent his art while he was still alive.
f. safeguard authors' rights and selectively monitor publications, and produce its own publications on the work of Paul Klee.
g. resell paintings and prints while ensuring that the works remaining in the possession of the Partnership and the Swiss museums provide the most complete possible picture of the development of Paul Klee's art and also ensure that reasonable prices for Klee works are maintained on the art market.

4. The Partnership undertakes to support Paul Klee's next of kin, that is to say his son Felix Klee and his sister Mathilde Klee.

5. All acts and arrangements which serve to achieve the purpose of the Partnership, in particular the conclusion of contracts and the fixing of sale prices, must be agreed or approved by a plenary sitting of the four members.

6. Partnership resolutions shall be adopted by a majority of votes. In the event of a tie the chairman shall have the casting vote.

7. Two members together shall sign on behalf of the Partnership with legal binding effect. Copies of letters which affect the Partnership's overall interests shall be deposited at the office at 1 Waisenhausplatz.

8. Unless otherwise stipulated in paragraph (9), the members shall make equal contributions and also have equal shares in the revenue to cover them. In particular, they shall be equally and jointly responsible for each agreed purchase, administration costs, rental charges on premises, and exhibition expenses etc.

9. Subject to approval by a plenary session as provided for in paragraph (8), the following powers shall be delegated to the management:

a. Paintings and prints earmarked for sale shall be handed over to Rolf Bürgi. In continuation of the agreement concluded with Mrs Lily Klee, he shall be authorised to deal with parties interested in making purchases and to draw up sales and agency agreements.
To cover the expenses incurred as a result of this management function Rolf Bürgi shall receive 15% of the net sale prices.
Swiss insurance premiums relating to transport operations shall be paid by the Partnership.
b. The proper administration of the Partnership's entire stock, including movable property but excluding finances and the paintings handed over to Rolf Bürgi for sale, shall pass to Werner Allenbach. He shall take care of arrangement and stock taking, where necessary enlisting the assistance of a second member. He shall charge for that work in accordance with the time spent on it.
c. H. Meyer-Benteli shall take care of safeguarding copyright, dealing with publishers and authors and preparing publications in person or through his publishing company Benteli AG, Bern. He shall be entitled to 15% of the proceeds to cover his expenses.
d. The Partnership's accounts shall be kept by Hermann Rupf. He shall charge for his costs and work.

10. Each member shall personally have the right to obtain, at any time, information on the progress of business affairs, also insofar as they are conducted by individual members pursuant to paragraph (9), and to inspect the accounts and papers. The managing partner shall also handle affairs and render an account after any dissolution of the Partnership.

11. The Partnership shall recognise the committee provided for in the event of the death of Mrs Lily Klee as an advisory body in respect of artistic matters.

12. In the event of the death of a member this Agreement shall remain in force and the members shall come to an agreement with the heirs of the deceased.

Bern, 24 September 1946.

The members of the Partnership:

[signed] H. Rupf [signed] R. Bürgi. [signed] H. Meyer [signed] W. Allenbach.

(Bürgi Archives, Bern)

The undersigned, **Hans Straub**, a notary of the Canton of Bern, with registered offices in Bern, **hereby records** that the following gentlemen who are entitled to act and who are known to him personally have appeared before him

1. **Hermann R u p f** , of Bern, a businessman in Bern,
2. **Rolf B ü r g i** , of Bern, a businessman in Belp,
3. **Dr Hans M e y e r - B e n t e l i** , of Holderbank, a director in Bümplitz,
4. **Werner A l l e n b a c h** , of Adelboden, an architect in Bern,
and declare as follows:

The ordinary partnership

Klee Society, B e r n

comprising the abovementioned gentlemen, Hermann Rupf, Rolf Bürgi, Dr Hans Meyer-Benteli and Werner Allenbach, hereby set up the following

F o u n d a t i o n :

I. Name, seat and purpose of the Foundation:

Article 1 The Klee Society Bern, hereby sets up under the name

Paul Klee Foundation

a foundation within the meaning of Article 80 et seq. of the Swiss Civil Code.

Article 2 The Foundation shall have its seat in Bern. The Board of the Foundation shall be authorised, at its discretion, to move the seat of the Foundation within the borders of Switzerland at any time with the consent of the supervisory authority.

Article 3 The purpose of the Foundation shall consist in:

a. creating an unsaleable art stock made up of a selection of the best paintings, drawings and graphic prints by the painter Paul Klee which can be displayed in representative exhibitions at home and abroad and is capable of demonstrating the importance of Paul Klee.
b. setting up a home in Switzerland, accessible for serious art-historical research, for paintings, studies, sculptures, documents, books and other items which may be of importance as an indication of the personality of the artist which stem from the legacy of the artist but are not intended for exhibitions.

II. Assets of the Foundation

Article 4 The Founder hereby dedicates the following to the Foundation

a. 40 panel paintings
150 coloured sheets
1,500 drawings and sketches
one copy of each of the extant prints
a number of reverse-glass paintings and sculptures
a number of documents and
the library of Paul Klee
b. A capital of 5,000 francs - in words five thousand francs. The assets of the Foundation may be increased at any time by donations from the Founder or a third party.

Article 5 The capital of the Foundation may be invested in securities, secure loans and immovable property. It may likewise consist in part or in full in a claim in respect of the Founder.

Article 6 The returns on the assets of the Foundation shall be used primarily to fulfil the purpose thereof. If the returns are insufficient, the assets may be drawn on.

Article 7 A statement of the Foundation's accounts shall be drawn up annually on 31 December, commencing on 31 December 1948.

III. Body of the Foundation

Article 8 The sole body of the Foundation shall be the Board of the Foundation. It shall be composed of 5–9 members to be designated by the Founder. The members of the Board of the Foundation shall remain in office for three years. After that period they may be re-elected.

The Board of the Foundation shall constitute itself. It shall adopt its decisions by a simple majority of the votes cast. In the event of a tie the Chairman shall have the casting vote.

Article 9 The Board of the Foundation shall represent the Foundation externally. It shall designate the members who may sign on behalf of the Foundation with binding legal effect and determine the nature of their signature.

IV. Amendment of the Deed of Foundation and dissolution

Article 10 The Deed of Foundation may be amended and the Foundation dissolved only in cases provided for in law.

Article 11 In the event that the founding partnership is dissolved, the Foundation shall continue to exist and the powers relating to the designation of members of the Board of the Foundation shall pass to the Board of the Foundation itself.

In witness whereof this Deed of Foundation shall be drawn up in **quadruplicate** as follows:

one copy for legal redress by the Foundation,
a second copy for legal redress by the Founder,
a third copy as evidence for the supervisory authority and
a fourth copy as evidence for the Bern Commercial Registry.

The notary hereby reads this Deed verbatim to the abovementioned persons who are appearing before him. Thereupon they shall declare that the Deed contains an expression of their will and sign the original together with the notary.

The recording is carried out without interruption and in the presence of all the participants in the office of the undersigned notary in

Bern, on the thirtieth day of September nineteen hundred and forty-seven

d.d. 30 September 1947

The original was signed by: the Founder: Klee Society, Bern: [signed] H. Rupf. [signed] W Allenbach. [signed] H. Meyer-Benteli. [signed] R. Bürgi. The recording notary: [signed] H. Straub, notary.

between the **Paul Klee Foundation** in Bern,
represented by attorney at law Dr E. Matter, of 37 Spitalgasse, Bern,
and the Department for the Realisation of German Assets
of the **Swiss Compensation Office** as the representative of
Mr Felix Klee, a director in Bern,
represented by lawyer Dr Rudolf Moser, Zurich

1. During their lifetime the late Mr Paul Klee and Mrs Lily Klee repeatedly expressed their intention to create an unsaleable artistic legacy of works by Mr Paul Klee. For that reason Mr Felix Klee has agreed to the continued existence of the Paul Klee Foundation set up by the Klee Society in 1947 using paintings, documents and the library of the painter Paul Klee. He accepts the stocks of the Foundation to the extent set out in Article 4 of the Deed of Foundation, insofar as it refers to panel paintings, coloured sheets, drawings and sketches and is contained as unsaleable exhibition stock in the catalogue of the Paul Klee exhibition in Bern, which was held from 22 November to 31 December 1947.

Mr Klee shall take over the assets and liabilities of the Klee Society pursuant to a separate agreement. The Klee Society shall be dissolved on 31 December 1952.

2. The following provisions are made in respect of the other assets presently owned by the Paul Klee Foundation, that is to say 15 panel paintings, 220 coloured sheets, 1,322 drawings and sketches, a number of prints, 38 reverse-glass paintings, 10 small sculptures, 6 reliefs, documents and the library of Paul Klee:

a) Mr Felix Klee shall receive one third of the 1,322 drawings and sketches which exist in addition to the 1,500 drawings and sketches referred to in Article 4 of the Deed of Foundation. The division shall be made between him and the Board of Foundation.

b) Likewise Mr Felix Klee shall receive one third of the existing prints.

c) The 15 panel paintings and 220 coloured sheets shall be handed over to Mr Klee.

d) Mr Felix Klee shall receive one third of the 38 reverse-glass paintings, 10 small sculptures and 6 reliefs under an arrangement with the Board of Foundation.

e) The following has been agreed in respect of the existing documents and the library of Paul Klee:

aa) The correspondence of Paul Klee shall, insofar as it is in the possession of the Foundation, be handed over to Mr Klee.

bb) The diaries, the educational legacy and the œuvre catalogue will remain with the Foundation, as shall the library insofar as it is important in respect of Paul Klee's artistic work and the importance of his personality. However, insofar as the library does not have the abovementioned importance, it shall be handed over to Mr Felix Klee under an arrangement with the Board of Foundation.

f) In the event of any dispute, experts shall be called in as mediators with each Party designating one such expert. Where it is not possible to reach agreement, the two experts shall, together with an arbitrator to be designated by the President of the High Court of the Canton of Bern, adopt a final decision on the dispute which is binding on both Parties.

3. The copyright to all the works by Paul Klee in the possession of the Foundation shall pass to it. In other respects it will remain with Mr Felix Klee.

Bern, 4 December 1952

Zurich,

[signed] Felix Klee

Paul Klee Foundation: [signed] H. Rupf [signed] M. Huggler

[stamped:] Department for the Realisation of German Assets of the Swiss Compensation Office
[signed] Ott [signed] {...}

Address by Rolf Bürgi on the Occasion of the Funeral
of Mrs Paul Klee in the Crematorium in Bern, on 25 September 1946

Ladies and Gentlemen, Fellow Mourners,

Lily Klee starts her memoirs of her youth with the words:
"Memory is the only paradise from which we cannot be banished."

Lily Klee was born on 10 October 1876, the daughter of a physician in Munich, Dr. Ludwig Stumpf. As she often told us, the best memories of her life were of her early years, up until the death of her mother.

She inherited her great talent for music and her love of art from her musically and artistically very gifted mother, from her father she inherited her steadfast, true character, and from her home town the fine, fresh humour of the people of Munich.

At the age of 16 Lily Klee lost her mother. As she still described it in the last years of her life, this was a wound that was never to heal. In accordance with her mother's wishes she studied music. Some of my own dearest memories as a young man were the hours when Lily Klee and my mother made music together. Perhaps Lily Klee's temperament and sensibility were nowhere so evident as when she was playing music.

It was in 1899 that she first met the academy student and painter Paul Klee, and the memoirs of her youth record the deep impression that this first encounter had on her.

In February 1901 they got to know and understand each other better through music. The lively, widely read, cultured girl, with her effervescent vitality naturally attracted Paul Klee. Now Lily Klee had to choose between her parental home and Paul Klee. With her infinite faith in Klee, the decision was not a hard one, and in 1906 they married in Bern, despite any uncertainty as to what the future would hold. It is only today that we can properly appreciate how right that choice was.

Up until 1918 she worked at full stretch, determined to free her husband from all material cares, giving up to fifty lessons a week in her pupil's homes, thereby making it possible – in her great love and admiration – for him to pursue his work undisturbed, without having to concern himself with their income.

However, this activity by no means completely occupied her. For she also took an interest in literature, continued with her own education, and spent her evenings together with Paul Klee playing music and in lively conversation with their many friends. Her belief in Klee always remained clear and strong.

1921 saw their move to Weimar, and Paul Klee's advancement through his appointment to the Bauhaus. This also meant that Lily Klee was relieved of any obligation to work for the family. Weimar, with all its memories of Goethe and Schiller, with its high level of culture, was a town in which Lily Klee naturally felt at home. Here she found the intellectual interest that was a fundamental requirement of her very being.

I shall never forget a visit that my mother and I made to Weimar in 1924. Lily Klee understood perfectly how to open Weimar up to us, how to introduce us to the historical past of this town. Lily Klee was happy, happy that Paul Klee now had the position that he deserved. Her life was focused entirely on him.

In 1927 the family moved to Dessau because Klee had been appointed to the Bauhaus there. The atmosphere that prevailed in the Klee household was not only created by Klee, but certainly also by Lily.

The home of the Klees was like a spiritual centre, constantly emitting new impulses. Particularly during that time, Lily's kind heart was in evidence. Many of Paul's students sought her advice, and she did indeed help many of them. Leading figures came to their house, honouring the maestro, respecting and admiring Lily. This was also the time when their immediate neighbours were the Kandinskys.

In 1931 Paul Klee was appointed Professor of Art at the Düsseldorf Academy.

This was a source of immense joy, and all of us who knew and admired Klee, shared in this joy. However, their feeling for Dessau was so strong that the Klees could never bring themselves to move once and for all to Düsseldorf.

Then came the heavy blow that was to affect them both.

I will never forget that day in 1933 when Paul Klee unexpectedly came to find me in Bern and told me that, during his absence, the Gestapo had searched the house in Dessau.

During that fateful time, Lily Klee demonstrated what a worthy and reliable person she was. Her own safety meant nothing to her. She thought purely and simply of Paul Klee, and it was at her insistence that Klee immediately left for Switzerland. Klee asked me to go to Dessau and to be of assistance to Lily.

There I did not find a bowed woman, but a person absolutely determined to save Klee and his work. She refused to be intimidated by the Gestapo, and she defended Klee and his work to the hilt. The decision was quickly made. Neither for Klee nor for Lily was there any choice other than to leave the country whose political stance they could not agree with, and which they were not prepared to tolerate, and to rebuild their life in Switzerland. I need say little of their time in Switzerland up until the death of Paul Klee because all of you shared in it.

Lily, with her spiritual vitality, her temperament, helped Paul Klee to build up a new, secluded existence which was immensely fulfilling to both. Her entire attention was devoted to Klee, to Klee's health and Klee's well-being.

For me the days of Paul Klee's death are just as unforgettable as those days in 1933. In Tessin I did not find a broken widow, wrestling with fate, but a composed person, whose first words were:
"I know what I have lost, but I also know that memory is the only paradise from which I cannot be banished; I know that through the death of my husband great duties now befall me, which I want to fulfil!"

And Lily Klee did indeed fulfil these duties with a loyalty to Paul Klee that went beyond death.

Besides her concern for the work of her late husband, she was also concerned for her children. In the last years of her life, Lily Klee had a heavy burden to bear. The uncertainty about the future and the whereabouts of her only, dearly loved son Felix weighed heavily on her. It was also a bitter hardship never to have seen her grandson. Nevertheless she did manage to have a very strong sense of this child through sparse items of news and just a few photographs. And the love with which she embraced her daughter-in-law and tried to comfort her was typical of her nature.

The news of Felix's return to his wife and his son shook Lily so deeply that she was not able to withstand the consequences of this turmoil. Similarly, her sister-in-law, Mathilde Klee, her only close relative living in Switzerland was so affected by this news that she is still confined to hospital and cannot be with us today.

Lily Klee always put herself second to Paul Klee. When she told me the news of the birth of her grandson, she said, "Paul has been granted a grandson. The heritage of the Klees continues!" No word of herself as grandmother.

Dear Lily Klee, your life is behind you. It was a rich life. You were given exceptionally much that was valuable, real, but you also had to carry a heavy burden. Your wish to see Felix, Frossca and Aljoscha before your death was not fulfilled. Shortly before your death you received the certain news that your son was still alive and had returned to his loved ones. In the fullness of that knowledge you departed this life. We, the friends of Paul Klee, your friends, we know, what you meant for Klee, but we also know what you mean to us: a person of value with an outstanding spirit. We thank you for that.

(hectographed typescript: Bürgi Archives, Bern)

Rolf Bürgi, '1922 – 1933 – 1939', in: *Du. Schweizerische Monatsschrift*,
Zurich, vol. 8, no. 10, October 1948, pp. 25f.:

Visit to Weimar, Summer 1922[7]

I had known Klee since my childhood, I knew that he was a painter and much admired by his friends. Now I was sixteen. Klee was a professor at the "Bauhaus", had exhibited successfully, and I was no longer a child when I travelled with my mother to Germany for the first time, to Weimar to see Klee. Would everything be just like it had been in Bern, where we spoke the "bärndütsch" dialect and were perfectly free and easy with each other?

Indeed it was, Klee had not changed. And he even looked just as he always had, with his Arab's beard, his deep black eyes, and his relaxed manner. No word of his worldly successes, just a quiet satisfaction that he had not disappointed his friends. We spoke "bärndütsch", the old sense of familiarity was there from the outset. He was happy to see my mother again, the first who had believed in him and who had been buying works from him since 1908 and hanging them in her own home. Much to the astonishment of her friends and relations who just smiled rather sceptically. If success pleased him then precisely because those who had believed in him proved to be right. It should be said that he retained this same modesty as long as he lived. We arrived at his flat, on the hill above the park in Weimar. It had very comfortable, old furniture, the grand piano in the centre, watercolours on the wall, the black cat on the sofa. There was always a cat, Klee loved cats, their calm, their philosophical adaptation to their owners' homes and work. We talked about Bern and mutual friends, his parents and school-fellows. And then, after supper, he fetched his violin and with his wife Lilly played Bach, Mozart. Mozart, whom he loved best of all composers. It was as though, having finished his work, he sought confirmation in music for all that he had made. Apart from occasional quartets, he played exclusively with his wife, and was happy that Lilly no longer had to earn their keep by giving music lessons as in Munich. Now he was earning, and Lilly had not trusted in his talent in vain. It was touching to feel that Klee was happy about his own success above all for her sake and for that of his friends. He said so too. He had wondered for a long time whether he should become a musician, now he knew that he had made the right choice. Now he was a painter. Everywhere people were beginning to be interested in him, in Berlin, even in Paris. Flechtheim came to see him, and later became his dealer, art critics came from abroad. Everything still fairly cautious, but promising.

Klee felt comfortable in Weimar. There was an opera company, concerts, people. Beautiful surroundings. And the Bauhaus with his colleagues. The next morning we went to his studio, through the park which he loved very much, past Goethe's garden house, the winding paths that so many had trodden before him, also on their way to work. We went many more times through the park, to Belvedere, to Tiefurt, and Klee showed us the things that interested him, the old memorial stones, one with a broken-off snake. As far as he was concerned, snakes were not sly creatures, he used to talk to them. Cats and

snakes had a similar meaning for him as they had for the ancient Egyptians. No coincidence that he allowed himself a journey to Egypt for his fiftieth birthday.

In Belvedere he showed us the open-air theatre where Goethe had played Orest in Iphigenie, he recited a few lines, inspired by the genius loci. He showed us how modestly the people of Weimar had lived in Tiefurt, when the now ancient park was still a tree nursery, laid out according to Goethe's instructions. Any form of grandiosity was distasteful to him, here he felt himself with kindred spirits.

The Bauhaus was filled with activity. Gropius was director, Kandinsky had arrived the winter before, Moholy-Nagy and Schlemmer were also there. He talked well of them all. He greatly admired Kandinsky, his clarity, his courage, the constructive composition of his pictures. Precisely because he himself was quite different. The two of them were already friends by then and stayed that way until death. Klee's studio was like an alchemist's kitchen. In the middle there were several easels, one chair. He always used to work on several pictures at once, the formats were still small at that time. Everywhere paint powder, oils, little bottles, little boxes, matchboxes. Whatever he needed for painting, he made himself. That paid off; I only know of one picture that did not last for technical reasons, and he painted a new one for the owner. My mother had brought roses for him. Klee arranged them carefully in a vase, just as he did everything with great circumspection. Painting, dressing – he always looked very clean – cooking. For Klee could cook, Italian food, enviably well. It had always been like that, from the earliest days of their marriage. He spoke about his pictures, quite simply, but helpfully. "I had to do it like that so that the birds could sing." He loved birds too, used to observe them in the park, listened to their music. A little later he painted his "Zwitschermaschine" which was in the National Gallery in Berlin, and "Die gelben Vögel", now with Doetsch-Benziger in Basel. Now he had students whom he was to initiate into the secrets of art. Klee took it very seriously and delighted in learning so much as he did so, through having to deal with problems that came to him from outside. The students loved him, because he was also very careful in the way he treated them. Many made names for themselves. He taught them never to pretend. He saw that as the greatest danger for young people.

We stayed for five days. Every day was beautiful, exhilarating, harmonious. Klee loved harmony in life as in music and in painting. We went for walks, every evening there was music, there were long conversations with my mother, but Klee also talked with me about art, and even more about philosophical and religious questions. He was very widely read and knew Kant just as well as he knew the eastern scholars. He was not as eastern as Kandinsky, but also not as western as Picasso. He was half-way between the two, receiving and passing things on. He also talked about his parents; he respected his father, the musician, but it seems that he had inherited more from his mother, as a musician and a painter. She was born in the west of Switzerland, her own mother came from the

[7] In fact this visit took place in August 1925, see p. 18 in this volume.

south of France, her family tree points to Algiers. Could this have been the source of Klee's interest in Islam?

Our days were at an end, we bade farewell, travelled back to his and our home town of Bern. Richly laden with good wishes and greetings and with the feeling that in Weimar lived a great man, worthy of those who had lived there before him.

Farewell to Germany in 1933

It is summer 1933. I am sitting in my office; a knock at the door – come in – Paul Klee enters. Rather pale, over-tired, uneasy. A few days previously he had returned to his home in Dessau from Düsseldorf, where he had been teaching since 1931, to find distress and disorder. The Nazis had searched the house, raked through everything, and had taken away three baskets of letters, notes and other documents. He declared that he could not live in a country like that. His question was whether I was willing to go to Dessau and to arrange everything for him, the move, the transfer of residence to Bern, negotiations with the authorities for the return of the confiscated goods. Meanwhile Klee himself was keen to spend a few days recovering and to travel to Italy.

Thus began my work for Klee; of course it concerned more the external business of living, but I was happy to relieve him of these matters, and hence to be involved in his life and work as my mother had been.

I travelled to Dessau, retrieved the three baskets of papers, sorted through them one night while the uniforms were noisily active down below, arranged Klee's departure from Germany and the move to Switzerland, and even managed to elicit an agreement that Klee would not be importuned if he should return to Dessau and Düsseldorf to regulate his affairs.

It was an unsettling time for Klee. Was this his reward? He knew that there were goodhearted Germans who were loyal to him, but they were scarcely able to help; most of them were themselves enduring hardship. And the collectors with whom he felt a bond, hardly dared to go on buying works. His departure from Germany was a risk in the sense that he had earned his living mainly by sales in Germany. Fate showed he made the right decision, things were deteriorating from one day to the next in Germany, and Klee's prospects abroad were improving. In Paris there were exhibitions and contracts, and on his return to Bern his first major, retrospective exhibition. Swiss museums bought his works, private collectors became more numerous – in short, Klee's hasty decision was rewarded, his work was saved. It not only continued in Bern, but was filled with new energy. Kistlerweg became the setting for his most mature works, and the destination for art pilgrims from all four corners of the world. Klee had become a European and was now all the more gladly Bernese too.

This is now my Matterhorn, Summer 1939

Klee is ill, very ill. Walks are a strain for him, he is almost entirely tied to his studio. Talking is also a strain for him. And he cannot play the violin any more, nor can he go to concerts. He needs the strength that remains to him for his work. That is all he lives for now. It is one year before his death. Does he know that he has to die?

We know it and are sad. Would like to help, but how? We think of every possible alleviation, of treatment, of his nutrition, and of how we can give him pleasure now and again. My wife calls by every so often with Fredi, and takes him a bunch of flowers, or a book, or some good news. And now and then I go over with my little horse-drawn carriage, set him in it, and take him for a drive. In the Bremgarten Wood, into the surrounding district. After one of those drives, one day he gave us a little drawing, "Landschaft des Pferdes" from 1923[8]. A precious souvenir. Klee enjoys the open air and nature which is so indispensible to him and he gladly breathes the summer air. He is tired, but content. He does not talk much, but after so many years of friendship we know what he is thinking, and he knows what we are thinking, and how much we love him. The love of his friends means more to him than the fame which is now his. Everything else has fallen away from him, he has no wishes. But one day it suddenly occurs to him that he would like, just once more, to see a proper little female circus rider, the kind we have admired in circuses, with a little ballet skirt and all the trimmings. Thoughts of a butterfly, a dragon-fly? We are able to fulfil his wish, and Klee comes with us once again to the Circus Knie.

The last concert he hears is conducted by Hößlin, the last soloist he hears is Szigetti, the last books that he reads are Greek tragedies and poetry in the original. Only his close friends visit him in his apartment on Kistlerweg, Hermann Rupf and his wife, Dr. Kayser, Dr. Meyer-Benteli, Blösch, his old schoolfriend. People talk about things that do him good, but the horizon is constantly darkening, one cannot avoid mentioning the war that is looming. Klee declares that he could not bear another war, in that case he would rather not be alive any more. He is right, he dies just as the struggle is beginning, he is spared the worst, but he also does not live to see the spirit of Evil extinguished.

In his studio everything looks as it used to. Klee works less, but intensely, large formats, new ideas both technically and artistically. The studio is now in fact too cramped, but modestly he manages and as always makes a virtue out of necessity. In any case he has to sit down while he is working. Bimbo, the Prince, a white angora cat has been his "Ka" for years, a spirit linking the different realms of nature. Apart from this, he does not like anyone to come into his studio. He is drawing things to a close, recording his last experiences in paintings and drawings.

It was from this balcony that he saw the Virgin. That was then. Now it is the red of evening, all day long. He will never set foot on a mountain path again. One day my wife goes a little way with him along the road, just a few steps, but Kistlerweg is on a slight incline. Klee in good health had never noticed that. Now he says, smiling quietly, "This is now my Matterhorn." That's how Klee was. He transposed ideas, was wise, and had no fear even of death. He had already experienced it in his spirit and in truth however many times, and had even portrayed it. "Geister der Abgeschiedenheit", "Angelus novus", "Engel im Werden", "Der Teufel jongliert" – indeed, he juggles, but Good is victorious, and Klee, who brought stars from the heavens down onto this earth, has now become one of those stars himself.

[8] Cat. no. 76.

List of Exhibitions

Exhibitions 1940–1946
(organised by Lily Klee and Rolf Bürgi)

Gedächtnisausstellung Paul Klee 1979–1940, Graphische Sammlung, ETH, Zurich, 19.10–21.12.1940 (no catalogue; 236 loans from the estate of Paul Klee)

Gedächtnisausstellung Paul Klee / Paul Kunz, Bern. Plastik, Kunsthalle Bern, 9.11–8.12.1940 (catalogue; 92 loans and 141 works for sale from the estate of Paul Klee)

Gedächtnisausstellung Paul Klee, Kunsthalle Basel, 15.2–23.3.1941 (catalogue; 358 exhibits, including 234 loans and 83 works for sale from the estate of Paul Klee and 12 loans from Rolf Bürgi)

Allianz. Vereinigung moderner Schweizer Künstler, Kunsthaus Zurich, 23.5–21.6.1942 (catalogue; 12 exhibits, including 5 loans and 3 works for sale from the estate of Paul Klee)

[Paul Klee], Galerie Bettie Thommen, Basel, approx. 26.9–24.10.1942 (no catalogue; 3 loans and 18 works for sale from the estate of Paul Klee)

Abstrakte und surrealistische Kunst in der Schweiz. Klee, Wiemken, Bill, Bodmer, Brignioni, Erni, Fischli, Museum Allerheiligen, Schaffhausen, 17.1–24.2.1943 (catalogue; 19 exhibits, including 6 loans und 5 works for sale from the estate of Paul Klee)

[Masken- und Fasnachtsbilder], Kunstmuseum Basel, from approx. March 1943 (no catalogue; including ca. 15 loans from the estate of Paul Klee)

Ausstellung: Moderne Malerei, Palace-Hotel, Gstaad, 30.7–15.8.1943 (catalogue; 2 loans and 4 works for sale from the estate of Paul Klee)

[Paul Klee], Kunst-Chammer, Zurich, approx. November 1943–approx. February 1944 (no catalogue; 15 works for sale from the estate of Paul Klee)

Paul Klee / Marc Chagall, Hans Ulrich Gasser, Zurich, until approx. 25.3.1944 (no catalogue; including several works for sale from the estate of Paul Klee)

Konkrete Kunst, Kunsthalle Basel, 18.3–16.4.1944 (catalogue; 16 exhibits, including 4 loans und 7 works for sale from the estate of Paul Klee)

Paul Klee zum Gedächtnis, Galerie Rosengart, Lucerne, 15.7–15.9.1945 (catalogue; 45 works on loan or for sale from the estate of Paul Klee)

[Group exhibition, including Paul Klee], Galerie d'art moderne, Basel, approx. 14–28.4.1945 (no catalogue; including several works for sale from the estate of Paul Klee)

[Paul Klee], Galerie d'art moderne, Basel, 3.11–approx. 10.12.1945 (no catalogue; 16 loans and 29 works for sale from the estate of Paul Klee)

Paul Klee 1879–1940, Tate Gallery in the National Gallery, London, [22] December 1945–February 1946 (catalogue; 137 exhibits, including 101 loans from the estate of Paul Klee and 14 loans from Rolf Bürgi)

Paul Klee 1879–1940, organised by the Arts Council of Great Britain, London: Castle Museum, Norwich, 11.5–1.6.1946; Graves Art Gallery, Sheffield, 8–29.6.1946; Hanley Public Museum and Art Gallery, Stoke-on-Trent, 6–27.7.1946; Art Gallery and Industrial Museum, Aberdeen, 3–24.8.1946; Bluecoat Chambers, Liverpool, 31.8–21.9.1946; City Art Gallery, Manchester, 28.9–19.10.1946 (catalogue; 51 exhibits, including 49 loans from the estate of Paul Klee and 1 loan from Rolf Bürgi)

Exhibitions 1947–1952 (organised by the Paul Klee Foundation and the Klee Society)

Ausstellung der Paul Klee–Stiftung, Kunstmuseum Bern, 22.11–31.12.1947 (catalogue; 365 exhibits)

Paul Klee 1879–1940, Musée National d'Art Moderne, Paris, 4.2–1.3.1948 (catalogue; 365 exhibits)

Paul Klee (1879–1940), Palais des Beaux-Arts, Brussels, March [6.3–1.4.] 1948 (catalogue; 365 exhibits)

XXIV Biennale di Venezia, Biennale, Venice, 6.6–10.10.1948 (catalogue; 18 loans from the Klee Society)

Paul Klee, Stedelijk Museum, Amsterdam, 9.4–13.6.1948 (catalogue; ca. 365 exhibits)

Paul Klee–Stiftung, Kunsthaus Zurich, 22.9–17.10.1948 (catalogue; 300 exhibits)

Aus der Stiftung Paul Klee, Kunsthalle Basel, 27.10–21.11.1948 (catalogue; 196 exhibits)

Späte Arbeiten von Paul Klee (1879–1940). Leihgaben der Paul-Klee-Gesellschaft, Bern, Hetjens-Museum, Düsseldorf, November–December 1948 (catalogue; 40 exhibits)

Paul Klee, Kunstverein Hamburg in der Hamburger Kunsthalle, 8.1–13.2.1949 (no catalogue; 91 exhibits, including 40 loans from the Klee Society)

Touring exhibition in the USA 1949/1950: Part 1 entitled *Paul Klee Foundation*, Part 2 entitled *Paul Klee: Paintings and Prints*. One catalogue, probably to cover both parts: *Paintings, drawings, and prints by Paul Klee from the Klee Foundation, Bern, Switzerland with additions from American collections*. The venues were:

(Part 1) San Francisco Museum of Art, 24.3–2.5.1949; Portland Art Museum, 16.5–21.6.1949; The Detroit Institute of Arts, 15.9–9.10.1949; The City Art Museum of St. Louis, 3.11–5.12.1949; The Museum of Modern Art, New York, 20.12.1949–14.2.1950; The Phillips Gallery, Washington, 4.3–10.4.1950; The Cincinnati Art Museum, 19.4–24.5.1950 (catalogue; 202 exhibits, including 189 loans from the Paul Klee Foundation) (Part 2) University of Texas, Austin, 19.9–10.10.1949; Northwestern University, Evanston, 24.10–14.11.1949; Smith College Museum of Art, Northampton, 28.11–19.12.1949; Norfolk Museum of Arts and Sciences, 1–22.1.1950; Vassar College, Poughkeepsie, 6–27.2.1950; Germanic Museum, Harvard University, Cambridge, 13.3–3.4.1950; Wellesley College, 17.4–8.5.1950; Grand Rapids Art Gallery, 22.5–12.6.1950

Späte Werke von Paul Klee. Leihgaben der Paul-Klee-Gesellschaft, Bern, Kunsthalle Mannheim, April [2.4–1.5.] 1949 (catalogue; 39 exhibits)

Späte Werke von Paul Klee. Leihgaben der Paul-Klee-Gesellschaft, Bern, Kunstverein, Freiburg i. Br., May 1949 (catalogue, 40 exhibits)

Der Blaue Reiter. München und die Kunst des 20. Jahrhunderts. 1908–1914, Haus der Kunst, Munich, September–October 1949 (catalogue; 50 exhibits, including ca. 10 loans from the Klee Society members)

Der Blaue Reiter 1908–14. Wegbereiter und Zeitgenossen. Kandinsky, Marc, Macke, Klee, Kunsthalle Basel, 21.1–26.2.1950 (catalogue; 60 exhibits, including 26 loans from the Klee Society and the Klee Society members)

Paul Klee, 1879–1940. Ausstellung aus Schweizer Privatsammlungen. Zum 10. Todestag 29. Juni 1950, Kunstmuseum Basel, 29.6–20.8.1950 (catalogue; 102 exhibits, including 87 loans from the Klee Society members)

L'Œuvre du XXe siècle. Peintures, sculptures, Musée National d'Art Moderne, Paris, May–June 1952 (catalogue; 5 exhibits, including 3 loans the Klee Society members)

Paul Klee, Kunstmuseum Winterthur, 14.9–2.11.1952 (catalogue; 99 exhibits, including 75 loans from the Paul Klee Foundation and the Klee Society members)

Notes:
The following works are not shown in Edinburgh: nos. 13, 15, 31, 38, 42, 47, 55, 68, 75, 89, 107, 145–147
Italics have been used for Klee's own entries in his handwritten œuvre catalogue, for alternative titles and technique, as well as for signatures and inscriptions on the works themselves. The numbers after the German titles are taken from Klee's œuvre catalogue and refer to the year and Klee's own ordering within that year.

1

Kinderzeichnung, fünf Geschwister darstellend, 1885–1889
Child's Drawing, Portraying Five Siblings
Coloured pencil and pencil on paper on card
18.3/16×14/13.3 cm; inscribed lower left on the card above border line with pen: *Kinderzeichnung, fünf Geschwister darstellend.*
Provenance: Lily Klee, Bern (1940–1946); Klee Society, Bern (1946–1950); Rolf Bürgi, Klee Society, Bern (1950–1952); Rolf Bürgi, Belp (1953–1967)
Location: Private collection

2

Ohne Titel, 1898
Untitled
Pencil on drawing paper from a sketch book
12.4×17 cm; signed lower left with pencil: *PK*; inscribed lower left with pencil: – *IX – 98*
Provenance: Mathilde Klee, Bern (until 1950); Rolf Bürgi, Klee Society, Bern (1950–1952); Rolf Bürgi, Belp (1953–1967)
Location: Private collection

3

Jungfrau (träumend), 1903,2
Virgin (dreaming)
Jungfrau im Baum
Radierung (geätzt) auf Zink; A
Etching on zinc; proof prior to numbered edition
23.6×29.8 cm; signed bottom centre on the plate: *P. K.* – on lower right edge of the plate with pencil: *Paul Klee f.*; inscribed centre bottom on the plate: *Jungfrau (träumend)* – below this: *Bern Juli 03* – on lower left edge of the plate with pencil: *Jungfrau im Baum (3. Inv.)* – on the right with pencil: *Juli 03. ("unpassendes" Geschenk)*
Provenance: Rolf and Käthi Bürgi, Belp (until 1967)
Location: Private collection

4

Erste Fassung "Weib und Tier", 1903
First Version "Woman and Beast"
Etching; printed in small edition
21.7×28.2 cm; signed lower right on the plate: *P. K.*; inscribed lower right on the plate: *Juli 03 (Bern)* – with pencil: *"Weib & Tier" V. Abzg. I. Platte.*
Provenance: Hanni Bürgi, Bern (before 1937–1938); Rolf Bürgi, Belp (1938–1967)

Location: Private collection
Related work: *Weib u. Tier.*, 1904,13, cat. no. 7

5

ein Mann versinkt vor der Krone, 1904,11
A Man Sinks down before the Crown
Radierung auf Zink, geätzt; A
Etching on zinc; proof prior to numbered edition
15.9×15.9 cm; signed lower right on the plate: *PK.* – above lower right edge of the plate with pencil: *Klee*; inscribed lower right on the plate: *Bern Dez. 04 Inv. Nr 7.* – on lower left edge of the plate with pencil: *1904 11*
Provenance: Lily Klee, Bern (1940–1946); Klee Society, Bern (1946–1950); Rolf Bürgi, Klee Society, Bern (1950–1952); Rolf Bürgi, Belp (1953–1967)
Location: Private collection

6

Perseus. (der Witz hat über das Leid gesiegt.), 1904,12
Perseus. (Wit has Triumphed over Grief.)
Der neue Perseus
Radierung auf Zink geätzt; A
Etching on zinc; first trial proof
12.6×14 cm; signed lower right on the plate: *PK* – above lower right edge of the plate with pencil: *Klee*; inscribed lower left on the plate: **Perseus. (der Witz hat über das Leid gesiegt.)** – lower right: *Bern Dez 04* – below this: *Inv. 8.* – on lower left edge of the plate with pencil: *1 Probeabzug.* – above lower right edge of the plate with pencil: *1904. 12.*
Provenance: Lily Klee, Bern (1940–1946); Klee Society, Bern (1946–1950); Rolf Bürgi, Klee Society, Bern (1950–1952); Rolf Bürgi, Belp (1953–1967)
Location: Private collection

7

Weib u. Tier., 1904,13
Woman and Beast
Radierung, auf Zink, geätzt; A
Etching on zinc; edition, no. 8/20
20×22.8 cm; signed lower left on the plate: *P. K.* – on lower right edge of the image with pencil: *Klee*; inscribed upper right on the plate: *(1. Inv.) Weib u. Tier.* – lower left: *1 Inv 1. Bern Nov. 04.* – on lower left edge of the plate with pencil: *8/20 Pl. zerstört.* – on the right with pencil: *1904. 13.*
Provenance: Lily Klee, Bern (1940–1946); Klee Society, Bern (1946–1950); Rolf Bürgi, Klee Society, Bern (1950–1952); Rolf Bürgi, Belp (1953–1967)
Location: Private collection
Related work: *Erste Fassung "Weib und Tier"*, 1903, cat. no. 4

8

Komiker. (Inv. 4), 1904,14
Comedian. (Inv. 4)
Komiker II. Fassung
auf Zink, geätzt; A

Etching on zinc; first trial proof
17.7×24.4 cm; signed lower right on the plate: *P. K.* – on lower right edge of the plate with pencil: *Paul Klee.*; inscribed centre bottom on the plate: *Komiker. (Inv. 4.)* – lower right: *Bern 04 März* – on lower left edge of the plate with pencil: *1. Probedruck* – on the right with pencil: *Probe Abzg. 1904 14*
Provenance: Lily Klee, Bern (1940–1946); Klee Society, Bern (1946–1950); Rolf Bürgi, Klee Society, Bern (1950–1952); Rolf Bürgi, Belp (1953–1967)
Location: Private collection
Related works: *Der Komiker*, 1903,3, etching on zinc, 11.8×16.1 cm; *Komiker*, 1904,10, etching, 14.6×15.8 cm

9

Pessimistische Symbolik des Gebirges. (Inv. 11.), 1904
Pessimistic Symbol of the Mountains. (Inv. 11.)
Etching on zinc; printed in small edition
14.6×6.9 cm; signed lower right on the plate: *PK*; inscribed lower left on the plate: *Pessimistische Symbolik des Gebirges. (Inv. 11.)* – lower right: *04. Bern Juli*
Provenance: Lily Klee, Bern (1940–1946); Klee Society, Bern (1946–1950); Rolf Bürgi, Klee Society, Bern (1950–1952); Rolf Bürgi, Belp (1953–1967)
Location: Private collection
Related work: *Weibl. Akt in e. Hemd schlüpfend*, 1905,4, pencil on paper on card, 15.7×7.4 cm, E.W.K., Bern

10

Greiser Phönix (Inv. 9), 1905,36
Aged Phoenix (Inv. 9)
Radierung auf Zink, geätzt; A
Etching on zinc; proof prior to numbered edition
27.1×19.8 cm; signed lower right on the plate: *P.K.* – centre right on lower edge of the plate with pencil: *Klee*; inscribed lower right on the plate: *Greiser Phönix (Inv. 9.)* – below this: *Bern März 05* – on lower right edge of the plate with pencil: *1905. 36.*
Provenance: Hanni Bürgi, Bern (before 1937–1938); Rolf Bürgi, Belp (1938–1967)
Location: Private collection

11

Drohendes Haupt, 1905,37
Menacing Head
Radierung auf Zink, geätzt; A
Etching on zinc; proof prior to numbered edition
19.5×14.3 cm; signed lower right on the plate: *PK.* – on the plate and on lower right edge of the plate with pencil: *Paul Klee*; inscribed lower left on the plate: *Drohendes Haupt* – lower right: *März 05 Bern.* – below this: *10. Inv. 10.* – on lower right edge of the plate with pencil: *1905. 37*
Provenance: Lily Klee, Bern (1940–1946); Klee Society, Bern (1946–1950); Rolf Bürgi, Klee Society, Bern (1950–1952); Rolf Bürgi, Belp (1953–1967)
Location: Private collection

12
Der Held mit dem Flügel, 1905,38
Winged Hero
Radierung auf Zink geätzt; A
Etching on zinc; unnumbered print
25.7×16 cm; signed bottom centre on the plate, not
inked: *PK.* – on lower right edge of the plate with
pencil: *Klee*; inscribed centre bottom on the plate, not
inked: *Januar 1905. Inv. 2* – lower right: *Der Held mit
dem Flügel. Von der Natur mit einem Flügel besonders
bedacht, hat er sich daraus die Idee gebildet, zum
Fliegen bestimt zu sein, woran er zu Grunde geht.* – on
lower right edge of the plate with pencil: *für Lily*
Provenance: Lily Klee, Munich/Weimar/Dessau/
Düsseldorf/Bern (1905–1946); Klee Society, Bern
(1946–1950); Rolf Bürgi, Klee Society, Bern
(1950–1952); Rolf Bürgi, Belp (1953–1967)
Location: Private collection
Related work: *held m. flügel*, 1905,7, pencil on paper
on card, 22×11.5 cm, E.W.K., Bern

13
Strasse in der Hirschau, 1907,22
Road in the Hirschau
Kohle auf Ingres; B
Charcoal on paper on card
30.2×23.5 cm; signed upper right with pen: *Klee*; in-
scribed upper right with pen: *1907 22* – lower left on
the card with pen: *1907 22 Strasse in der Hirschau* –
verso lower left with pencil: *frau Bürgi*
Provenance: Alfred and Hanni Bürgi, Bern (1915–1919;
gift of the artist); Hanni Bürgi, Bern (1919–1938); Rolf
Bürgi, Belp (1938–1967)
Location: Private collection

14
Kinder auf e. Bauplatz, 1908,44
Children on a Building Site
pantographisch verkleinert Feder Leinenpapier; B
Pen on paper on card
17.2×26.2 cm; inscribed lower right with pen:
1908 44 – lower left on the card with pen: *Kinder auf
e. Bauplatz* – lower right with pen: *44*
Provenance: Lily Klee, Bern (1940–1946); Klee Society,
Bern (1946–1950); Rolf Bürgi, Klee Society, Bern
(1950–1952); Rolf Bürgi, Belp (1953–1967)
Location: Private collection

15
belebter Platz vom Balcon aus, 1908,62
Busy Square as Seen from the Balcony
der Balcon
Schwarzaquarell hinter Glas; B
Reverse-glass painting in pen and watercolour
28.5×22.4/22.7 cm; signed lower left with pen:
Paul Klee; inscribed lower left with pen: *1908*
Provenance: Lily Klee, Bern (1940–1946); Klee Society,
Bern (1946–1950); Rolf Bürgi, Klee Society, Bern
(1950–1952); Rolf Bürgi, Belp (1953–1967)
Location: Private collection
Related work: *belebte Strassen (mit d. Balcon)*,
1910,12, pen on paper, 16.3×13.5 cm, private collec-
tion, Switzerland

16
d Uhr auf d. Kredenz, 1908,69
The Clock on the Sideboard
Uhr auf der Kredenz, bei Kerzenlicht
Tonzeichnung, Schwarzaquarell, beilpap.; B
Pencil, pen and watercolour on paper on card
18.7×20.7 cm; signed upper left with pen: *Klee*;
inscribed lower left on the card with pen: *d Uhr auf
d. Kredenz* – lower right with pen: *1908 69*
Provenance: Hanni Bürgi, Bern (before 1931–1938;
probably purchased directly from the artist); Rolf Bürgi,
Belp (1938–1967)
Location: Private collection

17
Osterm. Steinbruch, 1909,27
Quarry of Ostermundigen
*Steinhauerzelte Arbeitshütte u. Felswand von unten im
Ostermundigensteinbruch bei Bern*
Feder auf schlechtes Papier; B
Pen on paper on card
21.7×27.7 cm; signed lower left with pencil: *Klee*;
inscribed lower left on the card with pencil: *Osterm.
Steinbruch* – lower right with pen: *27* – and with pen-
cil: *1909* – verso lower left in margin on the card with
pen: *1909 27*
Provenance: Lily Klee, Bern (1940–1946); Klee Society,
Bern (1946–1950); Rolf Bürgi, Klee Society, Bern
(1950–1952); Rolf Bürgi, Belp (1953–1967)
Location: Private collection

18
Laubwald, 1909,42
Deciduous Forest
Laubwald (Eggholz bei Bern)
Feder auf leinen; B
Pen on paper on card
26.2×14.8 cm; signed lower left with pen: *Klee*; inscri-
bed lower left with pen: *1909* – lower right on the
card with pencil: *Laubwald 1909* – and with pen: *42*
Provenance: Hanni Bürgi, Bern (before 1931–1938;
probably purchased directly from the artist); Rolf Bürgi,
Belp (1938–1967)
Location: Private collection

19
Landschft. mit d. Eiche, 1909,44
Landscape with the Oak Tree
Landschaft mit d. Eiche (Wittikofen b. Bern)
Feder auf bläulich leinen; B
Pen on paper on card
19.7×25.7 cm; signed lower left with pen: *Klee*; inscri-
bed lower left with pen: *1909.* – lower left on the card
with pencil: *Landschft. mit d. Eiche* – lower right with
pencil: *1909* – and with pen: *44*
Provenance: Hanni Bürgi, Bern (before 1931–1938;
probably purchased directly from the artist); Rolf Bürgi,
Belp (1938–1967)
Location: Private collection
Related work: *Wittikofen b. Bern*, 1909, 66, pen on
paper on card, 11×23 cm, The Wadsworth Atheneum,
Hartford, Gift of Beatrice H. Kneeland in memory of
Henry T. Kneeland

20
Aare-Bad, 1909,58
Bathing Place by the Aare
Aarebad bei Muri
Feder auf leinen; B
Pen on paper on card
22.5×26.5 cm; signed lower left on sheet and card
with pencil: *Klee*; inscribed lower right with pen:
Aare-Bad 1909 – lower right on the card with pen: *58*
– and with pencil: *1909* – verso lower left in margin on
the card with pen: *1909 58*
Provenance: Lily Klee, Bern (1940–1946); Klee Society,
Bern (1946–1950); Rolf Bürgi, Klee Society, Bern
(1950–1952); Rolf Bürgi, Belp (1953–1967)
Location: Private collection

21
Gepflegter Waldweg, 1909,62
Well-Tended Forest Path
Gepflegter Waldweg, Waldegg b. Bern
Tuschzeichnung auf bläulich leinen; B
Brush on paper on card
17.5×25.8 cm; signed lower right on sheet and card
with pencil: *Klee*; inscribed lower left on the card with
pencil: *Gepflegter Waldweg* – lower right with pencil:
1909
Provenance: Alfred and Hanni Bürgi, Bern
(1909/1911–1919; purchased directly from the artist
for 100 francs); Hanni Bürgi, Bern (1919–1938); Rolf
Bürgi, Belp (1938–1967)
Location: Private collection
Related work: *gepflegter Waldweg (Waldegg b. Bern)*,
1909,16, reverse-glass painting in pen, brush and
scratched drawing, 13×18 cm, Paul Klee Foundation,
Kunstmuseum Bern

22
junge Allee, 1910,18
Avenue Lined with Young Trees
*Junge Allee, Militäravenue auf dem Oberwiesenfeld
bei München*
Feder auf leinen; B
Pen on paper on card
10.5×20.2 cm; signed lower left with pen: *Klee*; inscri-
bed lower left with pen: *1910* – lower left on the card
with pencil: *junge Allee* – lower right: *18 1910*
Provenance: Hanni Bürgi, Bern (1921–1938; purchased
directly from the artist for 60 francs); Rolf Bürgi, Belp
(1938–1967)
Location: Private collection
Related works: *Junge Allee*, 1910,22, etching,
15.2×22 cm, Paul Klee Foundation, Kunstmuseum
Bern; *Ohne Titel*, 1910, etching, 15.2×21.7 cm, private
collection, Switzerland

23
Flieder, 1910,25
Lilacs
Tonzeichnung Schwarzaquarell auf Zeichenpapier; B
Watercolour and pencil on paper, verso pen and brush
19.4×29.1 cm; signed lower left with pen: *Klee*;
inscribed lower left with pen: *1910* – and with pencil: *25*
Provenance: Hanni Bürgi, Bern (before 1931–1938;
probably purchased directly from the artist); Rolf Bürgi,
Belp (1938–1967)
Location: Private collection

24
Aare b. Bern, 1910,38
Aare near Berne
Aare unterhalb Muri, viel Wasser
Feder auf leinen; B
Pen on paper on card
15.5×27.3 cm; signed lower right on sheet and card
with pen: *Klee*; inscribed lower left on the card with
pen: *Aare b. Bern* – lower right with pen: *1910 38*
Provenance: Hanni Bürgi, Bern (before 1931–1938;
probably purchased directly from the artist); Rolf Bürgi,
Belp (1938–1967)
Location: Private collection

25
Gürbemündung, 1910,68
Mouth of the Gürbe
Gürbemündung in d. Aare
Feder u Pinsel naß in naß auf Ingres; B
Pen and brush, wet in wet, on paper on card
18×23.7 cm; signed upper left with pencil: *Klee*;
inscribed lower left on the card with pencil:
Gürbemündung – lower right with pencil: *1910* – and
with pen: *68*
Provenance: Homberger, Munich; Rolf and Käthi Bürgi,
Belp (until 1967)
Location: Private collection

26
Häuser im Park, 1910,72
Houses in the Park
Häuser im Park, sehr fleckig, ziemlich tief
Feder u. Pinsel naß in naß leinenpap; B
Pen and brush, wet in wet, on paper on card
10.4×17.5 cm; signed upper right with pencil: *Klee*;
inscribed lower left on the card with pencil: *Häuser im*
Park – lower right with pen: *72* – and with pencil: *1910*
– below this with pencil: *mr. l. Mama Neujahr 1914*
Provenance: Ida Klee-Frick, Bern (1914–1921; gift of
the artist); Hans Klee, Bern (1921–1940); Mathilde
Klee, Bern (1940–1950); Rolf Bürgi, Klee Society, Bern
(1950–1952); Rolf Bürgi, Belp (1953–1967)
Location: Private collection
Related work: *Häuser im Park (November)*, 1910,80,
pen and brush, wet in wet, on paper on card,
11.5×17.7 cm, Kunstmuseum Thun, Bequest of Mr
and Mrs Surbek-Frey

27
Radkrahn im Steinbruch, 1910,107
Crane in the Quarry
Kalte Nadel auf Celluloid; B
Drypoint on celluloid; printed in small edition
13.2×9.7 cm; signed upper right on the plate: *Klee* –
on lower right edge of the plate with pencil: *Klee*;
inscribed upper right on the plate with pencil: *1910*
107 – on lower left edge of the plate with pencil:
Radkrahn im Steinbruch – on the right with pencil:
1910 107
Provenance: Lily Klee, Bern (1940–1946); Klee Society,
Bern (1946–1950); Rolf Bürgi, Klee Society, Bern
(1950–1952); Rolf Bürgi, Belp (1953–1967)
Location: Private collection
Related work: *Krahn im Steinbruch*, 1910,41 pen on
paper on card, 13.4×10.4 cm, Paul Klee Foundation,
Kunstmuseum Bern

28
Krahn im Steinbruch, 1910,111
Crane in the Quarry
Krahn im Steinbruch (aufgenommen im
Stockerensteinbr.)
Fed. u. Pinsel n. i. n. Leinen; B
Pen and brush, wet in wet, on paper on card
23×18 cm; signed lower right with pen: *Klee*; inscribed
lower left on the card with pen: *Krahn im Steinbruch* –
lower right with pen: *1910 111.*– lower left in margin
on the card with pen: *39*
Provenance: Lily Klee, Bern (1940–1946); Klee Society,
Bern (1946–1950); Rolf Bürgi, Klee Society, Bern
(1950–1952); Rolf Bürgi, Belp (1953–1967)
Location: Private collection

29 (not illustrated)
Bahnhof, 1911,26
Station
auf Celluloid geritzt; B
Drypoint on celluloid; edition, no. 12/30
14.8×19.9 cm; signed on lower right edge of the plate
with pencil: *Klee*; inscribed upper right on the plate
with pencil: *1911 26* – on lower left edge of the plate
with pencil: *Bahnhof 12/30*
Provenance: Lily Klee, Bern (1940–1946); Klee Society,
Bern (1946–1950); Rolf Bürgi, Klee Society, Bern
(1950–1952); Rolf Bürgi, Belp (1953–1967)
Location: Private collection
Related works: *München Hauptbahnhof II*, 1911,25,
pen on paper on card, 9.1×19.6 cm, Paul Klee Founda-
tion, Kunstmuseum Bern; *München Hauptbahnhof*,
1911,23, pen on paper on card, 13.4×23 cm, private
collection, Switzerland; *München Hauptbahnhof I^*,
1911,86, pen on paper on card, 12.1×20.9 cm, private
collection, Switzerland

30
Junger Mañ, ausruhend, 1911,42
Young Man Resting
mit kleinem Pinsel auf Leinenpap.; B
Brush and pencil on paper on card
13.8×20.2 cm; signed lower right on sheet and card
with pen: *Klee*; inscribed lower left on the card with
pen: *Junger Mañ, ausruhend* – lower right with pen:
1911 42
Provenance: Lily Klee, Bern (1940–1946); Klee Society,
Bern (1946–1950); Rolf Bürgi, Klee Society, Bern
(1950–1952); Rolf Bürgi, Belp (1953–1967)
Location: Private collection

31 (not illustrated)
Blick auf einen Fluss, 1912,2
Looking onto a River
Lithographie; B
Lithograph; trial proof
19.8×28.7 cm; signed upper right on the stone: *Klee* –
on lower right edge of the image with pencil: *Klee*; in-
scribed lower right on the stone: *Blick auf einen Fluss*
1912. 2.
Provenance: Lily Klee, Bern (1940–1946); Klee Society,
Bern (1946–1950); Rolf Bürgi, Klee Society, Bern
(1950–1952); Rolf Bürgi, Belp (1953–1967)
Location: Private collection

Related work: *Blick auf einen Fluss*, 1911,74, pen and
brush, wet in wet, on paper, dimensions and location
unknown

32
Fabrikanlage am Wasser (mit den 4 Kaminen),
1912,24
Factory Building by the Water (with the
4 Chimneys)
schlechtes Papier Feder; B
Pen on paper
20.9×32.3 cm; signed upper right with pencil: *Klee*;
inscribed upper right with pencil: *1912, 24*
Provenance: Lily Klee, Bern (1940–1946); Klee Society,
Bern (1946–1950); Rolf Bürgi, Klee Society, Bern
(1950–1952); Rolf Bürgi, Belp (1953–1967)
Location: Private collection

33
Junger Pierrot, 1912,99
Young Pierrot
Kopf von d. jungen Pierrot
Feder u. Pinsel naß in naß, Japanpergam.papier; B
Pen and brush, wet in wet, on paper on card
14.3×12.5/12 cm; signed upper left with pen: *Klee*;
inscribed lower left on the card above border line with
pen: *Junger Pierrot* – lower right with pen: *1912 99.*
Provenance: Hanni Bürgi, Bern (before 1931–1938;
probably purchased directly from the artist); Rolf Bürgi,
Belp (1938–1967)
Location: Private collection

34
Praecision zweier Candide-Figuren, 1912,170
Precision of Two Candide Figures
exacte Studien zu zwei Figuren
Blei Leinenpapier
Pencil on paper, verso drawing, on card
22.4×26.2 cm; signed lower right with pen: *Klee*;
inscribed lower right with pencil: *1912* – lower right
on the card with pen: *1912 170*
Provenance: Lily Klee, Bern (1940–1946); Klee Society,
Bern (1946–1950); Rolf Bürgi, Klee Society, Bern
(1950–1952); Rolf Bürgi, Belp (1953–1967)
Location: Private collection

35 (not illustrated)
Selbstmörder auf der Brücke, 1913,100
Suicide on the Bridge
Hand-printed rubbing of a line block after the drawing
Der Selbstmörder auf der Brücke, 1913,100
18.5×13 cm; signed lower left on the block: *Klee*;
inscribed on the block at the bottom: *1913 100*
Selbstmörder auf der Brücke
Provenance: Lily Klee, Bern (1940–1946); Klee Society,
Bern (1946–1950); Rolf Bürgi, Klee Society, Bern
(1950–1952); Rolf Bürgi, Belp (1953–1967)
Location: Private collection
Related work: *Selbstmörder auf der Brücke*, 1913,100,
pen on paper on card, 15.7×11.5 cm, The Busch-
Reisinger Museum, Harvard University Art Museums,
Cambridge, Bequest of Betty McAndrew

36
Kummer eines Schöpfers, 1913,103
A Creator's Grief
Kummer eines Vaters
Feder gelbl. Ingres, französ.; A
Pen on paper on card
7.9/7.5×18.3 cm; signed lower right with pen: *Klee*;
inscribed lower left on the card with pen: *Kummer
eines* [written over an erased word:] *Schöpfers* – lower
right with pen: *1913 103*
Provenance: Lily Klee, Bern (1940–1946); Klee Society,
Bern (1946–1950); Rolf Bürgi, Klee Society, Bern
(1950–1952); Rolf Bürgi, Belp (1953–1967)
Location: Private collection

37
im Kampf mit Raubtieren, 1913,144
Fighting with Beasts of Prey
Feder auf franz Ingres; A
Pen on paper on card
7.8×10 cm; signed upper right with pen: *Klee*; inscri-
bed below on sheet and card with pen: *1913 144 im
Kampf mit Raubtieren*
Provenance: Lily Klee, Bern (1940–1946); Klee Society,
Bern (1946–1950); Rolf Bürgi, Klee Society, Bern
(1950–1952); Rolf Bürgi, Belp (1953–1967)
Location: Private collection

38 (not illustrated)
Garten der Leidenschaft, 1913,155
Garden of Passion
Zink geätzt; A
Etching on zinc; unnumbered print
9.3×14.8 cm; signed on lower right edge of the image
with pencil: *Klee*; inscribed on lower left edge of the
image with pencil: *Garten der Leidenschaft*
Provenance: Gutekunst & Klipstein, Bern; Rolf & Käthi
Bürgi, Belp (until 1967)
Location: Private collection

39
Am Abgrund, 1913,157
On the Abyss
Feder gelbl. Ingres; A
Pen on paper on card
7.6×5.4 cm; signed upper left on sheet and card with
pen: *Klee*; inscribed bottom centre on the card below
border line with pen: *1913 157. Am Abgrund* – lower
left in margin on the card with pencil: *am Abgrund*
Provenance: Lily Klee, Bern (1940–1946); Klee Society,
Bern (1946–1950); Rolf Bürgi, Klee Society, Bern
(1950–1952); Rolf Bürgi, Belp (1953–1967)
Location: Private collection

40
Mittelalterl. Stadt, 1914,15
Medieval Town
Feder ital. Ingres
Pen on paper on card
14.6×7/7.3 cm; signed centre right with pen: *Klee*; in-
scribed lower left on the card with pen: *1914. 15. _
Mittelalterl. Stadt*
Provenance: Lily Klee, Bern (1940–1946); Klee Society,
Bern (1946–1950); Rolf Bürgi, Klee Society, Bern
(1950–1952); Rolf Bürgi, Belp (1953–1967)
Location: Private collection

41
Blick zum Hafen von Hamamet, 1914,35
View Towards the Harbour of Hammamet
Aquarell auf ital. Ingres
Watercolour on paper
21.5/21.7×26.6/27 cm; signed upper left with pen:
Klee; inscribed lower right with pen: *Blick zum Hafen
von Hamamet 1914 35*
Provenance: Karl Wolfskehl, Munich (from 1914;
purchased for 100 marks); Rolf and Käthi Bürgi, Belp
(until 1967)
Location: Private collection

42 (not illustrated)
Park, 1914,145
Park
Facsimile lithograph of the watercolour *Park*,
1914,145. The lithograph was published to accompany
the luxury edition of the 2nd special issues of *Der Ara-
rat* by Goltz-Verlag, Munich, May/June 1920.
12.7×10.2 cm; signed lower right on the stone: *Klee* –
in the lower right margin on the paper with pencil:
Klee; inscribed lower left on the stone: *1914 145* –
lower right: *Park*
Provenance: Lily Klee, Bern (1940–1946); Klee Society,
Bern (1946–1950); Rolf Bürgi, Klee Society, Bern
(1950–1952); Rolf Bürgi, Belp (1953–1967)
Location: Private collection
Related work (another fragment): *kl. Hafen*, 1914,146,
watercolour on paper on card, 15.5×14 cm, Gift of LK,
Klee Museum, Bern

43
Ohne Titel, 1914
Untitled
Oil and pencil on drawing paper on card
14.2×5.9/6.5 cm; inscribed by Lily Klee lower left on
the card with pen: *1914* – lower left in margin on the
card with pencil: *1914* – verso: authenticated by Lily
Klee and dated with the Estate stamp
Provenance: Lily Klee, Bern (1940–1946); Klee Society,
Bern (1946–1950); Rolf Bürgi, Klee Society, Bern
(1950–1952); Rolf Bürgi, Belp (1953–1967)
Location: Private collection
Related works (other fragments): *Ohne Titel*, 1914,193,
doppelte Nummer, oil and pencil on paper on card,
33.3×20.3 cm, private collection, Switzerland; *Ohne
Titel*, 1914, oil and pencil on paper on card,
16.7×5.9 cm, whereabouts unknown

44
A 1 unterer Stockhornsee, 1915,164
A 1 Lower Stockhornsee
Schwarzes Aquarell auf Canson
Watercolour on paper on card
18.4/18.8×24.2 cm; signed lower right with pen: *Klee*;
inscribed lower left on the card with pen: *A 1 unterer
Stockhornsee* – verso lower left with pencil: *für Frau
Bürgi*
Provenance: Alfred and Hanni Bürgi, Bern (1915–1919;
purchased directly from the artist for 100 francs);
Hanni Bürgi, Bern (1919–1938); Rolf Bürgi, Belp
(1938–1967)
Location: Private collection

45
A 2. oberer Stockhornsee, 1915,165
A 2. Upper Stockhornsee
Schwarzes Aquarell auf Canson
Watercolour on paper on card
20.3×31.5 cm; signed upper right with pen: *Klee*; in-
scribed lower left on the card with pen: *A 2. oberer
Stockhornsee* – verso lower left with pencil: *frau Bürgi*
Provenance: Alfred and Hanni Bürgi, Bern (1915–1919;
purchased directly from the artist for 100 francs);
Hanni Bürgi, Bern (1919–1938); Rolf Bürgi, Belp
(1938–1967)
Location: Private collection

46
A 3 Stockhornsee, 1915,166
A 3 Stockhornsee
Stockhornsee (trübes Wetter)
Schwarzes Aquarell auf Canson
Watercolour on paper on card
18.4/18.1×24.3 cm; signed upper right with pen: *Klee*;
inscribed lower left on the card with pen: *A 3 Stock-
hornsee* – verso lower left with pencil: *Frau Bürgi*
Provenance: Alfred and Hanni Bürgi, Bern (1915–1919;
purchased directly from the artist for 100 francs);
Hanni Bürgi, Bern (1919–1938); Rolf Bürgi, Belp
(1938–1967)
Location: Private collection

47
Ohne Titel, 1915,211 doppelte Nummer
Untitled
Etching; printed in small edition
15.8×11.5 cm; signed on lower right edge of the plate
with pencil: *Klee*; inscribed lower left on the plate:
1915 211. – on lower left edge of the plate with pen-
cil: *1915 211 bis*
Provenance: Lily Klee, Bern (1940–1946); Klee Society,
Bern (1946–1950); Rolf Bürgi, Klee Society, Bern
(1950–1952); Rolf Bürgi, Belp (1953–1967)
Location: Private collection

48
Zerstörung und Hoffnung, 1916,55
Destruction and Hope
Ruinen und Hoffnungen, erobertes Fort
Lithogr. handkoloriert
Lithograph, pencil and watercolour; trial proof
40.5×33 cm; signed lower right on the stone: *Klee* –
lower right in the margin on the paper with pencil:
Klee; inscribed in the lower right margin on the paper
with pencil: *1916 55 Ruinen und Hoffnungen,*
Provenance: Rolf Bürgi, Belp (before 1946–1967)
Location: Private collection

49
**(Hafenbild m. d. schwarzen Halbmond u. d.
indischroten Sonne), 1917,90**
**(Picture of a Harbour with the Black Half–Moon
and the Indian Red Sun)**
Hafenbild
Feder leicht aquarelliert, Wattman
Pen and watercolour on paper, lower marginal strip
with pen, on card
12/12.2×22.8 cm; signed upper right with pen: *Klee*;

inscribed lower left on the card with pen: *1917. 90.*
Provenance: Galerie Neue Kunst – Hans Goltz, Munich (from ?1920; on commission); Lily Klee, Bern (1940–1946); Klee Society, Bern (1946–1950); Rolf Bürgi, Klee Society, Bern (1950–1952); Rolf Bürgi, Belp (1953–1967)
Location: Private collection

50
Bildnis einer Rothäutigen, 1917,112
Portrait of a Woman with Red Skin
Gipsgrund auf Leinwand, rückseits
Watercolour on canvas, verso gesso ground, on card
17.3/18.2×12.9/12.1 cm; signed lower right with pen: *Klee*; inscribed lower left on the card below border line with pen: *1917 112.*
Provenance: Gesellschaft zur Förderung Deutscher Kunst des 20. Jahrhunderts, Neuss (1919–1922/1924; purchased directly from the artist for 230 marks); Auction in Essen, 8.12.1924; Hans und Maria Koch, Düsseldorf/Hegnau (until 1954); Käthi Bürgi, Belp (1954–1995)
Location: Private collection

51
Schiffsrevue, 1918,9
Review of Ships
Aquarell Flugzeugleinen kreidegrundiert
Watercolour on chalk ground on linen on card
13.3/13.8×25 cm; signed centre right with pen: *Klee*; inscribed lower left on the card below border line with pen: *1918. 9. Schiffsrevue* – verso upper left with pencil: *VII* – in the centre with pencil: *frau Bürgi-Bigler* – centre right with pencil: *29 1/2 – 31 1/2*
Provenance: Hanni Bürgi, Bern (1919–1938; purchased directly from the artist for 200 francs); Rolf Bürgi, Belp (1938–1967)
Location: Private collection

52
Die Zahlenhölle, 1918,145
The Numbers Hell
Bleistift schlechtes Papier liniert
Pencil and coloured pencil on lined paper on card
16.7×20.8 cm; signed lower right on sheet and card with pencil: *Klee*; inscribed lower left on the card with pencil: *Die Zahlenhölle 1918 145*
Provenance: Lily Klee, Bern (1940–1946); Klee Society, Bern (1946–1950); Rolf Bürgi, Klee Society, Bern (1950–1952); Rolf Bürgi, Belp (1953–1967)
Location: Private collection

53
Glockentöne, 1918,177
Sounds of Bells
Feder (Tinte) Leinenpapier
Pen on paper on card
28.7×22 cm; signed lower left with pen: *Klee*; inscribed lower right with pen: *Glockentöne* – lower left on the card with pen: *1918 177*
Provenance: Lily Klee, Bern (1940–1946); Klee Society, Bern (1946–1950); Rolf Bürgi, Klee Society, Bern (1950–1952); Rolf Bürgi, Belp (1953–1967)
Location: Private collection

54 (not illustrated)
Vogelkomödie, ca. 1918
Bird Comedy
Lithograph; unnumbered print
42.5×21.5 cm; signed upper right on the stone: *K* – lower right with indelible pencil: *Klee*; inscribed bottom centre in the margin on the paper with indelible pencil: *Vogelkomoedie 1918*
Provenance: Lily Klee, Bern (1940–1946); Klee Society, Bern (1946–1950); Rolf Bürgi, Klee Society, Bern (1950–1952); Rolf Bürgi, Belp (1953–1967)
Location: Private collection

55 (not illustrated)
Ausloeschendes Licht, 1919,176
Dying Light
Litho f. das Kestnerbuch
Lithograph; trial proof
13.5×12.5 cm; signed lower right on the stone: *Klee* – in the lower right margin on the paper with indelible pencil: *Klee*; inscribed lower left on the stone below border line: *Ausloeschendes Licht 1919. 176*
Provenance: Lily Klee, Bern (1940–1946); Klee Society, Bern (1946–1950); Rolf Bürgi, Klee Society, Bern (1950–1952); Rolf Bürgi, Belp (1953–1967)
Location: Private collection
Related work: *Auslöschendes Licht*, 1919,129, pen on paper on card, 13.4×12.1 cm, Galleria Flaviana, Locarno

56
Blumenstöcke (nach 1915 114), 1920,46
Pot Plants (after 1915,114)
Lithogr. f. d. Ztschrift Schweizerland
Lithograph; printed in small edition
15×12.5 cm; signed lower right on the stone: *Klee*; inscribed lower left on the stone: *1920 46*
Provenance: Lily Klee, Bern (1940–1946); Klee Society, Bern (1946–1950); Rolf Bürgi, Klee Society, Bern (1950–1952); Rolf Bürgi, Belp (1953–1967)
Location: Private collection
Related works: *Blumenstöcke*, 1915,114, pen on paper on card, 15.3×12.3 cm, E.W.K., Bern; *Litho nach 15/114*, 1923,74, lithograph, 24.4×17 cm

57
Esel im Garten, 1920,53
Donkey in the Garden
Feder Zeichenpapier
Pen on paper on card
6.8/7.4×19.1 cm; signed lower right with pen: *Klee*; inscribed lower left on the card below border line with pen: *1920 53 Esel im Garten*
Provenance: Galerie Neue Kunst – Hans Goltz, Munich (?1921 – at least 1925; on commission); Lily Klee, Bern (1940–1946); Klee Society, Bern (1946–1950); Rolf Bürgi, Klee Society, Bern (1950–1952); Rolf Bürgi, Belp (1953–1967)
Location: Private collection

58
Circus–Scene, 1920,60
Circus Scene
Feder Briefpapier
Pen on paper on card
12.1/12.3×25.4 cm; signed lower right with pen: *Klee*; inscribed lower left on the card below border line with pen: *1920. 60 Circus–Scene*
Provenance: Lily Klee, Bern (1940–1946); Klee Society, Bern (1946–1950); Rolf Bürgi, Klee Society, Bern (1950–1952); Rolf Bürgi, Belp (1953–1967)
Location: Private collection

59
Waldvogel, 1920,81
Forest Bird
Vogel auf dem Waldboden
Aquarell (mit vorherrsch. Rot) Schirtig kreidegrundiert
Watercolour and pencil on chalk ground on gauze on paper, strip of paper collaged top and bottom, on card
14.2×21.5 cm; signed lower right with pen: *Klee*; inscribed lower left on the card with pen: *1920. 81. Waldvogel.*
Provenance: Hanni Bürgi, Bern (before 1931–1938; probably purchased directly from the artist); Rolf Bürgi, Belp (1938–1967)
Location: Private collection
Related work (another fragment): *Giftbeeren*, 1920,92, watercolour and pencil on chalk ground on gauze on paper, paper strips added top and bottom, laid on card, 12.5×22 cm, whereabouts unknown

60 (not illustrated)
nach 1915/29, 1920,91
After 1915,29
Litho f. d. Jahrbuch "die Freude"
Lithograph; proof print
20.3×14.5 cm; signed centre right on the stone: *Klee*; inscribed lower left on the stone: *1920 91*
Provenance: Lily Klee, Bern (1940–1946); Klee Society, Bern (1946–1950); Rolf Bürgi, Klee Society, Bern (1950–1952); Rolf Bürgi, Belp (1953–1967)
Location: Private collection
Related work: *Ein Genius serviert e. kl. Frühstück*, 1915,29, pen on paper on card, 19/18.5×12.9 cm, E.W.K., Bern

61
Traumlandschaft mit Koniferen, 1920,110
Dream Landscape with Conifers
Aquarell auf Saturnrot imit. Japanpap.
(v. d. Semamappe)
Watercolour on paper (book printing paper), strip of paper collaged top and bottom, on card
17.6/17.8×21.9 cm; signed upper right with pen: *Klee*; inscribed lower left on the card above border line with pen, faded: *1920.110. Traumlandschaft mit Koniferen*
Provenance: Hanni Bürgi, Bern (before 1929–1938; probably purchased directly from the artist); Rolf Bürgi, Belp (1938–1967)
Location: Private collection

62
abstract–phantastischer Garten, 1920,131
Abstract–Imaginary Garden
Kl Ölbild Papier, auf Pappe aufgezogen
(neapelgelbrötliche Zone)
Oil with pen on paper on card
21.8/22×28.7 cm; signed lower left with pen: *Klee*; inscribed lower left on the card above border line with pen: *1920/131* – below this in pencil: *S. Kl* – lower left in margin on the card with pencil, trimmed: *I Klee*

Provenance: Lily Klee, Bern (1940–1946); Klee Society, Bern (1946–1950); Rolf Bürgi, Klee Society, Bern (1950–1952); Rolf Bürgi, Belp (1953–1967)
Location: Private collection

63
Inschrift, 1921,3
Inscription
Ölfarbezeichng (rot) und Aquarell französisch Ingres, dunkel
Oil transfer, pen and watercolour on paper, strip of silver paper collaged top and bottom, with spots of glue on card
23.8/24.5×31.5 cm; signed lower right with pen: *Klee*; inscribed lower left on the card with pen: *1921/3. –* lower right with pen: *Inschrift.*
Provenance: Lily Klee, Bern (1940–1946); Klee Society, Bern (1946–1950); Rolf Bürgi, Klee Society, Bern (1950–1952); Rolf Bürgi, Belp (1953–1967)
Location: Private collection
Related work: *Lega!*, 1920,108, pen on paper on card, 19.4×28.3 cm, whereabouts unknown

64
Bartolo: La vendetta, oh! la vendetta!, 1921,5
Bartolo: La vendetta, oh! la vendetta!
Ölfarbzeichng und Aquarell französ Ingres (Canson)
Oil transfer and watercolour on paper, watercolour strip top and bottom, strip of paper coloured with watercolour collaged along lower edge of the paper, on card
24.4/24.7×31.3/31.6 cm; signed lower right with pen: *Klee*; inscribed lower left on the card above border line with pen: *1921/5. Bartolo: La vendetta, oh! la vendetta!*
Provenance: Imre Reiner, Stuttgart (from 1929); Rolf and Käthi Bürgi, Belp (until 1967)
Location: Private collection
Related work: *Zeichnung zu Dr Bartolo 1921/5.*, 1921,40, pen on paper on card, 18.6×28.3 cm, Paul Klee Foundation, Kunstmuseum Bern

65
Hoffmaneske Märchenscene, 1921,123
Hoffmanesque Fairy–Tale Scene
Litho, 1 Schwarzer 2 farbige Steine für die Meistermappe des Bauhauses gestiftet.
Lithograph; trial proof from inked stone
28.3×21.6 cm; signed below lower right edge of the image with pencil: *Klee*; inscribed below lower left edge of the image with pencil: *1921/123 Probeabzug vom schwarzen Stein*
Provenance: Rolf Bürgi, Belp (before 1946–1967)
Related works: *Hofmañesces Scherzo*, 1918,182, pen on paper on card, 28.8×21.9 cm, whereabouts unknown; *Hoffmañeske Geschichte*, 1921,18, oil transfer and watercolour on paper on card, 31.1×24.1 cm, The Metropolitan Museum of Art, New York, The Berggruen Klee Collection

66
‹zu 1922/130 Sternbehälter›, 1921,194
‹For 1922,130 Star Container›
Zeichnung zu Sternbehälter
Federzeichnung Briefpapier
Pen and watercolour on paper on card
21.4/21.6×27.7 cm; signed upper right with pen: *Klee*; inscribed lower left with pencil: *1921* – bottom centre left on card above border line with pen: *1921 /// 194* – bottom centre with pencil, over-written with pen: ‹*zu 1922/130* – and with pen: *Sternbehälter*›
Provenance: Lily Klee, Bern (1940–1946); Klee Society, Bern (1946–1950); Rolf Bürgi, Klee Society, Bern (1950–1952); Rolf Bürgi, Belp (1953–1967)
Location: Private collection
Related work: *Kunstvoller Sternbehälter*, 1922,130, oil transfer and watercolour on paper on card, 23.5×28.7/29.7 cm, Yale University Art Gallery, New Haven, Gift of the Société Anonyme

67 (not illustrated)
Narretei, 1922,68
Folly
Lithographie 16 signierte Drucke, 3 Probedrucke: 2 Vorzustand 1 Probedruck, 16 numerierte Drucke draufhin Auflage (Mappe)
Lithograph; edition, no. 5/16
19.5×15.2 cm; signed lower left on the stone: *K* – over–written with pencil: *Klee*; inscribed lower left on the stone: *1922/68* – bottom centre in the margin on the paper with pencil: *“Narretei” Litho 5/16*
Provenance: Lily Klee, Bern (1940–1946); Klee Society, Bern (1946–1950); Rolf Bürgi, Klee Society, Bern (1950–1952); Rolf Bürgi, Belp (1953–1967)
Location: Private collection
Related work: *Narretei*, 1922,191, pencil on paper on card, 23.2×16.8 cm, E. W. K., Bern

68 (not illustrated)
Vulgaere Komoedie, 1922,100
Vulgar Comedy
Litho (nur 12 signierte Dr.) 10 numerierte Druck 1 Probedruck, 1 Nachlassdruck (12)
Lithograph; edition, no. 10/10
21.5×27.3 cm; signed lower right on the stone using the lithographed *K* with pencil: *Klee*; inscribed lower right on the stone: *1922/100* – in the lower margin on the paper with pencil: *Vulgaere Komödie Litho 10/10*
Provenance: Lily Klee, Bern (1940–1946); Klee Society, Bern (1946–1950); Rolf Bürgi, Klee Society, Bern (1950–1952); Rolf Bürgi, Belp (1953–1967)
Location: Private collection
Related work: *Vulgaere Komoedie*, 1922,105, pencil on paper on card, 26×30 cm, private collection, Switzerland

69 (not illustrated)
Die Hexe mit dem Kamm, 1922,101
The Witch with the Comb
Litho: Auflage vorausgehend 16 sign. 1 Probedruck 1 Nachl.druck 14 numerierte Drucke (16)
Lithograph; numbered print prior to the edition, no. 12/14
31×21.2 cm; signed bottom centre on the stone using the lithographed *K* with pencil: *Klee*; inscribed lower

left on the stone below border line: *1922/101* – lower right: *Die Hexe mit dem Kamm* – bottom centre in the margin on the paper with pencil: *Litho 12/14 ‹vor der Auflage›*
Provenance: Lily Klee, Bern (1940–1946); Klee Society, Bern (1946–1950); Rolf Bürgi, Klee Society, Bern (1950–1952); Rolf Bürgi, Belp (1953–1967)
Location: Private collection
Related work: *Die Hexe mit dem Kamm*, 1922, 83, pencil on paper on card, 28.8×21 cm, private collection, Switzerland

70
Postkarte "die erhabene Seite" zur Bauhaus-Ausstellung 1923, 1923,47
Postcard "The Sublime Aspect" for the Bauhaus Exhibition 1923
Litho mit 3 Farben und schwarz
Coloured lithograph; unnumbered print
14.3×7.5 cm; signed on the stone and in lower right margin on the paper with pencil, over-written with in-delible pencil: *Klee*; inscribed top centre on the stone: *WEIMAR* – below this: *BAUHAUS AUSSTELLUNG 1923* – bottom: *Staatliches Bauhaus Weimar Ausstellung* – in the lower left margin on the paper with indelible pen-cil: *1923 47* – in the lower right margin on the paper with pencil: *2 Zustand*
Provenance: Lily Klee, Bern (1940–1946); Klee Society, Bern (1946–1950); Rolf Bürgi, Klee Society, Bern (1950–1952); Rolf Bürgi, Belp (1953–1967)
Location: Private collection
Related works: *Schrift-Architectonisch*, 1918,8, water-colour and pen on paper on card, 19.5×11.5 cm, whe-reabouts unknown; *Inschrift*, 1918,207, pen on paper on card, 21×7.6/7.3 cm, Gift of LK, Klee Museum, Bern; *Gedenktafel*, 1923,42, oil transfer and water-colour on paper on card, 30.8×20.3 cm, Bauhaus-Archiv, Museum für Gestaltung, Berlin

71
Kind an der Freitreppe, 1923,65
Child at the Front Steps
Ölfarben (klein) ‹in der Art einer Einlegearbeit in Stein› Briefpapier
Oil with pen on paper, bordered with oil, brush and pen, strip on lower edge with watercolour and pen, on card
24.4/24.6×18.2 cm; signed upper right with pen: *Klee*; inscribed bottom centre on the card in marginal strip with pen: *1923 /// 65 Kind an der Freitreppe*
Provenance: Lily Klee, Bern (1940–1946); Klee Society, Bern (1946–1950); Rolf Bürgi, Klee Society, Bern (1950–1952); Rolf Bürgi, Belp (1953–1967)
Location: Private collection

72
Der Verliebte, 1923,91
The Man in Love
Litho (mit einer Farbe) für die Bauhausmappe
Lithograph; trial proof from inked stone
27.4×19 cm; signed below lower left edge of the image with pencil: *Klee*; inscribed lower left on the stone: *1923 91* – below this: *1923 91* – lower right: *Der Verliebte.* – below the lower edge of the image with pencil: *Probedruck des schwarzen Steines* – on

the right with pencil: *zweiter Zustand*
Provenance: Lily Klee, Bern (1940–1946); Klee Society, Bern (1946–1950); Rolf Bürgi, Klee Society, Bern (1950–1952); Rolf Bürgi, Belp (1953–1967)
Location: Private collection
Related works: *D. Verliebte*, 1922,201, pencil on paper on card, 21.3×16 cm, private collection, Switzerland; *Der Verliebte*, 1923,169, oil transfer and watercolour on chalk ground on linen on card, 34.7×19.5 cm, whereabouts unknown

73
Seiltänzer, 1923,138
Tightrope Walker
Litho (1 farbe) für die Mappe der Maréesgesellschaft
Lithograph; trial proof from inked stone
44×27.9 cm; signed below lower right edge of image with pen: *Klee*; inscribed below lower left edge of image with pen: *1923 138* – below this with pen: *(Seiltänzer.)* – in the centre with pen: *zweiter Probedruck vom schwarzen Stein* – below this with pencil, over–written with pen: *eine Rarität für Frau Hanny Bürgi mit den besten Wünschen zu Weihnachten 1932. Kl.*
Provenance: Hanni Bürgi, Bern (1932–1938, gift of the artist/annual special issue for members of the Klee Society); Rolf Bürgi, Belp (1938–1967)
Location: Private collection
Related works: *Der Seiltänzer*, 1923,121, oil transfer, pencil and watercolour on paper on card, 48.7×32.2 cm, Paul Klee Foundation, Kunstmuseum Bern; *Seiltänzer*, 1923,215, pencil on paper on card, 28.1×22 cm, Paul Klee Foundation, Kunstmuseum Bern

74 (not illustrated)
Seiltänzer, 1923,138
Tightrope Walker
Litho (1 farbe) für die Mappe der Maréesgesellschaft
Lithograph with plate in monochrome red; edition, published in the folio: *Kunst der Gegenwart*, R. Piper & Co., Munich 1923
44×26.8 cm; signed on lower right edge of the image with pencil: *Klee*; inscribed on lower left edge of the image with pencil: *1923 138*
Provenance: Lily Klee, Bern (1940–1946); Klee Society, Bern (1946–1950); Rolf Bürgi, Klee Society, Bern (1950–1952); Rolf Bürgi, Belp (1953–1967)
Location: Private collection
Related works: *Der Seiltänzer*, 1923,121, oil transfer, pencil and watercolour on paper on card, 48.7×32.2 cm, Paul Klee Foundation, Kunstmuseum Bern; *Seiltänzer*, 1923,215, pencil on paper on card, 28.1×22 cm, Paul Klee Foundation, Kunstmuseum Bern

75 (not illustrated)
Ohne Titel, ca. 1923
Untitled
Lithograph; edition, no. 1/4
8.4×7 cm; signed bottom centre in the margin on the paper with pencil: *Klee*; inscribed in the lower left margin on the paper with pencil: *1/4* – above this in pencil: *1923*
Provenance: Lily Klee, Bern (1940–1946); Klee Society, Bern (1946–1950); Rolf Bürgi, Klee Society, Bern (1950–1952); Rolf Bürgi, Belp (1953–1967)
Location: Private collection

76
Landschaft des Pferdchens, 1924,50
Landscape of the Pony
Federzeichng (viol Tinte) Briefpapier
Pen on paper on card
8.5×28.5 cm; signed upper right with pen: *Klee*; inscribed upper right with pen, faded: *1924 3/12* – lower left on the card below border line with pen: *1924. 50.* – lower right with pen: *Landschaft des Pferdchens*
Provenance: Rolf and Käthi Bürgi, Belp (1939–1967; gift of the artist)
Location: Private collection

77
Buchstabenbild, 1924,116
Picture with Letters
Aquarell (cachiert) Pappe, verschiedene Papiere gekleistert
Watercolour, oil(?) and pen on paper over a paper collage on card, verso oil ground, nailed to painted stretcher; original coloured wooden frame
26.1/26.3×33.1/33.4 cm; frame: 27.7×34.7 cm; signed lower right with brush: *Klee*; inscribed lower right with brush: *1924 116* – verso upper left on the stretcher with pencil: *Buchstabenbild* – top centre right with pencil: *Klee* – incised into the oil paint ground in the centre of the card: *24 116 Klee*
Provenance: Galerie Neue Kunst Fides (Rudolf Probst), Dresden (1927–1928; on commission); Galerie Alfred Flechtheim, Düsseldorf/Berlin (1928–?1932; on commission); Lily Klee, Bern (1940–1946); Klee Society, Bern (1946–1950); Rolf Bürgi, Klee Society, Bern (1950–1952); Rolf Bürgi, Belp (1953–1967)
Location: Private collection

78
orientalischer Friedhof 1924,174
Oriental Cemetery
Federzeichnung nass in nass und Aquarell Briefpapier
Pencil, pen, wet in wet, and watercolour on paper, cut and re–combined, on card
10.9/11.2×22.8 cm; signed upper left with pen: *Klee*; inscribed top centre right with pencil: *24 7 [5]/12* – bottom centre on the card below border line with pen: *1924 174 orientalischer Friedhof* – lower left with pencil: *S.Kl*
Provenance: Lily Klee, Bern (1940–1946); Klee Society, Bern (1946–1950); Galerie Rosengart, Lucerne (1948–1949; on commission); Rolf Bürgi, Klee Society, Bern (1950–1952); Rolf Bürgi, Belp (from 1953)
Location: Private collection

79
Dünenlandschaft, 1924,194
Dune Landscape
Federzeichg auf nass und Aquarell deutsch Ingres
Pen, wet in wet, and watercolour on paper on card
16/16.3×30.4/30.6 cm; signed centre right with pen: *Klee*; inscribed bottom centre on the card below border line with pen: *1924 194 Dünenlandschaft*
Provenance: Rolf Bürgi, Bern/Belp (1925–1967; purchased directly from the artist for 60 francs)
Location: Private collection

80
Aquarium mit Blausilberfischen, 1924,211
Aquarium with Blue-Silver-Fishes
Aquarell leicht zeichnerisch mit Benützung von Schablonen Briefpapier
Pen and watercolour on paper on card
19.7×22.5 cm; signed lower right with pen: *Klee*; inscribed bottom centre on the card below border line with pen: *1924 211 Aquarium mit Blausilberfischen*
Provenance: Hanni Bürgi, Bern (before 1931–1938; probably purchased directly from the artist); Rolf Bürgi, Belp (1938–1967)
Location: Private collection

81
nach einer Impression v. 1910 (Blick auf den Neuenb. See), 1924,227
After an Impression of 1910 (View of the Neuenburgersee)
Impression des N.–Sees
Federzeichng. n. i. n. Ingres PLM Fabriano Italia
Pen, wet in wet, on paper on card
27.5×47.1/47.3 cm; signed lower left with pen: *Klee*; inscribed bottom centre below border line with pen: *1924 227 nach einer Impression v. 1910 (Blick auf den Neuenb. See)* – lower left in margin on the card with pencil: *Impression des N.–Sees* – lower right in margin on the card with pencil: *ital Ingres*
Provenance: Lily Klee, Bern (1940–1946); Klee Society, Bern (1946–1950); Rolf Bürgi, Klee Society, Bern (1950–1952); Rolf Bürgi, Belp (1953–1967)
Location: Private collection
Related work: *Aussicht auf e. See*, 1910,61, pen and brush, wet in wet, on paper on card, 10.4×25.2 cm, private collection

82 (Illustrations p. 251)
Skizzenbuch, 1924/25
Sketchbook
35 leaves, 1 page with writing, 15 pages with sketches, 54 blank pages; drawing paper, made by Fabriano, sewn; bound in raw linen with pencil loop
Leaves: 10×13.8 cm; overall size including front and back covers: 10.5×14.1 cm
Provenance: Lily Klee, Bern (1940–1946); Klee Society, Bern (1946–1950); Rolf Bürgi, Klee Society, Bern (1950–1952); Rolf Bürgi, Belp (1953–1967)
Location: Private collection

83 (not illustrated)
Esel, 1925,83 (R 3)
Donkey
Litho (für die Monatshefte f Bücherfreunde und Graphiksamler) 65 Exempl. + 15 für mich + Probedr.
Lithograph; unnumbered print
24×15 cm; signed lower left on the stone: *Kl* – below lower right edge of the image with pencil: *Klee*; inscribed lower left on the stone: *1925. R 3.* – below lower left edge of the image with pencil: *Esel*
Provenance: Lily Klee, Bern (1940–1946); Klee Society, Bern (1946–1950); Rolf Bürgi, Klee Society, Bern (1950–1952); Rolf Bürgi, Belp (1953–1967)
Location: Private collection
Related work: *«Esel»*, 1925,20 (L 0), brush on paper on card, 19.9/20.3×13 cm, whereabouts unknown

84
Kopf, 1925,84 (R 4)
Head
Litho
Lithograph; early print
22×15.4 cm; signed bottom centre on the stone:
Kl – on lower right edge of the image with pencil,
over–written with pen: *Klee*; inscribed bottom centre
on the stone: *1925. R 4.* – on lower left edge of the
image with pencil, over-written with pen: *Kopf* – and
with pen: *(Lithogr.)* – on the left with pencil, over-
written with pen: *für Frau H Bürgi zur Eriñerung an die
schönen Weimarer Tage August 1925 K*
Provenance: Hanni Bürgi, Bern (1925–1938; gift of the
artist); Rolf Bürgi, Belp (1938–1967)
Location: Private collection

85
rotgeflügelte Sumpfhühner, 1925,108 (A 8)
Red–Winged Moorhens
Aquarell Schreibpapier, schwarzer Grund
Watercolour on black ground on paper on card
22.2×28.8 cm; signed lower right with pen: *Klee*;
inscribed bottom centre on the card with pen: *1925 A.
8. rotgeflügelte Sumpfhühner** – lower left with
pencil: *III*
Provenance: Hanni Bürgi, Bern (1925/1926–1938;
purchased as a member of the Klee Society for 330
Reichsmarks); Rolf Bürgi, Belp (1938–1967)
Location: Private collection

86
Dorf, 1925,122 (C 2)
Village
kl. Zeichnung mit Spachtel u Ölfarbe Briefpapier
Oil on paper on card
12.3/12.5×15.9/16.1 cm; signed upper left with pen:
Klee; inscribed bottom centre on the card below bor-
der line with pen: *1925 C 2 Dorf* – lower left with pen,
faded: *für Frau Hanny Bürgi in herzlicher Freundschaft
K* – lower right with pen: *(Jahresgabe für 1926/27.)*
Provenance: Hanni Bürgi, Bern (1926/1927–1938; gift
of the artist/annual special issue for members of the
Klee Society); Rolf Bürgi, Belp (1938–1967)
Location: Private collection

87 (not illustrated)
die Sängerin der komischen Oper, 1925,225 (W 5)
The Singer of the Comic Opera
*Litho elf Schwarzdrucke, davon 6 handkoloriert für die
Mitgl. der Gesellschaft*
Lithograph; print from inked stone
41.2×28.3 cm; inscribed lower left on the stone:
1925 W 5
Provenance: Lily Klee, Bern (1940–1946); Klee Society,
Bern (1946–1950); Rolf Bürgi, Klee Society, Bern
(1950–1952); Rolf Bürgi, Belp (1953–1967)
Location: Private collection
Related works: *Die Sängerin L. als Fiordiligi*, 1923,39,
oil transfer and watercolour on chalk ground on news-
paper on card, 50×33.5 cm, private collection; *Fiordi-
ligi sich wappnend ‹zu 1923 39›*, 1923,95, drawing
scratched with a nail, blackened, on paper on card,
28.7×21.5 cm, Rosengart Collection, Lucerne; *Sänge-
rin der Komischen Oper*, 1923,118, brush, pencil and

watercolour on paper on card, 29.2×23.5 cm, Solo-
mon R. Guggenheim Museum, New York; *Sängerin der
Komischen Oper*, 1927,10, oil and paste colour, partly
sprayed, on oil-gesso ground on canvas on card,
49×53 cm, Bayerische Staatsgemäldesammlungen/
Staatsgalerie moderner Kunst, Munich, Bequest of
Theodor and Woty Werner

88
die Sängerin der komischen Oper, 1925,225 (W 5)
The Singer of the Comic Opera
*Litho elf Schwarzdrucke, davon 6 handkoloriert für die
Mitgl. der Gesellschaft*
Lithograph and watercolour; unnumbered print
41.2×28.3 cm; inscribed lower left on the stone:
1925 W 5 – lower left with pencil: *1925 W 5 Die Sän-
gerin der komischen Oper* – bottom centre with pencil:
Litho (zwei Proben, sechs Drucke) – lower right with
pencil: *für Frau Hanny Bürgi, Weihnachten 1925. Klee*
Provenance: Hanni Bürgi, Bern (1925–1938; gift of the
artist/annual special issue for members of the Klee
Society); Rolf Bürgi, Belp (1938–1967)
Location: Private collection
Related works: *Die Sängerin L. als Fiordiligi*, 1923,39,
oil transfer and watercolour on chalk ground on news-
paper on card, 50×33.5 cm, private collection; *Fiordi-
ligi sich wappnend ‹zu 1923,39›*, 1923,95, drawing
scratched with nail, blackened, on paper on card,
28.7×21.5 cm, Rosengart Collection, Lucerne;
Sängerin der komischen Oper, 1923,118, brush, pencil
and watercolour on paper on card, 29.2×23.5 cm,
Solomon R. Guggenheim Museum, New York; *Sängerin
der Komischen Oper*, 1927,10, oil and paste colour,
partly sprayed, on oil-gesso ground on canvas on card,
49×53 cm, Bayerische Staatsgemäldesammlungen/
Staatsgalerie moderner Kunst, Munich, Bequest of
Theodor and Woty Werner

89
buntharmonisch, 1925,256 (Z 6)
Colourful Harmonious
Pastell Papier, schwarzer Leimfarbegrund
Pastel on black distemper ground on paper, bordered
in distemper(?), on card
22.2×28.8 cm; signed lower right on the card in
gouache: *Klee*; inscribed lower left on the card in
gouache: *1925 Z. 6.*
Provenance: Lily Klee, Bern (1940–1946); Klee Society,
Bern (1946–1950); Rolf Bürgi, Klee Society, Bern
(1950–1952); Rolf Bürgi, Belp (1953–1967)
Location: Private collection

90
Ausgang der Menagerie, 1926,83 (R 3)
Outing of the Menagerie
Federzeichnung deutsch Ingres weiss
Pen on paper on card
16.4/16.7×30.4/30.6 cm; signed upper right with pen:
Klee; inscribed lower left on the card below border line
with pen: *1926 R 3* – lower right with pen: *Ausgang
der Menagerie*
Provenance: Lily Klee, Bern (1940–1946); Klee Society,
Bern (1946–1950); Rolf Bürgi, Klee Society, Bern
(1950–1952); Rolf Bürgi, Belp (1953–1967)
Location: Private collection

91
tanzt auch, 1926,99 (S 9)
Dances as Well
Federzchng. deutsch Ingres weiss
Pen on paper on card
20.5×14.5 cm; signed lower left with pen: *Klee*;
inscribed bottom centre on the card below border line
with pen: *1926 S. 9. tanzt auch*
Provenance: Hanni Bürgi, Bern (1934–1938; purchased
as the supplement to the luxury edition of *Paul Klee.
Handzeichnungen 1921–1930*, ed. by Will Grohmann,
Potsdam/Berlin 1934 for 120 Reichsmarks in total);
Rolf Bürgi, Belp (1938–1967)
Location: Private collection

92
wandernde Fische, 1926,212 (V 2)
Migrating Fishes
Federz. (Tusche) Briefpapier
Pencil and pen on paper on card
22.3×27.5 cm; signed lower right on sheet and card
with pen: *Klee*; inscribed lower left on the card above
border line with pen: *1926. V 2* – lower right:
wandernde Fische
Provenance: Lily Klee, Bern (1940–1946); Klee Society,
Bern (1946–1950); Rolf Bürgi, Klee Society, Bern
(1950–1952); Rolf Bürgi, Belp (1953–1967)
Location: Private collection

93
Vollmond, 1927,23 (L 3)
Full Moon
*(klein) Ölfarben, Pappe Kittgrund, geritzt Orig.leisten;
Gemälde*
Oil on grout ground on card on grout and oil ground
on card, verso with oil ground, nailed to bracing wood
strips; original coloured wooden frame
25.8×31.5 cm; frame: 27.3×33 cm; signed lower left
in ink: *KLEE* – above this in Indian ink: *Klee*; inscribed
lower left in ink: *1927 L 3* – above this in Indian ink:
1927 L 3 – verso centre left on upper wood strip in
ink, faded to the point of illegibility: *1927 L 3
"Vollmond" Klee*
Provenance: Lily Klee, Bern (1940–1946); Klee Society,
Bern (1946–1950); Rolf Bürgi, Klee Society, Bern
(1950–1952); Rolf Bürgi, Belp (1953–1967)
Location: Private collection

94
nördliche Seestadt, 1927,122 (C 2)
Northern Seaside Town
Rohrfederzeichnung / deutsches Ingres; Zeichnung
Reed pen on paper with spots of glue on card
18.5/18.7×41.5 cm; signed lower left with pen: Klee;
inscribed bottom centre on the card below border line
with pen, underlined with pencil: *1927. C. 2. nördliche
Seestadt* – lower right with pen: *für Frau Hanny Bürgi
Weihnachten 1927 Kl*
Provenance: Hanni Bürgi, Bern (1927–1938; gift of the
artist/annual special issue for members of the Klee
Society); Rolf Bürgi, Belp (1938–1967)
Location. Private collection

95
Wiesenflora, 1927,186 (J 6)
Meadow Flora
Federzeichnung / deutsches Ingres weiss; Zeichnung
Pen on paper with spots of glue on card
12.2/12.5×36.6/36.8 cm; signed lower right with pen:
Klee; inscribed bottom centre on the card below bor-
der line with pen: *1927 J. 6.* – lower right with pen:
Wiesenflora
Provenance: Hanni Bürgi, Bern (before 1931–1938;
probably purchased directly from the artist); Rolf Bürgi,
Belp (1938–1967)
Location: Private collection

96
Zuflucht der Schiffe, 1927,251 (Z 1)
Refuge of the Ships
Federzeichnung und Aquarell / deutsches Ingres;
Aquarell
Pen, reed pen and watercolour on paper, Indian ink
strips top and bottom, strip of paper with gouache
ground collaged along lower edge of the paper, on card
Condition: the original inscription on the card has
been trimmed away; it is no longer extant.
19.8×29.9 cm; signed lower right with pen: *Klee*
Provenance: Fritz Bürgi, Spiez (1928–1948; wedding
gift of the artist); Gertrud Bürgi, Spiez (1948–1963)
Location: Private collection
Related work (another fragment): *Festtag im Winter*,
1927,284 (Ue 4), watercolour and pen on paper on
card, 14.5×30 cm, whereabouts unknown

97
ihr habt hier eine Lumpenwirtschaft, 1927,260
(Z 10)
What a Shambles
Federzeichnung / deutsches Ingres weiss; Zeichnung
Pen on paper with spots of glue on card
30.3×25/25.2 cm; signed bottom centre with pen:
Klee; inscribed bottom centre on the card below
border line with pen: *1927 Z. 10. ihr habt hier eine*
Lumpenwirtschaft
Provenance: Hanni Bürgi, Bern (before 1931–1938;
probably purchased directly from the artist); Rolf Bürgi,
Belp (1938–1967)
Location: Private collection

98
Sie entgegnet, 1927,266 (Ae 6)
She Retorts
Federzeichnung / deutsches Ingres weiss; Zeichnung
Pen on paper with spots of glue on card
14×13.9 cm; signed upper left with pen: *Klee*; inscri-
bed bottom centre on the card below border line with
pen: *1927 Ae. 6. Sie entgegnet*
Provenance: Hanni Bürgi, Bern (before 1931–1938;
probably purchased directly from the artist); Rolf Bürgi,
Belp (1938–1967)
Location: Private collection

99
grosser Circus, 1928,22 (L 2)
Circus Big Top
Federzeichnung / deutsches Ingres weiss; Zeichnung
Pen on paper with spots of glue on card

45.3/45.6×29.9/30.4 cm; signed lower left with pen:
Klee; inscribed bottom centre with pen: *grosser Circus*
– bottom centre on the card below border line with
pen: *1928 L. 2*
Provenance: Lily Klee, Bern (1940–1945); Rolf and
Käthi Bürgi, Belp (1945–1967; gift of Lily Klee)
Location: Private collection

100
Schwarze Gaukler, 1928,39 (M 9)
Black Jugglers
Federzeichnung / deutsches Ingres weiss; Zeichnung
Pen on paper with spots of glue on card
8.7/9.1×45.3/45.5 cm; signed lower right on sheet and
card with pen: *Klee*; inscribed bottom centre on the
card below border line with pen: *1928 M 9 Schwarze*
Gaukler
Provenance: Hanni Bürgi, Bern (before 1931–1938,
probably purchased directly from the artist); Rolf Bürgi,
Belp (1938–1967)
Location: Private collection

101
"Höhe!", 1928,189 (J 9)
"Height!"
Radierung, Kupferätzung Reservage / zehn Drucke und
fünf Probedrucke; Radierung
Etching on copper (reservage); edition, no. 4/10
23×22.7 cm; signed upper right on the plate: *Klee* –
on lower right edge of the plate with pencil: *Klee*;
inscribed on lower left edge of the plate with pencil:
1928. J. 9 "Höhe!" – in the centre: *4/10 für Frau*
Hanny Bürgi freundschaftlich zu Weihnachten 1928
Provenance: Hanni Bürgi, Bern (1928–1938; gift of the
artist/annual special issue for members of the Klee
Society); Rolf Bürgi, Belp (1938–1967)
Location: Private collection

102
"Gaukler im April", 1928,197 (T 7)
"Jugglers in April"
Radierung (Zinkätzung) / 2 Proben und 12 Drucke
Etching on zinc; edition, no. 4/12
19.3×19.7 cm; signed upper left on the plate: *Klee* –
on lower right edge of the plate with pencil: *Klee*;
inscribed on lower left edge of the plate with pencil:
4/12 1928 T. 7 – in the centre with pencil: *"Gaukler im*
April" – in the lower right margin on the paper with
pencil: *für Frau Hanni Bürgi zu Weihnachten 1929*
Provenance: Hanni Bürgi, Bern (1929–1938; gift of the
artist/annual special issue for members of the Klee
Society); Rolf Bürgi, Belp (1938–1967)
Location: Private collection

103 (not illustrated)
Ohne Titel, ca. 1928
Untitled
Watercolour, sprayed using templates, on paper, verso
gouache
63×48 cm; verso: authenticated by Lily Klee with
estate stamp: *Entwurf 1940*
Provenance: Lily Klee, Bern (1940–1946); Klee Society,
Bern (1946–1950); Rolf Bürgi, Klee Society, Bern
(1950–1952); Rolf Bürgi, Belp (1953–1967)
Location: Private collection

104
rechnender Greis, 1929,99 (S 9)
Old Man Counting
Radierung / Kupfer geätzt; Sonstiges
Etching on copper; edition, no. 127/130
29.7×23.7 cm; signed on lower right edge of the plate
with pencil: *Klee*; inscribed on lower left edge of the
plate with pencil: *127/130*
Provenance: Hanni Bürgi, Bern (1929–1938; gift of the
artist); Rolf Bürgi, Belp (1938–1967)
Location: Private collection
Related work: *rechnender Greis*, 1929,60 (O 10), pen
and pencil on paper on card, dimensions and where-
abouts unknown

105
Nichtcomponiertes im Raum, 1929,124 (C 4)
Uncomposed in Space
Aquarell (und Feder) / Canson Ingres; Aquarell
Pen, pencil and watercolour on paper on card
31.8×24.5/24.7 cm; signed bottom centre with pen,
faded: *Klee*; inscribed lower left on the card below
border line with pen: *1929 C. 4.* – lower right with
pen: *Nichtcomponiertes im Raum* – lower left above
border line with pencil, erased: *für Lily Okt 1929 K*
Provenance: Lily Klee, Dessau/Düsseldorf/Bern
(1929–1946; gift of the artist); Klee Society, Bern
(1946–1950); Rolf Bürgi, Klee Society, Bern
(1950–1952); Rolf Bürgi, Belp (1953–1967)
Location: Private collection

106
Uebungen, 1929,286 (UE 6)
Exercises
Federzeichnung / deutsches Ingres; Zeichnung
Pen on paper on card
11.1×22.8/23 cm; signed upper right with pen: *Klee*;
inscribed bottom centre on the card below border line
with pen: *1929 UE 6. Uebungen* – lower left with pen:
X – lower right with pen: *für Frau Hanny Bürgi Weihn*
1930 K
Provenance: Hanni Bürgi, Bern (1930–1938; gift of
the artist/annual special issue for members of the Klee
Society); Rolf Bürgi, Belp (1938–1967)
Location: Private collection
Related work: *Uebungen*, 1930,254 (J 4), pen and
pencil, erased, on paper on card, 30×46.7 cm, Paul
Klee Foundation, Kunstmuseum Bern

107 (not illustrated)
Ohne Titel, 1929
Untitled
Etching
15×21.7 cm; signed upper left on the plate: *Klee*;
inscribed upper left on the plate: *29* – verso: authenti-
cated by Lily Klee with estate stamp, scored through –
above this with pen: *ungültig*
Provenance: Lily Klee, Bern (1940–1946); Klee Society,
Bern (1946–1950); Rolf Bürgi, Klee Society, Bern
(1950–1952); Rolf Bürgi, Belp (1953–1967)
Location: Private collection

108
über–beschwingte II, 1930,32 (M 2)
Over–Exhilarated ones II
Ölfarbezeichnung / saugendes Druckpapier; Zeichnung
Oil transfer on paper with spots of glue on card
37.1/37.4×45.8/46.4 cm; signed upper left with pen:
Klee; inscribed bottom centre on the card below
border line with pen: *1930 M2 überbeschwingte II*
Provenance: Lily Klee, Bern (1940–1946); Klee Society,
Bern (1946–1950); Rolf Bürgi, Klee Society, Bern
(1950–1952); Rolf Bürgi, Belp (1953–1967)
Location: Private collection
Related work: *überbeschwingte I*, 1930,31 (M1), pencil
and pen on paper on card, 24.1×33 cm, San Francisco
Museum of Modern Art, Long-term loan Carl Djerassi

109
die Frau mit dem Bündel, 1930,67 (P 7)
The Woman with the Bundle
*Ölfarbezeichnung in drei Farben / Kupferdruckpapier;
Zeichnung*
Oil transfer on paper on card
50.5/50.7×33.5/33.8 cm; signed top centre with pen:
Klee; inscribed lower left with pencil: *S Cl* – bottom
centre on the card below border line with pen: *1930
p.7. die Frau mit dem Bündel* – lower left with pencil: *X*
Provenance: Lily Klee, Bern (1940–1946); Klee Society,
Bern (1946–1950); Rolf Bürgi, Klee Society, Bern
(1950–1952); Rolf Bürgi, Belp (1953–1967)
Location: Private collection
Related work: *die Frau mit dem Bündel*, 1930,29 (L 9),
coloured crayon on paper on card, 28.6×21 cm,
The Menil Collection, Houston

110
räumliche Studie (Nr. IV.), 1930,112 (V 2)
Spatial Study (no. IV.)
*Vierte Studie nach drei Dimensionen (rationale und
irrationale Verbindungen)*
*Bleistift und schwarze Kreide / deutsches Ingres;
Zeichnung*
Pencil and chalk on paper with spots of glue on card
36.5/37×46.5 cm; signed upper left with pen: *Klee*;
inscribed bottom centre with pencil: *die durch Verbin-
dungslinien geschaffenen Flächen als primär erklärt
und neu (und irrational!) verbunden* – bottom centre
on the card below border line with pen: *1930. V. 2.
räumliche Studie (Nr. IV.)*
Provenance: Lily Klee, Bern (1940–1946); Klee Society,
Bern (1946–1950); Galerie Rosengart, Lucerne
(1949–1950; on commission); Theodore C. Uebel, Fo-
rest Hills (from 1950); Rolf and Käthi Bürgi, Belp (until
1967)
Location: Private collection

111
Feuermann, 1930,193 (D 3)
Man of Fire
Aquarell / Konzeptpapier kleistergrundiert; Aquarell
Watercolour, partly applied using templates, on paste
ground on paper, verso drawing, top and bottom strips
in pen and watercolour, on card
28.7/29.1×22.2 cm; signed centre right with pen: *Klee*;
inscribed bottom centre on the card with pen: *1930.*

d. 3 Feuermann – lower left with pencil: *II*
Provenance: Hanni Bürgi, Bern (1931–1938; purchased
as a member of the Klee Society for 270 Reichsmarks);
Rolf Bürgi, Belp (1938–1967)
Location: Private collection

112
trinkender Engel, 1930,239 (G 9)
Drinking Angel
Aquarell / deutsches Ingres; Aquarell
Watercolour and pen on paper, top and bottom strips
in watercolour and pen, on card
48.6×30.3/30.6 cm; signed lower right with pen: *Klee*;
inscribed lower left on the card with pen: *1930 G. 9* –
lower right with pen: *trinkender Engel* – lower left
with pencil: *VIII*
Provenance: Hanni Bürgi, Bern (1930–1938; purchased
as a member of the Klee Society for 500 Reichsmarks);
Rolf Bürgi, Belp (1938–1967)
Location: Private collection

113
bestandenes Abenteuer, 1931,136 (Qu 16)
Endured Adventure
*Feder und Pinselzeichnung / italienisches Ingres PMF;
Zeichenblatt*
Pen, brush and watercolour on paper with spots of
glue on card
42.1/42.3×51.5 cm; signed lower left with pen: *Klee*;
inscribed lower left on the card below border line with
pen: *1931 q^u 16* – lower right with pen: *bestandenes
Abenteuer* – lower left in margin on the card with
pencil, erased: *Nachl.*
Provenance: Lily Klee, Bern (1940–1946); Klee Society,
Bern (1946–1950); Rolf Bürgi, Klee Society, Bern
(1950–1952); Rolf Bürgi, Belp (1953–1967)
Location: Private collection

114
Überbrücktes, 1931,153 (R 13)
Spanned
*Wasserfarben gefirnisst / Baumwolle mit Leinwand ver-
klebt auf Keilrahmen, Originalleisten / 0,6 × 0,5; Tafel*
Pencil and watercolour, varnished, on cotton on canvas
on stretcher; original coloured wooden frame
60.4/60.7×50.3/50.5 cm; frame: 61.8/62.1×51.7/
52.3 cm; signed lower left in watercolour: *Klee*;
inscribed verso upper left on the stretcher with pen,
faded: *1931 R 13* – upper right with pen, faded:
"Überbrücktes" Klee
Provenance: Lily Klee, Bern (1940–1946); Klee Society,
Bern (1946–1950); Rolf Bürgi, Klee Society, Bern
(1950–1952); Rolf Bürgi, Belp (1953–1967)
Location: Private collection

115
draussen buntes Leben, 1931,160 (R 20)
Colourful Life Outside
*Aquarell / französisches Ingres d'Arches eigrundiert;
Farbiges Blatt*
Watercolour and brush on egg sizing on paper on card
31.2/31.4×48.9 cm; signed upper right with pen: *Klee*;
inscribed lower left on the card below border line with
pen: *1931 R 20* – lower right with pen: *draussen*

buntes Leben
Provenance: Lily Klee, Bern (1940–1946); Klee Society,
Bern (1946–1950); Rolf Bürgi, Klee Society, Bern
(1950–1952); Rolf Bürgi, Belp (1953–1967)
Location: Private collection

116
Stachel der Clown, 1931,250 (W 10)
Thorn the Clown
*Radierung (Reservagetechnik, geätztes Kupfer) /
3 Proben, 20 Auflagendrucke; Sonstiges*
Etching on copper; second trial proof
29.4×24.2 cm; signed on lower right edge of the plate
with pencil: *Klee*; inscribed on lower left edge of the
plate with pencil: *1931 W 10* – in the centre with
pencil: *Zweiter Probedruck Stachel, der Clown*
Provenance: Hanni Bürgi, Bern (?1931–1938; gift of
the artist/annual special issue for members of the Klee
Society); Rolf Bürgi, Belp (1938–1967)
Location: Private collection
Related work: *ländlicher Hanswurst*, 1925,47 (N 7),
brush and watercolour on paper on card, 26×10.5 cm,
private collection, Canada

117
junger Baum (chloranthemum), 1932,113 (P 13)
Young Tree (Chloranthemum)
*Wassserfarben / italienisches Ingres mit pastoser
Kreidegrundierung; Farbiges Blatt*
Watercolour on chalk ground on paper with spots of
glue on card
48.5×36.3/37.3 cm; signed upper right with pen: Klee;
inscribed bottom centre on the card below border line
with pen: *1932. p. 13. junger Baum (chloranthemum)*
– lower left with pencil: *VI*
Provenance: Hanni Bürgi, Bern (1932–1938; purchased
as a member of the Klee Society for 535 Reichsmarks);
Rolf Bürgi, Belp (1938–1967)
Location: Private collection

118
Ort der Verabredung, 1932,138 (Qu 18)
Meeting Place
*Wasser– und Ölfarben / Sperrholz, Originalleisten /
0,31×0,48; Tafel*
Watercolour and oil on plywood, bonded on both sides
with fabric, fixed to bracing wood strips; patchily ap-
plied final finish; raw edges of plywood and wood
strips covered with gauze; original wooden frame
30.5/30.8×47.9/48.5 cm; frame: 32.1/32.4×49.5/
50.2 cm; signed lower right with pen: *Klee*; inscribed
verso on upper left of wood strip with pen: *1932 qu
18 "Ort der Verabredung"* – on the right with pen:
Klee – centre, on the ground with pen, inside an oval
outline: *1932 qu 18 "Ort der Verabredung" Klee* –
below this with pencil: *Ort der Verabredung* – lower
left with coloured pencil: *reserv. Sept 32 für W.R*
Provenance: Hanni Bürgi, Bern (before 1935–1938;
probably purchased directly from the artist); Rolf Bürgi,
Belp (1938–1967)
Location: Private collection

119
gegensätzliche Meinungen, 1932,165 (S 5)
Opposing Views
Rohrfederzeichnung / italienisches Ingres; Einfarbiges Blatt
Reed pen on paper with spots of glue on card
30.6/30.8×48.2/48.4 cm; signed upper left with pen: *Klee*; inscribed lower left on the card below border line with pen: *1932. S. 5.* – lower right with pen: *gegensätzliche Meinungen*
Provenance: Lily Klee, Bern (1940–1946); Klee Society, Bern (1946–1950); Rolf Bürgi, Klee Society, Bern (1950–1952); Rolf Bürgi, Belp (1953–1967)
Location: Private collection

120
Ausgang, 1933,165 (T 5)
Going Out
Zulustift / Konzeptpapier; Einfarbiges Blatt
Lithographic crayon on paper with spots of glue on card
33×21 cm; signed top centre with pen: *Klee*; inscribed bottom centre on the card above border line with pen: *1933 T 5 Ausgang* – lower right with pencil: *Für Frau Hanny Bürgi zu Weihnachten 1933 K*
Provenance: Hanni Bürgi, Bern (1933–1938; gift of the artist/annual special issue for members of the Klee Society); Rolf Bürgi, Belp (1938–1967)
Location: Private collection

121
Schosshündchen N, 1933,234 (W 14)
Lap Dog N
Pinselzeichnung / Detailpapier; Einfarbiges Blatt
Watercolour, chalk and coloured pencil on paper, verso chalk drawing, with spots of glue on card
Condition: the original inscription on the card has been trimmed away; it is still extant.
18×20.2/21.4 cm; signed upper left with pen: *Klee*; originally inscribed bottom centre on the card with pen, underlined with pencil: *1933 W 14 Schosshündchen N* – lower right with pencil: *für Hanny Bürgi zum Weihnachtsfest 1935 K*
Provenance: Hanni Bürgi, Bern (1935–1938; gift of the artist); Rolf Bürgi, Belp (1938–1967)
Location: Private collection

122
Kleiner BLAUTEUFEL, 1933,285 (Z 5)
Little Blue Devil
Blauteufelskopf
Wasserfarben (gewachst) / Pappe mit Hilfe von Gaze gipsgrundiert / 0,29 × 0,235; Tafel
Watercolour, waxed, on gesso ground on gauze on card, verso watercolour on textured ground, on bracing wood strips; edge of the card covered with a gauze strip coloured with watercolour on a gesso ground; original coloured wooden frame
29.6×24.6 cm; frame: 31×26 cm; signed upper right in watercolour: *Klee*; inscribed verso top centre on the card with pen, inside an oval outline: *1933 Z 5 Kleiner BLAUTEUFEL Klee*
Provenance: Lily Klee, Bern (1940–1946); Klee Society, Bern (1946–1950); Rolf Bürgi, Klee Society, Bern (1950–1952); Rolf Bürgi, Belp (1953–1967)
Location: Private collection

123
Gelehrter, 1933,286 (Z 6)
Scholar
Wasserfarben (gewachst) / alte Holztafel mit Hilfe von Gaze gipsgrundiert / 0,35×0,26; Tafel
Watercolour, waxed, and brush on gesso ground on gauze on wood, verso with gauze, partially covered with a gesso ground; original decorative frame
35.3×26.3/26.5 cm; frame: 42.7×34/34.2 cm; signed lower left, incised into the gesso and over-written with pen: *Klee*; inscribed verso centre on gauze with a gesso ground in watercolour: *1933. Z. 6. G[blemish: e]lehrter Klee*
Provenance: Lily Klee, Bern (1940–1946); Klee Society, Bern (1946–1950); Rolf Bürgi, Klee Society, Bern (1950–1952); Rolf Bürgi, Belp (1953–1967)
Location: Private collection

124
KIND MIT <u>BEEREN</u>, 1933,358 (C 18)
Child with Berries
Wasserfarben gewachst / massive Gipsplatte / elliptische Form / 0,22×0,185; Tafel
Watercolour, waxed, on gesso ground on gauze on gypsum-panel, verso with wire loop set into centre top of gypsum-panel; elliptical original decorative brass frame
22×18.5 cm; frame: 23×19.5 cm; signed lower left in watercolour(?): *Klee*; inscribed verso centre on the gypsum-panel in watercolour, inside an oval outline: *1933 C 18. "KIND MIT BEEREN" Klee*
Provenance: Lily Klee, Bern (1940–1946); Klee Society, Bern (1946–1950); Rolf Bürgi, Klee Society, Bern (1950–1952); Rolf Bürgi, Belp (1953–1967)
Location: Private collection

125
trüb umschlossen, 1934,74 (M 14)
Wrapped in Gloom
Aquarellfarben (z. T gespritzt) I Konzeptpapier Gummiweiss grundiert; Mehrfarbiges Blatt
Watercolour, partly sprayed, on white ground on paper with spots of glue on card
16.8×20.9 cm; signed upper left with pen: *Klee*; inscribed lower left on the card with pen: *1934 M 14* – lower right with pen: *trüb umschlossen* – lower right with pencil, over-written in ink, faded: *für Hanny Bürgi mit den herzlichsten Wünschen Weihnachten 1934 K*
Provenance: Hanni Bürgi, Bern (1934–1938; gift of the artist); Rolf Bürgi, Belp (1938–1967)
Location: Private collection

126
Zweig und Blatt, 1934,165 (S 5)
Twig and Leaf
Bleistift, Aquarell– und Ölfarben / deutsches Ingres; Mehrfarbiges Blatt
Pencil, watercolour and oil on paper on card
20.7/19.9×31.9 cm; signed top centre with pen: *Klee*; inscribed lower left on the card with pen, faded: *1934 S. 5* – lower right with pen, faded: *Zweig und Blatt* – lower right with pencil: *meiner Freundin Hanny herzlichst zum 23 Dez 35 K*
Provenance: Hanni Bürgi, Bern (1935–1938; birthday gift of the artist); Rolf Bürgi, Belp (1938–1967)
Location: Private collection

127
Schlangen Wege, 1934,217 (U 17)
Snake Paths
Aquarellfarben gewachst / ungrundierte Leinwand auf Keilrahmen / 0,47×0,63; Tafel
Pencil and watercolour, waxed, on canvas pre-sized on both sides, on stretcher; original wooden frame
47.6×63.8 cm; frame: 49.3×65.3 cm; signed upper left with pen, faded to the point of illegibility: *Klee*; inscribed verso upper left on the stretcher with indelible pencil: *1934 U 17 "Schlangen Wege"* – top centre right with indelible pencil: *Klee*
Provenance: Lily Klee, Bern (from 1940); Rolf Bürgi, Belp (before 1945–1967)
Location: Private collection

128
Gras, 1935,2
Grass
Bleistift / Briefpapier; Einfarbiges Blatt
Pencil on paper with spots of glue on card
Condition: the original inscription on the card has been trimmed away; it is still extant.
12.4×27 cm; signed upper right with pen, faded to the point of illegibility: *Klee*; originally inscribed lower left on the card below border line with pen: *1935 2* – lower right with pen: *Gras* – below this with pencil: *für Hanny Bürgi mit herzlichen Wünschen zu Weihnachten 1937 K*
Provenance: Hanni Bürgi, Bern (1937–1938; gift of the artist); Rolf Bürgi, Belp (1938–1967)
Location: Private collection

129
Tor zum verlassenen Garten, 1935,58 (L 18)
Gateway to the Deserted Garden
Öl– und Aquarellfarben / Ingres grau aquarelliert, dann kreidegrundiert (und Eiaufstrich?); Mehrfarbiges Blatt
Oil and watercolour on chalk ground on watercolour on paper with spots of glue on card
31.7/32.3×45.5/46.4 cm; signed upper left with pen, faded to the point of illegibility: *Klee*; inscribed bottom centre on the card below border line with pen: *1935 L 18 Tor zum verlassenen Garten*
Provenance: Lily Klee, Bern (1940–1946); Klee Society, Bern (1946–1950); Rolf Bürgi, Klee Society, Bern (1950–1952); Rolf Bürgi, Belp (1953–1967)
Location: Private collection

130
neu angelegter Garten, 1937,27 (K 7)
Newly Laid Out Garden
Ölfarben / Ingrespapier; Mehrfarbiges Blatt
Oil, applied with a knife, on paper with spots of glue on card
24.2/25.1×31.3/31.6 cm; signed top centre right with pen, faded to the point of illegibility: *Klee*; inscribed bottom centre on the card below border line with pen, underlined with pencil: *1937 K. 7. neu angelegter Garten* – lower left with pencil: *III* – above this with pencil: *IV*
Provenance: Lily Klee, Bern (1940–1946); Klee Society, Bern (1946–1950); Rolf Bürgi, Klee Society, Bern (1950–1952); Rolf Bürgi, Belp (1953–1967)
Location: Private collection

131

Tiere spielen Komoedie, 1937,112 (P 12)
Animals Perform a Comedy
Kohle und Rötel / rötliches Tischtuch mit Sternen;
Mehrfarbiges Blatt
Charcoal and red chalk on linen on card
39.3/43.3×39/41.5 cm; signed upper right with pen:
Klee; inscribed bottom centre on the card below bor-
der line with pen: *1937. p 12. Tiere spielen Komoedie*
– lower left with pencil: *III*
Provenance: Lily Klee, Bern (1940–1946); Klee Society,
Bern (1946–1950); Rolf Bürgi, Klee Society, Bern
(1950–1952); Rolf Bürgi, Belp (1953–1967)
Location: Private collection

132

"ach, aber ach!", 1937,201 (U 1)
"Alas, oh alas!"
Schwarze Wasserfarbe (mit Kleister) / Briefpapier;
Einfarbiges Blatt
Watercolour, bound with paste, on paper, verso
drawing, with spots of glue on card
27.9×17.9 cm; signed lower right with pen, faded:
Klee; inscribed bottom centre on the card with pen,
faded: *1937 U 1 "ach, aber ach!"*
Provenance: Lily Klee, Bern (1940–1946); Klee Society,
Bern (1946–1950); Rolf Bürgi, Klee Society, Bern
(1950–1952); Rolf Bürgi, Belp (1953–1967)
Location: Private collection

133

Haelften, der Clown, 1938,27 (D 7)
Halves, the Clown
Schwarze Kleisterfarbe / Japan; Einfarbiges Blatt
Chalk(?) and paste colour on paper with spots of glue
on card
58.2/59.6×42.2/42.9 cm; signed centre left with
pencil: *Klee;* inscribed lower left on the card with pen:
1938. D 7. – lower right with pen: *Haelften, der Clown*
Provenance: Lily Klee, Bern (1940–1946); Klee Society,
Bern (1946–1950); Rolf Bürgi, Klee Society, Bern
(1950–1952); Rolf Bürgi, Belp (1953–1967)
Location: Private collection

134

Beet, 1938,113 (H 13)
Garden Bed
Pastose Kleisterfarben (gewachst) / Pappe /
0,355×0,09; Tafel
Paste colour, waxed, on card, verso with paste colour,
nailed to supporting strips of wood, edges of card and
supporting strips of wood covered with strips of cot-
ton; original wooden frame top and bottom
38.2/38.5×12.8/13.1 cm; frame: 39.9/40.2×15.7 cm;
signed bottom centre with pen: *Klee;* inscribed verso
on strip of wood at top with indelible pencil: *1938 H*
13. "Beet" Klee – upper right with pencil: *gewachst* –
below this with pencil: *R* – centre left with pencil:
[illegible: …]
Provenance: Lily Klee, Bern (1940–1946); Klee Society,
Bern (1946–1950); Rolf Bürgi, Klee Society, Bern
(1950–1952); Rolf Bürgi, Belp (1953–1967)
Location: Private collection

135 (Colour plate pp. 167f.)

Feuer–Quelle, 1938,132 (J 12)
Fire Source
Ölfarben / Jute mit Zeitungspapier überklebt /
0,7×1,5; Tafel
Oil on ground on newspaper on jute on stretcher,
original double wooden frame
70.3/70.5×150/150.2 cm; frame: 73.7×153.3/
153.5 cm; signed upper right in oil: *Klee;* inscribed
verso top centre left on the stretcher with indelible
pencil: *1938 J 12 "Feuer–Quelle" Klee*
Provenance: Lily Klee, Bern (1940–1946); Klee Society,
Bern (1946–1950); Rolf Bürgi, Klee Society, Bern
(1950–1952); Rolf Bürgi, Belp (1953–1967)
Location: Private collection

136

Regenwetter am Strom, 1938,200 (M 20)
Rainy Weather by the River
Aquarellfarben / Jute; Mehrfarbiges Blatt
Watercolour on gesso or chalk ground on jute on card
Condition: the jute has been separated from the card
and remounted on a new card covered in canvas. The
inscription on the original card is still extant.
10.5/12.9×62.4/62.8 cm; signed upper left with pen:
Klee; originally inscribed on the card, probably lower
left with pen: *1938 M 20* – probably lower right with
pen: *Regenwetter am Strom*
Provenance: Lily Klee, Bern (1940–1946); Klee Society,
Bern (1946–1950); Rolf Bürgi, Klee Society, Bern
(1950–1952); Rolf Bürgi, Belp (1953–1967)
Location: Private collection

137

Ohne Titel, ca. 1938
Untitled
Paste colour on gesso or chalk ground on jute
Condition: the jute was mounted on wood post-
humously.
20/20.4×6.8/7.2 cm
Provenance: Lily Klee, Bern (1940–1946); Klee Society,
Bern (1946–1950); Rolf Bürgi, Klee Society, Bern
(1950–1952); Rolf Bürgi, Belp (1953–1967)
Location: Private collection

138

Schnee–sturm–Geister, 1939,352 (Y 12)
Snow–Storm–Spirits
Wasserfarbe / Jute gipsgrundiert auf Keilrahmen /
0,5×0,58; Tafel
Watercolour on jute, verso gesso ground, on second
piece of jute covered with a gesso ground, verso sized
with watercolour(?), on stretcher; original double
wooden frame
50×58.3 cm; frame: 52.3×60.5/60.7 cm; signed upper
right with pen: *Klee;* inscribed verso upper left on the
stretcher with pen, faded to the point of illegibility:
1939 [illegible, probably: Y 12] *"Schnee–sturm–Geister"*
Provenance: Lily Klee, Bern (1940–1946); Klee Society,
Bern (1946–1950); Rolf Bürgi, Klee Society, Bern
(1950–1952); Rolf Bürgi, Belp (1953–1967)
Location: Private collection

139

der Ärmste zu Ostern, 1939,386 (A 6)
The Poorest at Easter
Ölfarben / Detailpapier; Mehrfarbiges Blatt
Oil on paper with spots of glue on card; edges of the
paper covered with strips of cotton
45.7/46×31.2/31.9 cm; signed upper right with pen:
Klee; inscribed lower left on the card with pen:
1939 A 6 – lower right with pen: *der Ärmste zu Ostern*
Provenance: Lily Klee, Bern (1940–1946); Klee Society,
Bern (1946–1950); Rolf Bürgi, Klee Society, Bern
(1950–1952); Rolf Bürgi, Belp (1953–1967)
Location: Private collection

140

armer Engel, 1939,854 (UU 14)
Poor Angel
Aquarell– und Temperafarben / Zeitungspapier schwarz
grundiert; Mehrfarbiges Blatt
Pencil, watercolour and tempera on black ground on
paper with spots of glue on card
48.7×32.2/32.7 cm; signed upper left with pen: *Klee;*
inscribed lower left on the card with pen: *1939 UU 14*
– lower right with pen: *armer Engel* – bottom centre
with pencil: *X*
Provenance: Lily Klee, Bern (1940–1946); Klee Society,
Bern (1946–1950); Rolf Bürgi, Klee Society, Bern
(1950–1952); Rolf Bürgi, Belp (1953–1967)
Location: Private collection

141

wachsamer Engel, 1939,859 (UU 19)
Vigilant Angel
Reissfeder mit weisser Temperafarbe / Zeitungspapier
schwarz grundiert; Einfarbiges Blatt
Pencil, pen and tempera on black ground on paper on
card
Condition: the original inscription on the card has
been trimmed away; it is no longer extant.
48.6×32.8/33 cm; signed lower left with pen: *Klee*
Provenance: Lily Klee, Bern (1940–1946); Klee Society,
Bern (1946–1950); Rolf Bürgi, Klee Society, Bern
(1950–1952); Rolf Bürgi, Belp (1953–1967)
Location: Private collection

142

Engel, übervoll, 1939,896 (WW 16)
Angel, Brimful
Aquarellfarben / Japan; Mehrfarbiges Blatt
Watercolour and pencil on paper with spots of glue
on card
51.8/53.1×36.3/37.3 cm; signed lower right in water-
colour(?): *Klee;* inscribed bottom centre on the card
with pen: *1939 WW 16 Engel, übervoll* – lower right
with pencil: *für Rolf und Käthi Bürgi z. Weihnachten*
1939 K
Provenance: Rolf and Käthi Bürgi, Belp (1939–1967;
gift of the artist)
Location: Private collection
Related works: *Vor Frǒme*, 1939,1049 (EF 9), paste
colour on paper on card, 45.5×30 cm, private collec-
tion, USA; *Engel vom Stern*, 1939,1050 (EF 10), paste
colour and chalk on paper on card, 61.8×46.2 cm,
Paul Klee Foundation, Kunstmuseum Bern

143
LEVIATHAN von der Dult, 1939,1048 (EF 8)
Leviathan of the Fair
Kleisterfarbe mit dem Messer / gelbliches Packpapier;
Mehrfarbiges Blatt
Paste colour and lithographic crayon on paper with
spots of glue on card
30/30.2×44.3/44.5 cm; signed upper left with lithogra-
phic crayon: *Klee*; inscribed upper left on the card with
pencil: *Leviathan* – lower left with pen: *1939 EF 8* –
lower right with pen: *LEVIATHAN* – and with pencil:
von der Dult – below this with pencil: *für Rolf Bürgi*
Weihnachten 1939 K
Provenance: Rolf Bürgi, Belp (1939–1967; gift of the
artist)
Location: Private collection

144
Geist der Schiffer, 1939,1094 (GH 14)
Spirit of the Navigators
Pinselzeichnung mit Kleister–Terra di Siena gebrannt /
gelbes Packpapier; Einfarbiges Blatt
Terra di Siena, burnt and bound with paste, on paper
with spots of glue on card
45×59.8 cm; signed upper right with pen, faded: *Klee*;
inscribed lower right with pencil: *Geist der Schiffer* –
lower left on the card with pen: *1939 GH 14* – lower
right with pen: *Geist der Schiffer*
Provenance: Lily Klee, Bern (1940–1946); Klee Society,
Bern (1946–1950); Rolf Bürgi, Klee Society, Bern
(1950–1952); Rolf Bürgi, Belp (1953–1967)
Location: Private collection

145
Ohne Titel, ca. 1939
Untitled
Pencil on paper
29.7×20.9 cm

Provenance: Lily Klee, Bern (1940–1946); Klee Society,
Bern (1946–1950); Rolf Bürgi, Klee Society, Bern
(1950–1952); Rolf Bürgi, Belp (1953–1967)
Location: Private collection

146 (not illustrated)
Wotan, ca. 1939
Wotan
Pencil on paper, verso pen
29.7×20.9 cm; inscribed bottom centre with pencil:
Wotan
Provenance: Lily Klee, Bern (1940–1946); Klee Society,
Bern (1946–1950); Rolf Bürgi, Klee Society, Bern
(1950–1952); Rolf Bürgi, Belp (1953–1967)
Location: Private collection

147 (not illustrated)
Ohne Titel, ca. 1939
Untitled
Pencil on paper
29.7×20.9 cm
Provenance: Lily Klee, Bern (1940–1946); Klee Society,
Bern (1946–1950); Rolf Bürgi, Klee Society, Bern
(1950–1952); Rolf Bürgi, Belp (1953–1967)
Location: Private collection

148
Assel, 1940,287 (K 7)
Woodlouse
Kleisterfarben / Biber Concept Pap; Blatt mehrfarbig
Paste colour on paper with spots of glue on card
29.5×41.6/41.8 cm; signed upper left on sheet and
card with pen: *Klee*; inscribed lower left on the card
with pen: *1940 K 7* – lower right with pen: *Assel*
Provenance: Lily Klee, Bern (1940–1946); Klee Society,
Bern (1946–1950); Rolf Bürgi, Klee Society, Bern
(1950–1952); Rolf Bürgi, Belp (1953–1967)
Location: Private collection

149
Pferd am Waldsee, 1940,309 (H 9)
Horse by the Woodland Lake
Kleister– und Aquarellfarben / Bambou Japon; Blatt
mehrfarbig
Watercolour and paste colour on paper with spots of
glue on card
29.2×20.7 cm; signed upper right with pen: *Klee*;
inscribed bottom centre on the card below border line
with pen: *1940 H 9 Pferd am Waldsee* – lower right
with pencil: *Pferd am Waldsee*
Provenance: Lily Klee, Bern (from 1940); Hans Fehr,
Bern; Rolf and Käthi Bürgi, Belp (until 1967)
Location: Private collection

150
vermält, 1940,363 (E 3)
Married
schwarze Kleisterfarbe / Bambou Japon; Blatt
einfarbig
Paste colour on paper with spots of glue on card
29.3×21 cm; signed lower right on sheet and card with
pen: *Klee*; inscribed bottom centre on the card with
pen: *1940 E 3 vermält*
Provenance: Lily Klee, Bern (1940–1946); Klee Society,
Bern (1946–1950); Rolf Bürgi, Klee Society, Bern
(1950–1952); Rolf Bürgi, Belp (1953–1967)
Location: Private collection

Bibliography

List of short titles of unpublished texts and documents

Bern 1937
'Paul Klee. Leihgaben der Frau H. Bürgi und Besitz des Kunstmuseums', Kunstmuseum Bern, September 1937–September 1938 (list of exhibits)

Bürgi 1947
Rolf Bürgi, 'Meine Erinnerungen an Paul Klee', [?1947] (typescript: ABB)

Bürgi 1951
Rolf Bürgi, 'Nachlass Klee. Meine Ausführungen zur Vernehmlassung der Schweizerischen Verrechnungsstelle vom 19. Oktober 1951', Bern, 28.11.1951 (typescript: ABB)

Bürgi 1998
Christoph A. Bürgi, 'Erinnerungen an meine Grosseltern und Eltern', recorded in November 1998 (typescript: ABB)

Huggler 1936
Max Huggler, 'Jahresbericht 1934/35 über die Tätigkeit des Vereins Kunsthalle Bern', Bern 1936 (typescript: KhB)

Klee L
Lily Klee, 'Lebenserinnerungen', from 1942, manuscript (copy: NFK)

PN
Paul Klee, 'Pädagogischer Nachlass', PN 10 M9, Transcript by Katalin von Walterskirchen, undated [?1960] (KmB/PKS)

RB - MK, 26.4.1933
Letter with enclosed report from Rolf Bürgi, Bern, to Mathilde Klee, Bern, 26.4.1933 (ABB)

Rupf 1951
Hermann Rupf, 'Bemerkungen zur Vernehmlassung der Verrechnungsstelle in Sachen Nachlass KLEE', undated [?1951] (typescript: ABB)

Vereinsprotokoll
'Protokoll des Vereins der Freunde des Berner Kunstmuseums' [Minutes of meetings of the Friends of the Kunstmuseum Bern], from 1921 (KmB)

List of short titles of cited literature and exhibition catalogues

Bäschlin/Ilg/Zeppetella 1998
Natalie Bäschlin, Béatrice Ilg, Patrizia Zeppetella, 'Beiträge zur Maltechnik von Paul Klee', lecture held at the International Symposium *Zur Kunst und Karriere Paul Klees*, 16–17 October 1998, Bern, organised by the Paul Klee Foundation, Kunstmuseum Bern; Institut für Kunstgeschichte der Universität Bern. The proceedings of the symposium are due to be published in autumn 2000.

Basel 1935
Paul Klee, Kunsthalle Basel, 27.10–24.11.1935

Beerhorst 1992
Ursula Beerhorst, 'Studien zur Maltechnik von Willi Baumeister', in: *Zeitschrift für Kunsttechnologie und Konservierung*, vol. 6, part 1, 1992

Berlin 1985
Paul Klee als Zeichner 1921-1933, exh. cat. Bauhaus-Archiv, Berlin, 5.5–7.7.1985; Städtische Galerie im Lenbachhaus, Munich, 28.8–3.11.1985; Kunsthalle Bremen, 17.11.1985–5.1.1986

Bern 1931
111. Ausstellung: Paul Klee, Walter Helbig, M. de Vlaminck, Philipp Bauknecht, Plastik Arnold Huggler, Kunsthalle Bern, 18.1–15.2.1931

Bern 1935
Paul Klee / Kleinplastiken von Hermann Haller, Kunsthalle Bern, 23.2–24.3.1935

Bern 1990
Paul Klee. Das Schaffen im Todesjahr, Kunstmuseum Bern, 17.8–4.11.1990

Bomford et al. 1990
David Bomford, Jo Kirby, John Leighton, Ashok Roy, *Impressionist Art in the Making*, New Haven/London 1990

Bürgi 1948
Rolf Bürgi, '1922–1933–1939', in: *Du. Schweizerische Monatsschrift*, Zurich, vol. 8, no. 10, October 1948, pp. 25f. (reprinted in this catalogue pp. 267f.)

Bürgi-Lüthi 1987
[Catherine E. Bürgi-Lüthi], 'Paul Klee hat an unserer Hochzeit Geige gespielt' (Klee-Erinnerungen 4), in: *Berner Zeitung*, Bern, 24.9.1987

Cat. Rais. vol. 1
Catalogue Raisonné Paul Klee, ed. by the Paul Klee Foundation, Kunstmuseum Bern, vol. 1, 1883–1912, Bern 1998

Cat. Rais. vol. 3
Catalogue Raisonné Paul Klee, ed. by the Paul Klee Foundation, Kunstmuseum Bern, vol. 3, 1919–1922, Bern 1999

Falkner 1996
Schweizerisches Musik-Archiv, *Werkverzeichnis Albert Moeschinger 1897–1985*, ed. by Felix Falkner for the Albert Moeschinger-Stiftung, Zurich 1996

Frey 1990
Stefan Frey, 'Chronologische Biographie (1933-1941)', in: Bern 1990, pp. 111–132

Frey 1996
Stefan Frey, 'Paul Klee in Bern', in: *Paul Klee – Die Zeit der Reife. Werke aus der Sammlung der Familie Klee*, exh. cat. Kunsthalle Mannheim, 23.3–16.6.1996, pp. 175–184

Frey-Surbek 1938
Marguerite Frey-Surbek, 'Rückblick auf eine Persönlichkeit', in: *Frauen-Zeitung "Berna". Organ des Bernischen Frauenbundes. Blatt für bernische und allgemeine Fraueninteressen*, vol. 40, no. 5, 9.9.1938, p. 38 (excerpts reprinted in this catalogue p. 259)

Frey-Surbek 8/1938
M. F. [Marguerite Frey-Surbek], 'Ein Hinschied', in: *Der Bund*, Bern, vol. 89, no. 387, 21.8.1938, Sunday edition, p. 5

Glaesemer 1973
Jürgen Glaesemer, *Paul Klee. Handzeichnungen I. Kindheit bis 1920*, Bern 1973

Glaesemer 1984
Jürgen Glaesemer, *Paul Klee. Handzeichnungen II. 1921–1936*, Bern 1984

Grohmann 1954
Will Grohmann, *Paul Klee*, Stuttgart 1954

Gutbrod 1968
Karl Gutbrod (ed.), *"Lieber Freund…". Künstler schreiben an Will Grohmann*, Cologne 1968

Haxthausen 1998
Charles Haxthausen, 'Ad Marginem: Klee's Art of Accommodation', lecture held at the International Symposium *Zur Kunst und Karriere Paul Klees*, 16–17 October 1998, Bern, organised by the Paul Klee Foundation, Kunstmuseum Bern; Institut für Kunstgeschichte der Universität Bern. The proceedings of the symposium are due to be published in autumn 2000.

Hopfengart 1989
Christine Hopfengart, *Klee. Vom Sonderfall zum*

Publikumsliebling. Stationen seiner öffentlichen Resonanz in Deutschland 1905–1960, Mainz 1989

Huggler 1939
Max Huggler, [Obituary for Hanni Bürgi-Bigler], in: *Bericht über die Tätigkeit der Kunsthalle Bern 1938*, Bern 1939, p. 3 (reprinted in this catalogue p. 259)

Huggler 1969
Max Huggler, *Paul Klee. Die Malerei als Blick in den Kosmos*, Frauenfeld/Stuttgart 1969

Huggler 1996
Max Huggler, '"Paul Klee aus persönlicher Sicht". Vortrag gehalten am 17. März 1994 im Kunstmuseum Bern anlässlich der Eröffnung der neuen Klee-Säle', in: *Berner Almanach*, vol. 1: Kunst, ed. by Norberto Gramaccini and Michael Krethlow, Bern 1996, pp. 100–111

Kain et al. 1999
Thomas Kain, Mona Meister and Franz-Joachim Verspohl, 'Eine Integrale Biografie Paul Klees. Der künstlerisch-intellektuelle und musikalisch-gesellige "Lebenslauf Werklauf" Paul Klees zwischen 1921 und 1926', in: *Paul Klee in Jena 1924. Der Vortrag*, ed. by. idem (Minerva. Jenaer Schriften zur Kunstgeschichte, vol. 10), Jena 1999, pp. 83–356

Kersten 1994
Wolfgang Kersten, 'Textetüden über Paul Klees Postur', in: *Elan Vital oder das Auge des Eros*, exh. cat. Haus der Kunst, Munich, 20.5–14.8.1995, pp. 56–74

Kersten 1997
Wolfgang Kersten, 'Paul Klee. Kunst der Reprise', in: *Lehmbruck, Brancusi, Léger, Bonnard, Klee, Fontana, Morandi: Texte zu Werken im Kunstmuseum Winterthur*, ed. by Dieter Schwarz, Winterthur/ Düsseldorf 1997, pp. 104–135

Kersten 1999
Wolfgang Kersten, '"Von wo aus Ihnen der Künstler gar nicht mehr als abseitige Angelegenheit zu erscheinen braucht" – Kunsthistorische Quellenkunde zu Paul Klees Jenaer Vortrag', in: *Paul Klee in Jena 1924. Der Vortrag*, ed. by Thomas Kain, Mona Meister and Franz-Joachim Verspohl (Minerva. Jenaer Schriften zur Kunstgeschichte, vol. 10), Jena 1999, pp. 71–76

Kersten/Okuda 1995
Wolfgang Kersten and Osamu Okuda, *Paul Klee – Im Zeichen der Teilung. Die Geschichte zerschnittener Kunst Paul Klees 1883–1940. Mit vollständiger Dokumentation*, exh. cat. Kunstsammlung Nordrhein-Westfalen, Düsseldorf, 21.1–17.4.1995; Staatsgalerie Stuttgart, 29.4–23.7.1995

Kersten/Trembley 1990
Wolfgang Kersten and Anne Trembley, 'Malerei als Provokation der Materie. Überlegungen zu Paul Klees Maltechnik', in: Bern 1990, pp. 77–91

Klee 1960
Felix Klee, *Paul Klee. Leben und Werk in Dokumenten, ausgewählt aus den nachgelassenen Aufzeichnungen und den unveröffentlichten Briefen*, Zurich 1960

Klee 1966
Felix Klee, 'Bericht zur Geschichte der Nachlasssammlung Felix Klee', in: *Paul Klee. Zeichnungen, Aquarelle*, exh. cat. Fränkische Galerie, Nuremberg, 23.10-11.12.1966, n. p.

Klee 1988
Paul Klee, *Tagebücher 1898–1918*, new critical edition, ed. by the Paul Klee Foundation, prepared by Wolfgang Kersten, Stuttgart/Teufen 1988

Klee BF/1
Paul Klee, *Briefe an die Familie 1893–1940*, vol. 1: 1893–1906, ed. by Felix Klee, Cologne 1979

Klee BF/2
Paul Klee, *Briefe an die Familie 1893–1940*, vol. 2: 1907–1940, ed. by Felix Klee, Cologne 1979

Klee-Gesellschaft 1947
Klee-Gesellschaft, 'Zur Entstehung der Paul Klee-Stiftung', in: *Paul Klee. Ausstellung der Paul Klee-Stiftung*, exh. cat. Kunstmuseum Bern, 22.11–31.12.1947, pp. 3–6; reprinted in: *Aus der Stiftung Paul Klee*, exh. cat. Kunsthalle Basel, 27.10–21.11.1948, pp. 4–7

Kuthy 1979
Sandor Kuthy (ed.), 'Aus dem Tagebuch des 100 jährigen Kunstmuseums Bern 1879–1978', in: *Berner Kunstmitteilungen*, Bern, nos. 190–192, August 1979

Okuda 1997
Osamu Okuda, 'Paul Klee: Buchhaltung, Werkbezeichnung und Werkprozess', in: *Radical Art History. Internationale Anthologie. Subject: O. K. Werckmeister*, ed. by Wolfgang Kersten, Zurich 1997, pp. 374–397

Schweiger 1994
Werner J. Schweiger, *Rudolf Ibach. Mäzen, Förderer und Sammler der Moderne. 1873–1940*, Bad Vöslau [1994] [Private publication, ed. by Adolf Ibach, Charlotte Mittelsten Scheid-Ibach and the heirs of Etta and Otto Stangl]

Stutzer 1986
Beat Stutzer, 'Paul Klee 1933–1940', in: *Paul Klee. Spätwerke 1937–1940*, exh. cat. Bündner Kunstmuseum, Chur, 27.6–14.9.1986, pp. 109–136

Werckmeister 1985
Otto Karl Werckmeister, 'Paul Klee in Exile,' in: *Paul Klee in Exile 1933–1940*, exh. cat. Himeji City Museum of Art, 31.8–29.9.1985 and elsewhere, pp. 27–174

Werckmeister 1987
Otto Karl Werckmeister, 'Von der Revolution zum Exil', in: *Paul Klee. Leben und Werk*, exh. cat. Kunstmuseum Bern, 25.9.1987–3.1.1988, pp. 31–55

List of Abbreviations: Archives

ABB	Bürgi Archives, Bern
KhB	Kunsthalle Bern: Archives
KmB	Kunstmuseum Bern: Archives
KmB/PKS	Kunstmuseum Bern / Paul-Klee-Stiftung: Archives (Archives of the Paul Klee Foundation)
NFK	Nachlass der Familie Klee, deponiert in der Paul-Klee-Stiftung im Kunstmuseum Bern (Estate of the Klee Family, deposited in the Paul Klee Foundation, Kunstmuseum Bern)
SS/AWG	Staatsgalerie Stuttgart/Will Grohmann Archives

Index of Names

Adler, Jankel, 242
Adrian, Walter, 223
Allenbach, Werner, 9, 204, 205, 207, 209, 214, 261, 263, 264
Anker, Albert, 189
Aragon, Louis, 109
Arp, Hans, 63, 74, 204, 229, 235, 241, 242

Bach, Gabriele, 261
Bach, Johann Sebastian, 202, 257, 267
Bach-Wagner, Carola, 261
Bach-Wagner, Rudolf, 261
Bailly, Alice, 24, 25, 259
Bauhaus, Weimar and Dessau, 18, 19, 75, 93, 94, 109, 110, 187, 194, 199, 220, 243, 247, 250, 266, 267
Baumeister, Willi, 75, 185, 235
Bayer, Herbert, 242
Benteli-Verlag, Bern, 205, 263
Bergson, 222, 235
Bernische Kunstgesellschaft, 13
Bigler, Johann Christian, 12
Bigler-Siegenthaler, Elise, 12
Bill, Max, 224
Blair, R. K., 231
Blaue Reiter, 63
Bloesch, Hans, 64, 268
Brahms, Johannes, 15, 257, 259
Brancusi, Constantin, 229
Braque, Georges, 158, 234, 235
Breuer, Marcel, 242
Brugger, Adrian, 250
Bührle, Emil Georg, 208
Bürgi, Alfred (husband of Hanni Bürgi), 8, 12, 13, 15, 16, 17, 22, 33, 199, 257
Bürgi, Alfred, called Fredi (son of Alfred and Hanni Bürgi), 13, 15, 17, 19, 20
Bürgi, Alfred, called Fredi (son of Rolf and Käthi Bürgi), 202, 268
Bürgi Archives, 7, 255, 256, 258
Bürgi, Christoph, 202
Bürgi, Emil, 16, 17, 18
Bürgi, Friedrich, 12, 13
Bürgi, Fritz, 13, 15, 17, 19, 21, 22, 25, 201, 203
Bürgi, Gertrud, 201
Bürgi, Hermann, 13, 200
Bürgi, Käthi, 159, 200, 202, 203, 242, 257
Bürgi, Magdalena, 12
Bürgi, Max, 201
Bürgi, Olga Johanna, called Hanni, 8, 11, 12, 13, 14, 15, 16, 17, 18, 19, 20, 21, 22, 23, 24, 25, 26, 27, 33, 34, 75, 109, 110, 139, 140, 151, 152, 199, 202, 203, 214, 219, 220, 221, 222, 255, 256, 257, 258, 259
Bürgi, Peter, 201
Bürgi, Rolf, 8, 9, 11, 13, 14, 15, 16, 17, 18, 19, 22, 25, 26, 27, 139, 140, 151, 159, 186, 199, 200, 201, 202, 203, 204, 205, 206, 207, 208, 209, 210, 211, 212, 214, 239, 240, 241, 242, 255, 256, 257, 258, 260, 261, 262, 263, 264, 266, 267
Bürgi Sketchbook, 242, 247, 250, 251, 252

Bürgi, Wolf, 257, 260

Calder, Alexander, 204
Carnegie Institute, Pittsburgh, 225
Cerny, Lado, 25
Chagall, Marc, 204, 229, 234
Chirico, Giorgio de, 229, 234, 238
Connolly, Cyril, 242
Cooper, Douglas, 206, 236, 237, 239, 240, 241, 242
Crankshaw, Edward, 236
Craxton, John, 242
Crevel, René, 23, 109
Croce, 235
Cursiter, Stanley, 229

Dalí, Salvador, 235
Däubler, Theodor, 74
Daumier, Honoré, 219, 223, 225, 226
Davie, Alan, 243
Delaunay, Robert, 63
Derain, André, 229, 231, 234
Doetsch-Benziger, Richard, 20, 205, 211, 240, 267
Dreier, Katherine, 93
Düsseldorfer Kunstverein, 110

Edschmid, Kasimir, 74
Einstein, Carl, 219, 222
Eliasberg, Alexander, 11
Elnain, Adolf, 17
Eluard, Paul, 109
Ernst, Max, 109, 229, 230, 233, 234, 235

Farner, Konrad, 224, 225
Fechner, Hanns, 235, 236
Feininger, Lyonel, 93, 203
Feldmann, Markus, 210
A. & H. Bürgi, 13
Fr. & A. Bürgi, 12, 15
Fischer, Fritz von, 23, 221
Flechtheim, Alfred, 109, 151, 234, 235, 237, 256, 267
Foggie, David, 232, 233
Freud, Sigmund, 222, 231, 232
Frey-Surbek, Marguerite, 14, 25, 259
Fry, Roger, 233
Fueter, Max, 25

Galleries:
 Galerie Alfred Flechtheim, Berlin und Düsseldorf, 23, 109, 110, 201, 236
 Galerie Fischer, Luzern, 202
 Gutekunst & Klipstein, Bern, 203
 Neue Kunst Fides, Dresden, 109
 Neue Kunst – Hans Goltz, München, 17, 63, 75
 Galerie Pierre, Paris, 109
 Galerie Simon, Paris, 139, 151, 201, 234, 237, 256
 Der Sturm, Berlin, 63, 74, 75
 Galerie Thannhauser, Munich, 63
 Galerie Vavin-Raspail, Paris, 109
Gascoyne, David, 234

Gear, William, 242, 243
Giacometti, Alberto, 229, 235
Giedion-Welcker, Carola, 207, 210, 261
Gieseking, Walter, 25
Goethe, Johann Wolfgang von, 266, 267
Gogh, Vincent van, 64
Goltz, Hans, 75, 109
Greschowa, Efrossina, 204, 261, 266
Grigson, Geoffrey, 234, 235
Gris, Juan, 234, 236, 237, 238
Grohmann, Gertrud, called Eulein, 203
Grohmann, Will, 22, 23, 24, 27, 109,151, 203, 211, 219, 222, 224, 256, 257
Gropius, Walter, 75, 109, 241, 242, 267
Grosz, George, 234, 235, 236
Guggenheim, Solomon R., 206

Haller, Hermann, 219
Hamilton, Richard, 242, 243
Hausenstein, Wilhelm, 74, 93
Havinden, Ashley, 242
Hepworth, Barbara, 229, 235
Hermann Bürgi & Co., 201
Hillier, Tristram, 235
Hitchens, Ivon, 235
Hitler, Adolf, 139, 140, 223
Hofer, Carl, 234
Hogrebe, Wolfram, 195
Hopfengart, Christine, 223
Huber, Othmar, 205, 208
Huggler, Max, 23, 24, 25, 27, 205, 209, 210, 214, 221, 222, 223, 224, 259, 265
Huxley, Julian, 242

Institute of Modern Art, Boston, 238
Ironside, Robin, 240

James, Philip, 240, 241
Jawlensky, Alexej von, 63, 93, 158, 203, 241, 242
Joyce, James, 222, 232
Jung, Carl Gustav, 222

Kahnweiler, Daniel-Henry, 139, 151, 158, 201, 206, 234, 235, 237
Kandinsky, Wassily, 63, 74, 93, 109, 139, 158, 189, 203, 231, 235, 267, 242
Kayser, Hans, 268
Kestner-Gesellschaft, Hannover, 110
Kirchner, Ernst Ludwig, 23, 213, 235, 259
Kirchner Estate, 207
Klee, Alexander, called Aljoscha, 204, 261, 266
Klee, Felix Paul, 9, 14, 34, 158, 199, 204, 207, 208, 209, 212, 213, 214, 247, 250, 260, 261, 263, 265, 266
Klee, Hans, 8, 14, 15, 259
Klee, Ida, 15
Klee, Mathilde, 15, 200, 209, 210, 240, 261, 263, 266
Klee Society (founded 1925), 8, 19, 20, 109
Klee Society (founded 1946), 183, 207, 209, 210, 211, 212, 213, 247, 260, 263, 264, 265

Klee-Grejova, Efrossina, see Greschowa, Efrossina
Klee-Stumpf, Karolina Sophie Elisabeth, called Lily, 8,
 9, 11, 14, 15, 17, 19, 20, 21, 25, 26, 27, 34, 139,
 158, 183, 188, 189, 199, 200, 201, 202, 203, 204,
 205, 206, 207, 208, 210, 212, 213, 219, 239, 240,
 241, 242, 256, 257, 260, 261, 262, 263, 265, 266,
 267
Klinger-Stumpf, Marianne, 261
Knirr, Heinrich, 33, 247
Koehler, Bernhard, 11
Kubin, Alfred, 34, 63
Kunsthalle Basel, 22, 34, 151
Kunsthalle Bern, 13, 22, 23, 24, 27, 151, 159, 187,
 203, 205, 219, 220, 221, 255, 259
Kunsthaus Zürich, 158, 211, 212
Kunstmuseum Basel, 209, 240, 263
Kunstmuseum Bern, 8, 9, 23, 25, 26, 34, 187, 204,
 205, 209, 210, 211, 221, 239, 240, 256, 257, 263
Kunstverein Jena, 93

Le Corbusier, 19, 229
Léger, Fernand, 234, 235, 237
Leicester Galleries, 239, 240
London Gallery, London, 238, 239, 242
Loosli, Carl Albert, 219
Lotmar, Fritz, 11
Lotmar, Heinz, 11
Lurçat, Jean, 235
Lüthi, Käthi, 202
Lyceum Club, 24, 25

Macke, August, 63, 64
Mandach, Conrad von, 23, 221
Marc, Franz, 63, 74, 203, 231
Marcoussis, Louis, 235
Marini, Marino, 204
Masson, André, 233, 234
Matisse, Henri, 229, 234, 240
Matter, E., 265
Mayor Gallery, London, 151, 233, 234, 235, 236, 237
Mayor, Freddy, 234, 237, 238, 240
McLellan Galleries, Glasgow, 230
Mesens, E.L.T., 242
Meyer, Hannes, 110
Meyer-Benteli, Hans, 9, 204, 205, 207, 209, 212, 214,
 261, 262, 263, 264, 268
Miliani, Pietro, 250
Miller, Oskar, 11
Miró, Joan, 204, 233, 234, 235, 236, 237, 238, 241,
 242
Moeschinger, Albert, 25
Moholy-Nagy, László, 242, 267
Moilliet, Louis, 25, 64, 158
Moore, Henry, 204, 229, 235, 242
Mortimer, Raymond, 240
Moser, Rudolf, 265
Munch, Edvard, 229, 230, 231, 232
Münter, Gabriele, 74, 231
Museum of Modern Art, New York, 110, 151, 211
Museums-Gesellschaft Bern, 13

Nash, Paul, 235
National Gallery, London, 206, 233, 239, 240, 242
Nationalgalerie Berlin, 110, 267
Nebel, Otto, 206, 222
Neumann, J. B., 158
New Burlington Galleries, London, 230, 238
Nicholson, Ben, 235
Nierendorf Gallery, New York, 206, 211
Nierendorf, Karl, 158, 206, 208, 211
Nolde, Emil, 235
Norton, Clifford, 206, 241
Norton, Noël, called Peter, 241, 242

O'Rorke, Brian, 235
Öffentliche Kunstsammlung Basel, 211
Oppenheim, Meret, 189

Paolozzi, Eduardo, 243
Pasmore, Victor, 242, 243
Paul Klee Museum, 7
Paul Klee Society, New York, 208, 209
Paul Klee Foundation, 9, 93, 159, 183, 187, 199, 204,
 210, 211, 212, 213, 214, 256, 257, 260, 261,
 264, 265
Penrose, Roland, 235, 237, 240, 241, 242
Phillips, Rodney, 240
Picasso, Pablo, 158, 229, 231, 234, 235, 237, 238,
 240, 267
Plaut, James S., 241
Porteus, Hugh Gordon, 234

Ralfs, Otto, 8, 19, 109, 110, 255, 256
Read, Herbert, 229, 230, 231, 232, 233, 234, 235,
 236, 237, 239, 241, 242, 243
Rebay, Hilla von, 206, 207
Richardson, John, 241, 242
Rilke, Rainer Maria, 74
Rodin, Auguste, 33
Rothenstein, John, 239, 240, 241, 242
Rotzler, Willy, 224
Royal Scottish Academy, Edinburgh, 230, 231
Rupf, Hermann, 9, 20, 22, 139, 151, 204, 205, 209,
 210, 212, 261, 262, 263, 264, 265, 268
Rupf, Margrit, 20, 151

Sadler, Michael, 231
Sauerlandt, Max, 231
Scheyer, Emmy (Galka), 93
Schlemmer, Oskar, 74, 267
Schmidt, Georg, 224, 225
Schmidt-Rottluff, Karl, 235
Schönefeld & Co., 188
Schubert, Franz, 15, 257, 259
Severini, Gino, 229
Société Anonyme, New York, 93
Society of Scottish Artists, 231, 232
Staatliche Kunstakademie, Düsseldorf, 110, 139, 201,
 223, 242, 266
Staatsgalerie Stuttgart, 247, 256, 257
Städtische Galerie im Lenbachhaus, Munich, 222
Stokes, Adrian, 234

Straub, Hans, 264
Stuck, Franz von, 33
Stumpf, Lily, see Klee-Stumpf, called Lily
Stumpf, Ludwig, 266
Surbek, Victor, 25
Sylvester, David, 243

Tate Gallery, London, 239, 240, 241
The Blue Four, 94
Tchelitchew, 231
Tzara, Tristan, 74

Utrillo, Maurice, 234

Valentin, Curt, 158, 159, 211
Vico, 235
Vömel, Alexander, 235
Voltaire, 63

Wadsworth, Edward, 235
Wagner, Hugo, 23
Walden, Herwarth, 63, 75
Washington Agreement, 9, 207, 209, 212, 213, 262
Watson, Peter, 242
Wedderkop, Hermann von, 17, 18, 75
Werckmeister, Otto Karl, 223
Werefkin, Marianne von, 158
Westwater, R. H., 232
Will-Grohmann-Archiv, 256
Winsor & Newton, 188
Wirtz, Otto, 261
Wellington, Hubert, 229, 231
Wollheim, Richard, 242

Zadkine, Ossip, 229
Zahn, Leopold, 75
Zervos, Christian, 109
Zschokke, Alexander, 223

List of Abbreviations

HB	Hanni Bürgi
KB	Käthi Bürgi
RB	Rolf Bürgi
KF	Konrad Fehr
GG	Gertrud Grohmann
WG	Will Grohmann
GGr	Gertrud Grote
MH	Max Huggler
FK	Felix Klee
IK	Ida Klee
LK	Lily Klee
MK	Mathilde Klee
PK	Paul Klee
K-G	Klee-Gesellschaft/Klee Society
RM	Rudolf Moser
OR	Otto Ralfs
HR	Hermann Rupf
SV	Schweizerische Verrechnungsstelle/ Swiss Compensation Office

Photographic Credits

Adolf Elnain, Wiesbaden; Bürgi Archives/Paul Klee Foundation, Kunstmuseum Bern: Frontispiece

Essay by Stefan Frey, pp. 11–31

Emil Vollenweider, Bern; private collection: 12 (left), 13 (left)
A. Wicky, Bern; private collection: 12 (right)
Franz Henn, Bern; Staatsarchiv, Bern: 13 (right), 24 (left)
Schweizerischer Nationalfonds, Bern: 14
Private collection: 15 (left)
Kunstmuseum Bern: 15 (right)
Werkzeitung der Schweizerischen Industrie, Dec. 1938: 16
Peter Lauri, Bern; Bürgi Archives/Paul Klee Foundation, Kunstmuseum Bern: 18, 21, 22, 24 (right)
Franz Henn, Bern; Estate of Victor and Marguerite Surbek-Frey, Bern: 26

Essay by Nathalie Bäschlin/Béatrice Ilg/Patrizia Zeppetella, pp. 183–197

Paul Klee; Estate of the Klee Family, deposited in the Paul Klee Foundation, Kunstmuseum Bern: 187
Béatrice Ilg, Bern; photo archive of the restoration department, Kunstmuseum Bern: 188 (top left)
Peter Lauri, Bern; Bürgi Archives/Paul Klee Foundation, Kunstmuseum Bern: 188 (bottom left; right)
Patrizia Zeppetella, Bern; Restaurierungsateliergemeinschaft Bösiger und Zeppetella, Bern: 190–192, 194

Essay by Stefan Frey, pp. 199–217

W. Waeber, Thun; Bürgi Archives/Paul Klee Foundation, Kunstmuseum Bern: 200, 201
Paul Klee Foundation, Kunstmuseum Bern: 205
Peter Lauri, Bern; Bürgi Archives/Paul Klee Foundation, Kunstmuseum Bern: 207, 209–211
Martin Hesse, Bern; Bürgi Archives/Paul Klee Foundation, Kunstmuseum Bern: 213

Essay by Osamu Okuda, pp. 219–227

Roland Aellig, Bern; Kunsthalle Bern: 219
Peter Lauri, Bern; Paul Klee Foundation, Kunstmuseum Bern: 220, 222 (left), 225
Gerhard Howald, Bern/Kirchlindach: 221
Gaston Cauvin, Paris; Paul Klee Foundation, Kunstmuseum Bern: 222 (right)

Essay by Richard Calvocoressi, pp. 229–245

National Galleries of Scotland, Edinburgh: 230, 232, 233, 236, 238, 239
Variétés, vol. 2. no 7, 15.11.1929: 234
Howard Coster / National Portrait Gallery, London: 228
The Museum of Fine Arts, Houston: 237

Essay by Wolfgang Kersten, pp. 247–253

Peter Lauri, Bern; Paul Klee Foundation, Kunstmuseum Bern: 249
Peter Lauri, Bern; Bürgi Archives/Paul Klee Foundation, Kunstmuseum Bern: 251
Paul-Klee-Stiftung, Kunstmuseum Bern: 252

Appendix

Peter Lauri, Bern; Bürgi Archives/Paul Klee Foundation, Kunstmuseum Bern: 255, 257, 258
Gaston Cauvin, Paris; Paul Klee Foundation, Kunstmuseum Bern: 256 (left)
Peter Lauri, Bern; Paul Klee Foundation, Kunstmuseum Bern: 256 (centre; right)